The Memories of an American Impressionist

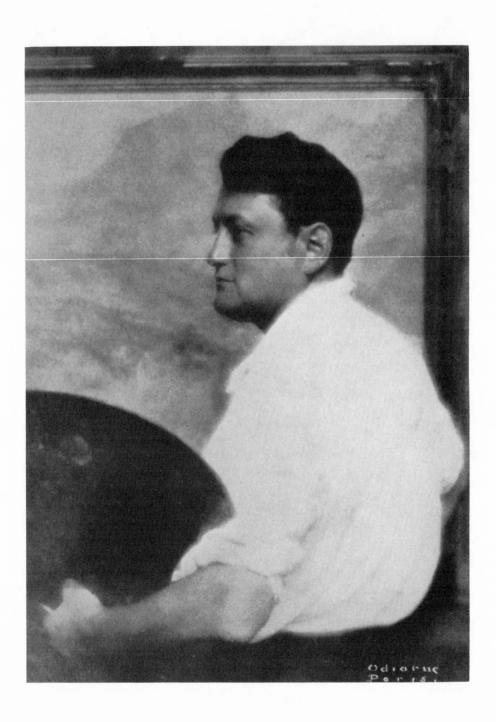

The Memories
of an
American Impressionist

ABEL G. WARSHAWSKY

Edited and with an Introduction by

BEN L. BASSHAM

The Kent State University Press

Copyright © 1980 by The Kent State University Press, Kent, Ohio 44242
All rights reserved
Library of Congress Catalog Card Number 80-82203
ISBN 0-87338-249-8

Library of Congress Cataloging in Publication Data

Warshawsky, A G 1883–
The memories of an American Impressionist.

Includes index.
1. Warshawsky, A. G., 1883– 2. Painters
—United States—Biography. 3. Impressionism
(Art)—United States. I. Title.
ND237.W3534A2 1980 759.13 [B] 80–82203
ISBN 0-87338-249-8

Contents

Illustrations

Preface

THE AUTOBIOGRAPHY of Abel G. Warshawsky came to the Kent
State University Press in 1978 in the form of an untitled, 432-page
typescript. Its episodic and disjointed organization suggests that the
writer used a diary or journal as the basis for his narrative, but no such
documents have been located, and, unfortunately, the original manu-
script, written during or just after 1931 while Warshawsky was recov-
ering from a crippling injury, has also been lost. Was *The Memories
of an American Impressionist* dashed off in a matter of weeks, *au premier
coup*, like one of his landscapes painted in an afternoon? Or did War-
shawsky write several drafts of the story of his career over a long period
of time, carefully refining his sentences and, more important, distilling
their content until he gave the reader only what the author (and the
book's protagonist) wanted him to know? The answer is probably that,
yes indeed, it was written quickly, with little attention paid to organiza-
tion, clarity of chronology, and a number of other aspects to be discussed
shortly. But at the same time it is a carefully crafted and highly selec-
tive self-portrait, a success story, in fact, from which all but one or two
moments of sadness or instances of setback have been expunged. We are
presented, for example, with a lovingly composed profile of the vital and
rather rebellious Arthur Burdett Frost, Jr., pictured in the prime and
with all the promise of his youth, but hear nothing from Warshawsky
on Frost's tragic early death from tuberculosis in 1916.

In a sense Warshawsky edited the story of his life himself in his Paris
studio in 1931. I helped him out by providing a title, organizing the book
into chronological periods, each of which seems to make sense as a major
episode of his early days, and by deleting some sections which, because
they seemed interruptions rather than contributions to his narrative,
were better, I felt, left out. For example, a long discussion of the romantic
life of artists and models in Paris, written in Warshawsky's Victorian
prose with a delicacy extraordinary even for him, seemed to me to be
expendable. Similarly, Warshawsky's denunciation of the practice of
forging Old Masters and a sentimental prose portrait of his little dog
Bicot were, I felt, major digressions, which, if retained, would have been
quite out of proportion in terms of length of treatment with other sub-
jects. I would estimate, however, that less than five percent of the
original text has been deleted, and it is my firm conviction that the
book was improved in the process.

In addition, Warshawsky's spelling and punctuation have been

vii

brought up to date, and French phrases and place names have been checked and corrected for spelling and consistency. But neither I nor the editors of the Kent State University Press have tinkered with Warshawsky's colorful style of writing. The author's use of contemporary idiomatic expressions has been retained, even when in some cases their meaning is less than clear.

A major dilemma was presented by the literally hundreds of names in this autobiography. Shouldn't the reader be told at least something about all those painters, sculptors, gallery dealers, journalists, poets and novelists, some of whom have already been all but completely forgotten? If something should be said about them, where should it be said, and how much? To be sure, Warshawsky briefly identifies some people, but he wasn't consistent in doing so. At first a footnote for each personality mentioned in the text was an option considered, but because of the huge number of names, and the bulk of small, gray type envisioned at the bottoms of pages, the use of footnotes was rejected in favor of the idea of a slightly expanded and enhanced index, in which names are accompanied by the birth and death dates and a phrase describing the person's activity. I researched every personality mentioned in the text in order to ascertain the correct spelling of the name, to learn when he or she lived and might have come into contact with Warshawsky, and to determine the person's profession or artistic specialty. Warshawsky did not always spell names correctly and, occasionally, garbled them badly. "Otto Anton Fiedo," a mysterious figure in the original typescript, turned out to be Anton Otto Fischer. "Adolf Kleiminger" in the original was probably A. F. Kleminger, a painter from Chicago. There are other examples but they are not numerous. On the whole Warshawsky's recording of the past is correct concerning details such as ship sailing dates, the years other artists were in Paris, the occasion of important exhibitions, and so forth.

Finally, I added the dates of the years to Warshawsky's text in order to clarify the chronology for the reader. In general, however, the original book has been changed little in the process of editing.

Many other people had a hand in the preparation of the manuscript for publication or aided my work in an indispensable way. I want to thank first and foremost Florence and David Warshawsky, Abel Warshawsky's sister-in-law and brother, for making me welcome in their home and for providing family photographs and the artist's paintings for study and for use in the book and for their many reminiscences about Abel and Alexander Warshawsky. The publication of *The Memories of an American Impressionist* could not have been done without their generosity and interest. My thanks also to the Office of Research and Sponsored Programs of Kent State University for financial support in the typing of the book, and to my typist, Carolyn Dambrowsky, for her excellent work. My colleagues John Kane and Douglas Radcliff-Umstead helped me a great deal with French names and idiomatic expressions; but any errors in this connection, however grave or acute, are my responsibility and not theirs. I also wish to acknowledge the con-

tributions of David Gray and Jane Farver, both former art history graduate students who helped out in my research; Kenneth P. Goldberg of the library of the Cleveland Institute of Art; Larry Rubens, staff photographer of the Kent State University Audio-Visual Services; and the staff of the library of the Cleveland Museum of Art.

Ben L. Bassham
Kent, Ohio

Introduction

ABEL G. WARSHAWSKY was born in Sharon, Pennsylvania, on December 28, 1883, and died May 30, 1962, in Monterey, California. This book, which he wrote in 1931, is the story of the first and no doubt the happiest half of that long life. Warshawsky, who once described his own work as "classic Impressionism," was a member of the second generation of American Impressionists that came of age in the first decade of the century. From 1908 to 1938 he made his home in France, dividing his time almost equally between Paris and Brittany, and enjoying what must have been one of the most productive, colorful, and happy careers in the history of American art. A gregarious and attractive man, he seemed to know just about everybody of any consequence in the artistic and intellectual community of pre-World War I Paris. When an art student he was entertained by Winslow Homer at Prout's Neck. He was shown around London by Jacob Epstein, and once worked as a model for Antoine Bourdelle. He talked art and drank wine at the Dôme in Paris with Alfred Maurer, Jo Davidson, John Marin, and dozens of other American painters. He painted alongside of Paul Signac in the south of France, and he met the aged Auguste Renoir at Cagnes. In short, he led a rich and rewarding life in art, and because he could write with apparent ease and pleasure and with a touch of pride in his literary abilities, he made it possible for us to enjoy reading the story of that career. The literature on the American artist in Paris at the beginning of the century is varied and vast, but Warshawsky's memoirs add important new information to our knowledge of that period and its personalities.

He wrote his book while laid up for months in his Paris studio with a severe leg injury. Denied access to his easel and his outdoor scenes, he passed the time by converting his journals into a narrative of his life as an artist up to that point. Forty years later and nine years after the artist's death, the only surviving member of his family found the manuscript at the bottom of his brother's steamer trunk. That manuscript, virtually unchanged in the process of editing, is the basis for this book.

Warshawsky's autobiography is a remarkable and valuable document that tells us a good deal about the mentality of a young American painter born in the late nineteenth century who came of age in France during one of the most exciting and confusing periods in the history of art. How Warshawsky came to terms with the conflict between traditional formal values and the challenge of modernism is an important theme of the book, but Warshawsky's memoirs are not complicated by

tortured theorizing and confessions of personal crises, artistic or otherwise. Warshawsky lived on good terms with himself and his art, and it shows in his writing. The book is a celebration of art, and life, and youth in which he shares with us the joy of the many personal discoveries and triumphs he experienced in finding his own way as an artist. Certainly his autobiography will be compared to those of Thomas Hart Benton, Lee Simonson, William Zorach, and Jo Davidson, all of whom were artist friends of his in Paris. Warshawsky's book has a warmth and charm which theirs lack, however, and its greater concentration on the early years of the century, specifically the pre-World War I period, provides a richness of details about the travel, study, and social life of American painters in France.[1] Students of American art will probably be most interested in this connection in the glimpses provided of Benton, Zorach, Hugo Robus, Leon Kroll, Samuel Halpert, and Arthur Burdett Frost, Jr., when they were young men at the beginnings of their careers.[2] They were all close friends of Warshawsky's and of the more than two hundred names in his memoirs, theirs appear most often. With them Warshawsky shared many fondly remembered good times. Like his paintings, his autobiography deals with the sunnier aspects of his life, and it is written in a romantic and colorful style. Warshawsky never ate a large meal, he always consumed "a copius repast." He never drank just wine, but "potations" or (in Sicily) "Vesuvian vintage." Never content with mere fun, he had to enjoy "jollifications." Fishermen are "votaries of the rod," prostitutes are "votaries of Venus," and so forth.

[1] For other painters' autobiographies, see Thomas Hart Benton, *An American in Art* (Lawrence: University Press of Kansas, 1969); Lee Simonson, *Part of a Lifetime, Drawings and Designs, 1919-1940* (New York: Duell, Sloan, and Pearce, 1940); William Zorach, *Art is My Life* (Cleveland: The World Publishing Co., 1967); and Jo Davidson, *Between Sittings* (New York: Dial Press, 1951).

[2] Thomas Hart Benton (1889–1975) arrived in Paris in August of 1908, and was one of the first Americans Warshawsky met there (Benton calls Warshawsky "Abe" in his autobiography). Benton attended the Academie Julian during the fall of 1908 and the Academie Colarossi in the spring of 1909. More important, he was introduced to Impressionist color with which he quickly began to experiment. Like Warshawsky, Benton was mystified by Fauvism, Cubism, and Cézanne. In 1909, however, Benton met Stanton Macdonald-Wright, whose color abstractions inspired Benton's brief period as an avant-garde painter. Benton returned to the United States in July of 1911. There is no evidence that he and Warshawsky met again.

William Zorach (1887–1966) was born in Lithuania and grew up in the Cleveland area. He studied with Warshawsky in Cleveland while employed by the Morgan Lithograph Company. From 1907 to 1909 he was a student at the National Academy of Design in New York. He went to Paris in 1910 where he shared a studio with Warshawsky, who appears to have been an important influence on his decision to make a career in art. Zorach was more receptive to modernist influences than either Benton or Warshawsky: he sent two abstract paintings to the Armory Show, both of which have been described as "wildly modern." He turned to sculpture in 1917. During a long and distinguished career, he produced monumental figures in stone which combined traditional, even classical, imagery and symbolism with abstracted and generalized natural forms.

Hugo Robus (1885-1964), too, began as a painter. He studied and worked in France between 1912 and 1914. At this time he painted in the style of Impressionism, but back in America in the teens he abandoned Impressionism for Futurism. In 1920 he took up sculpture. Like Zorach, Robus studied under Warshawsky, and the two became

His book is rich in imagery and lively in pace, and his sometimes unconsciously humorous prose becomes ultimately one of the most appealing qualities of the man. One cannot help liking a fellow who wears bright new spats over worn-out shoes and who describes the results as adding "an unwonted air of dandyism to my nether extremities."

Warshawsky wants us to know that he had his successes and that he enjoyed every one of them. There is, in fact, a great deal of pleasure awaiting the reader of this book, akin to the kind of good feeling one has when learning of a close friend's good news. There is, too, an exhilarating sense of freedom in these pages, a feeling that the man can go almost anywhere and do almost anything he wants, supported uncompromisingly by family and friends, and sustained by his deep love of art.

Warshawsky was especially well-liked in Cleveland, where he grew up. The Cleveland newspapers never tired of reporting that Abel and his brother, Alex, also a gifted painter, were homegrown artists who had achieved international success.[3] In the years between the wars the press always noted Abel's annual return to Cleveland from Paris and commented favorably on the new pictures he brought back with him. He was an outgoing, handsome, athletic man and had about him a cosmopolitan air that was particularly attractive in the midwestern cities—Chicago and Cincinnati as well as Cleveland—he visited to make personal appearances at exhibitions of his work. But although he had lived *la vie Boheme* in both New York and Paris he somehow did not seem the type. There was nothing effete about him. Instead, he fairly exuded that

especially close. Before the publication of Warshawsky's memoirs, little was known of Robus's activity in France.

Leon Kroll (1884–1974) and Warshawsky met at the Art Students League of New York in 1905 and the next year were classmates at the National Academy of Design, where in later years Kroll served on the faculty. Kroll went to Paris in 1908. His art took on the vivid colors and geometric structure of modern painting—Kroll was especially influenced by Cézanne's art—but he never abandoned the figure and his work retained an essentially conservative character throughout his life. In the 1930s he was quite active as a muralist.

Samuel Halpert (1884–1930) was one of the most promising of America's early modernists. He and Warshawsky traveled through Italy in 1909 and later painted together at Vernon in France. Halpert successfully combined Fauvist color and simplified forms in his paintings of such landmarks as the *Brooklyn Bridge* (1913) and *Notre Dame, Paris* (1925).

Arthur Burdett Frost, Jr. (1887–1917), son of the famous American illustrator, is one of the most intriguing figures in early twentieth-century American art. His early paintings done in France from 1907 to 1912 reflected the influence of Renoir's Impressionism and Matisse's teaching (he was one of the few Americans to study with the French painter). In 1912 Frost met Patrick Henry Bruce and Robert Delaunay, and thereafter Frost was a devoted proselytizer for Orphism. He returned to America in 1914 to spread the theories of color abstraction. Little is known about Frost's art, for his anguished father, who disliked the modernist tendencies in his son's work, burned nearly all of Arthur's canvases after his death in 1917.

[3]Alexander Warshawsky (1887–1945), like his older brother, spent the greater part of his career in France. He arrived in Paris at the age of twenty-eight. For many of the twenty or so years he lived there he occupied Gustave Courbet's former studio. Alex painted landscapes and portraits of Breton peasants and fishermen in a style distinctly differ-

peculiarly American blend of artistic sensitivity and masculine assertiveness found so frequently in the personalities of our painters active early in the century, and for which George Wesley Bellows, another Ohioan, stands as the outstanding example. Like Bellows, Warshawsky was a baseball player, a pitcher, in fact, who, by his own account, was good enough to support himself during his art student days in New York City by playing on weekends with a semipro team. He was also a skillful, "scientific" boxer, who in his quiet, modest way was on virtually every occasion able to outfeint, outfox, and, eventually, flatten every opponent, thereby gaining the awestruck respect of Americans and Frenchmen alike. He was a vigorous man who was always happiest when he was outdoors. In the last months of World War I and for a brief period after the Armistice, he was employed by the French government as a physical education instructor for French troops. With his thick chest and massive jaw he cut a striking figure. Someone nicknamed him "Buck" and the name stuck. Everyone liked him. "A more un-arty type than Buck would be hard to imagine," said one friend.[4] Despite his athletic and dynamic personality, Warshawsky was a sensitive artist, capable of achieving an art of great delicacy and gentle moods. His art lacks the swagger of the better-known "masculine" painters, like Edward Willis Redfield and W. Elmer Schofield, men who worked in heavy-handed impressionist styles.

Warshawsky was the second son of Orthodox Jewish parents recently arrived from Poland. After the family moved to Cleveland Abel grew up on Orange Street on the East Side and graduated from the Brownell School on Fourteenth Street. The family was poor, and large (Abel had four brothers and four sisters), but there seems never to have been any opposition to his choice to make a career in art, despite the fact that few American artists prospered at the time Buck began attending classes at the Cleveland School of Art around 1900.

The profession of artist, in fact, was close to the bottom of an economic depression caused by the persistent demand in the art market for European pictures at the same time that an extraordinary number of young Americans decided to become artists. The handful of economically successful American painters at the turn of the century, except Winslow Homer, were those who worked in the latest European style from Paris or Munich, a style usually tempered by a native tendency toward realistic treatment and emphasis upon sentiment. Although Thomas Eakins, the greatest of America's realist painters, urged his countrymen to stay at

ent from Abel's. In fact, Alex's pictures appear at first glance to be the work of a naive artist, but their flat shapes with clear outlines, their smoothly brushed surfaces and high-keyed colors are really the creations of a highly sophisticated and sensitive artist. Despite the obvious differences in style, Alex's paintings were occasionally confused with Abel's, because both brothers were at times listed in exhibition catalogs as "A. Warshawsky." With good humor Alexander put an end to that problem by taking the professional name of Xander. This interesting artist's life and work are deserving of a separate study.

[4]*The Plain Dealer*, June 6, 1962.

home to develop native themes and a national "school," our young artists more than ever looked to Europe for guidance in artistic matters. The attractive superficialities of John Singer Sargent and William Merritt Chase, achieved through a combination of high-keyed colors and "spontaneous" brushwork, and the silvery elegance of James Whistler's art represented the most advanced American work. Significantly, the sensibilities of Sargent and Whistler were more European than American. Most young artists followed their lead, as, for example, did the young Alfred Maurer ("Alfy" in Buck's memoirs), or attempted, with varying results, to adopt the colors, light, broken brushstrokes, texture, and subject matter of the French Impressionists. A group of American Impressionists known as "The Ten," which included some of the brightest painters of the generation born before the Civil War, constituted America's "avant-garde."[5]

Impressionism had its beginnings in France in the 1860s, but did not take hold in the United States until the 1880s, largely as a result of the immense influence of Claude Monet, the most consistent and orthodox Impressionist and easily that movement's strongest personality. After Monet settled at Giverny in 1883 a small colony of American painters grew up there and in nearby Vernon. Giverny became practically a pilgrimage shrine for the American painters Lilla Cabot Perry, John Singer Sargent, Willard Metcalf, and Theodore Robinson. Theodore Butler, another American convert to Impressionism, married Monet's stepdaughter and lived in Giverny for many years. Frederick Frieseke, who executed conventional figure compositions with a bright palette of blues, lavenders, and pinks, bought a house next to the French master in 1906.

Partly because of deeply ingrained native tendencies and partly no doubt because of an inability to understand Monet's teaching entirely, the American Impressionists never completely went over to his perceptual mode of painting, with its overriding concern for what Monet called the *enveloppe*, that representation of the light, air and moisture that surrounded the subject, all expressed through Impressionism's primary tools, color and texture. As Donelson Hoopes has written.

[The Americans] were perhaps more enchanted with the technique than with the substance of Impressionism. For in French hands, Impressionism was always a consideration of light and color, and subject matter only secondarily. No American artist ever went so far as Monet. . . in dissolving form and subject matter into pearly color.[6]

[5]"The Ten" were Thomas W. Dewing, Edmund C. Tarbell, Frank W. Benson, Joseph De Camp, J. Alden Weir, John W. Twachtman, Willard L. Metcalf, E. E. Simmons, Childe Hassam, and Robert Reid. Robert W. Vonnoh was also associated with the group. "The Ten" may have been our "avant-garde" of those years, but they were certainly far from being radical.

[6]Donelson F. Hoopes, *The American Impressionists* (New York: Watson-Guptill, 1972), p. 8. Two other major studies of the movement are Richard J. Boyle, *American Impressionism* (Boston: New York Graphic Society, 1974) and Moussa Domit, *American*

Despite the gap that existed between practice and total understanding, there did emerge in the late 1880s a distinct school of American Impressionism, but the Americans were neither collectively nor individually interested in the theoretical aspects of Impressionism. Twenty years later the radically new way of seeing and recording reality with which French Impressionism had shocked the world had largely been assimilated by the next generation. And during the rise of modernism, the brushstroke, high-keyed palette, and emphasis upon surface pattern arrived at in the 1860s and 1870s were used by conservative artists in England and Germany as well as the United States "to rejuvenate the old tradition of Beauty."[7]

Young Warshawsky probably knew little of this as he received his academic training in provincial Cleveland before 1905, or when he studied in New York City during the next years, first at the Art Students League and then at the ultra-conservative National Academy of Design. All evidence suggests strongly that his training was conventional in every way. Indeed, the most advanced art he recalled seeing during his early years in Cleveland was the work of Frederick Gottwald, who taught at the Cleveland School of Art from 1885 to 1926. Gottwald's impressionistic landscapes with their unconventional blue and violet shadows impressed Warshawsky at the time, but he was not prepared to follow suit.[8] It must be stressed that in all but a few American cities Impressionism was still a daring art form before World War I; most teachers and pupils found it difficult to understand, even if they were inclined to try. William Zorach, a student of Warshawsky's at the Council Educational Alliance in 1907, remembered in his autobiography that when he was studying at the National Academy of Design in New York, everyone there thought in terms of local color:

> The effect of light or sunlight on color was not taken into consideration. Brown was brown, blue was painted blue, and a yellow dish was yellow. My friend, Abe Warshawsky, came back from Paris with a palette of brilliant, impressionistic color. I remember a conversation he had with a little woman in Cleveland. "The Impressionists, are they really taken serious?"
>
> "Oh yes," said Abe, "everyone is taking them seriously, even in New York." I was eighteen at the time, and it was the first time I had heard the word Impressionist.[9]

When Warshawsky arrived in France for the first time in the fall of 1908, he was still painting in the brown and gray tones of American

Impressionist Painting (Washington, D.C.: National Gallery of Art, 1973).

[7]Alan Gowans, *The Restless Art: A History of Painters and Painting, 1760–1960* (Philadelphia: Lippincott, 1966), p. 222.

[8]Gottwald's *The Umbrian Valley, Italy* (n.d.) in the Cleveland Museum of Art is an excellent example of the work of this little-known American Impressionist.

[9]Zorach, *Art is My Life*, p. 32.

academic art.[10] He had learned that drawing was the basis for all great and lasting art, and that tonal values were to be used for modeling the figure. It was only after a trip to Italy with Samuel Halpert in 1909, during which he learned to use a broader and bolder palette, and after absorbing French Impressionism and Post-Impressionism in Paris that he could begin to fill his canvases with color and light. For Warshawsky, Kroll, Halpert, Benton, and many other American painters living in France, Impressionism was a liberating influence. It showed them that color could be freed of naturalistic description and the darkly romantic moods that still dominated traditional American art. Significantly, Warshawsky took this message back to Cleveland and awakened a number of young artists there to "the new tendency." The dazzling colors of Impressionism suited Warshawsky's bright and extroverted personality, while the gentle and "quietist" treatment of subjects painted in the out-of-doors fit perfectly his attitude of romantic reverence for nature. But while his countrymen went through impressionistic phases in their early careers and then went on to experiment with other idioms, Warshawsky happily and successfully remained faithful to its color, brushwork, and subject matter for the rest of his life. This is not to say, however, that he totally abandoned those values he had learned in art school, values he continued to find attractive in the art of older painters he looked up to, Louis Loeb and Max Bohm, for example. Warshawsky could shift from spontaneous brushwork and luminous colors in his landscapes to the most tightly controlled drawing and tonal modeling in his subject pictures.

Warshawsky found both his style and his new home in France around 1910 when "going abroad" was more fashionable than ever and the ease and relative cheapness of transatlantic travel gave rise to a cosmopolitanism affordable even to the son of a poor Cleveland family. Romantically in love with art and with the life the artist could have in France before the wars, he enjoyed an undreamed-of freedom and had a new awareness, to use the words of the art critic and dealer Horace Holley, "of the status enjoyed by the artist as a type essential to civilization."[11] Warshawsky had a deep respect for the great tradition of European painting, of which Impressionism and Post-Impressionism were the latest and freshest expression to him, and he sincerely believed that through hard work and dedication he could make a place for himself within that tradition. He developed a heartfelt contempt for the early

[10]"Grayness, sallowness, not only impregnated the American painters' palettes but tinged the American environment as well. The traditional brown of the brown decades had lightened somewhat into the tints of oatmeal and sand—into the fumed and 'mission' oak that superseded omnipresent walnut and mahogany, granite and limestone replacing the brownstone facades of homes and mansions or the cast-iron fronts of emporiums. Men's clothes in particular seemed dyed with the color of fountain-pen ink, with the hues of dust, soot, and ashes, of spring mud, or brightened occasionally into pepper-and-salt mixtures." Simonson, *Part of a Lifetime*, p. 17.

[11]Barbara Rose, ed., *Readings in American Art Since 1900: A Documentary Survey* (New York: Praeger, 1968), p. 6.

twentieth-century movements, which he (along with many other American artists) looked upon as fads dreamed up by confidence men to turn a quick profit in the marketplace. He lumped the Cubists, Fauves, and Futurists together into the "modern delirium tremens school of painting." In his view Picasso was nothing but "a misbegotten doodler on a big scale," and the work of Matisse was "pure idiocy." Warshawsky held the conventional opinion that the early modernists suffered from some physical or mental affliction, the manifestations of which they might well have kept to themselves.[12] Thus the distortion of Cézanne's work resulted, in Buck's opinion, from astigmatism.

Although they may not have recognized the distinction at the time, Americans in Paris between 1900 and 1910 tended to fall into two camps: the conservatives and the modernists, or to use the words of Alan Gowans, those who continued to believe in Beauty and those who sought a new pictorial Reality. Buck belonged to the first camp. He believed in artistic terms that have long since been discredited by modernism. He thought the good painter should rid his work of all traces of unpleasantness and esoteric experimentation. To Buck, the artist was one of God's special creatures, blessed with extraordinary powers to edify the mind and comfort the soul. Art was not an end in itself, but a means of making people's lives better.

He became even more bitterly critical of modern French painting after World War I, when "dishonesty, showmanship, and fakery" had taken over and, to his deepest regret, terms like "beauty, ideals and sacrifice for ideals had been eliminated from artists' vocabularies." Holding resolutely on to the old standards of "consummate craftsmanship, soundness, and sanity" in art, he sought to achieve in his own work that "happy look" he thought all great pictures possessed. That "essential happiness," he believed, should never be made subservient to organized movements. Of course, only beauty could make for "essential happiness," the need for which Warshawsky clearly felt to be even greater after the madness of the Great War.

Warshawsky sought beauty and sanity in the out-of-doors, as the French Impressionists had done a generation earlier. To escape the hothouse artistic atmosphere of Paris, he took his easel, canvases, and colors to Vernon, to Brittany, and to the south of France.

Living and practicing the traditional role of the artist as one who discovers, responds to, and interprets the beautiful and the picturesque in nature, he began just before World War I to concentrate on two basically different but not unsympathetic kinds of subjects: landscapes, which provided him the opportunity to express his love for light and charming scenery in brilliant, often arbitrary colors, and figure studies, usually of Breton peasants, which allowed him to deal with character and mood. The landscapes were painted *en plein air* and reflect his aim

[12]Some Americans had a tendency to become overwrought in the presence of modernist art. Royal Cortissoz, the art critic, once called Cézanne a "complaisant ignoramus," Van Gogh a "crazy incompetent," and Picasso "a man whose unadulterated cheek resembled that of Barnum." Hoopes, *The American Impressionists*, p. 17.

"to look on Nature and to endeavor to interpret her moods in a simple and direct fashion." His figure compositions are products of the studio and result from his realization that art "was more than the mere production of pretty pictures; that great art suggested moods, moments of suffering, or of joy, and an understanding of nature and of mankind." It is fair to say that the impressionistic landscapes with their expertly painted surfaces and bright colors continue to delight and refresh the viewer today, while the figure compositions, painted in his Paris studio for the annual Salons, possess a good deal of the sentimental and literary character of nineteenth-century narrative art and have not held up as well over the years. *People of Brittany* (Plate IV) of 1913, featuring careworn, simple folk in their quaint costumes set against a background of their village and harbor, can be considered typical of Warshawsky's best efforts in the second category. In this and countless other paintings of groups or single figures, Warshawsky reveals himself to be the heir of a long tradition of rather sentimental doting on the noble French peasant, a tradition dating back to the work of Jean-Francois Millet, Constant Troyon, and, in the later nineteenth century, Jules Bastien-Lepage, a particular favorite of the American Impressionists. What could perhaps be found only in the early twentieth century is Warshawsky's synthesis of academic draftsmanship and presumably impressionistic colors (I know only the black-and-white photograph) for which he was probably in the debt of Louis Loeb, whom Warshawsky idolized. The composition of this painting, however, may have been inspired by the work of the contemporary Spanish painter Ignacio Zuloaga y Zabalet, the artist who had such an impact on Thomas Hart Benton. Zuloaga frequently arranged figures in friezelike groups and used the lower edge of the canvas as a groundline, as did Warshawsky in *People of Brittany*.

Warshawsky was at his best when he painted landscapes. Working in the out-of-doors in the French countryside he loved, he could be very impressive indeed. The bird's-eye-view panorama called *The Hills of Vernay, Autumn* (Plate IX) of about 1912, with its consistent texture of crisply painted, small brushstrokes distributed evenly from edge to edge, is reminiscent of the work of an earlier American Impressionist, Theodore Robinson, who had a similar inclination to emphasize surface texture, to work from an elevated viewpoint, and to establish trees, houses, and other objects more solidly in space than did Monet, his mentor. As Moussa Domit has observed, American Impressionists tended to give priority in their landscapes to the subject, to form and structure, whereas the French were concerned with the unified appearance of the total scene.[13] Americans could not "paint everything as if it were of equal importance," as Monet tended to do. Robinson and Warshawsky appear to be closer to Camille Pissarro than to any of the other French Impressionists in this respect. Indeed, Warshawsky's *Potato Planting in Brittany* (Plate V), with its view of a village seen through leafless, transparent trees, might easily be mistaken for a work by Pissarro, who among the French was probably most interested in

[13]Domit, *American Impressionist Painting*, p. 12.

clarity of form and structure.

But Warshawsky possessed a surprising virtuosity within the somewhat limited idiom of Impressionism. A 1917 canvas, the *Washerwomen at Goyen* (Plate XI), is, in contrast to the two previous Warshawsky landscapes, a most sensuous and decorative picture, filled with dazzlingly imaginative colors, especially in the sinuous blue strokes of the water's surface and in the small spots of pink, lavender, orange, and yellow-green in the central mass of foliage. Here Warshawsky comes close to the pictorial extravagance and stunning colors of Monet's work of the 1880s. But in *Normandy Village along the Seine* of 1923 (Plate X), buildings and trees are firmly fixed in space by the artist's decisive brushstrokes, intense colors, and unifying pattern of light and shadow, and one is reminded of Cézanne's classical solidity.

In the 1920s Warshawsky turned his attention increasingly to Paris, whose streets, quays, and picturesque landmarks he painted with bolder colors and greater attention to descriptive detail than can be found in paintings of the city by the French Impressionists. The *Place de l'Opéra* (Plate XII) of the mid-1920s is typical of Warshawsky's many casual views of Paris, similar to the second-floor glimpses of busy streets and enframing buildings of Monet and Pissarro, but with clever, unobtrusive updatings of their pictures in the form of realistically rendered modern dress, automobiles, and streetcars.[14]

After World War I, Warshawsky made Paris his home, establishing himself in a studio at 7 Rue Antoine Chantin. During the warm months he visited Brittany, his favorite part of France, or ranged more widely to Venice or Switzerland. From the time he first arrived in France in 1908 until he left his studio in the care of friends and moved back to the United States in 1938, he spent all but a few weeks of each year in France. When he returned home it was only to visit family and friends, make personal appearances at the exhibitions of his work, or to paint portraits so he could earn enough "to paint for fun," as he put it, in Paris. He was probably right when he said he could not work in America, cut off from the support of a community of artists. He feared that if he stayed in Cleveland he would "sink down to the level of a local artist and possibly be forced to take a job in commercial art." With the favorable exchange rate of Warshawsky's times, dollars earned in America went a long way as francs in Paris or Brittany. "It seemed to me," he wrote, "that it would be better to work wholeheartedly and untrammeled abroad, returning to America at intervals to earn money for fresh studies, than to stay on in America in the hope of earning more money, without leisure to paint and study in the way I longed to do."

When he finally had to leave France as the threat of war became more and more real in the late 1930s, he settled in Monterey, California, because its rocky coast reminded him of Brittany. He worked the last years of his life there in a studio he built to resemble his studio in Paris. He taught sketching and painting classes and painted portraits

[14]Sixteen of Warshawsky's views of Paris served as illustrations for Robert F. Wilson's book *Paris on Parade* (Indianapolis: Bobbs-Merrill, 1925).

of Californians for a living. Isolated from his beloved Brittany during the war, he sought a kind of substitute in Mexico, whose colorful villages and cities (Taxco was a favorite) he visited on several occasions.

He remained a productive artist well into his seventies, and was to the end a cheerful and outgoing man and a popular and charming reconteur. In his lapel he proudly wore the ribbon signifying that the French government had named him a Chevalier of the Legion of Honor in recognition of his achievements in painting. He also must have taken great personal satisfaction in the knowledge that his paintings had been acquired by the French government and by thirteen American art museums.[15]

Warshawsky's goal in art was not a complicated one. He simply wanted to paint colorful, decorative pictures of the things he loved. If he was dissatisfied occasionally with his work, it was because he felt he lacked all the skills necessary to paint all the beautiful things he saw as well as he wished. But, as he writes in his autobiography, the Old Masters at the Louvre taught him that "the only way to succeed as a painter was to work constantly, to study from nature, and never be discouraged. If one cannot sing like a nightingale, it may still be possible to warble like a lark or to twitter pleasantly like a canary." In the perhaps unconscious irony of that statement, Abel Warshawsky tells us a great deal about his life as an artist.

B. L. B.

[15]Corcoran Gallery, Washington, D.C.; Cleveland Museum of Art; Toledo Museum; Akron Art Institute; Minneapolis Art Institute; Canajoharie (New York) Library and Art Gallery; Sweat Memorial Art Gallery, Portland, Maine; Brooks Memorial Art Gallery, Memphis; Los Angeles Museum of Art; San Diego Art Institute; M.H. de Young Memorial Museum, San Francisco; Maryhill Art Museum, Maryhill, Washington; and Frye Art Museum, Seattle, Washington.

·1·

1887-1905

EVERY Thursday, in our little home in Cleveland, Mother asked to bake a batch of bread for the coming week. With the excess dough she would model decorative shapes, flowers and fantastic little figures with raisins for eyes. These would be stuck into the loaves and painted over with the yoke of an egg, so that when they came out of the oven they were crisp and golden. Sometimes Mother would let me try my hand at fabricating these little embellishments of our daily bread, but I was never able to acquire her deftness and knack of improvisation.

These were my earliest attempts in search of Art and Beauty.

As a child I always drew, and there is no time I can remember when I was not trying to depict something. My first ambitious subjects were inspired by the adventures of Buffalo Bill, Kit Carson, and Daniel Boone, the chronicles of whose exploits gave me my first literary thrills. Unfortunately, my early attempts at depiction did not enhance my standing in the drawing class I attended; for instead of being clean and tightly drawn, as prescribed by our teachers at that time, my productions had a decidedly smudgy look.

Haunted by the desire to express my cult for the heroic and picaresque in art, I had made a habit during the hated arithmetic classes of ensconcing myself behind a rampart of books and giving myself up to the joy of delineating my favorite heroes. One morning, while I was engaged on a pictorial representation of our boxing champion, Jim Corbett—mighty arms bulging over a nude and brawny chest—a fellow student behind me glimpsed my drawing and set up a snicker, whereupon the teacher, having promptly discovered the reason for this disturbance, confiscated my labor of love and soundly lectured me before the whole class. As punishment, I was made to stay after school and do my lessons over again.

Only a few days before, I had suffered another humiliation in the name of Art. I had been sent home in disgrace, after having been told by our teacher to remember that my neck and ears needed to be washed sometimes, as well as my face. My forgetting to do so, she added, was doubtless due to my artistic talent and temperament, the implication being, of course, that artists were notoriously unclean in their personal habits. I went home feeling that my life had been ruined and promised myself to forswear Art altogether.

Lulu Bailey was the champion artist of Brownell School. Her drawings on the blackboard were veritable works of art, such, as I told myself,

1

I could only hope to rival in the dim future, if ever. It is true she had for almost a year taken private lessons with Robert Moxley, a young colored artist who had graduated from the Cleveland School of Art. His special course in shading had greatly aided Lulu. Though I felt I could draw as well as she could, I realized that the superior technique she had acquired gave her an advantage I could not hope to overcome.

During my sixth year at school, Palmer Cox, of "Brownies" fame, came to Cleveland with a light-opera troupe, which was performing a musical version of his "Brownies," and it was announced that prizes would be awarded for the best drawings of "Brownies" done by the school children of Cleveland. Needless to say, Lulu won first prize, but again I felt her success was principally due to her superior technique. My own drawings took second place.

Soon there were to be other favorable omens to encourage my family in the belief that Art was indeed my vocation. It was during the presidential campaign when McKinley and Bryan were candidates. Being like my Dad a staunch supporter of the Republican Party, I made a drawing showing McKinley dressed as a "Brownie," stirring a huge cauldron of soup in which Bryan surrounded by clouds of steam was being stewed. This production, entitled "Bryan in the Soup," was awarded a prize in a political poster competition by a jury of whom I suspect the majority must have been Republicans. Who could doubt, after such public recognition of my talent, that fame and fortune awaited me. What was there to prevent me from becoming a great artist, a best-seller like Michelangelo and Rembrandt, whose works, I had heard, fetched huge prices. Even at school my talent was now being recognized officially, so to speak, for in honor of Thanksgiving I was requested by the teacher to depict on the blackboard our pilgrim fathers surrounding a huge turkey served up on a smoking platter. Mine was also the glory to perpetuate George Washington in his white wig on the occasion of his anniversary and, at Yuletide, Santa Claus climbing down steep chimneys or careering across the snow with his reindeer.

Lulu was now being given a fight for her laurels. In any case, she would soon be out of the running, for, being several grades above me in school, her day of graduation was approaching. Then from all appearances I should be undisputed drawing champion of the school. Fate, however, had a bump in store for me in the shape of a new boy from out of town, who had come to live in Cleveland and joined our school. One day he brought in a copy of a lion by Rosa Bonheur, which he claimed he had painted himself. . . in oils! It was so lifelike, so real, so grand, that I was overwhelmed with admiration. I suddenly realized that there were still vast fields to conquer in the realm of art, and that once out in the world, competition would be a very different thing from that obtaining at school. To paint in oils was now my one ambition. At the time I possessed only watercolors, which I had acquired by trading a complete set of campaign-motto buttons, very popular in those days, with George Drew, whose father owned a theater. He was the rich boy of our school.

At the library one could obtain the loan of large reproductions of pictures in color to take home. As a rule I chose "genre" pictures, represent-

ing swashbuckling dandies in high boots, plumed caps, and gorgeous cloaks, full of color and movement. These I copied patiently with my watercolors.

In our neighborhood, where one met only drably clad beings, there was nothing to satisfy my thirst for color, but in the nearby Italian quarter things were different. There life might be sordid, but it had glamour. There one could meet swarthy men, wearing bandanna kerchiefs, colored sashes in lieu of belts, and often earrings, and women decked out in bright petticoats and shawls. Of course I believe that all this color was in bad taste and that "nice people" should always dress unostentatiously. In the world of respectable citizens, to wear anything colored was to be "dressed dutchy." Houses were furnished in art-gray, and the sign of high culture was the possession of black or sepia prints of Corot on the wall or photographic reproductions of the Parthenon. A red necktie was anathema, and the wearer was termed a sissy, or, as they say today, a "pansy."

Rosa Bonheur's lion stirred my ambition and urged me on to nobler efforts. Oil painting was the great art. Rembrandt, Franz Hals, Turner, and Corot were oil-painting artists, and to become equally famous one had to paint in oils.

Fortune favored me. Our local butcher, who wanted a pictorial heading for his stationery, gave me my first commission, and I set to work. With pen and ink I made a drawing of artistically arranged sausages with a background of bologna—my favorite delicacy. With the dollar and an added gift from my eldest sister, I bought some oil colors and brushes. I remember particularly wanting a tube of flesh color, and was greatly disappointed to learn it was not a ready-made color—that, in fact, no such paint was manufactured for artists. The dealer kindly explained to me that there are many different shades of flesh, whose tints changed in different lights. At a drygoods shop I then bought a strip of canvas of the kind used for awnings, unaware that for painting purposes one uses a specially prepared canvas, sized and primed with white-lead.

With these purchases, I at once set about to carry out the great idea I had conceived—a painting of the Battle of Gettysburg. Alas, the paint soaked into the raw, unprepared canvas surface. "Ah," I said to myself, "that explains why oil painting is such a difficult art, and why great pictures are so rare!" I had more success with a sign I painted for my sister Celia's millinery shop, depicting a lovely lady wearing a chic little bonnet. This was executed on a large piece of tin. It was slippery work at first, but I found that after a thin coat of paint had been washed on, the colors adhered more easily. Later a neighbor, who was a scene painter, taking an interest in my struggles, initiated me into the mysteries of sizing a canvas. He also presented me with a real palette, so that I was no longer obliged to mix my colors on an old kitchen plate as I had previously done.

It was through this benefactor of mine, Charley Copperman, whose dark-toned visage was in keeping with his name, that I first came into contact with stage life in its domestic aspects.

Charley was occasionally employed to paint sets for the neighbor-

hood theater, owned by the local political boss, Harry Bernstein, otherwise known as "The Czar." On such occasions he would often have recourse to my artistic accomplishments.

A stock company, consisting of two families and one unattached bachelor, who played the leading roles, had come from New York and was giving a lurid and varied program of repertoire. The dual aspect of the life lived by this troupe of veritable bohemians gave me my first glimpse of what the existence of an artist might mean—at night the make-believe of cardboard palace with glittering halls in which, to the accompaniment of voluptuous music, the protagonists of high romance or stirring drama made love, spun intrigues, and fought duels; and then the daytime reality, when "Madame Simone," the heroine with the queenlike carriage and the rippling voice which fluttered our heartstrings, was turned into a scolding shrew, trailing a soiled faded wrapper.

As for her husband, who excelled at night as the somber villain or the subtle, cunning priest whose rolling eye and sardonic smile had such devastating effects on his hapless victims, the daylight hours revealed him in the role of henpecked husband, with a cast in one eye which gave him a helpless, hunted look. As for the leading man, whose pale beauty and languishing airs played such havoc among the impressionable damsels of the neighborhood, the ruthless light of day revealed him to be a hollow-chested, middle-aged man, with deeply lined features and cheeks blue from close shaving, ill-kempt and down at heel, perpetually cadging for drinks at the corner saloons, where he could be heard vaunting his past successes on the stages of New York.

Yet despite the dreary contrast between the fictitious splendor of their night existence and their humble day life, I felt that these stage folk were living on a higher plane than their more prosperous bourgeois neighbors. Imagination, temperament, and art had gilded their lives and brought them moments of emotional bliss which compensated for the brutal, so-called "realities" of their daily existence.

At this time we were at war with Spain. Admiral Dewey's great victory at Manila Bay had thrilled my boyish imagination and inspired me with a new subject for artistic expression. With laths procured from a carpenter, I constructed a stretcher, upon which was drawn a strip of canvas that had been previously primed with glue. Upon this I painted a life-size reproduction of Admiral Dewey, copied from a magazine. I depicted him standing on the swaying deck, sword in one hand, telescope in the other, surrounded by blue ocean and Spanish ships sinking all over the horizon.

Upon the completion of this masterpiece, one of our neighbors, struck by the importance of this work, conceived the idea of selling it by means of a raffle. He was a born salesman and managed to dispose of some seventy tickets at ten cents each. At any rate, I remember receiving over seven dollars from this venture. The lucky winner of my picture sold it back to the super-salesman for five dollars. These monetary transactions made me feel I was being initiated into high finance. The folks at home, especially my Dad, would be shown I was someone to be reckoned with henceforth. Only a short while before I had received an epic wallop-

ing. It was during the first weeks of the Spanish-American War and I was full of patriotism. Having read a lot about the War of 1812, I conceived the idea of going downtown to the recruiting station and enlisting as a powder monkey in the Navy, for history had taught me that this was what all the brave lads had done in 1812. Unfortunately, the recruiting officials saw fit to blow the gaff on me, with the aforementioned humiliating result to my pride and person. Afterwards, whenever there was a possibility of my being lured from the path of duty, it was sufficient for my father to look me in the eye and ask sarcastically if I would like to enlist as a powder monkey.

At this period of my life I was a scrawny, sallow kid. Mother's friends would worry her about my looks, telling her they feared I was going in for consumption and would not last long. There was, in fact, a form of consumption I indulged in, but it concerned my belly and not my lungs, for my feeding capacity in those days equalled that of the ostrich. My looks belied me. Despite my frail appearance, I was as tough as a wire, and active with the boys of the neighborhood in all types of games, especially baseball by day and "run, sheep, run" at night. A neighborhood social center had installed a gymnasium with an excellent athlete as instructor, and the "Hiram House" soon became the scene of many activities.

But more important to me than athletics and games was the arrival in our midst of Ernest Dean, a commercial artist, who started a weekly life-sketching class, which I attended. Before this my artistic education had been confined to copying pictures. To draw from nature was a revelation. Mr. Dean was both kindly and understanding, and at his little studio would show me reproductions of great pictures by celebrated masters, commenting on their special qualities. From him I learned about great art schools where masters taught, and also how precarious an artist's life was. He told me tales of great artists, unappreciated during their lifetime, who had been sneered and railed at by their contemporaries, and who had often literally starved for their ideals. They became great heroes to me.

Mr. Dean advised me to earn and save more money, so that later, if I really wished to realize my ambitions, I could go to an art school and study. My parents, who had eight hungry youngsters to provide for besides myself, could give me no financial aid, but heroic little Mother insisted that if I went to work, all my earnings should be put aside for the art school fund. My eldest sister also helped and encouraged me by putting aside some of her money for this purpose.

I believe I was around sixteen before I glimpsed my first genuine oil painting. Hung in a shadow box, and illuminated by a concealed light from above, it was on display in the darkened window of a large department store. The subject was that of a smith at his forge. In ecstasy I stood before the wonder of it, marvelling at the flames that writhed so vividly from their glowing bed of coals, the scorching bar of red-hot steel that should have set fire to the very canvas itself, so deeply was my imagination disturbed. And there was the figure of the smith, his mighty arms veined in such painstaking detail and high relief! "This," I said to

5

myself, "is great art." Later, in the same window, a picture of the French school was shown—as I realize so amusingly now, a typical academic Salon picture of the type derisively referred to as *trompe l'oeil*, i.e., "eye-bluff." *Nana* was its title, and it presented the questionably alluring prospect of a life-size nude woman lying full length and at her sensuous ease upon an embroidered couch. The pearls about her throat seemed almost to be real, and the same effect of realism was impressed upon me by the painted steps of marble leading up to the languorous lady's divan. A step of genuine marble was brought with such deft precision to the base of the canvas by the window dresser as to produce the illusion of continuous flight into the painted stairs within the frame. Who would have dreamed to question the greatness of such illusion in those far off and immature years! To achieve cast-iron reality—that became the ambition of the exciting moment.

However, the first real thrill I experienced from a picture was that from a marine, painted by Max Bohm, a native of Cleveland. It showed a Breton sailing boat with a crew of hardy fishermen, tremendous sea, and windblown sails. There was no trickery in this! I could see each vital brushstroke and the colors laid on thick and crudely, as I thought then. It gave me the feeling of seeing more than just a pretty picture. Since then I have spent many years in Brittany, and though I viewed that picture thirty years ago, I never see a Breton sailing boat setting out to sea without thinking of Bohm's painting.

Later when I got to Paris and met Bohm, he was highly pleased when I told him of my reactions and described his picture in detail. I had acquired a slight insight into what art might be, and realized that it was more than the mere production of pretty pictures; that great art suggested moods, moments of suffering, or of joy, and an understanding of nature and of mankind.

Through Ernest Dean's kindly assistance, I was introduced to the Cleveland School of Art, and the director, Miss Georgina Norton, who appeared to my boyish eyes a most austere and impressive person. On nearer acquaintance I found her to be a woman of fine sensibility and great sweetness. Though the fees for tuition at the school were then merely nominal, the price was far above my little store of savings. Dreams of becoming an "Old Master" began to fade. But Miss Norton, after looking over my little stock of drawings and paintings, thought "perhaps something might be done," and went off to consult with someone. On her return, she suggested that if I cared to make myself helpful around the school in spare moments, my tuition could be arranged. Oh, joy! The road to Art was open to me, and one day my name might be linked with those of da Vinci, Raphael, Velázquez!

Late that September I trudged for the first time to the art school, my mind filled with great dreams, the two miles from our home seemingly incredibly short. The school in those days, a vast old-fashioned mansion, was separated from what was then Wilson Avenue by a beautiful lawn, shaded with tall elms and chestnuts. At the rear was an annex, originally a stable, on the upper floor of which the antique classes were conducted.

6

Here first-year pupils were initiated into the mysteries of drawing. Miss Nina Waldeck, a charming young person who had lately returned from Europe, had charge of these classes, and it required all her patience and forbearance to discipline our impetuous young spirits into a sense of order and harmony. Most of us "just drew out of our heads." As for construction, light and shade—these were mere words to us. We imagined we would forthwith be taught a sure way to produce great works of art, so it was a considerable disappointment when we were set to copying a plaster foot or a head blocked out in planes.

With great tact and patience Miss Waldeck made us understand that these modest beginnings would lead to interesting and thrilling work later, and that it was an essential discipline to learn to see beauty in simple forms, to grasp the meaning of design, and the wonders of proportion and movement. Many of the plaster casts were magnificent reproductions of Greek and Roman masterpieces. But we longed only for the moment when we should be allowed to draw from living models.

Looking back after years of experience, I realize what a mistake it is to set before immature minds, which have no comprehension of the significance of form, the task of drawing from the great antiques. It is only after years of study that we can realize the significance of these works, and it is only then that we should attempt to draw them. On the other hand, plaster casts present the advantage of immobility, with light and shade remaining clear and definite.

Our method of drawing from these casts was as follows: setting ourselves in front of the cast, we would, after an intricate system of careful measuring, proceed to draw a thin outline of the model with sharpened charcoal sticks. The contour finished, we would shade the drawing up and down, following the grain of the paper. Shadows, halftones, and then the reflections and highlights were marked out with a chamois leather or soft rubber. Without thought or understanding for the form, we would stupidly try to copy the varying shadows, up and down, following the grain. The best results were generally tight and dry imitations of the model. The outline was, as a rule, done on the first day, and the balance of the week devoted to the shading. Our first models were block feet, ornamental designs, and acanthus leaves.

With the termination of each month a competition was held, the winners to be awarded the opportunity of competing for a scholarship to embrace the subsequent year. The first competition in our class was won by Llewellyn Jones, a tall, red-headed son of Wales, who later became a successful newspaper artist. Him we regarded as a potential genius. His drawings were so precise that they seemed to have been printed. He would take a large piece of paper with ruled squares, each square numbered. Then, having squared his own drawing paper in a like manner with corresponding numbers, he would place his model of the blocked foot before the first paper and draw around the squares and numbers revealed behind the model on his own sheet. This system, I later discovered, was used for enlarging drawings, especially those executed on a large scale.

As for my own performances, they won as little recognition or en-

couragement from my teacher as they had at the grammar school. Caring nothing for neatness or slick shading, I concentrated on the character of the object I was drawing with the usual result that my work was condemned as too smudgy and not at all in keeping with academic standards. I was in despair, for, try as I might, I could not work along the precise lines of the others. And yet I felt somehow that they, too, were not going about their work in the right way.

Once Miss Waldeck observed me staring at my drawing for half an hour without touching it. I confided to her my dreams of the great pictures I wanted to paint. She sympathized, but tactfully told me I should have to work and learn a great deal before I could hope to realize my ambitions. At times she would indicate the beautiful forms in the passing clouds, and disclose how in winter snow brought beauty and glorified even the ugliest, most commonplace objects. During this period I continued to use my colors at home, and whenever I found opportunity, for students in the first-year class were not allowed to paint in the school.

I had started a portrait of my sister. With her beautiful red-gold hair and lovely skin, she proved an ideal model for one who revelled in color. She had already given me a number of sittings, and the portrait was almost completed, when one day my baby sister, Minna, aged three, wandered into the small backroom, which served as my studio and wherein the still wet canvas was reposing. Entering a few moments later, I found her whacking away at the canvas with my wet brushes, shouting joyously, "I do like brudder do!" Thus ended my first portrait, for Winna had done her job too thoroughly to permit of clearing up the mess, and I was forced to start afresh.

My second attempt at portraiture enlisted my brother David as subject. Still ignorant of my medium, I used kerosene, with the result that the picture turned dark and cracked. But Time, the healer of most ills, has since bestowed on it a mellow patina, which, at least in this respect, puts it in the class of the "Old Masters" to which I then aspired.

Two of my class comrades, who since have made their mark as artists, fared no better than did I in the monthly competitions. These were Marsden Hartley, later one of the leaders of the advanced school of American painters, and Arthur Burchfield, who, after many years of struggle in obscurity, made his name with a series of remarkable watercolors depicting the American scene.* Museums and collectors are acquiring his work.

I cannot recall any other of my classmates who made names as artists. The fact is that few aspiring artists survive the first years following graduation from art school. Of those who survive this first ordeal of waiting and struggling, the majority find employment with commercial

*Warshawsky's memory is a bit faulty here. Marsden Hartley attended the Cleveland School of Art up to 1899, when he moved to New York City to study under William Merritt Chase at the National Academy of Design. Charles (not Arthur) Burchfield was a student at the school from 1912 to 1916. Since Warshawsky left the school in 1905, it is at least possible that he knew Hartley there, but he could not have been a classmate of Burchfield's.

art studios, others work for newspapers, a few take to illustrating. The percentage of those who continue to paint for art's sake alone is, indeed, infinitesimal. One of the anomalies of the art school is that the most brilliant and cleverest students are often those who quit earliest. This is possibly due to lack of patience, the gifted ones being often more easily discouraged than the patient plodders who are content in any slight degree of progress they may make.

We also had classes in modeling and mechanical drawing. The latter was so much mathematics to me, and if I attended at all, it was merely to bask in the genial presence of Grace Kelley, the instructress, a buoyant Irish lass, bubbling over with good humor. Miss Kelley has since made her name as watercolorist and art critic in the Middle West.

I reveled in the modeling. To knead and mould the wet clay into reproductions of living things seemed like a primitive act of creation, a direct contact with the source of life, without which no art can exist. Our modeling instructor, a handsome young man with a profile like Julius Caesar, had studied for years in Paris and Munich. He seemed to us endowed with a marvellous facility for transforming with a few magic touches a lump of clay into something alive and beautiful. How mature and sedate he seemed to me, though now I realize he was only a little older than his pupils. We loved him for his friendliness and lack of condescension, for in his dealings with us there was no hampering feeling of master and pupil. He seemed to be one of us, only richer in experience and general proficiency. Though he never marked his superiority, we inevitably came to feel it, as on the occasion when, entering the classroom while a skirmish of clay flinging was in progress, he received a missile from my hand, intended for another mark, full on his classic countenance, and with a wet, resounding smack. During the moment of terrible silence, while he wiped the wet clay from his face, I saw myself expelled and disgraced. But all I heard was a very normal voice saying, "Let's get to work, boys." The incident was closed; in fact, as far as he was concerned, it had never existed.

This man was Louis Rorimer, today one of the foremost interior decorators in America, and an authority on furniture and fabrics. I worshipped him as a boy, and as a man have counted him for thirty years as one of my dearest friends, who has always measured up to the standard of tolerance and understanding he displayed on the occasion of that clay fight.

My progress in modeling was so much more marked than that in painting that I entertained at moments hopes of becoming a sculptor. Now for the first time I received good marks at school. But my urge toward color was too strong. Sculpture, at its best, seemed cold to me. Besides, a sculptor could not model trees, running water, moving clouds, or the changing light of the sun.

AT THE END of the school term in June, fourth-year students were graduated, and the most successful competitor at the monthly concours was awarded a scholarship to the Art Students' League in New York, the

goal of art students all over the United States. By a miracle, largely effected by the kindness of Miss Waldeck, I was advanced to the second-year class, in which we were to learn to draw from life, to study portrait and the nude. My record for mechanical drawing was deplorable, but a certain proficiency in modeling may have justified my advancement. Needless to say, I was awarded no honors.

During that first year I also made some progress in the social arts and learned to dance a bit. After the lunch hour, one of the girls would tune up on the piano in the main hallway, and couples would start dancing. In those days I was timid and girl-shy, but the fair ones took pity on me, dragging me round, till I learned the semblance of a step. From one kind tormentor—whose charms, I need hardly say, far outshone those of her rivals—I learned also the sweet torments of adolescent love.

For a long time my head was more full of her than of art, and she knew it. She had only to glance at me and I would redden like a lobster. But even her teasing was a welcome form of torture. How exquisitely I suffered when she condescended to put me through my paces on the dance floor! But what chance had I of capturing such a prize—I, who was just out of short trousers!

Unrequited love, however, did not interfere with appetite—three huge sausage sandwiches and an assortment of fruit for lunch sufficed, and yet the end of the term found me gangly and skinny, but full of vim and energy. Besides the long walks to school and back (a five-cent carfare was too big an item for my purse), there were several "gym" evenings during the week, not to mention basketball and a little boxing. I was becoming seriously interested in athletics, little realizing then how helpful they were to prove in my career of painter.

With the arrival of summer, I began looking around for my first job, as I wanted to earn the wherewithal to meet the tuition for the coming year. Armed with a recommendation from the gymnasium master at the Hiram House, I obtained the post of assistant to the director of an outdoor playground—twenty-five dollars a month, and all my mornings free. What fun to be paid just to play about with youngsters and have a good time!—and to be addressed as "Mister" in the bargain, to say nothing of wonderful shower baths every evening before going home. Working at the gymnasium developed me wonderfully, and by the end of the season I turned the scales at one hundred-fifty pounds. My old nickname of "Skinny" was no longer applicable. Mother's cronies, who had feared my early demise through TB, were, however, not to be reassured, for when they saw my drawings and heard of the career I had in mind, they prophesied I should starve to death, that being the inevitable end reserved for all artists.

By September I was back at the art school, where everyone exclaimed at my changed appearance. However, despite my new huskiness, I was as girl-shy as ever, and still the butt of the heartless fair ones, but, as an incipient athlete and budding pugilist, I was able to hold my own with my own sex.

Frederick Gottwald was instructor for the life and portrait classes. He had been trained in Munich but later had come under French influence. He was the first painter I had observed to use pure color. His method of rendering shadows in blue and violet tones I afterwards recognized as French impressionistic technique. In class, however, students were taught to use a purely academic palette, consisting of earth colors, such as burnt sienna, amber, yellow ocher, a little vermilion, and blue.

Our models for the life class were mostly Negroes, who posed in breechcloths. In the art schools of New York and Europe the model always poses entirely nude. It was very difficult in those days to obtain white models, but I enjoyed drawing the shiny black and bronze bodies of the Negroes, which suited my smudgy technique. We had female models for the portrait class, but never for the nude. The W.C.T.U. had strongly opposed such practice, and to this day puritanical dictates are still a great force in the art life of our land, though of late years most art schools have freed themselves from such fanaticism, and female models are now to be found in all academies.

Some years ago I exhibited a nude called *A Resting Dancer*, previously shown at the Paris Salon, the New York Academy, and Corcoran Institute in Washington. When it was shown in Cleveland, I found a huge potted plant in front of it. It appeared that an outraged lady had indignantly announced she would never visit the gallery again if that "obscene" work were not removed. Need I say there was nothing offensive in my picture, which now hangs in the New York home of Will Irwin and his wife, Inez Haynes, the well-known American writers who purchased it, and that it has never shocked any of their visitors?

The Middle West is yet overrun with prejudices of this type. A well-known Western museum, which had invited me to hold a one-man show, requested of me in the invitation "not to send any nudes, please." A large decorative picture I had painted, entitled *The Judgment of Paris*, was bought by an interior decorator of Chicago. He exhibited the picture in the main corridor within the building, but owing to protests made to the owner of the building, was obliged to remove the picture, which was later reproduced as a frontispiece in *Arts and Decorations* and in several publications in the East. What a storm was raised over Paul Chabas's *September Morn*! The result in that case was to make the picture sell in thousands of reproductions and to render the painter's name famous.

The cleverest students in art schools are, as a rule, women, who carry off most of the prizes. In our class there was one exception, a boy named Clifton Crittendent. In a few hours he could finish a drawing more striking than any of the others could do in a week. Of course, he was first in every competition. Commenting on his work, Mr. Gottwald would often tell him it was "too clever." At the time I could not appreciate the justness of his criticism. How could one be "too clever?" Great was my envy of "Crit," but he soon dropped out of the school, tempted by a well-paying job in commercial art. In time he merely drifted on, making no progress, while many of the plodders at school surpassed him, even at his own line of work.

At that time there were few professional artists in Cleveland, where a local exhibit was held once a year. Gottwald's pictures were easily the best, and his technique outstanding. In his work I first began to see the possibilities of painting outdoors. He possessed a poetic strain which enhanced even the commonest object he painted. Studying his pictures, I began to realize that shadows can be violet and luminous in color, not merely gray and brown as they had appeared to me thus far in outdoor scenes, and that nature is interpreted to the public through the eyes of the artist. I noted many varieties of tints in grass and herbs that formerly I had classified as "green," also that the sky is reflected on foliage, roofs, trees, and pastures, as well as in water. Therefore, adding yellow, cadmium, and rose madder to my palette, I hied me outdoors to paint.

Even the drabbest of gray houses now took on for me a new dignity and beauty of tone when seen at dusk with the glory of the fading sun in the sky. But to see these effects was one thing, to render them as my master did another! "Values," or the relation of one tone to another, were problems that were just beginning to dawn on me. For example, I learned that to render light one had to get the exact tone of a green in juxtaposition to the exact tone of red, of gold to violet, and so forth. If everything went right, there was harmony—if not, a riot. At first, trees appeared easy subjects to paint, until I realized that each tree is as individual as a human being. I tried painting still life and found it easier. Apples were round, and the light on them indoors did not shift and change as happened outdoors. Brass and copper were fascinating to paint, but when it came to flowers, I found their fragile beauty very elusive and hard to capture.

CULLEN YATES of New York, a well-known American landscape painter, came to Cleveland about this time and held an exhibition at the leading art gallery. He was a vigorous painter, whose work was colorful and luminous, while his treatment was simple and direct. It was the first one-man show I had seen. I was struck by the fine modeling of his birch trees and the quality of color of his autumn leaves. Mr. Yates had a flaming red beard, trimmed in Van Dyck fashion, and wore pince-nez eyeglasses attached to a broad black ribbon—quite my conception of what an artist should look like. He was more affable and easier to approach than my master, full of quick enthusiasm and warm praise, and very kind to the youngsters who came to see his show. Later he took over an outdoor class, and though unfortunately I did not belong to it, he let me show him the few outdoor scenes I had attempted and gave me helpful criticism. He advised me to get to New York to study, assuring me I could learn more there in a short time than if I stayed for years in a provincial art school. There, besides the great galleries and exhibitions, I would find an art school to which advanced students came from all parts of the country. He promised me, if I came to New York, to help get me started and to criticize the work I might then bring him.

Feeling I was making little headway in the life class, where work was

conducted on the same principles as in the antique, and that the course also called for severe and complicated mechanical drawing for which I had no aptitude, I decided to try for the big city where a line was drawn between an artist and a mechanical draftsman who might merely be in search of a steady job. But I managed to stick out the year, working a little in the portrait and still-life classes. During the winter and spring months I took a position as gym instructor in the evening at the Educational Alliance, a settlement house in Cleveland. This work kept me physically fit, and the small salary I earned paid for my painting materials and left me a small profit. This Mother insisted I should lay aside for my future studies.

Though both Dad and Mother wished to keep me with them, they realized that there would be small chance of my attaining my ambition if I stayed at home. So, after much consulting of the family council, it was decided that I should have my chance in New York. The decision was taken soon after my eldest sister's marriage. Great as was my joy, I had qualms and heartaches at the thought of breaking away, for we had always been a closely united family circle.

As we had relatives in New York who would befriend me, it was decided I should go to them for the summer months. This would enable me to get my bearings and possibly pick up a little work, so that by the fall I might have some savings to carry me through my art studies during the winter.

My outfit had to be looked after, for I was growing out of my clothes, and my appetite had developed into something devastating. I was always hungry, and here I was going into a strange land among people who would no longer look on me merely as a normal, hungry boy. Father took me to a misfit clothing place, where bargains could be had, and there picked out for me a fine-looking suit, with a new pair of suspenders thrown into the bargain. The fit was a trifle tight, but in view of the lean days to come, that was no great disadvantage.

Leaving home for the first time, though I had looked forward to it for months, was a greater wrench than I had imagined. My childhood had been a singularly happy one, and I was devoted to my parents. Dad, though terrible in his wrath, had a sweet, kindly nature and nobility of character. Though his earnings were small and we were a numerous family, we were always well fed and warmly clad. Yet Father was not what is called a "practical person," his mind being immersed in books and in helping some unfortunate neighbor. As for Mother, she accomplished daily miracles with the small amount of money at her disposal. She cooked and swept, sewed for us, and nursed us when we were sick, always without help, the other children being too young to pitch in; all were still at school. Yet not once did my parents suggest I was old enough to contribute toward the household expenses.

I realized what an egoist I was to leave them, but the urge to paint was a hunger that clamored for satisfaction. It was hard to part from them all, especially from Mother and my baby sister, Minna, who was the idol of my heart. Dad came to the station to see me off, gave me his

blessing, and told me to write often. My large paper valise was packed with clothes and every essential for bachelor life, including a "housewife" with needles and thread for casual mending of my wardrobe. I had need of this sooner than I expected, for during the weary night journey while the train rocked and swayed, I uncurled myself from my corner in the day coach to go for a drink, when I heard something rip. I looked down at my trousers in horror. An entire seam along the leg had burst asunder. I was in agony. Fortunately, all my fellow travelers were asleep, so I confided my troubles to the kindly colored porter who steered me to the lavatory. There I sewed up my trousers so solidly and so awkwardly my repair work must have been apparent to any observant eye.

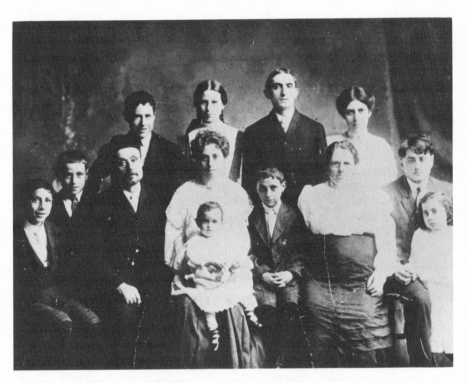

The Warshawsky family. Abel is seated on the far right,
Alex is standing in the rear on the left.

·2·

1905–1906

ON ARRIVING in New York, I went to the home of some distant relatives, who gave me a kindly welcome and the hospitality of a couch in the living room for sleeping, since they themselves were crowded for space. The heat was stifling. I had been used to tree-shaded streets and open spaces and to nights that brought relief following the heat of day. But here the nights seemed even hotter than the days, and though all that first night I slept as a tired boy sleeps, the following morning discovered me fagged out, exhausted.

But the first thing was to find a job of sorts, to lay by money for the fall and winter. After paying my traveling expenses, I had left only ten dollars. As the relatives I was visiting were far from wealthy, I intended paying for my board. Friends of theirs who kept a restaurant at Coney Island were looking for a young fellow to hand out hot frankfurters to clients. I was taken out, looked over, and engaged—board, lodgings, and five dollars a week—the wherewithal to lay by money. But there were moments of stage fright when I first had to face a hungry public. I was to cry my wares, "C'mon and get your hot dogs! All hot—all hot." But at first my voice stuck in my throat through nervousness and shame. However, after awhile I became callous and could yell with the best of my rivals all about me. I held this job for two weeks. The weather was bad; it rained almost every day, and customers were scarce. Suddenly I was fired, the pretext being that I ate more frankfurters than I sold. That I had accounted for many, I will not deny. It was then I realized in what an unjust world we dwell.

I was not sorry to be quits of Coney Island. The glamor of its haunts of pleasure had worn itself out, leaving nothing but an impression of tawdriness and vulgarity. I was likewise tired of being the butt for the ill humor of my employers when things were going badly. The only thing I regretted was my early morning dip in the ocean and the fine sea air.

My next job in New York was that of assistant shipping clerk in a large firm dealing with cloth stuffs, where one of my young relatives was employed as bookkeeper. My earnings there were $4.50 per week, my board and lodging with my friends amounting to only $2 weekly. The main item which weighed on my budget was carfare, amounting to sixty cents per week, for it was too far to walk to my work. My new employers took care to get their money's worth and found extra tasks for me whenever there was an idle moment in my department. I suggested a weekly raise of fifty cents, but in vain; so I quit once more, this time of my own accord.

16

There were summer classes at the Art Students' League, of which St. John Harper was then director. To be admitted to the life class, a student had to submit drawings that were judged proficient. I had heard that two Clevelanders who had won scholarships for New York had been refused admittance to the life class. Nonetheless, I decided to try my luck, so I submitted a roll of my drawings and a few paintings to Mr. Harper, and to my joy was advised I could enter the life class. But at once my triumph was dimmed by the thought of tuition fees and means of subsistence. Mr. Harper divined my embarrassment and drew me out on the subject of finance. Having admitted my plight, he informed me there were several scholarships—so-called "faker scholarships"—available for students of my sort and that he would let me know more within a week.

When I then reported, I was informed to my joy that not only might I work in all the day classes but that there was a job for me in the evenings at the desk, noting attendance, hiring models, and so forth, for which I would be given five dollars a week. It seemed too good to be true. Working at the desk with me in the evening was another "faker scholar," Arthur William Brown, from Canada. After a hard struggle, he made good as one of America's most successful illustrators, whose work is familiar to readers of the *Saturday Evening Post*.

In one of the classes I made acquaintance with Ben Kafka, with whom I at once struck up a friendship. He came from San Francisco, and was then living on Fiftieth Street, within easy walking distance of the League. As his room was a large one, he asked me to share it with him, an offer I was only too happy to accept, as it meant economizing in carfare and time. My relatives, who lived in lower New York and were crowded for room, approved of the idea. So Kafka and I joined forces.

Every evening at six, after classes, I would take a walk in Central Park, eating bread and peanut bars. They were good and filling. Later with Kafka I did a little cooking in our room. A gas stove being forbidden, we'd buy a string of frankfurters, put those in a large tin, and take turns holding them over the gas jet. When we'd cooked a yard or so in this way, the can would be refilled and water boiled for tea. That and a loaf of bread made a grand feast. How many yards of sausage we must have consumed that winter! Sometimes we'd dine at a little restaurant on Third Avenue, where for ten cents we were served a dish of stew, a cup of coffee, rice pudding, and bread. As Kafka and the little girl at the desk had a mutual crush on each other, we were well served. In moments of affluence we would blow ourselves to a full-course dinner for fifteen cents at an eating place in Houston Street. There were also weekly Sunday invitations to dinner from our relatives.

Kenyon Cox and H. Siddon Mowbray were the teachers at the League's life classes. Mowbray, who taught the morning class which I attended, was a sickly, dyspeptic-looking person, inclined to savage criticism. If a student was told that his drawing was not bad, he had reason to be proud. Mowbray's ideas on drawing were extremely academic and reactionary, and his own productions, mostly mural paintings, dry and unimaginative. But he was a driver at the school and taught drawing in a very precise, proficient manner. He was also a great discipli-

narian, and in his presence the most unruly class was quelled to silence.

We had a large choice of models. One of them, "Thundercloud," a full-blooded Indian, often posed for us. Clad in his feathered regalia and breechcloth, his massive head thrown back, chest and legs well-muscled, he made a fine study. Like poor Lo, he had a fondness for firewater and sometimes arrived with an unsteady gait. But once on the model's throne he posed like a rock. Another favorite model was Corsi, an Italian. Once a year he would be strapped to a ladder, head thrown back, in the classic attitude of the crucified savior. To hold this pose took extraordinary energy and will power. His proudest boast was that he had posed for Sargent for several figures of Prophets on the frieze of the Boston Library, and that once he had held a pose for three hours to permit Sargent to paint the drapery in which he was robed. Had he moved an inch or disturbed a fold, all would have been spoiled. We also had female models, the first I had thus far been given an opportunity to draw.

Another instructor at the League was Bryson Burroughs, already a promising and brilliant young painter, and today director of the Metropolitan Museum of Art. He was the antithesis of Mowbray, radiating vigor and good humor. I remember we had a soap slide at one end of the studio, and during rest periods he would lead the crowd in skidding over the floor.

The arrival of a new student in a class was hailed with cries of "treat, treat!" In the life class it was customary for a newcomer to stand treat on Saturdays, beer and pretzels or a punch of light sherry being the usual offerings at the shrine of Good Fellowship. These ceremonies seemed to me the quintessence of la Vie de Boheme—a flowing cup and a roisterous crew. At the top of our voices we would bawl the class song, and inevitably after a few glasses of beer some of the fellows became, or pretended to become, tipsy.

Inspired by Carrie Nation's saloon-smashing campaign, then in full progress, our song went something like this:

Oh, when Carrie Nation dies,
Oh, when Carrie Nation dies,
We'll have a spree, a jubilee,
We'll shout, "Hip, hip, hurrah!"
We'll be merry
Drinking whisky, wine, and sherry,
We'll be merry
When Carrie Nation dies!

Singing our song, we'd march in procession through classrooms and halls, picking up recruits. On one occasion this rowdy ceremony ended in a scandal. Some roisterer picked a model from the throne on which she was posing and hoisted her onto the shoulders of the tallest ones, who carried her triumphantly through the school, which was bad enough; but to make matters worse, the procession, carrying aloft the unclad

18

lady, exclaiming with terror and cold, issued into the street to make public its triumphant defiance of American morality. Threats of expulsion and suspension of the ringleaders put a stop to such extravagances in the future.

During rest period we practiced wrestling and boxing. My training in these sports gave me an easy advantage and a prestige among my fellow students which I should not have obtained through artistic merits, owing to my lack of drawing proficiency. My most difficult opponent in hand-wrestling was Putnam Brindly, a young giant, six feet three in his socks, whom I met many years later decorating army huts on the French front when my brother and I were similarly engaged. He was then so tall that he could do stencils on the ceiling without using a ladder.

It was at hand-wrestling that I gained the nickname which has struck to me through life. So far "Warso" or "Warhorse" had been my sobriquet. One day someone challenged me to a wrestling match, saying, "Come on, you big buck! I'll take you on!" Since then my friends and even my family have called me "Buck." In France, my French friends at first believed that it was my real name, and when I explained it was a sobriquet, attributed it to my extreme fondness for beer, a "bock" being the French designation for a small measure of beer, this appellation deriving from the German "Bock Bier." My reputation as a beer drinker has been undeservedly amplified owing to my nickname.

OF THOSE who were studying with me at the Academy that year, many have since established their names. Herb Meyer and Rudolph Shabelitz, my classmates, as inseparable and mischief-loving as the Katzenjammer Kids, are well-known illustrators, the latter being especially successful. Another brilliant student was Samuel Wolfe, who while still in school had exhibited a portrait of an old violinist and had won the Hallgarten Prize at the Academy's annual exhibition. There were also Louis Francher, called "Butch," now with *Collier's Magazine*, and Leon Kroll, pluckily working his way through school by doing odd jobs. The latter, a small, slight boy who attracted no attention, has achieved a brilliant career and is one of America's best painters. In contrast to him, Chadwick, a big, husky chap resembling a football player who invariably obtained first or second place at the weekly competitions though he would only start his work the day before, seemed marked out for early success and fame. I have heard he is teaching art in one of the New York high schools. And so it goes. Often the most gifted are handicapped by their very ability and lack the stamina that a struggle against handicaps develops in lesser talents.

The ambition of most of the lads was to become illustrators. *Harper's, Scribner's*, and the *Century Magazine* employed the most gifted draftsmen of the time, and their monthly issues were eagerly scanned. Handsome prices were paid for drawings and wide publicity given to the artist. In the vanguard of these able illustrators were F. Luis Mora, Walter Appleton Clark, F. C. Yohn, Albert Sterner, F. I. Keller, and Louis Loeb. Abbey was as well known for his illustrations as for his

19

murals. Frank Vincent Du Mond had created a sensation with his drawings for the Christmas number of *Scribner's*, and Remington had popularized the American Indian and cowboy. Maxfield Parrish covers were framed in every self-respecting home, and the Gibson Girl had set American womanhood a new ideal to attain. Compared with these successful illustrators, even our best painters had a hard struggle. Those who did portraits had the best of it, and names like those of William Chase, John Alexander, and Irving Wiles, whose portrait of Julia Marlowe had made him famous, were household words.

Another popular favorite was Childe Hassam, although an Impressionist; while Robert Henri, recently returned from Europe, had made a deep impression by his work exhibited at the Society of American Artists and at the Academy. Henri taught at the Chase School of Art, where his dynamic personality attracted many pupils. Among these, Bellows quickly stood out and soon outstripped his master, having acquired all his skill in an incredibly short space of time.

In Mowbray's class very few did any painting, which was only permitted to pupils who had high numbers at the concours. One month, having obtained a fair number of good points, I was permitted to paint Thundercloud. Placing myself behind one of the most proficient pupils, I watched him set to work. Having first made an accurate drawing of the model in charcoal, he proceeded to paint, starting at the hair, forehead, and eyes, finishing a small section at a time. To paint the background, which was the back wall, he went close to the wall, mixed his colors on his palette, and tried them on the wall itself. When the color corresponded to the tint of the wall, he returned to his canvas and painted the mixture as a background. It was a clever device, but it did not take into consideration the surrounding atmosphere and the reflections on the wall. Having messed about on my canvas, I made a hash of the drawing and everything else, with the result that Mowbray, after indulging in his usual savage criticisms, told me to suspend painting and return to charcoal and black and white. Charles Curran, who later replaced Mowbray during the latter's illness, was more charitable and allowed me to go on painting.

WHENEVER WEATHER permitted, Kafka and I sketched in black and white in Central Park. Later in our rooms we attempted to give color impressions of our pencil notings. That was the way in which most American painters worked at that time. The picture done directly from nature has a more spontaneous and virile quality than that reproduced indoors from notes and memory.

Kafka often worked in watercolors with a vigor and breadth that were startling. The academic teachers at school discouraged him, for he paid little attention to detail, and his compositions were not orthodox enough for their tastes. I now realize he was far in advance of his time and that, coming at a later date, he would have been hailed as a great and rare talent. Kafka, who had very small means of subsistence, later went to France, where he worked until his resources ran out. Since his

return, I have only seen him once in New York in 1923, when I was holding an exhibition at the Andersen Art Galleries, of which he had seen an announcement. He was the same fine Kafka of old, still painting and still struggling. Occasionally we did portraits of one another, but canvases being expensive, the study when completed would be scraped off and the fabric used for other work.

I also recall my attempts to paint night impressions of Columbus Circle, then surrounded by unpretentious buildings and several theaters. Reflections from street lamps on the wet streets, passing hansoms, with the Columbus Monument in the foreground, tempted me again and again. But the few things I did in those days have turned dark. Possibly I painted in a key so low that now it is difficult to see what I intended originally. At that time we were all influenced by Whistler's work and the poetic quality of his delicate, low-toned nocturnes. The simplicity of his treatment suggested it was easy to do, but at the first attempt one realized how difficult it really was.

Anxious, like many of my fellow students, to exhibit something at the annual show of the National Academy and Society of American Artists, I did a portrait of a young cousin of mine, David Kasner, who later lost his life in France during the War. This picture, showing David in a white jumper with toys at his feet, I showed to Cullen Yates, who had continued to encourage and advise me. At his advice I sent it to the spring show of the Society of American Artists. After a week of anxious waiting, my picture was rejected. I felt I had been put in my proper place, but determined to do better next time and perhaps get in.

It was through the brother of my little model, Jacques Kasner, a very talented young musician, that I was initiated into the world of sound. At Mendelssohn Hall I first heard great music performed by the Kneisel Quartet. On the walls of the hall were the beautiful murals of Robert Blum—nymphs dancing among the blossoms of an exquisite landscape. It was a glorious place to dream in! Through Jacques I obtained tickets to the symphony concerts, and heard Kubelik, Thibaud, Harold Bauer, Paderewski, and Hoffman. He also took me to the Tonkuenstler Society, a club of professional musicians, mostly Germans and Russians, where there was a treat of music.

There were also memorable visits to the Metropolitan Museum, where I learned to worship Rembrandt, who to me is still the god among painters. Velázquez I could not then quite understand, but today I can see that his painting, as technique, is unparalleled, even by the godlike Rembrandt. But while worshipping the great, I confess I also bowed a knee at what I now feel to be very mediocre divinities, such as Cot, with his *Paul and Virginia*; Bonnat, with his *Little Girl at the Well*; Meissonier; and others of their sort—painstaking virtuosi, devoid of true inspiration. I remember being strangely attracted by Manet's *Boy with a Sword* and *Girl with a Parrot*. Dimly I began to feel what a great master painted into a picture. How Manet would have painted my little cousin!

I longed to emulate the artists copying in the galleries. How much one might learn in copying a Rembrandt! But I realized that first I must

21

learn the rules, the rudiments and grammar of my art; must apply myself to drawing the human figure, to an understanding of form, not merely copying shadows of halftones on the surface. I must realize the bony and muscular structures underneath, which were the direct cause of such marvellous shadows and halftones. I made careful sketches of the skeleton at the art school and waded through a book of anatomy. The better way, as I now realize, was to study anatomy from corpses. It was not difficult for art students to obtain permission to draw in the clinics, but my squeamishness always prevented me from doing this.

After I had absorbed some knowledge of anatomy, my drawing improved greatly. When I had finished the outline from the model, I amused myself drawing in the bony structure and the principal muscles.

To break the monotony of the life classes, we had weekly classes in composition, subjects being generally taken from mythology. This gave us the opportunity to show our knowledge of the human form and to practice the grouping of nude figures in graceful lines and masses. But our compositions, derived mostly from pictures we had seen, generally resulted in stiff and lifeless productions. The professor would lecture to us on balance, harmony, line, color, but on nothing bearing on life or the reactions of human beings under certain circumstances. These things, I now realize, are so personal that we have to learn and comprehend them from our own experience. Only life itself and the understanding of living can give us the emotion we instill into a work of art. However, the composition class gave us a chance to express ourselves imaginatively and to suggest that we could do things other than drawing a figure well.

Winter and spring passed quickly, but not without twinges of homesickness, despite my interest in my work. So I wrote to the Settlement House in Cleveland, which had given me a summer job the year before, to inquire whether a similar job would be available. Having received an affirmative reply, I waited until the school year ended in June, packed up my depleted wardrobe, said goodbye to my fellow students, promising to return in the fall, and started for home. The joy of that first homecoming and the welcome that awaited me is one of the happiest memories of those early years.

·3·

1906-1908

THAT SUMMER at the playground and the good meals at home put me in such trim that I was soon literally bulging with flesh and muscle. All afternoon I was exercising in the sun, bareheaded and barearmed, and at night there would be classes and games. But my mornings were devoted to drawing and painting, often outdoors, in Wade Park, or along the old canal road. I also painted a portrait of my mother, endeavoring with my feeble powers to express on canvas all the love I bore her. It was a good likeness, and I enjoyed the satisfaction of having it accepted and hung at the Academy exhibit in New York the following season. My two sisters, Ethel and Flora, also posed for a double portrait on an ambitious scale, but this work has been lost to posterity, having disappeared in a family moving. Of the various portraits I attempted at the time, that of my mother is the only one which had any artistic merit.

That summer is also memorable to me for having seen the realization of an old dream of mine—I was initiated into the noble art of self-defense by a master of that art. He was the owner of a nearby cigar store and poolroom and an occasional frequenter of our gym. In his day he had been a noted pugilist, runner-up to Johnny Lavack, world lightweight champion. He was now in his forties and would drop in to work off some of his superfluous flesh. I was quick and strong, but my knowledge of boxing was quite elementary, so I seized this opportunity to get some first-rate instruction.

Having struck up an acquaintance with the ex-pugilist in the gym, I soon became his pupil. Though he was much lighter than I, a flick of his experienced arm sufficed to send me staggering. I recall how once, having received one of his flicks, I rushed at him. He seemed not to move, yet there I was sprawling on my back. Again I made at him, but he held me, puffing a little but laughing, and told me to wait. Then he showed me how it was not necessary to throw my arms and swing; how to time a blow and at the same time push with the shoulders; how, when a blow landed on the opponent, to twist the hand and give an upward shove, what I believe is called a "corkscrew"; and how, above all, not to lose my head and come in with my guard open, giving my opponent the chance of striking where he pleased.

But, first and foremost, there was one lesson which my instructor never tired of dinning into me—namely, that of learning how to guard myself. This knowledge, he told me, was as important, if not more so, than the science of dealing blows. Every blow which an opponent fails

to land weakens him and leaves him open for a return. "Never lose your head," he would say, "fight more with the noodle than with the fist." I was taught how to cover my face and crouch so as not to offer the heart or solar plexus as target—"and smile, kid, always smile! Make the other guy think he can't hurt you." That, I believe, is a maxim for success in any walk of life.

Working almost daily with my boxing instructor taught me many other things—how to use my weight on an adversary instead of leaping out of the way and using up my energy; how to ride with a blow, as in catching a baseball, letting one's hands go back in the same direction; how to close in and stifle a blow before it gains force; and how to glide in and out. I was taught to time my left in a cadence with musical rhythm—one, two, one, two—and I was surprised to discover how much faster the arm can move than the eye. As a sport I loved it, but prizefighting I have always hated.

But I have not set out to write a treatise on boxing. The point I wish to make is that this training gave me confidence in myself. I was living in a man's world. The playground was often a rendezvous for young toughs from the nearby slums, and my ability to hold my job depended on my ability to match any hoodlum looking for trouble.

During the various seasons I have worked in a gym or playground, I have only twice been put to this test, and that was, curiously enough, during the period I was learning to box. The first occasion occurred when a young tough invaded the corner of the playground reserved exclusively for small children and dragging a little girl out of her swing took the place for himself. The crying youngster came to me and told me what had happened, whereupon I ordered the intruder to get out of the swing at once. He answered me with an obscene oath, so I dragged him off, and as he came at me, I cuffed him in the face. As he staggered back, one of the swings, manipulated by a little girl behind him, caught him on the back of the head and laid him out. I am convinced he thought and still thinks it was the wallop I gave him which knocked him out.

The only other battle I had was with a former schoolmate of Brownell School, who was some years older and in a class above me. On one occasion, the origin of which I cannot remember, he gave me the most brutal licking I ever had, and to cap it, kicked me black and blue when I was down. One of my ambitions since then had been to pay him back. He often came to the playground at night, generally in an aggressive mood, and would taunt me with the licking he had given me when we were boys, giving me to understand he could still do it whenever he liked. I was still secretly afraid of him and he knew it. However, it was up to me to show him his place, so I finally told him that, though he might still be able to lick me, I was boss on the playground and he would have to obey me. His answer was to tell me to go to hell and that he would do as he liked.

"Out you go," I retorted, "and you don't return until I give you permission." He laughed at me and tried to turn his back. But he didn't have the chance. Remembering my boxing teacher's advice, I laughed back at him and tapped him at the same time a few light blows with my left

hand. That roused his temper, and he rushed at me in a rage. It was over in a few seconds, and he lay on the ground, cringing and apologizing.

After that there was no more trouble at the yard, and I was not again called upon to exercise my pugilistic science. The confidence I had gained in myself kept me out of scrapes in which I might otherwise have become involved. Needless to say, the two mimic battles were enhanced with a legendary glamor by the frequenters of the playground.

THE FIRST WEEK in September, when the public schools reopened, ended my job for the season, and I returned to New York, with a stouter heart this time, knowing what to expect.

Unfortunately, things did not work out as smoothly as I had expected. My old job at the League had been given to another young fellow, and it was up to me to find some other means of subsistence, as my slender savings from the summer would not suffice to see me through the winter.

After looking around for some time, I finally obtained a job as assistant shipping clerk in a coffee-importing house in Front Street. There was a delightful aroma about the place, and the old neighborhood was picturesque; but hours were long, and it was only at night that I found time to study my art, this time at the National Academy of Design, where there were no tuition fees.

I learned a good deal about coffee. Near my place of employment were other coffee and tea houses, and it amused me to watch the tea tasters smelling and sampling the various blends, with heads tilted back, gargling small mouthfuls. My lunch consisted of sandwiches, washed down with the finest brews of coffee. Ever since, the smell of coffee summons up visions of Front Street. But the milieu was hardly a sympathetic one for a budding artist. To my fellow employees the idea of aspiring to be a painter seemed a sign of moral depravity, for, as the shipping clerk once put it, "Artists is just a lazy lot of bums," an opinion which, I was to find out, is not confined to shipping clerks and coffee importers.

Many of the students attending the night classes at the Academy were in the same position as myself, earning enough during the day to continue their studies. Others were commercial artists and lithographers, often earning good salaries.

Kroll would also drop in at times. He was discouraged, as the "art departments" of various newspapers to which he had applied for work had turned him down—very fortunately for American art! For had his services been accepted at the time, he might never have been anything but an illustrator, instead of becoming one of our most brilliant and successful painters. I often went to his home, where, large as the family board was, there was always room for a friend. An added charm of their hospitality was the family music, for Kroll Senior came of a line of musicians and had followed the family tradition, as had also Theresa, the youngest member, who was already an excellent pianist. Her sister Bertha, who is now conducting a very successful art gallery in New York where she handles the work of young artists strug-

gling for recognition, was at that time the moral support of her brother, who but for her constant encouragement might well have lost heart. Since those days she has launched many other young artists on the road to success.

The director of the Settlement House in Cleveland had given me an introduction to Miss Lillian Wald, head of the Nurses' Settlement in Henry Street, on the Lower East Side, hoping that she might find me a job similar to the one I had had in the summer. But there was no gymnasium then connected with the Settlement, though there were a few embryonic athletic clubs. Of one of these, an association football club, organized by the older boys of the Settlement, I became a member. In the evenings we would practice in vacant lots and on Sundays play matches with similar teams, the far-off Bronx or the marshy meadows of New Jersey being the scenes of those encounters. In the warm spring days we played baseball, with which I was more familiar. My skill as pitcher soon procured me an offer from a semiprofessional team. As a result, I was soon earning more money playing baseball on Saturdays and Sundays than I was paid for a week's work at the coffee house. Thanks to Miss Wald, I was further able to increase my income by putting in a few hours in the afternoon as milk carrier to the sick and needy in the squalid tenements of the district. So once more I was able to quit my job and devote my available time to painting.

A stimulating acquaintance which I made through Miss Wald was that of James Kirk Paulding, a distinguished man of letters, descendant of the J. K. Paulding who had been the intimate friend of Washington Irving. On Sunday mornings at his home in Twenty-third Street there would be gatherings of talented young men in whom Paulding took a sincere interest, which often went to the length of giving them financial support. It was there I first met Jacob Epstein, then studying sculpture with George Grey Barnard at the Art Students' League. Epstein was completing a powerful series of drawings to illustrate a book by Hutchins Hapgood on the East Side of New York.* Another visitor was Bernard Gussow, a pioneer among the younger Impressionists in America, who had recently returned from Paris. Listening to his account of Paris filled me with longing to visit that Land of Desire of all artists.

Mr. Paulding, who was well informed regarding painting and who possessed fine reproductions of modern masterpieces, was also helpful in guiding my choice of reading, opening up to me unsuspected sources of intellectual pleasure. I persuaded him to sit for his portrait through many hot summer afternoons, during which the struggle against drowsiness was often more than he could cope with. The portrait could not be termed an entire result, and there was justice in the comment of Mr. Paulding's young nephew who remarked that uncle's portrait looked like that of a boiled lobster. The hot weather had congested my model, and it looked as if my palette had been steeped in red.

*Epstein executed the drawings for Hapgood's *The Spirit of the Ghetto* (1902) in 1901. Richard Buckle, *Jacob Epstein-Sculptor* (Cleveland and New York: The World Publishing Co., 1963), p. 12.

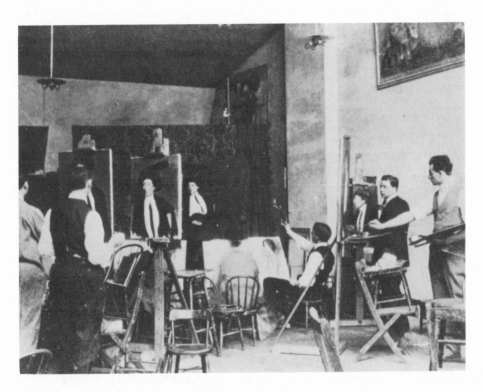

A painting class at the National Academy of Design, c.1910.

Notwithstanding, I managed to get some small commissions for other portraits, which helped to swell my exchequer. One was a portrait of Mrs. Kasner, mother of my cousin Jack, which made such a good impression on the Kasner family and their friends that I was commissioned to paint (by subscription) the portrait of a well-known medical professor at Post Graduate Hospital, as a presentation gift from his colleagues. This man of science appeared to me a dour and stern person, with imposing brow, keen, frowning eyes, and powerful jaws, veiled by a well-trimmed Van Dyck beard. I was greatly intimidated by my sitter, but managed to hide my fears. The completed portrait was proclaimed by the donors to be an excellent likeness, but I learned later that the professor's wife and family disliked it exceedingly on account of its forbidding aspect, for it appeared that in his family circle and among his friends the professor was a genial, smiling person. Which goes to prove that a portraitist should be acquainted with the real personality and the home environment of his subject.

MY FRIEND and former teacher at the Cleveland School of Art, Louis Rorimer, had sent me an introduction to Louis Loeb, then enjoying wide celebrity as a painter. Loeb, a native of Cleveland, had formed a close friendship with Rorimer when both were students in Paris. As illustrator, Loeb was in the first rank, his work in *Harper's*, *Scribner's*, and other leading publications having gained for him a wide reputation in artistic and literary circles.

By a happy coincidence I met Loeb at the Varnishing Day of the Society of American Artists, which had accepted the portrait of my mother for their show. My name and the title of my picture, with its number, were in the catalog. But where was my portrait? Search as I would throughout the galleries, I could not locate it. Was it possible that by some oversight my work had been omitted? I was almost in despair, when I came across Cullen Yates and confided my apprehensions to him. Laughing, he pointed upwards. There, on the second line, between two large canvases, which dwarfed it into something resembling a dark postcard, hung my portrait. My dismay must have been evident, and I was doubly grateful when Yates assured me that my picture was a very creditable effort.

Standing close to Yates I noticed a dark, bearded, handsome man of about thirty-eight, with somber, deep-set eyes. There was something strangely magnetic about him, and it was with a thrill I heard the name of Louis Loeb pronounced. Ever since my arrival in New York I had been longing to meet my distinguished fellow townsman, but his reputation and the prestige of his name were so great that I had not had the courage to avail myself of Rorimer's introduction to call on him. Now that we were face to face, I spoke of the introduction and mentioned the fact that his aged mother was a neighbor of ours in Cleveland. My naive chatter evidently pleased him, for he invited me to call on him, promising to criticize and help me in my work.

Late that spring Kafka left for Europe, leaving me alone in the little room in East Fiftieth Street, so when kind-hearted Mamma Kroll, at whose house I was a frequent guest, suggested I should move into a vacant room in the same house and take my meals with her family, I eagerly availed myself of the opportunity. The happy, congenial surroundings were all I could desire, and as my kind hostess, who regarded me as "one of her boys," would not hear of accepting money for my board, I was in every way the gainer by this arrangement. With nothing but the small rent of my room to pay, I was able to indulge myself in paint and canvas to a greater extent than before. With Leon Kroll I attended the night classes at the nearby Academy, and during the warm months we both sketched outdoors, mostly in Central Park.

I paid weekly visits to Louis Loeb, who had a studio in the Sherwood Building on Sixth Avenue. With its high skylight facing north, its rich draperies, easels, lay figures, and canvases carelessly strewn about, this studio appeared to me a veritable temple of art, filled with glamour and mystery. Loeb himself, to my relief, turned out to be a simple, straightforward person, filled with the milk of human kindness. Though his criticism of my work was often ruthless, it always contained some encouragement, as every useful criticism should.

On my first visit I found Loeb engaged on a portrait of the actress Eleanor Robson, then leading lady in Zangwill's *Merely Mary Ann*. But the genre in which he excelled and which was nearest to his heart was allegory. Of the Old Masters Nicolas Poussin and of the moderns Boecklin and Franz Stuck had chiefly influenced his work. The poet Theocritus was a constant inspiration to him, and his visions were peopled with nymphs, dryads, and piping Pans, dancing in sunny glades or in twilight mists.

One of his large canvases, entitled *The Temple of the Winds*, which had met with considerable success at the Paris Salon, was now back in his studio. But Loeb was no longer satisfied with the picture and intended repainting some parts of it, notably the large figure of the youth in the foreground. He suggested that I might pose for this figure, and I gladly accepted, whereupon he made a drawing of me as the model. Later I helped him scrape off the paint where he intended to work afresh, and also squared the drawing he had made to the requisite size and traced it onto the canvas. For this work, which took up part of the summer, I was generously paid. The repainted picture was subsequently bought by a wealthy New Yorker, who presented it to the Metropolitan Museum of Art.

Before leaving for the country, Loeb asked me whether I would care to work for him as assistant during the coming year. Such a piece of luck seemed almost unbelievable! I was offered a training in my craft far superior to any I could acquire at an art school. In addition to this, the salary he offered me, though modest, would be ample for my modest needs. With a thankful heart I accepted this welcome offer and bade him goodbye until the fall.

That summer was a memorable one, for it gave me the first chance to paint outdoors for an uninterrupted spell of several months. Miss Wald had asked me to take charge of a summer camp organized by the Henry Street Settlement on the shore of Lake Mohegan, celebrated by Fenimore Cooper. As my camp duties were not exacting, I spent long hours outdoors sketching from nature, profiting greatly in body and mind by the healthy outdoor life.

That autumn at Mr. Loeb's studio, Kroll and I made the acquaintance of Henry Mathes, just arrived from Chicago, who already had won a name in the West as illustrator and was now attracting the notice of Eastern magazine publishers. We were soon a congenial trio. At Mathes's suggestion, Kroll and I, who were in need of a workshop, took a small apartment high up in a building in Eighty-sixth Street, where a large room facing north made a suitable studio. Our little place was heated with a cast-iron stove, but some nights were so cold that the three of us slept together for mutual warmth. I was the cook of the establishment and provided the evening meal, which generally consisted of boiled potatoes and three huge steaks. I would buy a cheap cut, called the chuck steak, twelve cents a pound. Three pounds of this with plenty of onions and potatoes, washed down with quantities of hot tea, made a copious repast.

One Sunday, when as usual we were on our way to dine at the Kroll's house, Leon Kroll surprised us by revealing an unsuspected side of his character. We were passing through a tough neighborhood after a heavy fall of snow, when we came upon a band of young roughs mercilessly pelting an old man with snowballs. When we tried to interfere, the band of hooligans turned on us, and we were obliged to make a fight for it. Kroll, who was of small physique, was our first casualty. An old shoe, hitting him on the head, bowled him over down the area steps where we had taken our stand. In a moment, he was back, blazing with the lust of battle, a veritable David ready to slay his tens of thousands. His onset was so terrific that the enemy was soon put to flight. But there were several black eyes among us to tell the tale of the Sunday battle, and that evening we were to attend a concert! How to save our telltale faces! It was then we remembered the lower Bowery expert who painted out black eyes, and we proceeded to do likewise, so successfully that no one that evening or the next day noticed the traces of our combat.

My work at Loeb's studio consisted mainly in making drapery studies and tracing drawings on canvases. At times he would send me to the Museum of Natural History, where I made careful drawings of animals which he needed as details for his pictures. At other times I posed for him. A drawing he made of me as Pan, scampering up a hillside in pursuit of a nymph, became the subject of a painting called *The Summit*, later acquired by the Metropolitan Museum of Art. The studies he made for this picture I traced onto the canvas, and then painted in the figures and landscape, a mixture of raw amber and white, modeling the whole in a thick impasto. I prepared the sky portion with cadmium yellow, the lower part very light, becoming darker and more orange in

scale as it reached the top. When this was thoroughly dry, it was scraped and sandpapered to remove the roughnesses of the paint, after which Loeb glazed pure color over the whole, giving the finished picture a mellow richness that can hardly be equaled by direct painting.

I was particularly impressed by the ingenious device by which Loeb caught the effect of the flying draperies of the escaping nymph. He made a small clay model of the nude figure in action, which was then cast in plaster. A miniature dress with flowing robes was made to fit the cast. The dress, soaked in starch, was then placed on the figure, and an electric fan behind blew out the robe into lovely flowing folds. In a short while the starched garment dried in the shape it had been blown into by the fan, and the fugitive moment was permanently fixed. Loeb then proceeded at his leisure to make his study of the flying draperies. From him I learned much about the chemistry of colors and many small practical things about the craft of painting.

Among the well-known persons who sat for Loeb at this time was Jacob Schiff, who came punctually at 8:30 A.M., leaving as punctually an hour later. Loeb began by making a small sketch in colors, which I squared up on a large canvas. This I painted in a broad, direct way, keeping as closely as I could to the proportions of the original sketch, thus saving my master a bit of tedious, mechanical labor, and enabling him to get to work without having a cold white surface to disturb his eye. Often in the morning, on my way to Loeb's, I met Mr. Schiff on his way to pose, and we would continue our way together. I was agreeably surprised to find that the great captain of industry was a simple and very human person, genuinely interested in painting. Sometimes we would meet May Wilson Preston on her way to her studio in the Sherwood Building after her morning canter in the park, looking in her riding habit like a modern Diana.

That season I posed for a *David*. Loeb wished to show the young warrior resting after battle, playing on the harp. In order to give an accurate picture of the instrument David would have played on, I was dispatched to the Metropolitan Museum of Art to search for a specimen which might serve as model. Applying to a guardian, I explained that I was looking for a biblical harp and was forthwith taken to a case where I was told I should find what I needed. All I could discover was a diminutive mouth-organ, popularly known as Jew's harp. The story, when I recounted it in Loeb's studio, roused shouts of laughter. The *David* picture was never completed, however, and after my master's death the sketch for it came into the possession of Leon Gordon, the portraitist, a relative of Loeb's.

While I was with Loeb, he finished two of his major works, *The Siren* and *Lush Summer*, both of which were awarded important prizes at national shows. *The Siren*, awarded first prize at the initial Corcoran Biannual at Washington, was acquired for the permanent collection, while *Lush Summer* received the Carnegie Prize at the National Academy in New York. This did not prevent the jury of the Pennsylvania Academy from rejecting both these honored canvases, for no valid reason. Possi-

bly some members of the jury wished to show that they were not to be influenced by awards and honors. Loeb took this rebuff in very good spirit, but I confess I rejoiced when I heard later that all the work sent in by one of these strong-minded jurymen to the Paris Autumn Salon had been rejected as being too old-fashioned and academic.

In the evening Loeb's studio was frequently the meeting place of many celebrities. While I washed the brushes in the twilight hours I listened to the conversation of these brilliant men—Israel Zangwill; Hapgood; Judge Sulzberger;* Luis Mora, the brilliant young Spanish painter; A. B. Wenzell; Albert Sterner; George De Forest Brush, Loeb's master and close friend; Arthur and William Schneider, of whom the former had been one of the first to paint in Morocco when that happy hunting ground for painters was still practically unknown. William Beauley, a brilliant watercolorist and architect, was also among Loeb's intimate friends. There would also be visitors from Paris, Leo Mielziner, the portraitist, Orville Root Benson from Kentucky, known as "the colonel." The two latter had been intimate friends of Loeb's during their Paris days, and the word "Paris" was ever present in their conversation. To my eager ears it had already a magic sound—a word to conjure with— an "Open Sesame" which would bring success and glory to the painter who could get there.

Louis Loeb, whose health was not strong, had taken to physical training to strengthen his constitution, and he would spar with me in the evenings, often in presence of the Schneider brothers and Beauley, who, as ring frequenters, gave us pugilistic advice.

We were on the best of terms, and I was given every facility to develop my art, making use of his models in my spare time. But Loeb's influence on my work was becoming so marked that it soon became obvious to both of us that if I continued to work for and under him, I should at best only develop into a small and inferior edition of my master. He was the first to broach the subject, to my relief, for my affection for him was so great that it would have been hard for me to find a pretext for separating from him. As it was, we parted in the best of terms, I promising to see him often so that I might continue to benefit by his advice and criticism.

ON THE ADVICE of Loeb and Mathes, I made the rounds of the various art editors to get illustration work. I managed to obtain a few orders, but soon realized that there was little hope of my succeeding in this line. Meanwhile both Kroll and I were working at the Academy at night, and at the end of the school year we were both awarded prizes.

It was hard going for all of us. Mathes, generally well paid for his illustrations, was the most prosperous. At a crucial moment I was lucky enough to sell a drawing of a pretty girl for a magazine cover to one of the cheaper periodicals, but that was only a flash in the pan. Meanwhile

*Probably Mayer Sulzberger (1843-1923), judge of the Court of Common Pleas No. 2 in Philadelphia and an active figure in Jewish education and philanthropic causes.

Mathes, Kroll, and I had moved into new quarters, a real studio in the Fleischmann Building, facing Broadway and Tenth Street, one of the original studio buildings in the United States. Downstairs was the Fleischmann Bakery, which was by way of being a celebrated philanthropic institution. Every night the charitable owner made free distributions of bread and coffee to the down-and-outs. Among the poor wretches waiting in line we often picked up excellent models, willing to pose for a small sum. I painted one with Union Square as background, giving full expression to the hopelessness and despair inspired by my subject. For a while it aroused the interest of Mr. Drake, art editor of *Century Magazine*, who asked me to leave the picture with him. Finally it was returned to me on the grounds of being "too revolutionary" for reproduction in *Century*.

Grace Church stood next to our building, and at first its musical chimes sounded pleasant to our ears, but before long their insistent recurrence got on our nerves, especially in the early morning. Mathes alone remained untroubled, being a very sound sleeper, though he would never admit the fact. To convince him, Kroll and I had recourse to a stratagem. One night when Mathes was asleep, we uncovered him, rolled up his pajama legs, and proceeded to paint socks round his ankles without awakening him. After that the argument whether or not he was a slight sleeper was definitely clinched.

Chris, the janitor of the building, was a popular character with the tenants. He collected rents, gave advice, and recounted tales of the artists who had lived there in the past, some of whom had risen to fame and fortune. There had been J. Francis Murphy, famed for his gray hillsides, and the two Dirks brothers, creators of the Katzenjammer Kids. In a fit of depression one of the brothers had committed suicide in the studio next to ours. It would also happen that when Chris came to collect rent from some poor fellow who was on the rocks, a hard-luck story from the latter would result in a loan of a few dollars from the good-hearted Chris, though he prided himself on being hard-boiled and sympathy-proof.

George Davidson, from Hartford, Connecticut, and Salvatore Lascari, a young Italo-American, both studying at the Academy, were our floor neighbors. Davidson managed to pick up a good living by devoting a few hours daily to the fabrication of "spot-knockers"—i.e., crayon portraits done after photographs. As for Lascari, he worked in his father's barber shop, earning enough to pay for his studies. Both have made a success, Davidson winning the American Prix de Rome, while Lascari has made his name as portrait painter. Thanks to him there were never any long-haired artists in our circle, for he graciously saw to it that we were regularly and neatly shorn.

And thanks to some sketches I had made of East Side life, I was commissioned by the then-budding *Woman's Home Companion* to illustrate an immigrant story. To obtain the needed atmosphere, I obtained permission to visit Ellis Island. It was a depressing sight to see the immigrants herded like cattle. What a disillusionment for the poor

wretches who for years had saved to reach the Promised Land of their dreams, and to receive such a welcome! I found plenty of material for my sketches, which were well paid for.

Becoming increasingly affluent through his illustrations, Mathes made another move, this time to the Miller Building at Sixty-fifth Street and Broadway, where he rented a studio. Quartered at this address were two young Clevelanders, Raymond Thayer and Hugo Robus, who had studied at the Cleveland School of Art. They occupied an immense studio with plenty of living space. When they suggested my joining forces with them, I gladly accepted, happy to leave the noisy district of the Fleischmann Building and the nerve-wracking chimes of Grace Church.

But in place of church chimes to disrupt my slumbers, I was now forced to accustom myself to another nightly disturbance—the thunderous creaking of the spring mattress on which my two companions slept! As for my own mattress, it consisted of a thick layer of newspapers covered with a woolen blanket spread over a wooden bunk, made up during the day to resemble a Turkish divan. Once accustomed to the creaking wire mattress, I slept more soundly there than I have since on many a luxurious bed—this, despite the nightly incursions of roaches, which infested our building. My horror of these beasts was insurmountable. One Sunday morning, while lying on the couch, I was discussing with my companions ways and means for ridding ourselves of this pest. Glancing up at the ceiling, I saw three of the loathsome vampires. With a cry of horror I seized my shoes and started bombarding the enemy. Roars of laughter broke from my companions. The roaches had been painted on the ceiling, while I slept, for my special benefit!

Hugo Robus and I took turns at cooking, in which he far excelled me, Thayer functioning as dishwasher. One evening, eager to emulate Hugo in varying my menu of frankfurters and potatoes, I decided to improvise a rice stew. Knowing nothing of the swelling properties of this cereal, I poured about two pounds into a cooking pan. To my consternation the expanding grains kept overflowing, until we were inundated with rice and had to use up every available receptacle to cope with the situation.

Clarence Conaghey and "Hicks" Culberg, both from Minneapolis, were our neighbors on one side, while "Micky" Spero, from Cleveland, had a studio further down our corridor. Spero, besides being an excellent illustrator, was proficient on the mandolin, and in the evenings would perform as soloist or accompanist to our choral efforts.

Fire alarms were frequent in the ramshackle Miller Building. Generally due to smouldering rubbish which was allowed to accumulate in the cellar, the smoke would pour up the elevator shaft, spreading panic through the crowded building. One evening there was a serious alarm. Staircase and elevator were shrouded in thick smoke. We scurried over the rooftops to shelter in the neighboring buildings until the firemen had extinguished the quickly spreading flames. In my hasty flight I remember grabbing a portfolio of drawings and several canvases as my most valued possessions.

Our ten-ounce boxing gloves were in frequent use and provided me with ample opportunity for keeping in trim. The colored elevator man often attended our bouts as a connoisseur, having himself often gone into the ring for preliminary contests at Billy Elmer's Consolidated Athletic Club, which had its premises in our building and where we sometimes attended. Among the regular ring seaters I often noted George Bellows and Charles Dana Gibson.

Jim, the elevator man, had evidently told Elmer that I was promising material, for one day I received a visit from him, inviting me to spar a preliminary with the aforesaid Jim as adversary. I was assured it would be a friendly encounter. Though I had some apprehensions regarding this assurance, the ten dollars offered as fee was an inducement difficult to resist, so I accepted.

The following Monday evening found me in boxing togs, uneasy and perspiring, waiting my turn to go on. My opponent Jim, who shared my dressing room, sustained me with friendly advice, assuring me he would not cut me up. He was taller than I, though not as heavy, and his manner of reassuring me only increased my apprehension. I knew he was no Fitzsimmons, but the fact remained that he had had actual ring experience and knew many tricks of the trade. Despite his friendliness, I felt convinced that once in the ring he would be out to finish me.

When the dreaded moment came, I found myself somehow pushed through the ropes, half dazed. The sea of upturned faces below was a blurred mass, while the admonitions of my seconds, who shoved me into the middle of the ring, and the monotonous voice of the referee imparting his instructions, sounded like far-off murmurings.

With the ringing of the bell and Jim's smiling face advancing toward me, I collected my nerves and settled down to box as though sparring with a friend. To my relief I quickly discovered that my adversary was far from being a champion; in fact, he was very much of a novice, swinging his arms about and leaving his body exposed while I hammered him at will. Becoming confident and careless, I left myself open for the fraction of a second. A windmill swing caught me under the ribs with such force that I felt as if I were caving in! My wind was going, and the short moments until the gong sounded seemed an eternity.

In the following round Jim was in a worse state than I, and appeared so tired that he could scarcely raise his arms. Much to my surprise, after I had caught him a not too hard left to the jaw, he went down and let the referee count him out. He had just lost his nerve.

The successful conclusion of my first public appearance in the ring brought me enthusiastic comments on my potential qualities as a boxer and an offer from Billy Elmer to take up pugilism as a career. But I was thoroughly disgusted, and for a long time did not even tell my companions about this exploit. As for my discomfited opponent, he positively bragged of the fact that I had knocked him down, and he remained my friend and admirer.

After haunting the anterooms of the art editors of the various magazines, I was finally commissioned by Mr. Wells of *Harper's* to illustrate a story for *Harper's Weekly*. By this time I had satisfied myself that I

was the second worst illustrator alive (the worst of all had just quit). But it seemed to me a far better trade than that of a successful "bruiser." The story I illustrated concerned an Italian shoeblack. Mr. Wells was kind enough to pass the drawings, and the resulting check left me richer than I had ever been in my life.

Summer was approaching, and with it the longing to paint outdoors became an obsession. In the Miller Building I had become acquainted with a landscape painter, Samuel Weiss, a short, stout, quiet man of about thirty-five, already well known for his low-toned poetic landscapes. He was going to the coast of Maine, near Portland, and suggested that I spend the summer with him and benefit by his experience, an offer which I gladly accepted.

FROM PORTLAND we proceeded to Prout's Neck, a tiny old New England village. Its clapboard houses, painted white, with their fan-shaped windows, had a charming air of prim antiquity which appealed to my imagination. Winslow Homer, whom I considered then, as now, the greatest painter America has ever produced, had chosen this village as his home. There, in his studio overhanging the sea, he painted those heroic seascapes replete with power and the tragedy of those who "go down to the sea in ships," which have secured for him a place among the great masters.

The heroic note in his pictures, so in keeping with the name of Homer, suggested to me some superman, physically as well as morally. Stories of his misanthropy, his secluded life—bound up in his art and the little world of fisher folk, who idolized him for his sympathy and help in time of need—had created a legendary atmosphere about Winslow Homer, which made me apprehensive about the reception in store for us, especially as we had been told that his well-known dislike for women was only equaled by his aversion for painters, who had often refused admittance to his house.

Our surprise was all the pleasanter on finding when we called on the famous artist a bald and quite un-Homeric little man in a tieless high collar, bidding us welcome with a typically New England accent. Then, ushering us into a small bar, he offered us a choice of liquors. The fact that Maine was a temperance state made this display of hospitality doubly appreciable.*

A few years before, Weiss had seen one of Homer's pictures at the Luxembourg Museum in Paris—a night scene with figures dancing on a

*Warshawsky's recollection of his pleasant visit with Homer in 1907 presents a picture of the famous painter that is quite at odds with the universally accepted legend of the old man as a crotchety recluse, jealous of his privacy and suspicious of outsiders. But there is additional evidence that Homer could be quite charming to visitors. Philip C. Beam offers this anecdote in *Winslow Homer at Prout's Neck* (Boston and Toronto: Little, Brown, 1966), p. 221:

Mrs. Marguerite Dowing Savage, a painter, met Homer at Prout's Neck at this time [1902], when she was twenty. Running out of yellow ocher while painting at the Neck, she ignored warnings about his unfriendliness, and knocked at Homer's door. To her

verandah, dark rocks and the sea as background—one of the few pictures with a moonlight effect which can be ranked among great works of art.* This picture, Homer told us, had been painted from the very house we were in. He showed us magnificent watercolors he had done in the West Indies, remarking that he had taken a dislike to painting in oils as the shiny canvases merely served to reflect his old, bald pate. He had spent a year in Paris painting flower girls and pretty genre pictures without much character. It was only when he had secluded himself on the coast of Maine that he had really found himself.

Among his reminiscences he recounted a visit he had paid to the South just after the Civil War. His object had been to make studies of the Negro before the old traditions and customs had passed away. But he had hardly gotten started when a committee of citizens called on him, telling him he would do better to devote his art to depicting white people, and requesting him to leave town.

Having settled us in Maggie Lee's boarding house (hotels at Prout's Neck, he assured us, were too expensive for young painters), Winslow Homer continued to befriend us during our stay. He turned over to us a cabin along the shore that had formerly served him as studio and workshop, and criticized our painting. Unlike most artists, who confine their criticism to craftsmanship, Homer was the first painter I had thus far met who discoursed on motive and the fundamental question of whether a thing is worth doing or not.

The mornings were generally foggy, but after the sun had cleared off the mists, we would get to work. I made many studies of the huge rocks and pounding seas along the heroic coastline where the elements seem never to be at rest. One of these canvases, a nocturne—white rocks with a few tiny figures on them—earned for me a tribute of praise from Homer which was as gratifying as it was unexpected. "It is beautiful," he remarked in his simple, straightforward fashion when I showed it to him. Unfortunately, the scene, painted in dark colors of poor quality, has almost vanished from the canvas.

Kroll, to whom I had written enthusiastic descriptions of Prout's Neck, came to join us, bringing with him his sister Bertha, Louis Mann, the comedian, and his wife, Clara Lippman, then starring in *Julie Bon-Bon.* Friends of Weiss's also joined our group. Mann, having taken up painting as a hobby, counted himself "one of us." Whenever he had finished a sketch, he would run to meet us, flourishing his wet canvas and soliciting our admiration. Like many of the acting profession, Louis

delighted surprise, he gave her a large tube of ocher in his favorite Winsor & Newton brand, and they became very friendly. He showed great interest in her work, gave her many hints, and went out of his way to introduce her to people who might further her career. Once he brought John W. Beatty, then art director of the Carnegie Institute, to her studio to see her paintings.

*Homer was awarded a gold medal for *A Summer Night* when it was exhibited at the Paris Exposition of 1900. The picture was then purchased by the Ministry of Fine Arts. Albert Ten Eyck Gardner, *Winslow Homer* (New York: Bramhall House, 1961), p. 202.

Mann had an exaggerated idea of the importance of his role in ordinary life. "Do they know who I am?" was the question which obsessed him, and about which he would consult us anxiously whenever we came in contact with the local public. His concern about this vital point was so naively sincere it simply had to be allayed.

In addition to her well-earned reputation as the finest pie baker on the Neck, our landlady, Maggie Lee, was happy in the possession of two fair daughters, a happiness in which I was lucky enough to share during some memorable evening strolls along the beach. Much as I enjoyed these nocturnes, I was forced to admit to myself, with some mortification, that I was taking *faute de mieux*. For my heart was full of another— but, alas, she never knew, though she was close at hand! To quiet the pricks of conscience and ward off the string of mosquitos, which were even more troublesome, I learned to smoke a pipe. But this mannish habit was discarded with the occasion which gave rise to it.

After six weeks I departed with Leon and Bertha Kroll, leaving Weiss behind. We took the boat as far as Boston. There, during our short stopover, we visited the Museum, which contains some of Homer's finest pictures, and also the Library, where Puvis de Chavannes's murals made the overwhelming impression on me they cannot fail to make on any sensitive artist. As Louis Loeb put it, "If you don't understand and appreciate Chavannes, it is because *you* are wrong—not Chavannes."

On my return to New York I showed my new sketches to Wells of *Harper's*, who remarked that I had the painter's sense, and advised me with true kindliness to give up the idea of illustrating as a career. Somewhat discouraged by this advice, I returned to Cleveland, still determined to try my hand at commercial art. But I found I could make as little headway there as in New York.

DURING THE FALL and winter of 1907 I was given charge of a night drawing-class at the Educational Alliance. My class consisted of seven pupils, of whom five have since made their mark in the world of art—a far higher proportion, I am happy to believe, than may be recorded by most art schools. These five pupils were: William Zorach, who, with his wife, Marguerite, has been rated among the leaders of modern American painters; Max Kalish, the sculptor of labor subjects; Sidney Laufman, one of the Paris group of American painters; Robert Stewart, the illustrator, whose work is familiar to readers of the *Saturday Evening Post*; and my brother, Alex Warshawsky.

The following summer I spent at Camp Wise on Lake Erie. This camp, which has continued to function every summer since, was one of the public philanthropies instituted by Samuel Wise, the well-known, public-spirited citizen of Cleveland. There, throughout the hot weather, fifty boys and fifty girls of the poorer classes are given a fortnight's holiday, the little colony being renewed by successive drafts. A group of boys swimming, which I painted at the camp, was later exhibited at the Autumn Salon in Paris. But for the time being it looked as if I should

have to rely on physical culture, rather than on art, as a source of livelihood.

While I was speculating somewhat gloomily about the future, a letter from Kroll informed me that he had won the Mooney Scholarship at the Academy, entitling him to two years' study abroad. He urged me to join him in Europe, but for the moment that possibility seemed more remote than ever—so at least I thought.

Miss Norton, director of the Cleveland School of Art, who had seen the work I had brought back from Prout's Neck, arranged an exhibition of my canvases at the school. This show, which was very favorably noticed by the press, actually resulted in a few sales. One of my purchasers, a retired banker, loomed for a while very large on the family horizon as a potential Maecenas for my budding talent, but that bubble soon burst. A small canvas was all he bought.

But though the material results of this exhibition seemed to bring me no nearer my goal, they proved to be in fact the turning point of my career. Louis Rorimer, who had seen my show and noted the progress I had made, told me the moment had come when I must make a break if I hoped ever to become a painter. This advice was coupled with an offer to pay for a trip to Italy and for several months abroad. The extreme tact and kindliness with which this generous offer was made quickly overcame my first feeling of embarrassment. It was a case of "now or never," an opportunity which might never recur. Feeling that I could never express in words the gratitude I felt, I resolved to prove to my benefactor, through study and work abroad and the results I hoped to achieve, that his faith in my talent was justified.

It seemed as if I should burst with joy before I could arrive home and break the news to my family. Dad and Mother knew how discouraged and impatient I had become, but the thought of my crossing the ocean and living in a foreign land filled them with misgivings. On the other hand, I had already proved to them that my years of struggle in New York had made me self-reliant, and they knew how long my heart had been set on reaching the goal to which all young artists aspire—Paris! They insisted that I keep the money I had earned as salary for my camp work, as well as the sums realized by the sales of my small canvases at the Cleveland exhibition. Some portion of this money was invested in much needed articles of clothing, and within a few days I was ready to start on the great adventure.

Arriving in New York, I made a beeline for the steamship office and secured a passage on the White Star liner, *Arabic*, sailing the following morning. Then I paid a last happy visit to my master, Louis Loeb, who was as pleased over my good fortune as I was myself. We spoke of his intended visit to Europe the following year, when, he assured me, he would not fail to look me up. Alas! We were destined never to meet again, for he passed away shortly after my return from Italy the following year.

I had informed the Kroll family of my impending departure, and it was under their hospitable roof that I spent that last night in America.

The next morning Bertha Kroll and her youngest brother, Carl, with some of their friends, wished me Godspeed and waved me farewell from the pier.

Opening before me were new windows on the world—sublime creations of art, mysterious lands, and the eternal wonder that ever haunts the artist and dreamer.

·4·

1908–1909

IN THOSE HAPPY-GO-LUCKY prewar days—before Kaisers, Tsars, Sultans, and other despots had been abolished in order to "make the world fit for democracy"—the adventure of traveling to foreign parts was a relatively simple affair, a matter of packing trunks, buying a steamer ticket and, possibly, obtaining a letter of credit. The stimulus of getting out a passport, obtaining visas, *permis de séjour*, and other credentials was left to another and more enlightened age. During my first years abroad—whether in England, France, Italy, or Switzerland—I was never asked to produce credentials of any sort, and had none to show, not even a passport.

Owing to the fact that international traveling had not been as extensively advertised as it has been in recent years, and also, I believe, to a rate war between various steamship companies at that time, there had been a general lowering of prices. As I left in November, when passenger traffic was very low, I had my choice of steamers and dates of sailing. I decided on the *Arabic*, an old boat of the White Star Lines. For the price of sixty dollars—less than steerage passage on any modern liner today—I was accommodated with a four-berth, airy cabin all to myself, an outside room with porthole, in the second class. My fare included railroad transportation from Liverpool to London, where I was entitled to make a two-weeks' stopover, a railroad trip to the Channel, the crossing to Dieppe, and the fare to Paris. Seldom when traveling have I been so comfortably lodged and so well looked after by the steward, who first accustomed my transatlantic ear to the cadences of polite cockney, which has a cheery, soothing sound to one adventuring for the first time on an ocean trip.

When I arrived at the dock to embark, the *Arabic*'s few passengers were already going up the gangplank and the siren blowing its warning of departure. The Great Adventure was on. I stayed on deck, gazing at my friends on the wharf until their figures were blurred from sight. A twinge of loneliness overcame me, and I realized what the French mean when they say *partir c'est mourir un peu.* How much might happen while the ocean lay between me and my native land! The air was beginning to feel raw and cold. We were pulling out of the harbor and already the Statue of Liberty was bidding us farewell, as our boat began to rock heavily. Passengers were striding up and down to acquire their sea legs, and I followed their example until the welcome sound of the lunch gong.

41

The ocean breezes had whetted my appetite. There were very few people at table, which was not surprising, seeing that in the entire second class there were barely thirty passengers. At my table the gathering consisted of an English curate with his daughter, returning from Canada, an army officer from Jamaica, and a chap with a decided cockney accent, who, as I discovered later, was a music-hall performer. It was a little distressing to find, when we met again at dinner that evening, that all my fellow diners had donned evening dress, whereas my only change of raiment had been the addition of a heavy sweater. Having no dinner jacket in my wardrobe, I could only hope that they would bear with me in patience and make allowances for the obvious fact that I was an American.

Before retiring that night, I got out the luxuriously bound notebook, inscribed in gilt lettering, "My Trip Abroad," which an old friend in Cleveland had presented me as a parting gift, and noted down the principal events of that memorable day, resolving to maintain a faithful record throughout my trip. But the night was to add new experiences, for I was awakened after a brief sleep by the slamming of doors and the sliding and bumping of my valise under my berth, while the ship heaved and groaned. To keep myself from tumbling out of bed and joining my valise in skidding about the floor, I had to grip the sides of the berth. A sinking feeling within me warned me to anticipate the worst. It came, and I realized more desperately than before that *partir c'est mourir un peu. . . beaucoup!* Let those who have never known the horrors of the "evil of the sea," as the French so aptly dub it, cast the first stone of derision at me! Soon S.S. *Arabic* and I were heaving and groaning in unison, while I kept my finger pressed on the bell button to summon the steward. He, too, came at length, having already spent the night hours ministering to my fellow passengers. With his help, I dressed in order to go on deck, as he advised, but it was too late. A fatal giddiness had overcome me. I felt my last hour had come, and I preferred to die in my bed.

After three days of this misery I decided to make an attempt at resurrection, but I found that all my strength had left me, and the most I could do was to lie stretched out on a deck chair, muffled in rugs, glowering at the callous persons walking cheerily about the decks or playing shuffleboard. Nor was I spared the usual bore, who came to inquire how I fared, and regaled me with ill-timed jokes about the fell malady from which I was recovering, the originals of which Noah must have noted down in his logbook.

Next morning, after a good night's rest, I was miraculously restored to life, and though a heavy swell was running, managed to lurch about the deck and exercise my limbs. A fog blew in later, and the dismal tooting of the foghorn drove most of us indoors.

As for my travel diary, its maiden entry remained its last, and the only other contributions to "My Trip Abroad" were in the guise of sketches and addresses.

The only acquaintance I made on board was that of the captain from Jamaica, who occupied the deck chair next to mine. Unfortunately, he

was not going to London, but he gave me the address of a modest hotel in Bedford Square within walking distance of the British Museum.

The trip was a long one—eleven days to Liverpool, and when we at last sighted land, my joy at catching my first glimpse of the Old World must have been comparable to that of Columbus when he first set eyes on the shores of the New World.

The tiny railroad carriages that were to convey us to London seemed toylike in comparison with our American coaches, but I found them comfortable and more speedy than I had anticipated. The glimpses I had of the English countryside were entrancing. For the first time I saw the thatched roofs and quaint cottages I had so far seen only in pictures. In spite of the cold, late season, my first impression of England was that of a very beautiful, romantic country. The trip to London was all too short, and before I could really become accustomed to the novelty of my surroundings, we were pulling into Victoria Station.

A taxi whirled me off to the hotel in Bedford Square, where I was ushered into a large, cold room. Having vainly searched for radiators to turn on the heat, I rang for a bellboy and asked whether it was possible to warm the room. He pointed to the fireplace, and returned with a bundle of wood, which he proceeded to light. The result was more smoke than heat. The public sitting room downstairs, with its large fire blazing on the hearth, seemed far more inviting, but I found draughts blowing in continuously from every side—a discomfort to which the English hotel clients appeared to be serenely oblivious. I was fairly hardened to the cold of our American winters, but there was a penetrating chilliness to the English air which defied all my efforts to promote a reaction in my blood. The joy of sampling the copious English breakfast, of which I had heard so much and which lived up to its reputation as far as variety was concerned, was offset by the glacial atmosphere of the dining room, where smoke from the fireplace mingled with the November fog oozing in with the draughts from without.

In the innocence of my heart I had imagined that being in the "old country" would feel very much like being in America. Of course, there would be certain variations—differences of local customs and local speech—such as obtained in New England or in the South. But, essentially, things would be the same. My first walk in London showed me I had been greatly mistaken. Things here were not superficially, but *essentially* different—the very speech, though the words might be the same, was another idiom, and behind those familiar words were other thoughts and other motives, often for utterance or silence. Life was busy, bustling, even intense, but it was composed and somehow rounded off to some steady purpose. The very roar of the traffic in Fleet Street and Cheapside was a measured and orderly roar, compared with the bellowing and clanging of New York or Chicago. The top-hatted businessmen and city clerks, the strangely attired bank messengers, the stately, bemedaled commissionaires, the red-coated bootblacks—all seemed to go about their business with a leisurely briskness and cheerfulness, a placid contentment, which was a striking contrast to the restless, nervous urge of our

great cities. As for the famous London bobbies, they were a veritable tower of strength and dignified repose—aloof, but friendly. Their manner of imparting information when appealed to for help or guidance was something I felt our coppers in America might well imitate.

Mr. Paulding had given me the address of Jacob Epstein, the sculptor, who had already been living in London for several years, and suggested that I should call on him. Epstein, an American by birth, had made a splendid career abroad, and was considered by many the leading sculptor in England. His monument to Oscar Wilde, recently erected at the Père-Lachaise Cemetery in Paris, had, on account of its stark unconventionality, created a furor. He had also carved the figures for an important public building in London, which had aroused another tempest of protest and defense.*

At his studio in Cheyney Walk in Chelsea, Epstein greeted me hospitably and showed me some of his work, compelling in its power and sheer ugliness. The man was sincere and his vision that of a true artist. After lunching together we wandered about London all that afternoon. Realizing he was a busy man, I was reluctant to intrude further on his time, so I promised to call on him again before leaving London, thanking him for his kindness.

That night I went to a music hall, where I was surprised to find that the leading numbers were American talent. I especially remember two Negro comedians, who made a great hit, and was amused by the efforts of my British neighbors to imitate the darkey drawl.

During the rest of my short stay I devoted my time to the National Gallery, the British Museum, and the delightful Wallace Collection, and spent an entire day bus riding all over the city. Everything was new and exciting. Already in those days the problem of unemployment was making itself felt, for I recall groups of men parading the streets bearing placards "WE WANT WORK." I was also struck by the number of intoxicated people I saw on the streets, many of them women—an almost unknown sight in Latin countries, where wine is cheap and plentiful. To complete my experiences in the British capital, there was a genuine London fog of the pea-soup variety. I had not gone out far enough to get lost, which would inevitably have happened if I had ventured further, for the

*In the words of his biographer, Epstein carved "a fallen angel, an angel of debauch, with bags under his eyes, and wearing the Seven Deadly Sins in a diadem worthy of Heliogabalus. The angel's face with its closed, slanting eyes, high cheek-bones and protruding lower lip seems Mongolian; the rigid rendering of the limbs is Egyptian, while the highly formalized but meticulously detailed wing, whose rectangular shape reflects and emphasizes the original cube of the stone block, recalls the great Assyrian winged bulls from Khorsabad in the British Museum." Richard Buckle, *Jacob Epstein—Sculptor*, p. 63. When Epstein arrived at the cemetery in October of 1912 to put finishing touches to the statue, he found it covered with a tarpaulin and guarded by a gendarme. French authorities, he was told, had banned the tomb. A bronze plaque covered the figure's sexual organs and the entire tomb remained covered by a tarpaulin until World War I. There had been a similar storm of protest when Epstein's monumental nude statues for the British Medical Association building in the Strand were unveiled in 1908. These sculptures, executed in a peculiar style that combined naturalistically rendered bodies with highly stylized heads, were also criticized for being "immodest." Ibid., p. 44.

gloom was so thick it was only by groping I managed to find the way back to my hotel.

THE URGE to see Paris and "la belle France" was becoming irresistible. So on the eighth day I repacked my bulky valise, and stalked by the entire hotel staff, bellboys, life man, clerks, and others lined up for the departure of the American guest, with, I suspected, itching palms and questing eyes—itching and questing in vain, I fear. For there was no gesture on my part to encourage them in the belief that all Americans can be flattered or frightened into behaving like millionaires or Derby Sweepstakes winners.

The morning boat train to Dieppe departed early enough to allow us to cross by daylight, for the days were growing very short. I had somewhat dreaded the four hours on the small Channel boats, in view of past experiences and of what had been told me about the choppy Channel water. But the sea was smooth, and we arrived at Dieppe just as it was growing dark.

During my ocean trip from America I had tried to familiarize myself a bit with the French language, but once on French soil I found that all I could remember was "wee, wee, wee," like the five little pigs in the nursery rhyme, while the strange language volleyed and thundered all about me. I felt more completely lost than I had in the pea-soup fog of London. But this time there was no turning back. This linguistic fog would have to be dispelled through my own efforts. Meanwhile the only thing was to "wee, wee" one's way forward, and trust to luck and a mutual understanding of the sign language.

At Dieppe, after a short examination of my few belongings by the French customs, I was politely shown into a railroad coach marked second class, which was divided into small compartments. The one in which I found myself was already occupied by an elderly Frenchman with a handsome, bleached blonde woman, evidently his wife, and two red-trousered young soldiers.

A thin, cold drizzle was beginning to fall, not at all in keeping with my conception of "sunny France." I had long dreamed of this Paradise of Tradition, the Land of Great Painters. There were to be sunny skies perennial, quaint gray cities, flowered walls, and tree-lined streams and rivers. I was to find them all. But except for the Riviera and the Midi, I have found the conception of "sunny France" to be a myth.

Our train to Paris was an *omnibus*—what in America we would call "a milk train special." It stopped at every station, and I gathered the impression that both the engineer and fireman took turns in getting off for a drop of vin rouge, slowing up the train so that they could catch up after their refreshments.

Having had nothing but a few sandwiches for lunch before embarking, I was beginning to feel the pangs of hunger. At one of our many halts I imitated the soldier boys and bought some sandwiches and a small bottle of vin rouge. My first taste of a French sandwich was a tough disappointment. Old age and cement could alone account for such

45

solidity. As for the ham, it was mostly conspicuous by its absence. But it was something to set my molars to work and give my poor stomach the illusion of being fed. No less disappointed was I in the wine of France, which to my American palate, used to the sweet variety served in liqueur glasses at home, tasted sour and sharp. My offer of the remainder in sign language to the soldier laddies, who were munching huge hunks of bread and sausage, was instantly and gladly accepted. They talked away politely at me and all I could say in response was "Américain" and "*Paree,*" while "*tres joli, oui, oui,*" was all I could understand of their chatter. I gathered, however, that they were young recruits going home on permission.

A myriad of lights coming through the drizzle-laden atmosphere, a blowing of whistles, and a stir among the passengers warned me the long-awaited moment had come. I was entering Paris. Too late I regretted my oversight in not sending a telegram to Kroll to announce my arrival, for it was cheerless business entering Paris in the cold, drizzly darkness, and I practically speechless. The soldiers helped me onto the quays with my luggage and out through the gates to a taxi. I wrote out the address to which I was going and showed it to the driver, shook hands with my train companions, and off I rode.

The streets round the station were dazzling in reflected light from the rain-washed pavements, and an odor of gasoline mingled with the aroma of roasting chestnuts came to my nostrils—a smell I have always continued to associate with Paris. We kept turning in and out of a labyrinth of narrow streets, the chauffeur tooting his horn continually. In which direction we were driving I had no idea, naturally. If only it had been light enough for me to catch a glimpse of the magic city!

Finally we turned into a narrow, dark lane and stopped in front of a two-storied plaster studio building with a wooden staircase on the outside, leading to the second floor, a balcony following the entire length of the building. "*Oui, oui-Passage Guibert,*" the cabby assured me in answer to my mute questioning. I handed him the fare marked on the dial and a tip, but he seemed dissatisfied, hunching his shoulders and protesting, "*non, non!*" with a torrent of comment. Feeling certain that my tip was sufficient, I told him so in English, but to no effect, for he kept up his voluble discourse, cursing me for all I might know. The racket brought out a young fellow from a ground-floor studio, who came to my rescue. Sizing me up as an American, he asked me in English, to my great relief, what it was all about. After I had explained and he had spoken with the driver, he told me the latter was not trying to rob me, but that as my large valise had been taken on the outside of the cab, there was a small extra charge. This paid, I was volubly "mercied" by the driver, to our joint satisfaction.

Edgar McAdams, the young American sculptor who had come to my rescue, and the first compatriot I met in France, told me he knew Kroll very well. It seemed that Kroll attended a sketch class at Julian's every evening, dining later at a pension, and that he usually returned to his studio rather late.

It was Thanksgiving Eve, a fact I had entirely forgotten. McAdams was going to the American Club, otherwise he would have asked me into his studio until my friend arrived, but he advised me there were some American chaps upstairs who would look after me in the meantime. There, to my agreeable surprise, I found Alfred Rigny, whom I had known very well at the Academy in New York, and who had played base-ball on the school team with me. Thomas Benton, from Missouri, was with him. They were just about to sit down to a late Thanksgiving dinner. When they heard I had not dined, they asked me to pitch in with them and my lonesome heart warmed to their hearty welcome.

A big-bellied iron stove was radiating its cheerful glow from the center of the studio, while the rain, beating against the large glass window, added to the feeling of comfort. A long loaf of delicious tasty bread, utterly unlike the adamant stuff I had eaten on the train, with a large helping of beef steak smothered in onions and fried potatoes, and a cup of coffee *"A l'Américain"* soon put me in a state of beatitude.

The boys drank red wine during the repast, but I feared it would take me some time to relish the rather tart taste of vin ordinaire. When asked how I liked the steak, I replied, "Delicious!" So it was, though perhaps a little tough and more sweetish in taste than the beef at home. Roars of laughter greeted my reply. They told me I had been eating horsemeat! For a moment I felt as if I would be sick. My stomach turned. Then I reasoned with myself that, after all, many people did eat the flesh of the horse, a cleaner beast than the steer. But a deep-rooted prejudice and a fondness for the noble animal spoiled the feast for me that evening. In later and leaner years I have shared many a repast with comrades where an equine steak was the *pièce de résistance*, yet never without feeling certain qualms, however much the steak was smothered in onions.

Rigny, who had been in Paris for two years, spoke French like a native. Although born in America, his parents were French. He had been studying at Julian's Art Academy and was preparing himself to become a mural painter. His ideal was Puvis de Chavannes, whose frescoes he often copied. Thanks to his native cleverness and sense of style, he was constantly winning small money prizes at the monthly competitions at Julian's whereby he helped to eke out the small allowance he received from home.

Rigny's companion, Tommy Benton, was a short, swarthy, compact young fellow, whose grandfather had been a pioneer and an important political personage in Missouri. When I first met Benton, he was lonely and homesick, groping his way and unable to acclimatize himself to his surroundings. Zuloaga represented to him all that was finest in painting, and he was unhappy to find that the newer generation of painters showed little consideration for his idol.* Many a night I'd walk him about for miles, trying to restore him to a normal and cheerful mood. Finally, he conquered himself and returned a year later to America, where he struck

*Ignacio Zuloaga (1870–1945), Spanish genre, figure, and portrait painter.

out and made an enviable place for himself among the younger group of painters.

Naturally, I was all agog to find out what was going on in this New Art World. Only vague rumors had come to us in the United States of what was currently called over here "The New Movement," the vast upheaval which was taking place in the world of art, where old gods were being overthrown and tradition stamped into the dust. There were new gods, whose names I had scarcely heard—Cézanne, Van Gogh, Matisse, Gauguin. There was talk of "Fauvism" and "Post-Impressionism," and I learned that Monet and his school had ruined all sense of form in their pernicious search for light, and that the Impressionistic school had degenerated into painters of perfumed and colored jams. As for Robert Henri, who, I had believed, stood for all that was new and daring in art, he was considered old hat over here, and his work had been rejected by the jury of the Autumn Salon.

The arrival of Kroll and our mutual joy at seeing each other broke up our symposium on art. Kroll, for whom I had many messages from his family, had received my letter from New York and had installed a bed for me in the anteroom of his studio.

We talked into the early hours of the morning before retiring. It was cold and muggy, and even in bed, with my heavy coat over the coverlet, I shivered. It seemed hours before I could fall asleep, tired out though I was. The building in which we were, of recent construction, was a flimsy affair of thin bricks and stucco, through which the outside dampness penetrated. I suffered intensely from the cold. It was only by keeping the stove going continually that we found it possible to experience any satisfactory degree of warmth. I have since found that I was not the first foreigner who had had to come to "sunny France" to learn what it was to shiver indoors.

Kroll's studio was the average *atelier d'artiste*, roomy, square, and rather barren, the north side almost entirely taken up by glass panes (hence the icebox atmosphere when there was a north wind), with an interior ladder staircase leading up to the *soupente*—a sort of alcove-loggia, serving as bed—and dressing room. On the walls were a number of sketches Leon Kroll had painted in Normandy, revealing the marked progress he had made since his student days in New York.

KROLL took a day off to show me something of Paris. Needless to say, the first and foremost thing to see was the Louvre.

The Passage Guibert, where we were living, is close to the Montparnasse station. There we boarded one of the huge horse-drawn buses plying down the Rue de Vaugirard, across the Seine to the boulevards. The Paris *omnibus* in those days carried outside passengers on what was known as the *imperial*, where we ensconced ourselves to have a better view, unprotected even by an awning against the drizzling rain. I had heard of the squeamishness of the French regarding exposure to the elements, but I noted to my surprise that our fellow passengers on the

bus roof appeared stoically indifferent to the rainy skies. I, too, soon forgot the discomfort of sitting in the wet, so absorbing was the sight of the new, strange world through which we were passing. Never had I seen such weird contrasts blending so harmoniously in a "city-picture," as the Germans say. In the gray, ancient streets, vividly painted kiosks and gay, parti-colored posters and signs made colorful splashes against hoary masonry and dun-hued walls. Weather-beaten facades of once patrician dwellings bore commercial signs over their huge stone portals. The roof lines were an unending variety of jumbled chimney pots interspersed with dormer windows. Beyond the placarded walls were peeps into lovely bits of old-world gardens, where time seemed to have stood still, while outside roared the modern traffic. Innumerable cafés of all dimensions; ornately decorated apartment houses; bric-a-brac shops; up-to-date department stores; small, antediluvian trade shanties; and last, but by no means least in number, these odoriferous little "temples of convenience" which in France perpetuate the name of the Emperor Vespasian, being politely referred to as *vespasiennes*—everything seemed haphazard, and to mock the first principles of city planning, about which we hear so much in America.

Every street, every square, almost every block of buildings had a life of its own, a distinct individuality. Gradually I also became aware that, despite the dull skies and drab atmosphere of a drizzly November day, there was everywhere color of a subdued but luminous quality, such as I had never before noted in any city under existing atmospheric conditions. Paris, "under her cloak of chilliness and rain," as the old poet sang, was smiling her welcome to me, discreetly, and with a frowning shyness, but full of secret invitation and undefined promises of what might be in store for one who learned to love and to woo her in all her moods. To have fallen in love with her under a blue sky, a summer breeze, and dancing sunlight would have been a facile victory, for no city in the world can vie with Paris in a holiday mood. But to feel her subtle, half-concealed allurements in this November mood was surest proof that the reputed power of enchantment of the Siren City was no idle tale.

True, this Paris, through which I was passing from the Montparnasse region down toward the river, was a little disconcerting, often disappointing. Much of it seemed neglected, bedraggled, even mean and squalid in parts. Narrow, shabby little streets adjoining spacious boulevards were not at all what one might expect in the heart of a great modern city. But depite my critical American standards of what I might deem essential to a well-planned city, there was no denying there was charm about this paradoxial Left Bank, something quaint and ingratiating. But the Thrill I expected—the Paris Thrill—was lacking.

It came at last as our lumbering vehicle emerged from the network of narrow streets onto the quays. There before me was the rain-washed Seine, gurgling under its many bridges, so airy and toylike compared with the monumental structures which span our great rivers at home, diminutive steamers plying to and fro, slowly drifting barges and swing-

ing cranes unloading cargo under the very shadow of the great Louvre palace, as if the waterway were yet, as in bygone times, the main road of traffic for the capital of France.

Every detail of the scene was familiar to me from the pictures and photographs I had seen—Notre Dame, set midstream on its island, widely arched Pont Neuf astride the prow of the green river garden of the vert-Galant, the somber pile of the Conciergerie with its menacing twin towers, evoking tragic memories, and the famous quays, lined with book cases where studious loafers frittered away precious time, instead of hustling along and "getting things done," as good citizens should. All this I knew by heart and recognized. This was the Paris I knew, that all the world knew. And yet. . . . Perhaps it was the very familiarity of the scene which made it so entrancing, so surprising, as if a dream picture had suddenly materialized. I had almost feared that this much-depicted aspect of Paris would appear too hackneyed, too banal, when seen in real life. But now I realized—and with what a thrill!—that so far from being an exhausted subject, it was still awaiting other painters.

Having crossed the bridge, we passed under the gloomy arches of the Louvre to the Place du Carrousel, where Gambetta in flamboyant marble—a symbol of democratic eloquence and the rhetoric of the Third Republic—is forever thundering mutely at the spectre of the now-vanished Tuileries palace, the home of tyrants—royal, republican, and imperial. Behind him, modestly screened by trees, a very gentlemanly George Washington stands on his pedestal, executing a military salute with West Point correctness. Here we descended for my first view of the Louvre galleries.

Of my first conflicting emotions on seeing, so to speak in the flesh, so many of the great landmarks in painting, I recall most distinctly my vague disappointment on coming face to face with the famous *Mona Lisa*! I had always visualized this picture as something immense and breathtaking, but Leonardo's canvas looked small and almost insignificant in contrast with the huge, magnificent paintings in that immense gallery. But I, too, soon fell under the spell of the Gioconda, fascinated less by the supposed magnetic quality of her mysterious smile, as by the rare craftsmanship, the rhythm, and the matchless composition which make this picture one of the supreme works of art.

Those were breathless hours, which passed all too quickly, for closing time in November comes early. Owing to fear of fire, the Louvre galleries have never been lit artificially. Yet it seems a great pity that some means of lighting cannot be resorted to, for many of the galleries remain in semiobscurity even on the brightest days.

On leaving the Louvre, I took my first long walk in Paris, following the Seine along the quays. Everywhere there were subjects to be painted, and my fingers itched for the sketch book. We proceeded as far as the Boulevard St. Michel, the famous "Boul' Miche," main thoroughfare of the Latin Quarter, and stopped at the Café d'Harcourt, near the Pantheon, for a belated lunch. This was my first glimpse of the inside of a French café, and this particular establishment was one of the land-

marks of the Bohemian Quarter. Girls with large floppy hats, their faces painted a dead white, lips stained with scarlet, and penciled eyes, appeared to have stepped out from those posters of Paris life which had hitherto seemed too fantastic for truth.

The Sorbonne students and the *rapins* (i.e., the struggling painters) wore large berets and wide-brimmed felt hats, ample capes by way of cloaks, and often peg-topped corduroy trousers. All wore beards of som sort or another, the youngest often being whiskered and moustached like veritable buccaneers. Everybody seemed to be in a state of elation, despite the fact that coffee and beer were the prevailing drinks served to this curious crowd. I still recall the thrill with which I noticed an elderly gentleman imbibing a long, pale drink of a greenish hue; wondering whether, like the hero-victim of Marie Corelli's *Wormwood*, he went about accompanied by the phantom of a green-eyed tiger, until I was assured it was milk, and not the baleful absinthe, he was drinking. It was also curious to remark that in this topsy-turvy French world a glass of port, instead of following a meal in the traditional Anglo-Saxon manner, was often taken as an appetizer before dinner, one of the long variety of aperitifs. This, however, was more or less a "bourgeois" luxury, the attribute of businessmen and employees. In Latin countries, then as now, alcoholic stimulants play no great part with the rank and file of youth, which is quite able to kick over the traces without being primed up by artificial means. In fact, in France to be called an *ivrogne*, or drunkard, is not regarded as a joke—far from it!

The *pension de famille* where we had dinner that evening was situated in one of the old houses in the Rue Jacob, well known to the Anglo-Americans of the Left Bank. There I found the usual cosmopolitan gathering, the proprietress the only French person present. French, however, was the common idiom and was spoken with a variety of foreign accents. A young Polish woman, sitting opposite me, conversed with me in fluent English. She was a Sorbonne student, who gave French lessons to earn her livelihood. I have since found that in Paris most teachers of the native language are foreigners; Germans, Poles, Russians, seeming— at least in those days—to have cornered the market as instructors of French. I refer to professional teachers. For there are other forms of very private tuition by uncertified teachers of the fair sex, which can be found as readily in Paris today as when Laurence Sterne engaged on his memorable *Sentimental Journey*. If ever I was to acquire a mastery of the French language, I resolved then it should be in a less cosmopolitan atmosphere and from a trueborn native.

The dinner was excellent and entirely in the French tradition: soup was followed by fish, meat and vegetables, served separately, after which came the salad. For the first time I tasted rabbit, stewed in a delicious sauce, and found it an excellent dish.

THE ACADÉMIE JULIAN, popularly known as Julian's, where Kroll worked both mornings and evenings, had for several decades been one of the most popular art schools of Paris, so popular, in fact, that it had

two branches: one on the right bank of the Seine, and the other in the picturesque Rue du Dragon, on the outskirts of the Latin Quarter, which is the better known of the two to foreign students. It had been founded by the Père Julian, in his day a well-known model, and was carried on by his son, an enterprising person who enlarged the school and engaged many of the best-known painters to act as instructors. As the famous Beaux Arts School, a state institution, only accepted a limited number of foreigners who were forced to pass the very stiff entrance examination, Julian's filled a real need in the art student life of Paris, where the demand for instruction had been much greater than the supply. Almost every country was represented among its students—the Anglo-Saxon element predominating—with the result that Julian's Academy was a veritable babel of languages.

Jean-Paul Laurens was then the leading instructor at Julian's. For years he had been a powerful factor in French Academic Art, and a recognized master of the younger generation in the first decade of the century. However, by the time I reached Paris his influence was waning. He was already *pompier*, or old hat, to the new generation, which was looking for newer methods and so-called "stronger meat." The art language was changing with the shifting direction of taste. "Rhythm," "volume," "dynamic symmetry" had superseded the old terms "composition," "form," "values." Deftness and sound craftsmanship were at a discount with the *jeunes*, who sneered at such qualities as mere tricks of the art trade. To their minds, only what was crude, primitive, and therefore supposedly "naive" could express sincere feeling and true art.

Accordingly, when the revolutionary Matisse opened a school of his own, there was a rush by all the young discontents to enroll themselves under the New Teaching, the Art of the Future.* Great was their disgust when they found that here, too, they were submitted to the old academic restrictions. Drawing and painting from the model in the correct fashion were required as first essentials before initiation into the mysteries of new technique. Even Matisse could not, or would not, show them the desired shortcut to Art!

Having heard from Kroll that there was an evening sketch class at Julian's, which required no formalities except the payment of a small fee, I decided to have a look at this famous academy, located not far from where we dwelt.

The immense atelier in the Rue du Dragon, where the evening class

*The atelier of Henri Matisse has been described as "the severest in Paris." As in any other studio in Paris, the students worked from casts and from the model. Matisse dropped by on Saturdays to criticize the work his students had done during the preceding week. On his first visit to the studio, Matisse was shocked to find "an array of large canvases splashed with garish colors and distorted shapes." He left the room briefly and returned with a cast of a Greek head, which he placed on a stand in the center of the class and, instructing his students to turn their canvases to the wall, told them to begin drawing "from the antique." Alfred H. Barr, Jr., *Matisse: His Art and His Public* (New York: The Museum of Modern Art, 1951), p. 118. Most of the students of Matisse were from Scandinavian countries and Germany. Max Weber, Patrick Henry Bruce, and Arthur B. Frost, Jr., were the Americans in the class. Ibid., p. 117.

was held, was crowded with students of all nationalities, some staid and serious like those frequently observed at the night classes I had attended at the National Academy in New York. The walls were covered with studies of the nude and portraits, all works of students which had been awarded prizes. Two of these were by the Leyendecker brothers, whose magazine covers had become so popular in the States.

Criticism was optional, and the instructor only visited the class once a week. The students near the model stand were seated very low, so as not to obstruct the view of their comrades, those toward the back being perched on very high stools. The model's pose was changed every twenty-five minutes, and if a student wished to finish his study, no time was to be lost. Compared with the day classes, these night sessions at Julian's were quiet, orderly affairs. Except for an occasional cry of "*Fermez la porte!*" no notice was taken of late arrivals. Very different was the impression of a newcomer arriving at a morning life class at Julian's, where the racket was continual, a veritable Bedlam of shouting, singing in various languages, accompanied by imitations of barnyard sounds. It seemed a wonder that work of any kind could be accomplished under such conditions. The old clamoring of "Nouveau! Treat!" which I had first heard at the Art Students' League in New York, was as the bleat of the lamb compared with the roaring turmoil at Julian's when a newcomer was received into the academy. The novice was assailed on all sides, and only instant acquiescence on his part with all demands, or the interference of the *massier*, or monitor, appeared to save him from destruction. Often, too, *nouveaux* would be made to engage in single combat. Stripped to the waist, with palettes as shields, and long paint-laden brushes as weapons, they would whack away at each other until they were both covered with paint and too exhausted to fight on.

On one occasion a luckless newcomer, a big, handsome Rumanian, with a curly, well-trimmed beard, refused to pay attention to the clamor which beset him. Evil befell him. He was bustled into a corner by the mob, and held down while two students with scissors cut patches out of his whiskers. As a rule, however, the tradition of standing treat was gracefully submitted to by the novice, who, after class hours, would regale his fellow students at a nearby café with coffee and bocks of beer and drink to his health.

Most of the boys at Julian's took their meals at various restaurants near the school, where prices were lower, though food was not so good as at our pension. One franc and twenty-five centimes (then the equivalent of twenty-five cents) was the standard price of the popular Paris meal, which included wine or beer, and coffee. By buying a book of meal tickets, the price was reduced by fifteen centimes. The regulation tip was two sous. After dinner it was the custom for all except the very impoverished to go to a café and spend the evening there.

FAR FROM BEING a place of debauchery and a resort of sin, I found the Paris café—especially the type frequented by impecunious youth engaged in studies—to be a moral refuge for the poor and friendless, a

convivial center where, for the price of a cup of coffee or a glass of beer, a customer can read the newspapers and write his letters, writing materials being supplied by the establishment. For the poor student it is cheaper and more cheerful to go to the café than to burn coal or gas in a cheerless bedroom or a chilly studio. At the café he may meet friends and exchange ideas, and he is not importuned by waiters hovering round to order more drinks. At the café for a few pennies an agreeable evening may be spent in cheerful and comfortable surroundings.

Every group, of course, had its favorite café as a general rendezvous. The few cafés then existing in the neighborhood of the Montparnasse station were the favorite resorts of the English and Americans of the Quarter. The Brasserie Dumesnil, opposite the station, with billiard tables and a small orchestra, was a favorite resort for well-to-do French bourgeoisie, who could be seen dining there in the moderate-priced restaurant. American and English painters had elected Lavenue, on the other side of the boulevard, as their favorite meeting place. There after dinner an excellent quartet played classical music. Shumaker, the Austrian violinist, was a great attraction in those days, both on account of his fine playing and his resemblance to the popular Beethoven mask to be seen in nearly every studio—a resemblance he did his best to accentuate by facial contortions. So impressed by him was Oscar Hammerstein on one of his visits to Paris that he planned to bring him out in America as a star violinist. Had it not been for the war, which upset this plan, the name of Shumaker might have become world famous. As it was, the poor lad was interned in a civilian prison camp until the Armistice, and then sent back to his country. The other performers were all *premiers prix du Conservatoire*, which seems to be the usual fate of French prizewinners in music.

At Lavenue's gossip and small talk were exchanged with as much gusto as in any small-town grocery or sewing circle at home. Shop was discussed and reputations torn to shreds. A certain corner table was pointed out as being the one at which Robert Louis Stevenson would sit of an evening, for he lodged just across the street. There was also a legend, more or less credited, that one of the marble tabletops had been adorned with a drawing by John Singer Sargent, and that the café proprietor had had the precious graffito cut out and framed.

Harpignies, the celebrated landscape painter, could be seen here every afternoon at the aperitif hour with his favorite glass of absinthe before him. It was said that when his doctor prescribed medicine for him, he would take it mixed with his absinthe. He was a well-known figure in the Quarter, hale and hearty even in his nineties. When still an active octogenarian he had been smitten by the charms of a fair milliner. Asked how his courtship was getting on, he replied disgustedly that he couldn't make much headway owing to the fact that Madame's old duffer was always around. The old duffer of a husband was still under fifty.

The door of the café would be continually swinging open, admitting one picturesque type after another. The interior, with its framed wall mirrors, plush sofas, and quaintly garbed occupants, resembled more a

scene on the stage of the Opéra Comique than a resort for workers in art and literature. At the dinner hour a sprinkling of conventionally dressed persons—the men in evening clothes, the women in décolleté with flashes of color—could be seen dining at the restaurant adjoining the café, where they would later forgather for coffee and liqueurs, and to listen to the music. Lavenue's was well known for its good cooking, as were several other Paris cafés.

Jo Davidson, the sculptor, and Louis de Kerstrat, his friend, would stroll in almost every night: Louis, tall, red-bearded and debonair, a wide-brimmed black hat drawn over his eyes, and dark, ample sweeping cloak with a red lining draped round him; Jo, short, squat, and powerful, most of his face covered with dark beard, and thick, black eyebrows drawing straight across his forehead, under which twinkled a pair of merry, brilliant eyes. To many he was known as "Black Santa Claus."

Jo and de Kerstrat, who later became his brother-in-law, lived together in a large studio on the Rue Delambre, at the back of a small hotel. In lean days they would cook a large supply of oatmeal and live like stoics. The sale of a picture or a piece of sculpture would inevitably result in a feast of high living to make up for the lean days; after which, they would resume their regime of abstinence, both as jovial as ever.

As booster for the talent of the friends, Jo had not his equal. One of his cronies was John Ferguson, the well-known Scotch painter, a much remarked exhibitor at the Autumn Salon. Both were loud in praise of each other's talent, Ferguson proclaiming Jo to be the greatest sculptor since Rodin, while Jo announced that John Ferguson was undoubtedly the finest colorist since Titian.

Jo Davidson had also a huge hound, which was perhaps his greatest responsibility, especially during protracted periods of the oatmeal regime, when bones were few and far between. Owing to the fact that French butcher shops are all open, with their wares exposed on tables and racks, Jo's hound was in constant temptation and became an expert at illicit foraging. One day while he was lifting a chop, he was caught by the irate butcher, who threw his knife at the thief, grazing his side sufficiently to leave a wound. When during their evening walks Jo and his dog parted company to pass the time of day with their friends, the latter would always know where to find his master. He would shuffle up to Lavenue's and wait until someone opened the door, when he would make an eager entry, his huge bulk quivering as he searched for his master. On seeing him, he would wag his long bushy tail so violently that glasses and cups were often swept from the tables, to the fury of the waiters. Fortunately, Jo was well known and had a way of appeasing their wrath.

In the Lavenue coterie was Ivor Duffy, a young Irish poet, who spent most of his working hours at the café. Yet he maintained he made a good living by his pen. "My living," he would announce, "is made by writing—by writing home." There were also the Armingtons, Frank and Caroline, well known for their etchings and paintings of Paris scenes. Jerome Blum, when not on a painting trip in China or the South Seas, might as

like as not be found at Lavenue hobnobbing with Maud Squire and Ethel Mars, two brilliant American painters, who formed a striking couple: Maud, dark and quiet, almost Indian in countenance, while blond Ethel was eager and voluble, suggesting something of the exotic.* The most piquant scandals and the most risque stories were reserved for these two, who, however, were always ready to see the best side of everyone and of everything.

Anne Estelle Rice, who ruined a career as a really great mural decorator by marrying, and Mary Banks, an imposing Scotch lassie, who drew with the power and vigor of a man, were often there in company of John Ferguson, who exercised a great influence on their work.

GETTING UP of a morning in the studio during the dark winter days was something of an ordeal. Our *femme de ménage*, or charwoman, would come in very early, poke up the dying fire into a semblance of a glow, and set things in order, while we made our ablutions. Needless to say, there was no running water in our place, but we kept a reserve in a large zinc pitcher, and tubbed as best we might in the icy liquid poured into our rickety china washbowls. A brisk rubdown and strenuous calisthenics were needed to stir up circulation. But at night it seemed as if I could never get warm in bed.

While Kroll worked at Julian's in the morning, I was at the Louvre, where I had begun copying Paul Veronese's *The Flight from Sodom*, a beautiful piece of painting, marvelous in its color. I followed the method of the professional copyist. The copy was the exact size of the original. Having procured a very good photograph of the picture, I divided this into a certain number of squares and divided my canvas likewise. Then I copied the photograph in brown and white oil colors on the canvas.

When this was completed, I began work at the Louvre before the original, finishing the copy first in monochrome, and endeavoring to get the texture and quality as close to the original as possible. The darks in the picture I painted much lighter at first, so that I could glaze or wash over the color in order to get more richness, instead of painting the colors on at once.

Having thus occupied my mornings, I spent the afternoon wandering around the city, seeing the current art exhibitions in the Rue Drouot and the Boulevard de la Madeleine; in the evening I sketched at Julian's.

After a month of this, I decided to get a model and attempt an original picture in the studio.

Every Monday morning at the Grande Chaumière and Colarossi's art academies, a veritable models' congress was held, for then the models for the week were chosen. The overflow were parked all round on the Rue de

*"Two midwesterners with cultural ambitions—they both dabbled in watercolors— who had arrived in Paris, early in the century, somewhat mousy, tailored, and prim. Within a year they were habitues of the local cafes. Miss Mars had dyed her hair flaming orange, and both appeared in public so heavily made up their faces had the appearance of masks." James R. Mellow, *Charmed Circle: Gertrude Stein & Company* (New York: Praeger, 1974), p. 133.

56

la Grande Chaumière, where these academies are situated. The majority of the models of both sexes and all ages were Italians, entire families following the profession. Infants were trained to take poses as cupids and angels, while the older models specialized in the roles of beggars and saints. Whether posing for the head or the "all-together," these models were happily free from all self-consciousness or false shame. One of the curious sights was to see the models of both sexes, of every hue and age, promenading in the classroom stark nude, waiting to be chosen for the various classes in the schools.

The picture I had decided to paint being a Madonna with the Infant, I went to pick out my models. Having found a handsome young woman, who looked like a model for one of Bellini's masterpieces, I conveyed my offer to her through a young American who spoke French, and was told she was willing to pose. Had she a child to pose with her? Yes, of course. There was a regular traffic in children among models, and one could always be borrowed among their large broods. Next morning she came with a small baby. After I had decided on the light and pose, I began composing my picture, but the séance was continually interrupted by the crying and struggling of the infant, so I did not make much headway that morning. Through gestures and a few words of broken French, I made her understand that it was impossible to do any work with such an obstreperous bambino. She reassured me by the same means that she would arrange matters. She did. Next morning she arrived with the infant peacefully slumbering, and throughout the morning's séance it hardly stirred. It had evidently been drugged in some way, as I found out later.

A small picture by Rembrandt at the Louvre, *The Last Supper*, had made a great impression on me, so I decided to take the preliminary steps to obtain permission for copying it. Certain pictures had a long waiting list of copyist applicants. The *Mona Lisa* and several pictures by Correggio were in special demand, and sometimes applicants would have to wait over a year for their turn. However, the room in which the Rembrandts were hung was a very dark one, so I found very few copyists there. The one I wished to copy was protected by glass, which is often necessary to protect a canvas; therefore it was difficult to work except on very bright days. A wealth of exquisite, broadly handled detail was almost lost in the shadows, and only by careful peering could I really look into the canvas.

I did this copy in the same manner as the previous one. But as the original was painted on a thick wooden panel, I procured a similar one, well seasoned and corresponding exactly in size. In the studio I prepared a copy after an excellent photograph, and started it in warm brown colors, with the paint heavily laid on. When well advanced, I took this to the Louvre and proceeded to finish from the original with a series of glazes—a preparation in equal parts of oil, mastic varnish, and turpentine, with a few drops of water added, the whole well shaken up. The color is mixed up with this medium and applied in wash as thin as water-color, over and over again, until the proper tint is procured, thus giving a

richness and brilliancy impossible to be attained by direct painting. In this way even the patina of years can be obtained.

The Louvre is a great school in which to study the Old Masters, but the more one studies them, the more one is apt to despair of ever attaining their knowledge of the craftsmanship and the technique of painting. The lesson they taught me was that the only way to succeed as a painter was to work constantly, to study from nature, and never to be discouraged. If one cannot sing like a nightingale, it may still be possible to warble like a lark or to twitter pleasantly like a canary. To be born with genius is a gift of the gods, but talent and hard work can bring one somewhere near the goal one has in view. That is perhaps the most useful lesson I learned from the Old Masters.

In studying their works I also realized that however profitable it might be for my instruction to copy their pictures, what would ultimately qualify me for the rank of artist was that which I learned to see with my own eyes, to feel with my own senses, in the living world about me. In art, as in every other branch of man's activity, there are certain homely truths everyone has to discover for himself, or they never become truths to him. Here in the Louvre I was discovering them daily. Here was a universe of painting, of various degrees of excellence and mediocrity; for the Louvre galleries are more a museum than a selected collection—like the Luxembourg, for instance. The selection, one had to make for oneself, more or less, which in itself is a valuable training. Here, more than elsewhere, one realizes that the only value in what purports to be a work of art is the individual outlook of the artist—provided, of course, he has acquired sufficient craftsmanship to express his point of view. As Goethe has said so truly: "The highest happiness for the sons of men is the sense of Personality." To the artist the expression of the Personality, provided it exists as an entity and not as a faked product for purposes of self-advertisement, must always be the highest degree of earthly happiness. That is why there is a "happy look" about all great pictures, as there is a "happy sound" in all great music, and why there is truth in Nietzsche's affirmation that "all beauty goes light-footed." I might also add that this essential "happiness" which characterizes all true works of art is ample proof, if more be needed nowadays, that the production of such works can never depend upon or be subservient to any organized movement—political, nationalistic, or so-called artistic.

My next attempt at self-expression was to be an interpretation of Eve, a very hackneyed subject, but one which continues to tempt the painter today as it has in former times. As model for my picture, I engaged a voluptuous blonde, with large, swimming blue eyes, and the build of a young goddess, Louise Saraszy by name. Once the pet of an American sculptor, who had since returned to his country, she had acquired a fair smattering of English, which made conversation possible, and at times agreeable.

I had not yet worked from a model who understood and kept a pose as well as Louise did. For almost three weeks I worked on my picture, but it turned out a complete failure, as has happened so often since to works

58

I have labored on with equal devotion. And yet whenever failure occurs, my disappointment is as keen as it was in those days. A blank canvas is a field of battle, where defeat is more likely than victory. However, it is always the next battle which promises a triumph, for your true artist is a born fighter. He may be beaten, but like the proverbial British soldier, he never knows when he is licked.

NOW THAT THE URGE for work had seized me, I was hampered by the fact that I could not paint in the studio in the afternoon, when Kroll took possession. Though he often worked from a model, it was difficult for the two of us to paint there at the same time. So I decided to look for a studio of my own.

With the help of friend Rigny, who had a thorough knowledge of the studio facilities of the neighborhood, I finally located one in the Villa Brune, close to the fortifications and the Porte de Chatillon. It was situated in a picturesque courtyard, embellished by a garden and a few spreading trees. The interior was high and barnlike, but the light was good and there was a reassuring-looking stove with a plentiful supply of pipes running up to the ceiling. There was also a tall wall mirror. These furnishings, the landlady informed me, had been left by the former tenant in part payment of unpaid rent and would be turned over to me for a nominal price. But the chief inducement was the low rent asked—four hundred francs a year, then about eighty dollars. Rigny concluded the financial arrangements to the satisfaction of all parties, and the deal was closed.

My landlady, of Italian extraction, must have been a handsome person in her youth, but those early charms had become duplicated in chins, amplified in extending curves of hip and bosom, definitely abandoned in her ill-kempt person. Distinct traces of a silky moustache on her upper lip did nothing, to my mind at least, to evoke that *primavèra di bellezza*, as the Fascists sing today in her native land. In her youth, as I learned later, she had been a model and had married a sculptor, who in his day had known success and was now a member of the French Institute. But she had never been able to fit into the social life of her successful husband, and when, with the passing of years, her good looks faded, she had slipped into a shoddy existence, acting as caretaker and cook for her distinguished husband, whose studio and apartments were on the other side of the courtyard from my studio. But during my stay there I rarely saw him.

Moving into my new abode was a simple affair, my belongings consisting of my bed, an easel, a kerosene lamp (there was neither gas nor electricity in my studio), my paintbox, and my valises. With Rigny's help, I hired a two-wheeled handcart, into which my stuff was loaded, and off we went, I pulling the cart and Rigny pushing behind. This was a comparatively easy moving job. Being a husky lad, I had on several occasions been impressed to help comrades on moving day, and many are the trunks and stoves I have toted up and down endless staircases, some of

the studios being on the seventh floor. My reward for this labor was generally a meal, which had been well earned.

A table and a chest of drawers, purchased at a neighboring junk shop, completed my studio equipment. I was happy. At last I had a place all to myself where I could work as I pleased with little prospect of being disturbed, as all my friends lived a good half-hour's walk away. All the more reason for me to learn French as quickly as possible. So I bought a French newspaper every morning with my rolls and milk, and with the aid of a dictionary puzzled out the text. I learned the meaning of the inscriptions on street posters and shop fronts, and made a point of memorizing each day some sentences from Chardenal's French grammar. Soon I was able to do my own shopping, and though my language must have sounded comical to the tradespeople, they never laughed, but did their best to puzzle out the meaning of the weird sounds I emitted.

What the pitfalls of literal translation from one language to another can be, I also learned to my cost. Spending the evening with some French people I had met, I was attacked by a splitting headache and felt I must get back to my studio. Desiring to make explanation to my hosts for leaving so abruptly, I made the literal translation of "I must leave, I feel bad," which I phrased "*Il faut que je pars, je sens mauvais*," not realizing that I should have said, "*Je me sens mal*," for "*sentir mauvais*" means "*to smell bad*." This astounding avowal was too much for even French politeness, and the laughter that greeted it still rings in my ears. Such verbal faux pas were a speciality of mine in those days, and caused me often great embarrassment, for I never knew to what I might commit myself.

It was at the Villa Brune that I was first initiated into the amenities, the implications, and the embarrassments of Paris studio life. Rigny, Benton, and Kroll continued to look me up in my distant abode, and so did that amiable young person, Louise Saraszy, who would help to cook an extra dish whenever there was convivial feasting. I noticed that my landlady smiled approvingly at Louise's visits, and expressed real disappointment when I assured her that there was no likelihood of her becoming a fixture at the studio. Like Saint Paul, it was Madame's conviction that it was not good for man to be alone, especially a young man who lives in a studio. What I needed to keep me happy and properly looked after was an angel in the household, in short, *une petite amie*. This was a point of view I had not yet encountered among landladies with whom I had dealt.

Seeing that I was, for the time at least, unwilling to set up a ménage, Madame began to show solicitude about my well-being. She would often knock at my door and bustle in, asking whether she could be of any service whatsoever, while her ample bosom seemed to be aflutter with what might befall if I were to meet her burning glances. But I preferred to flee from temptation. Yet it must be said to her credit that this timidity on my part aroused no resentment on her part, and she continued to show me every kindness she could.

One of my studio neighbors was Marcel Lenoir, a French painter of some standing. As he suffered from lung trouble, he would keep his studio door open all the year round. He was a tall, thin figure, with long beard and long locks, always muffled up in scarves, even when he painted. Though himself a professed atheist, the subjects he treated were invariably of a religious nature, and his huge canvases were peopled with saints, martyrs, and angels. During the holiday season, Lenoir used to exhibit his lesser works in a small booth on the boulevards, where his mistress acted as vendor. Some of his drawings—really beautiful work— could be bought there for ridiculously small sums.

My neighborhood, that of the fortifications of Paris (recently demolished), was a shabby and a sordid one. The fields near the old walls were occupied by squatters of every description, many of whom led a lawless existence, and even policemen knew better than to wander alone about the *fortifs* after dark. Nor were the constant funeral processions to the nearby cemetery calculated to enliven the daytime. There were days— gray, dark, and gloomy, filled with mist and drizzle—when my nerves would go to pieces, and I would experience intense pangs of homesickness. At such moments I would have given anything to summon up courage enough to return to America. But a visit to the Louvre or to a friend's studio helped to cure me of the blues, and to restore my courage to carry on with my studies.

THE ART WORLD was just then in the throes of revolution, and Paris, as always, was the storm center of the new upheaval. Academic traditions were being ruthlessly swept aside. Between the pitiless iconoclasts and the defenders of the old order, there was a small band of artists who tried to find a line of compromise. One of their favorite devices was to paint a blue line round everything, and it was strange to see how even a very academic painting would snap up with this blue outline. But the younger element, in their mania to emphasize form, set out deliberately to distort it. Horrible monsters, with arms and legs in the last state of elephantiasis, colored in crude green, violet, or scarlet, were painted from slim, delicate, ivory-tinted models. Agonizing landscapes with writhing, reeling forms, as if afflicted with the dance of Saint Vitus, were hailed by critics as symphonies of rhythm and plastic design. Totem and idol of jungle Africa were studied and imitated by sophisticated Americans and Europeans. The cry was raised by these extremists that the moment had come to destroy, in the name of Liberty in Art, all the Bastilles of academic tyranny, beginning with the Louvre and Luxembourg galleries. As for the art schools, they should be suppressed as temples of superstition. According to the new doctrine, Art should be visualized with the naive eyes of children and be rendered with the most primitive and simple means. As for craftsmanship, the sooner it disappeared, the better, since it merely served to hamper true creative impulse in the "natural genius," which was cropping up on all sides, and in the most unexpected quarters.

The "cult of the naive" at all costs became a rage. Had it not brought

fame and fortune in the most unheard-of places? In Montmartre a fried-potato merchant, who painted in his spare moments, leaped into fame, collectors and connoisseurs buying up his work, which sold more quickly than his hot potatoes. At St. Tropez, a fishing village in the south of France, a fisherman who painted boats to amuse himself was "discovered" by a well-known theatrical manager who was down there on a vacation. Having persuaded the fisherman that his real career was painting pictures, not fishing, the manager arranged an exhibition of his protégé's works in the lobby of one of his Paris theaters, where his friends were brought to admire the new "master" and persuaded to buy his pictures. As a result of this "boom," the picture market was for a while flooded with crude chromos of fishing boats.

A group of painters in Montmartre decided to exploit this hysteria and have some fun with the critics. Procuring a donkey, they tied a large paintbrush to his tail, first dipping the brush into an assortment of colors. Then a canvas was set up within striking distance of the donkey's tail, which in its gyrations soon covered the canvas with a weird conglomeration of color—quite a stunning study in the new style, as the spectators all agreed. Witnesses and a notary, who had been invited to attend, attested to the manner in which the work had been done. This canvas was framed and sent to the Salon des Indépendants. It bore as title, if I remember rightly, *Sunset on the Red Sea.* After several well-known critics had remarked it and written about it as a work of extraordinary interest, the story with the signatures of the witnesses was published, and the laugh was on the "new art" critics.

Nevertheless, one weird school followed another, all bent on the search for something new and sensational. Their most representative works were to be seen at the Salon des Indépendants, which was open to anyone who painted, drew, or sculptured. There was no jury; all that was required of an exhibitor was his application and the payment of a nominal fee for the hanging or placing of his work.

Originally the "indépendants" had been founded by a serious group of artists, who were precluded from exhibiting in the official Salons on account of their too-advanced conceptions. Soon this Salon, however, degenerated into a showplace for amateurs and weekend artists, ladies who showed portraits of their pet dogs and cats with blue ribbons round their necks, and misunderstood geniuses who filled vast canvases with symbolic and literary images. There were propaganda pictures, naively crude chromos of religious subjects, and strange sculptures done with pieces of stove pipe, bits of glass, show brushes, etc. Among these insane concoctions one occasionally came across a really striking piece of work by a competent artist, gifted with true originality and daring, such as could not be seen in any other Salon. But these were oases in the desert of incompetence, inanity, and bad taste, which marked the productions of the "wild men"—the "fauves," as they were called.

Picabia, a front-rank "fauve," one year exhibited a large framed canvas on which his friends had inscribed their names with little drawings, while in one corner was to be seen a human eye and various hiero-

glyphics.* Another large canvas was painted entirely in black, except for one corner which contained two pairs of eyes with stark white eyeballs. This work was entitled *Two Negroes Fighting in a Cellar at Midnight.* Another much-discussed canvas showed the rulers and potentates of various countries clad in the primeval costumes of Adam and Eve—Kaiser Wilhelm with nothing but his famous moustache, Roosevelt in a wide, horse-toothed grin, the Emperor of Abyssinia in shiny shoeblack polish, while Queen Wilhelmina of Holland exposed charms abdominal, which as the rhyme says, "were something phenomenal." It was too clamorous a case of *lèse majesté* to be allowed to survive the *vernissage* opening, and had to be taken down after a day of joyous success.

A very popular exhibitor at this Salon was the famous "Douanier" Rousseau. I knew the old chap very well—a simple, naive soul, a primitive in the true sense, whose great dream was to be admitted into the official Salon des Artistes Francais, which, however, would have none of his work. The masters he most admired were Bouguereau and Gerome, who are held in abhorrence by those who have hailed the Douanier as a genius.

During his youth the Douanier had lived in Mexico, and memories of that colorful land filled his pictures with exotic plant forms. For his figures and nudes he never used a model, contenting himself with copying what he needed in that line from old magazines or newspapers. I once saw him painting a view of Paris with the Eiffel Tower in the center, which he copied from an illustrated postcard. One of his works, which hung in his studio, never failed to give me joy. It was a picture he had been commissioned to do for a tradesman in his quarter, and purported to be a portrait of that gentleman with his newly wedded wife, while the image of his first spouse was inset among billowing clouds in an upper corner of the picture. *"Quel sentiment, hein?"* exclaimed its author when he showed it to me.

The Père Rousseau also gave lessons in music, mandolin, violin, and flute. From time to time there would be a *soirée musicale* given by his pupils at his studio in the Rue Texel. To reach it he had to climb up a narrow wooden ladder to the first floor of a rickety old building. On these occasions pupils, parents, and admiring friends would provide refreshments after the manner of a bottle party. When leading his student orchestra, the old Douanier was prouder than he ever was when showing his pictures. But I must admit that I preferred his painting to his music, for it took considerable courage to sit out one of his concerts.

Rousseau at that time had a small coterie of admirers who would buy his pictures, for which the usual price was from twenty to fifty francs.

*Francis Picabia experimented with virtually every one of the modernist idioms before he achieved a reputation as a Dadaist during World War I. In 1909–10 he combined neo-impressionist brushwork with the color of fauvism and the faceted forms of cubism. A landscape of 1909 in the collection of Alex Maguy, Galerie de l'Elysee, Paris, is a good example of Picabia's fauvist phase. William A. Camfield, *Francis Picabia* (New York: The Solomon R. Guggenheim Museum, 1970), p. 18. The painting with the "hieroglyphics" is *The Cacodylic Eye* of 1921. The other works Warshawsky refers to are not identifiable by the editor.

Only rarely did it reach three figures. Leading his humble existence in the poorest of surroundings, he could afford only the cheapest colors and canvases. After his death the dealers got hold of his pictures, and they fetched tremendous prices. One of his largest canvases now hangs in the Louvre.

CLOSE TO my new domicile was the best-known pleasure haunt of prewar Montparnasse, the Gaîté Montparnasse theater with its adjoining café, situated in the street of the same name, then the Bowery of the Montparnasse district. Despite its jovial name, this street had enjoyed an evil reputation as a resort for apaches and toughs, who had recently terrorized the district. Policemen had been frequently attacked there, and some had even been killed. The apaches' method of attack was for one member to attract the attention of an *agent*, while another crept up from behind and garrotted him. But the police had eventually done a thorough job of cleaning up the locality, establishing a station in the Rue de la Gaîté to maintain order. Though still rough, it was, in my time, an orderly thoroughfare, lined with cafés, movies, catch-penny pleasure resorts, and music halls, very much as it is today. Despite sensational newspaper stories, Paris, besides being the best illuminated city, is probably the safest of all large metropolises, owing to its efficient and ever-watchful police force, which can be found on duty in every public pleasure resort, however low or respectable.

It was Rigny who introduced me to the Café de la Gaîté Montparnasse, which adjoins the theater. There, during the intermissions, public and performers would resort for refreshment. With its huge wall mirrors, alternating with painted panels depicting Parisian types, its billiard tables, restaurant, and orchestra, this noisy, seething caravansary was one of the most colorful sights to be seen in Paris. Its habitual customers were actors, singers, and artists of every description, with, of course, the usual quota of damsels, more or less bedizened, all drinking coffee or beer and listening to the cheap music. These were mostly of foreign importation—popular songs from Vienna, Berlin, and the States, arranged for the French text, which was generally of a far more Rabelaisian quality than the original. It amused me to hear old favorites, like "Hiawatha" and "Because I Love You," long out of date at home, sung in French with all the gusto of the latest thing.

Most of the artists, including students from Julian's and the Beaux Arts, were known to Rigny. One, a little hunchbacked Italian sculptor, was excellent company, witty, and as cheerful as if the world were at his feet. He was generally to be found with his cousin, Louis d'Ambrosio, a handsome, splendidly built young sculptor. Luigi, as we called the latter, a relative of the Italian composer of the same name, had undergone a bitter struggle in his early youth, having started as an artist's model. Fired with ambition to emulate the artists for whom he posed, he had educated himself at evening classes, until he was able to qualify as assistant to a sculptor, from whom he learned the practical side of his profession. Finally, having scraped and saved from his meager

earnings, he had set up for himself and quickly made his mark as an original and creative artist. Though already a successful exhibitor at the Salon, Luigi did not disdain to pose for his brother sculptors in order to earn a little extra money. In his studio I saw a plaster cast done of him when he was still a lad. I took it first to be a genuine Carpeaux, so finely was it executed. It was the work of John Flanagan, the American sculptor, and worthy to figure in any museum.

Besides being a master at his craft, Luigi was a first-rate cook, and the dishes of spaghetti he prepared in my studio, when coming to supper with his cousin, were genuine chefs-d'oeuvre, which I have not found equaled in the best restaurants in Italy.

The witty hunchback cousin passed away during the early years of the War, but Luigi and I are still the good friends we were in former times. As an artist, his reputation is established, and specimens of his work can be seen in the official museums of France. In recent years his name has become known in America as the creator of a fine monument for the Cleveland cemetery and of another piece of statuary which William Randolph Hearst commissioned him to do for his estate in California.

Samuel Halpert, the American painter, with Michael Brenner, sculptor, often dropped in for a chat. Halpert had been living in Paris for several years, and spoke French fluently, and without the trace of an accent.

I soon became an habitué of the Gaîté Montparnasse, and a regular attendant at the monthly revues at the theater, which generally presented political satires. The talent displayed was of no high order, and the chorus and female attractions somewhat overripe in years; but the entrance price, which included coffee or beer, was correspondingly low, so there was no call to be critical. Apart from the old-timers—artists who had seen "better days"—there was debutante talent, which sometimes showed great promise. Many famous music hall artists, including Maurice Chevalier, had begun their careers at the Gaîté. To see family parties, including young daughters and adolescent sons, heartily enjoying the most risqué songs and situations, revealed an aspect of the French public which seemed at first paradoxical, for I knew enough about the petit bourgeois of France to realize that he was a stickler for family morality. Long residence in France has taught me that from the point of view of the lower classes, there is nothing really illogical about the whole family having a good laugh at such Rabelaisian exhibitions. When the Frenchman goes to a vaudeville show, he checks his private morals at the door and sits down to have a good time.

Walking home at night after these shows down the Avenue du Maine and the lonely Rue des Plantes toward the fortifications entailed some risks, for holdups and crimes were fairly frequent in that tough neighborhood. So I would arm myself with the huge key of my courtyard door, which I held in my fist, and would keep to the middle of the road.

THAT WINTER was one of the coldest I can remember in Paris. There

were heavy falls of snow and in the Luxembourg Gardens children were skating on the little pond. Notre Dame and the barges on the Seine covered with snow were enticing problems in arabesque and simple color patterns for the painters.

I made small pastel sketches and pencil notes of these winter scenes, but it was chilly business and even woolen mittens could barely keep my fingers from being frostbitten. In my studio I would paint from these studies but, lacking experience, I never succeeded in rendering the effects I wanted and still remembered.

Halpert did some lovely pictures of these snow scenes from a hotel window overlooking the Seine. I often visited him in his studio in the Rue Moulin-de-Beurre, a quaint, old-fashioned street that suggested part of some old Norman town. His neighbor, Adolph Kleminger, was an American painter of talent, who had formerly been a first-class lithographer in New York and a friend of Louis Loeb. Both he and Halpert were very helpful to me in my painting, while I was a sincere admirer of their work. Halpert painted with a strong modern touch, but without distortion. His color was pure, but never lacked tone, and his landscapes, for all their simplicity of treatment, were never raw, but informed with a true feeling for nature, and, in addition, highly decorative. He worked slowly and deliberately, always using a clean brush for every color, and never hesitated to cleanse it with turpentine whenever there was a suspicion of muddiness in his coloring. He maintained clean brushes were essential to clean color.

Having painted a good deal in rural France, Halpert knew many lovely spots in the neighborhoods of Paris. Early in March, with the first spell of mild weather, the three of us—Halpert, Kleminger, and I—set out to spend a few weeks in Rouen, where we took quarters in a modest pension in the Rue Nationale. We spent the days wandering and sketching on the quays of the Seine and among the hills of Bon Secour, overlooking Rouen.

With my sketch box and small wooden panels, I set to work, discarding all the browns and blacks on my palette in my endeavor to emulate Halpert and Kleminger, and paint with more brilliant tones. But try as I would, the academic background of the schools in New York and the palette of my master, Louis Loeb, kept intruding with relentless persistence. My colors would flow into gray and muddy tones. For my eyes had not as yet learned to see the true colors in nature, though they would infallibly recognize them on the canvases of my two more experienced friends.

Rain, which falls almost continuously in Rouen and that part of Normandy, spoiled the latter part of our stay. Regretfully we decided on a return to Paris.

·5·

1909

FOR SOME TIME Halpert had been planning a trip to Italy, but the prospect of going alone was not tempting. He therefore suggested that I might join him. To visit Italy in the company of such a congenial and experienced comrade presented a unique opportunity, but unfortunately I was financially unprepared to make a prolonged tour such as he had planned; nor was I ready to start at the beginning of April, as he intended doing, in view of the fact that my next remittance from America would not be due until the latter half of the month. But Halpert brushed aside my scruples and hesitations, promising to finance me until I received my money. I was only too happy to be persuaded, and left him to make the necessary arrangements, planning the trip, obtaining addresses, and buying the tickets for the Grand Tour.

When I notified my landlady that I intended giving up the studio, I found she was anything but pleased. I should, it seemed, have given her notice a month in advance, to say nothing of the fact that she was entitled to claim damages for holes burned into the floor by burning coals falling from my stove. Although these damages were strictly imaginary, I thought well to placate Madame by making her a present of the mirror and stove, which I had purchased from her, and which, as I realized, had probably been acquired from my predecessors by similar means. My other belongings, except my easel, which I stored with a friend, were disposed of for a trifling sum to the *brocanteur* (owner of a junk shop) who originally had sold them to me.

We left Paris one night in the first week of April, 1909, going straight to Marseilles, where we were to embark for Naples. Traveling for fourteen hours in a third-class compartment on one of the most frequented lines in France is not an unmixed pleasure. By the time we had taken our seats, there was scarcely a spare inch of room left, below or above, where the baggage was piled up to the roof. The hard wooden seats grew harder as the hours dragged by, and the atmosphere in the hermetically closed compartment became almost opaque with the suspirations of our fellow-travelers and the spicy emanations from provision-baskets suited to Mediterranean tastes. Sleep under these conditions became impossible. Halpert and I got out at every station where the train stopped and breathed in a supply of fresh air to carry us on to the next stop.

Early in the morning we caught a glimpse of a magic city, turreted walls, embattled towers, moats, and bridges—Avignon. Already the air was growing perceptibly warmer, and by noon, when we arrived at Mar-

seilles, it was full summer. Blessed sun of the Midi! For the first time in months I felt that warmth had penetrated to my bones.

As the steamer which was to take us to Naples, the first Italian city on our itinerary, was not due to leave until the following evening, we put up at a small hotel facing the old port. It was there I had my first taste of bouillabaisse—the famous Marseilles dish, combing all sorts of fish and crustacea with an infinite variety of spices. This, like the glorious sunshine, I found lived up to its reputation, and so did the colorful scene in the old port, its quays, narrow, winding streets, and motley crowd, plying all trades and wearing all costumes of the East and West. For if there is a spot where these twain do meet, it is Marseilles, the gateway through which Occident and Orient have been flowing and intermingling since almost legendary days.

It was the most highly colored spectacle I had ever seen: Arabs, Turks, Moors, Algerians, in their native costumes, mingling with sailors from every country, the only really familiar note supplied by the red trousers of the French *pioupiou*, the little ill-dressed infantryman of prewar France. Everywhere there were cafés, bistros, bars—low dives, for the most part, and in the doorways of the squalid side streets, formidable and sinister "daughters of joy" in the scantiest of "working attire," accosting passersby and offering their wares as freely as the other street vendors. A favorite diversion of these light-o'loves was to snatch off the hat of a passerby and refuse to give it up until a drink had been paid for in a neighboring café. These pranks were always taken in good part, no one seeming to object to being ransomed in this way, nor did we see any attempt on the part of policemen to interfere in these frolics.

We were awakened early next morning by the terrific din and traffic of the port trucks pounding along the quays, the creaking of cranes and pulleys, and the incessant clatter of the sailors in their wooden clogs on the rough stone pavements.

That morning we spent visiting the Public Gardens, where we admired gorgeous tropical birds, and the Art Museum, which, after the Paris galleries, seemed somewhat mediocre. As our boat sailed only at six o'clock that evening, we availed ourselves of the afternoon to visit the Cannebiere, the Broadway of Marseilles, as famous in Europe as our Broadway in America. Nor were we disappointed. The celebrated thoroughfare was teeming with life as typical of the great southern metropolis as the boulevards are of Paris. Every terrace of the countless cafés was crowded, many of them encroaching on the sidewalks. It seemed as if the Marseillais had nothing else to do of an afternoon than to forgather on the Cannebiere and enjoy life. Not even the noisy traffic could drown the exuberance of those voices, nor the severest crowding curtail those ample gestures. It was also a satisfaction to note that even my novice ear could detect the pungent accent of Marseilles, which differs as widely from the dry, staccato of the Île-de-France, as the intonations of Alabama differ from those of Manhattan.

The steamer, which was to take us to Naples and was ultimately bound for Alexandria, to judge by smell and dirt, must have been one of the senior craft of the Mediterranean. Most of the passengers went steerage. That is, they only paid for deck passage, trusting to luck that the weather would be fine, as they ate, slept, and lived on deck. These were, for the most part, Levantines and Egyptians. In our second-class dining room we found only half a dozen table companions.

After dinner we went on deck. The sea was calm as the calmest of lakes, but as our ship passed through its placid waters, they seemed to kindle and break into pale, liquid flame, which trailed in our wake—a phosphorescent pathway of unearthly beauty. When finally we retired to our cabin, the extreme stuffiness, in spite of open portholes, made us envy the passengers on deck, who at least could breathe fresh air.

Another long day and night brought us into sight of Naples. The famous panorama from the bay has been described too often for me to attempt another description. Suffice it to say that on that spring morning it was all I had dreamed it would be. It was one of the few occasions where reality surpassed expectation. As customs and frontier formalities in those happy days were quickly accomplished, we were allowed to indulge our dream of beauty, and it was only after debarking that we were faced with sordid reality in the shape of clamoring hordes of young hooligans, struggling for custom, exhorting and pleading in wharf-side polyglot to be engaged as baggage-bearers for the *signori*. Halpert and I, with our paintboxes slung over our shoulders and our valises tightly gripped in our hands, refused these overtures, both cajoling and menacing, and tried to shoulder our way through the crowd to a cab stand. But it required police assistance to do so.

The cabman, to whom we entrusted our persons and our belongings, greeted us in our mother tongue, or at least in that species of it which his compatriots acquire in America, where he had worked for several years. Having given him the address of a hotel which had been recommended to us by a friend of Halpert's, he started to protest with vehement eloquence, assuring us that it was not at all the sort of place we should stay at, that he knew the very *albèrgo* we needed, kept by very good friends of his—"*ottimi amici!*"—where we should be treated like sons of the family for a merely nominal consideration—a purely friendly arrangement! For, as he confided, whereas the usual price for "gentlemen" was twenty lire a day, we should only have to pay five. It took all our firmness to convince him finally that, regardless of consequences, we had elected the Globe Hotel, and it was there we intended to be taken.

It was only a short drive to our destination—doubtless an added grievance to our *vetturino*. We were well rewarded for our firmness as the hotel turned out to be just the place for us. It was pleasantly situated, with a delightful view overlooking a small square with palm trees and, beyond, the bay itself with Vesuvius gently smoking in the background.

The entire population, so it seemed to us, was outdoors on that and every other day we spent in Naples. A considerable proportion were

beggars, who literally swarmed in the pathway of the *forestièri*. To cope
with this nuisance, we made it a practice to provide ourselves with a cer-
tain amount of small change whenever we went out, for we found a
refusal of largesse would bring on us maledictions and curses of the most
comprehensive kind, extending to generations past and future, while the
bestowal of even a *piccolo sòldo* would cause a shower of blessings and
the invocation of all the saints in the calendar to speed our way.

Better acquaintance with the Neapolitans revealed more gracious
sides of their characters. Pleasure-loving, simple folk, whose need had
been reduced to a minimum, most of them were content to live in filthy,
ill-smelling tenements. We delighted in the picturesqueness of the steep,
narrow, ill-paved streets, ablaze with color where the family washing was
hung out to dry. But the merely pictorial qualities, on nearer view, were
depressingly offset by the squalor and extreme indigence of these gay
abodes.

Yet even in the slummiest of slums, life seemed to offer these happy
natures many compensations—such as those queer-looking sandwiches,
thick slices of bread interlaid with what seemed small raw fishes and
tomato sauce, which could be bought for a few *sòldi* from street vendors
and were devoured with such relish, and at noon the devouring of
macaroni of prodigious length and with prodigious gusto, turning those
squalid alleys into scenes of uproaring festa and merrymaking. Ragamuf-
fin children, having to content their appetites with hunks of coarse bread
and large, raw green beans, seemed to enjoy their meals as hugely and
noisily as the eaters of pasta. It seemed as if the warm spicy air was suf-
ficient to inebriate these revelers, for all were shouting and singing. What
voices we heard—vibrant, rich, and warm! How many potential Carusos
and Scottis could be heard caroling in those back alleys!

And every night also seemed to be a festa, for through our open win-
dows we could hear the singing and chattering and laughing go on until
the early hours of the morning. We soon realized that a large part of the
population never went to bed at night, preferring to do their sleeping in
some sunny secluded corner during the daytime. In the old port and on
the sands, it was a common sight to see the most disreputable of the
lazzaro'ne, shirtless and often trouserless, attending to their morning
toilets in the same manner and with the same undeterred concentration
of purpose as monkeys in the zoo.

It was, in fact, at night that Naples seemed most thoroughly awake
and the streets more crowded than ever. Everyone was out for the noc-
turnal *passeggiata*—parents with their children, lovers, loafers, street
vendors—all chattering, singing, tinkling on mandolins, strumming on
guitars. Darkness stamped out all sign of squalor, and romance lurked
in the shadows. Puppet shows were a great attraction, even to the adult
members, who would watch the naive, century-old versions of heroic
legends with all the concentrated interest of an audience spellbound by a
successful "thriller." Some of these puppet plays were of epic dimensions
and lasted for several weeks, the tragic and pathetic developments being
interspersed by "comic relief" in the shape of harlequinades. The end of

these plays invariably showed the triumph of virtue over vice, with the villain generally carried off by the Devil. Crude and naive as these marionette shows were, they helped to keep alive in Italy the stories of once world-famous epics and moralities. It is to be feared that the advent of the cinema has destroyed the real popularity of these shows, which, however, still survive, especially in Sicily, as a more or less literary cult.

In those days, when the comstockery of the Fascist regime, with its morality crusades and patriotic uplift, would have seemed less credible to the healthy southern mind than the exploits of Paladin and Saracen in his puppet shows, the old aspects of pagan mentality were very noticeable in certain parts of Italy, most of all in Naples. Not only was the courtesan allowed to ply her trade openly and unashamed, but even the other and less natural lusts of human nature were publicly, though more discreetly, displayed. In the less frequented streets of the old quarter, panders could be seen pursuing their ancient, if disreputable, calling as shamelessly as in the days of Petronius or Apuleius—old hags offering children, male prostitutes, and *tutti quanti*. Against this vice traffic the police were powerless, for it was the Mafia, then all-powerful in Naples, which protected and exploited this underworld.

The rule of early rising, which we had adopted, was made the easier for us in Naples by the sunshine pouring into our rooms. It helped even to make the Neapolitan *caffè-latte* with its vanilla flavor and the anemic rolls (so different from the delicious crisp and crusty French bread) pass for a sufficient breakfast.

ALTHOUGH I did not as yet venture to sketch out in the crowded streets, the view from our window was not to be resisted. The palm-shaded piazza, a corner of the old harbor beyond, and a glimpse of Vesuvius in the distance inspired my first Italian sketch. Long as the days were, they hardly sufficed to get in all we wished to see and do. There were the famous museums with the magnificent Greek and Pompeian bronzes, the picture gallery (somewhat of a disappointment after the sculptures), and, above all, the matchless surroundings of Naples. Entire days were spent sketching at Posilippo. Gradually my eyes were becoming trained to seeing color. The sea was purple and blue, with here and there reddish streaks, and at our feet the water looked a pale and luminous green. The raw earth showed red and often cadmium or yellow. Here were greens of a richness I could not match on my palette. As for the sky, apparently so simply and serenely blue, the more I gazed at it, the more varied it became in color and tone: verging on purple at the dome, pink, yellow, and pale green near the horizon, while in the heat of the day streaks of rose and yellow seemed to vibrate over the whole.

A new world was beginning to unfold itself to me. It seemed as if up to this time I had been blind. Halpert, with his experience and knowledge of color, was doing beautiful things, and I was profiting to a great extent through his companionship. It is true that my studies were still very crude, but I worked less timidly and attempted combinations of color which hitherto had been taboo to me. The mysteries of cool and warm

71

color and color complimentaries were here before me in all aspects of Nature.

In the fields about us we could hear the peasants singing as they worked—rich, wild voices, with that peculiar warmth of color which I had already noticed on the all too rare occasions when I had heard Caruso sing at the Metropolitan in New York. What I now sensed with my eyes— the new and unsuspected beauties of light and color—was then already revealed through sound in the accents of that matchless voice.

One day was spent at Pompei, wandering through the ruins with friend Baedeker as guide, thanks to whom, once we had shaken off the clamorous swarm of *cicero'ni*—no easy task—we were able to see and enjoy all we had a mind to, without being hurried. We took our lunch on the steps of a temple.

Another of the expeditions we had planned was the ascent of Vesuvius. Setting out very early one morning, we took a streetcar that brought us near the foot of the ascent. Early as it was, the sun was already very warm and growing ever warmer as we began to toil up the stony paths. The only shade obtainable was that of a ruined wall here and there, and of these we availed ourselves to rest, surrounded by myriads of little lizards, popping in and out of the old masonry, from which they were hardly distinguishable in color.

As we ascended, we were thrilled by the sight of a godlike creature, barefooted and in short breeches, carrying a basket on head, who was walking in front of us, swaying gracefully—the living replica of a Greek athlete we had admired in the Naples Museum. But as we approached the divine creature, the ambient air grew of a sudden noisome with a most vile stench. Walk as we would, we could not escape it. There seemed no visible cause to explain it until we saw the godlike being in front of us stop, put down his basket, and proceed with shovel and broom to sweep something into it from the roadway. Then we realized we had been following the local garbage department.

After endless toiling and climbing we seemed no nearer the summit than when we had started. Finally we spied a modest caravansary on the hillside, surrounded by a few shady trees. Feeling that rest and refreshment would put new heart into us, we made for the little *trattoria*. A homey stew was simmering on the charcoal oven. On this and goat's cheese we made an excellent meal. But the *clou* ("nail or spike") of the banquet was a bottle of genuine Lacrimachristi, the famous wine grown on the slopes of Vesuvius. Remembering the inscription we had seen in an excavated wineshop at Pompei, *"Nihil si semel!"* (evidently the classic equivalent of "Just one more!"), we ordered a second bottle, after which a brief siesta under the trees became imperative, for our heads were dizzy with the ardent fumes of the Vesuvian vintage.

When we awoke it was nearly sunset, and there was only time to hurry back down the steep hillside to catch our last tram for Naples. Thus ended our ascent of Vesuvius!

THE FORTNIGHT we had allotted to Naples over, we started to collect

our impediments. These had increased considerably, owing to the accumulation of sketches. Most of these had not had time to dry, so we were forced to make voluminous parcels, packing the sketches in pairs, separated by intervening corks to prevent their sticking together. Thus encumbered, we started for Rome.

When we arrived in the Eternal City, a rainstorm of quite classical dimensions and fury was raging. These veritable cloudbursts are fairly frequent in spring and autumn, and while they last—luckily not long—the only thing for man and beast is to get under shelter. Neither umbrella nor mackintosh is any protection against the deluge which turns the seven hills into so many cataracts.

Fortunately, we had reserved a room at a pension in the Via Bocca di Leone, near the Piazza di Spagna, in the heart of the aristocratic old-world district, which has still escaped the fury for "modernization" of Roman architects. The room turned out to be a vast apartment, big enough to contain an entire modern Paris flat. Our two beds and the essential furniture seemed lost in an ocean of space. Three windows opened on the street, whereon the old-world paving served alike for vehicles and foot passengers, no separate sidewalk being reserved for the latter.

Our fellow-lodgers were a typically cosmopolitan set, including the inevitable elderly Englishwomen, a buxom German Frau who went in for painting, a French couple, and some Austrians. Throughout our trip we met more Germans than any other foreign nationality, for at that time the *tede'schi* were very popular in Italy. The owner of the pension, a good-looking, well-dressed Italian, sat at the head of the table and did the directing. We were struck by the fact that nearly all our table companions had small bottles of pills or medical potions which they took during meals. Everyone was served with a half-bottle of red wine. The heavy, spicy cooking seemed to need the addition of wine to aid the digestion, which was further stimulated by a siesta, as I found. As the weather had already turned very warm, it was impractical to go out of doors during the hot afternoons, and the siesta became a habit we adopted throughout our Italian trip.

The time-honored saying of "doing in Rome as the Romans do" we found to be the only practical rule of life. Accordingly, we arose early and did all our sightseeing in the morning, mostly on foot or by tramcar. Only on the occasions of our arrival and departure did we resort to cabs. After lunch and siesta we would turn to sketching in the nearby gardens of the Pincio and the Villa Borghese or in some secluded piazza or side street. As for subjects and motifs, there was an *embarras du choix*. Every street, every square, almost every house had its distinctive character, except, of course, in the blatant modern quarters, which I for one refuse to regard as belonging to "Rome," however much they may belong to the capital of Italy.

A noted French writer, famous for his travel books, Paul Morand, refers to Rome as a "city devoid of the picturesque." If that is to be taken as a serious judgment, one can only suppose that M. Morand confined

his Roman rambles to the Vie Nazionale, Cavour, Venti-Settembre, and similar regions evoking the history of modern Italy. It may, in fact, be taken as a general rule that any street or square in any town of Italy bearing the patriotic label of recent origin is guaranteed to be both unpicturesque and devoid of character, when it is not downright hideous and vulgar. In Rome, more than in any city I know, one is impressed by the fact that whatever patriotism (or shall we say "nationalism"?) may have meant in the past as a stimulus to art, it is now—and has been for the last century—a veritable blight to all artistic expression. To realize to what lengths this aberration can drive a cultivated nation, one has but to look down the once glorious Corso of Rome at the "wedding cake," as it has been aptly described, which is officially known as the "National Monument," symbol of the triumph of New Italy.* To make room for that piece of flamboyant marble rhetoric, an exquisite Renaissance building was carefully taken to pieces and rebuilt a little further off. However, it is better not to insist! Yet close by, as if to prove how truly inspired a public monument may be, there still stands, in undiminished glory, the Capitol, as devised by that ardent patriot, Michelangelo. The warning adage of the Tarpeian Rock, close to the Capitol, seems to have acquired a new meaning.

Needless to say (though perhaps the "needless" will cause some of our younger colleagues to smile), we got all the "kicks" we hoped to get out of St. Peter's, the Vatican, especially the Sistine Chapel with its glorious frescoes, the "Moses" of Michelangelo, and most of the other consecrated "sights of Rome."

One day in the Loggie at the Vatican, we met a friend from Paris, an American painter, Phil Sawyer, copying one of Raphael's frescoes. Sawyer took us to the American Academy on the Gianicolo where the Prix de Rome students were studying. There we met Barry Faulkner, whom I had known in New York. He was a nephew of Abbot Thayer and had been assisting George de Forest Brush. Faulkner invited me to visit him at his studio, where he was working on a large decorative panel, destined, if I remember rightly, for one of the Vanderbilt homes. There, to my astonishment, I found Ivan Olinsky, who was paying Faulkner a visit.

Olinsky was a clever young painter, who had been for years with John La Farge, America's foremost mural decorator. Olinsky had been of the greatest assistance to La Farge. With his blond moustache and small goatee, he looked like a handsome and younger edition of Paderewsky. Having passed some time in Venice, where he had worked throughout the last winter, he was full of enthusiasm for the city of St. Mark's. He assured us that Venice under the snow was an inspiring sight for the painter. This remark, I remember, surprised me, as, like many other Americans, I could not associate "sunny Italy" with scenes of snow and frost.

*The Monument to Victor Emmanuel II, designed by Giuseppe Sacconi and built between 1885 and 1911.

This reunion of old friends was the occasion for a little private festa, which lasted until the early hours of the morning. The wine of the Castelli Romani, for all its lightness of taste, is a potent and insidious beverage. Most of its varieties were sampled that night, ending with the traditional *Aleatico* and *Vino Santo* (the Roman dessert wine which takes the place of port or Madeira), with the result that Olinsky suffered a lapse of memory regarding the address of his hotel and was obliged to share our room that night.

We spent a full and profitable month in Rome and its environs, sketching at Tivoli, Hadrian's Villa, and in the Campagna. At the same time we picked up a smattering of Italian, enough to stutter along on.

Early in May we started for Florence. Olinsky, who had decided to return to Venice, accompanied us part of the way.

ASSISI and the Giottos at St. Francis's Church on our program, we broke our journey at the Umbrian Mecca. The tourist season had arrived, and we found runners and employees of the hotels on the train, making advance publicity for their various establishments. So we were able to make our arrangements for a brief stay before reaching our destination.

The journey through the beautiful Tiber Valley, then in all the glory of early summer, the enchanting views of the Apennine landscape, the famous little hill towns with their towers and ramparts, and finally the long drive from the railway station up to the town of Assisi, perched halfway up the mountainside, furnished a succession of thrilling surprises. One of them was the realization that the backgrounds of the Umbrian masters, with their ranges of hillocks, almost perpendicular in their abruptness, the mystically colored horizons, and the deep tones of earth and pastures, were no stylized convention of a school, but an actual representation of nature.

During the leisurely drive along country roads, often lined with blossoming hedgerows, we were struck by the curious atmosphere—a sort of serene solemnity, a composed gaiety, quite different from the romantic melancholy of the Roman campagna or the somewhat flamboyant, almost theatrical effects of the Neapolitan landscape. The coloring was as rich, perhaps even richer, than any we had observed thus far, the brownness of the soil and the darkness of the greens surpassing in tonality anything I had seen or even thought possible in nature. It was certainly "something rich and strange," yet in no way disconcerting or even startling. On the contrary, there was a deep, luminous tranquillity, an almost seraphic repose, transfiguring the entire countryside. The very peasants we met on the road and the majestic snow-white oxen appeared to have stepped out of some classic frieze and seemed inbued with the same spirit of serene contentment and dignified repose.

The little hotel we put up at was kept by an Englishwoman, and it turned out that it was her Italian husband who had acted as her agent on the train and secured our custom. My room was adorned with an elaborately painted ceiling, representing a blue empyrean with floating cupids—or perhaps they were choiring seraphim, which would have been

more in keeping with the religious atmosphere of the Franciscan city. That night in brilliant moonlight, the three of us rambled through the medieval streets, gazing at the famous shrines and the little temple of Minerva (which alone had tempted Goethe to visit Assisi) and speculated on the wonders to be revealed within.

Nor were we disappointed the following morning when we came before the Giotto frescoes in the Upper Church, depicting the life and miracles of St. Francis. Here were divine treatment of color and composition, so simply, so naively conceived that only a great master could have achieved a convincing and enduring whole, transcending the usual limits of the "primitives." Plainly I could see whence another master, Puvis de Chavannes, had derived his greatest inspiration.

While we were wandering round the church, a minor miracle took place—apparently. For there we met friend Halpert, robed as a priest, serenely meditating; at least the resemblance was so striking that Halpert himself kept gazing at his "alter ego" in amazement.

We spent an entire day studying the frescoes, of which I should have liked to make copies, had there been time. Another day was spent sketching in the surrounding country. Silhouetted against the sky, we could see the towers and battlements of "Proud Perugia" beckoning to us across the Umbrian plain and decided to accept its call.

The contrast between the quietude and peacefulness of Assisi and the forceful, dominating Perugia could hardly be greater. The almost cyclopean Etruscan gateways—leading into winding, arched streets, climbing and descending with dramatic abruptness, overtopped by buttresses, with loopholes for observation and defense—evoked a past of military glory, violence, and drama. And the fact is that the history of Perugia can vie with that of any other Italian city for "battle, murder, and sudden death." But to me its associations had been with Perugino, Raphael, and the early Umbrian masters, with all that is gentle and seraphic in art. Nor was I disappointed, for all are amply represented in the picture gallery, churches, and civic buildings, except Raphael, of whom I can remember only an early fresco, very much in the manner of his master, Perugino.* As for the latter, I frankly confess that for nobility of expression and beauty of color I rank him above his illustrious pupil. Nowhere can he be appreciated so well as in his native surroundings. Apart from the richly glowing decorations of the "Cambio," there are frescoes and altarpieces in Perugia and some of the small neighboring towns—I remember especially a lovely Adoration of the Magi at Citta della Pieve, the painter's birthplace—which proved, at least to me, that my cult for Perugino was more than justified.

Impressed and thrilled as we were by the paintings and architectural beauties of Perugia, we were no less delighted by the magnificent panorama that stretched round us and burst upon us at every turn and in the

*This fresco, representing a group of prophets, was executed between 1497 and about 1500 by the workshop of Perugino, of which Raphael was almost certainly a member. It is located in the Collegio del Cambio. John Pope-Hennessey, *Raphael: The Wrightsman Lectures* (New York: New York University Press, 1970), pp. 129-30.

most unexpected places, so rich and varied in color, especially toward sunset when the whole landscape would be bathed in violet, mauve, and deep purple tones, that the effect was almost overwhelming.

Another delightful trait about this and all the other Umbrian towns we visited, with the notable exception of Assisi, was the surprising cleanliness and the absence of beggars. The people, too, whether peasants or townsfolk, bore themselves with a quiet dignity and absence of unnecessary noise, which seemed to mark them down as a race apart in Italy.

One of the most interesting and memorable excursions we made from Perugia was to Gubbio, an ancient hill-town, where every May a famous festival is celebrated. It took, in those days, over four hours by carriage, but the time was well spent, for we passed through some of the wildest and most romantic country I have ever seen. Gubbio, of which the foundation dates from prehistoric times, straggles up the mountainside. To one side lies a charming little Roman amphitheater, gay with spring flowers.

Leaving Perugia, we skirted for a while the shores of beautiful Lake Trasimeno, where Hannibal won his great victory with the aid of nature (much as Hindenburg did at the Masurian Lakes) and where Saint Francis, as hermit on one of the wooded islands, celebrated a mystic Easter. For sheer poetry and unspoiled loveliness, Trasimeno, among the bigger lakes of Europe, is undoubtedly without a rival.

Siena, where we made only a brief stop, despite the glories of Pinturicchio and the Pinacoteca, has, strangely to say, an aural, rather than a visual, association for me. For it was there, resting from our sightseeing in a small public garden, that I heard for the first time in Italy the song of the nightingale. Never before or since have I heard such ecstatic singing, such a shower of golden notes, such lyric rapture. In a moment I realized that what had often seemed to me poetic exaggeration regarding the vaunted philomel was no literary fiction but as true to fact—at least under certain circumstances and in certain places—as the backgrounds of the Umbrian primitives. That was the song that Keats had heard in his Hampstead garden. It was, I realized, merely a true transcription of actual experience in the terms of his art.

AT FLORENCE, after seeing us comfortably installed, Olinsky bade us farewell, to continue toward Venice. His knowledge of Italian had been most helpful in smoothing the way for us. Luckily, before he left, I received the expected remittance from America to pay for my Italian trip, so that I was able to treat my two comrades to a Chianti festa, which proved to me very effectually that, like the song of the nightingale, that famous vintage must be sampled in its right surroundings to be appreciated at its true worth. When Olinsky left next morning Halpert and I were still abed. But the parting was not a final one, as we had arranged to meet again in Venice.

The first subject which tempted my brush in Florence was a beautiful view of the Duomo from my window. Of this I made several studies, one of which was exhibited later at the Autumn Salon. It is one of the few

things I painted in Italy which had any real merit and has been for years in the possession of a friend.

I note that from this time on it seems to have become more and more my habit to paint from windows. For street scenes it has the advantage that people, vehicles, and animals appear in their right proportions, whereas on the street level objects in the foreground assume too-large dimensions and tend to dwarf what is behind them. The habit became so strong with me that if I were asked where I had been at a certain hour at a certain date, I could risk a guess that I was painting out of a window.

When not sightseeing, Halpert and I would wander through the picturesque old quarters, having soon tramped Florence from end to end. Even a walk round the entire city, skirting the old walls, was a small feat. The fact is that famous Florence, capital of Tuscany (even for a short while of Italy) and metropolis of art, covers a relatively restricted territory due to the surrounding hills, hence the huddled, somewhat jumbled-up appearance of the streets, especially in the lower quarters along the Arno. The cream-coffee color of its water, especially after rain, was a tempting subject for the painter in contrast to the famous Ponte Vecchio, and we spent many hours sketching along the quays.

Some part of every day we spent at the galleries, especially the Uffizi, where we were struck by the number of copyists, among whom there were many very expert workers. They seemed to be devoting their labors particularly to the "Primitives." These copyists, for the most part Italians, worked in tempera on panels prepared with a gesso ground—the same materials as employed in the originals—and the copies they produced were surprisingly exact. The paintings in tempera, even as far back as the fourteenth century, had still preserved their beauty and brilliance of color, appearing far fresher than pictures painted in oils centuries later. I noted how often the "Primitive Masters" employed a technique of crosshatched colors, very similar to that of the Impressionists of the school of Monet and Pissarro (the "broken color" method), and how far they had extended their science in the matter of warm and cool colors and their opposition. Why these painters should be denoted as "Primitives" is a mystery to me, for apart from their not applying our rules of perspective, their works are peerless in craftsmanship and in beauty of color and arrangement.

Of the masters of later date, Botticelli appealed to me most. He was a first-class decorator, and yet in many instances he would depict subjects with amazing realism. At the Palazzo Pitti collection—which, in point of importance, compares with the Uffizi as the Luxembourg Gallery with the Louvre in Paris—I was especially impressed by the important collection of Titians, particularly a superb nude, the last word in sophisticated painting.*

In his portraits, nudes and pictures of a pagan type, Titian appears to me incomparable; but his large religious canvases still strike me, as they did then, as sublime chromos. I was beginning to realize the fact

*The Reclining Venus of 1538.

78

that, then as now, there existed a "commercial art" and that "divine subjects" painted to order do not necessarily result in divine art.

As a further proof of this verity there were the famous Raphaels at the Pitti. While his portrait group of cardinals seemed to me great human documents, the famous and often-reproduced circular canvas representing the Madonna and Child—the so-called *Madonna della Sedia*—is another example of the high-class commercial art of his day. His portraits struck me as a far greater achievement in the field of art. But I suppose that in spite of the fact that he had a whole troupe of very able assistants, the divine Sanzio must have been hard put to fill all the orders of his noble clients and powerful patrons.

After so many conflicting impressions and mental adjustments, it was a relief to rest in the cool quiet of the lovely Boboli Gardens which surround the Pitti Palace. The strain of so much sightseeing, the constant effort of registering and absorbing the accumulated treasures of art in galleries, churches, and ancient monuments, was often too much. I seemed to have reached the point of saturation, and discouragement would set in. How was it possible to think of competing with the Great Masters who could produce such superb works—works whose authority dominated today as they did in former centuries?

I now realize that this form of depression was not merely due to being overawed by so much beauty. It was my reaction to the atmosphere of Florence itself—an atmosphere of great tradition, but not of creation—a sort of "deadness," like that of most museums, seeming to result from a too-great accumulation of a Past and not enough of a living Present to create balance and produce real stimulation. It is a place in which to dream (but not for too long!) of past achievement; but there is danger for the modern artists of being stifled by the power and grandeur of that Past.

While in Florence I made the acquaintance of a local sculptor named Faggeo, who had worked as assistant to George de Forest Brush, during the latter's stay in that city. Although unable to speak each other's language, Faggeo and I became very friendly, roaming about together and exchanging our youthful ideas and enthusiasms. He would speak in short sentences, enunciating slowly and supplementing with signs and gestures, to which I would reply in my smattering of French and pidgin Italian. We soon understood each other perfectly, and I came to understand how the explorer in an African forest establishes verbal contacts with the jungle-men.

To me Faggeo confided his desire to leave his beautiful *Firenze*, where there was very little opportunity for him to achieve anything more than the status of assistant to some established sculptor. Like many of his countrymen, he was dreaming of America as a new field. This dream he was able to realize, and eventually he met and married an American girl of a prominent Chicago family. When I met Faggeo some years later in America, he told me he had been doing well and was getting many orders.

I found the Florentines a charming and cultivated people—more cul-

tivated, in fact, and less brusque than the Romans, and far more courteous than the Neapolitans and southern Italians.

As regards the latter, our Florentine acquaintances were eager to impress upon us that they came of a race different from the southerners, of whose goings-on (especially in connection with Mafia exploits) they, the Florentines, seemed genuinely ashamed.

In Florence, as in Rome, we found very little night life. The few cafés were far from gay. Women unaccompanied in the streets were rare. So our evenings were very quiet. As a rule, after dinner we would take a stroll and then turn in to bed.

We wandered about the hills of Fiesole and Settignano and reveled in the lovely Tuscan landscape, basking in the sunshine, which never failed us. I particularly remember our delight when rambling along the heights of San Miniato, we came across the radiant *David* of Michelangelo on the belvedere, which commands one of the loveliest panoramas in the world. Other memories, which stand out in connection with our visit to Florence and which left a deep impression, are the sculptures of Donatello and the Fra Angelicos at San Marco.

The paint supply we had brought with us from Paris was running out, for we were painting almost every day. It was only with difficulty that we found color dealers to supply us with what we needed. In spite of the fact that Florence at all times harbors visiting artists, there seemed to be no adequate art store. Supplies were limited and of mediocre quality. Colors were either of German or French origin and consequently much more expensive than in the lands which had produced them. We did, however, discover cardboard panels for painting in oils, much lighter and cheaper than the wooden ones we had been employing so far.

After a month, which had passed all too quickly, we regretfully tore ourselves away from these enchanting sights, and, with a considerably increased stock of paintings, entrained for Venice.

OLINSKY had written us that he had secured a dwelling place for us overlooking a small canal, near the Church of the Salute. This turned out to be the very spacious spare room of a flat belonging to a cobbler and his wife. As if to confirm the exception to the rule, the couple was childless. Only breakfast being included in the arrangement, we had to go out for our meals.

The railroad trip to Venice proved a disappointment. Instead of being able to enjoy a succession of lovely panoramas, we were only afforded tantalizing glimpses, owing to the seemingly endless series of tunnels through which we passed and which only diminished when we reached the somewhat monotonous northern plains. We finally arrived in Venice grimy with soot and cinders and parched with thirst.

Friend Olinsky was at the railway station to meet us. Evening was closing in and the afterglow of a glorious sunset still gleamed over the Grand Canal. A gondola, propelled by its picturesque oarsman, took us and our belongings to the lodgings awaiting us. The old palaces and buildings past which we floated were transfigured in the evening light. I

seemed to recognize a thousand places familiarized in pictures and photographs. The picturesque gondola with its swaying motion, the long drawn-out calls of gondoliers as they rounded the corners—"*Ah, sta-lì!*"—were romance come true to life.

Our cobbler-host and his wife were hospitable souls, and the cool glasses of beer they offered us added to their kindly welcome. Our little room overlooking the canal, with its tiled floor, was clean and cheerful, and we were glad to note that our two small beds were provided with mosquito nettings, for with the approach of darkness the menacing sing-song of the pernicious little insects warned us that we would need sanctuary for the night.

We dined that evening at a little restaurant which was frequented by artists and bore the queer-sounding name Lunaticci, which seemed to accord well with the eccentric appearance of many of the diners. Olinsky, who knew the city thoroughly, piloted us through the narrow byways and back streets, so that we rarely had need to take the public conveyance, i.e., the *vaporétto* ("small steamer") which plies along the main canals, doing service for tramcars. There were always shortcuts to be taken, which reduced apparently long distances in a surprising manner. Thus the passage by boat from the *ferrovìa*, or railway station, to the Piazza San Marco in the heart of the city is quite a long trip, whereas it is only a short walk to the initiated.

Every promenade on foot in Venice means crossing innumerable bridges, and I learned that the admirable way in which Venetian women bear themselves—the erect carriage of their heads, and the beautiful straight lines of their bodies draped in black shawls—is attributed to the ancient habit of crossing bridges.

We found Venice a paradise for sketching. The narrow canals with their quaint old buildings reflected in the water, the dark mass of a gondola stealing through and giving motion to the scene, were tempting opportunities for the painter to be seized at every turn. Peeling plaster on the old walls, with the red bricks shining beneath and the mouldy green tints near the water's edge, the parti-colored mooring poles for gondolas—all those motifs, though they have been painted innumerable times, were still a tempting lure for our brushes.

We painted, on an average, two sketches a day, one in the morning and one in the afternoon. Sometimes we would experiment with a hasty study in the evening light—a sunset over the lagoons. The great Piazza di San Marco was always swarming with painters at work. The loitering crowd, feeding pigeons or seated at the open-air cafés, the display of banners on fête days, and the gorgeous colors of St. Mark's Cathedral, made an incomparable picture. Artists from every land flocked here, and many were the fine works I saw being painted in the famous square.

As we lived only a short distance from the Salute Church, we availed ourselves of the steps of that famous basilica for painting views of the Grand Canal. One day I climbed up onto one of the abutments underneath the bridge near the Belle Arti Museum in the hopeful expectation of finding there a viewpoint which had not yet been exploited by painters.

Alas! The sides of the wall were all smeared over with old palette scrapings! I believe it would be impossible to find a single vantage-point anywhere in Venice which has not held a painter's easel.

One day we noticed a crowd gathered along the Grand Canal, curiously watching a large flat boat which was conveying a horse, the only one I had seen since we left the mainland.

That morning I also saw an elderly, bearded gentleman painting a small canvas of one of the doors of the Salute. He was working in a very slow and precise manner. It was a striking study. When viewed from nearby, it looked as if it had been painted in a very loose and careless manner, but at a distance of six feet, it took on remarkable strength and reality. I found him working on that study two subsequent mornings and learned he was John Singer Sargent. William Chase was also in Venice at the time with a class of pupils. Among them was Jane Peterson, who has since made a reputation for herself as a painter of Venetian scenes. Rarely a year passes without her paying a visit to the City of Lagoons.

Halpert and I worked together a great deal. When curious onlookers would praise his work, Halpert would often become irritated and maintain his work was turning out badly. If it appealed to the crowd, it must be banal and inartistic.

At lunchtime we would return to our lodgings, our noon repast usually consisting of bread, cheese, and vegetables, mostly raw tomatoes, or raw eggs, washed down with red wine and water. For *céna* (the evening meal) we went to one of the small "*trattorie*," generally Lunaticci's, where we would find Olinsky and other artists with whom we had become acquainted. The nights were gay. Often there were band concerts on the Piazza San Marco, which one could enjoy from one of the open-air cafe's. On rare occasions we took an hour's ride on a gondola—a mixed pleasure at night, owing to the mosquitoes.

Tintoretto could be seen at his best in Venice. *The Miracle of St. Mark* has always been to me the most astounding piece of painting I have ever seen, whereas the series of paintings he did for the Scuola San Rocco appear to me black, pompous, and, in many cases, disagreeable performances. It is said that many of the canvases were painted in a single night (he often worked by lamplight or candlelight), which is surely an exaggeration, though there is a hurried and negligent air about these pictures.

The Belle Arti houses superb works. The Bellinis and Carpaccios are the finest in Europe. Though there were many interesting works at the museum of modern painting, my impression was that modern Italian painting had sadly degenerated since the great periods of the Renaissance and the Primitives. Many of the modern works appeared to me merely acrobatic feats of technique, as in the case of Mancini, one of the best known of the latter-day artists. Though doubtless a very talented man, he appears to have lost himself in an eccentric and often banal handling of paint and subject. For instance, in one of his portraits in the Museum of Modern Art in Venice the subject is holding a glass carafe in his hand. The bottle is painted in thick relief, and a piece of real glass is

82

stuck in the center to reflect as a highlight. Mancini has frequently painted on newspapers, and in many instances he has left the charcoal square with which his canvas had been prepared for work. Tiepolo was the last of the great Italians to paint in the Grand Manner, and in Venice can be seen his most beautiful frescoes.

That year the Exhibition of International Art was held at Venice. There were rooms devoted to the works of the Frenchman, Albert Besnard, the German, Franz Stuck, and to the Americans, Carl Frederick Frieseke and Richard Miller. A separate room was devoted to each country participating in the exhibition, the works of Italian painters naturally predominating. Of the American exhibits, the best to me seemed a girl in brown by Robert Henri, a portrait vibrant with life by John Sargent, and some small exquisite pictures by Arthur Davies. Frieseke and Miller enjoyed a great deal of success at this exhibition, which was, to a large extent, bought up by members of the royal family and by various museums.

On the occasion of his birthday, Olinsky invited us to lunch to celebrate the event. Having foregathered somewhat early, our host announced that he would do a portrait of me in exactly fifteen minutes. I sat in profile for him, and he painted me on a small panel. When time was called, he dropped his brushes and exhibited a very creditable likeness. We lunched, if not wisely, very well and liquidly, with the result that we floated, rather than walked, from the table. Despite the festive occasion, it was decided not to waste the afternoon, so we sat down and sketched. My subject was a view of San Giorgio with boats in the foreground. Everything appeared topsy-turvy and the colors were blurred. The boys swore it was the best thing I had yet done, and a masterpiece of its kind. But I wondered what their verdict would be when the effects of our potations had worn off. We ended that afternoon with a fine nap in the shade.

Whenever I look at that wine-inspired canvas—for it still figures among the souvenirs of my Italian journey—I must modestly confess that it would have held its own among the effusions of the modern delirium-tremens school of painting.

Why, I wonder, does it invariably happen as soon as one starts a study of a sailboat or gondola in Venice a sailor gets into the boat and starts lowering the sail; or the gondolier becomes suddenly active; or, in either case, the subject promptly departs? This coincidence occurred so regularly, not only in my own experience but in that of all my fellow artists, that it appears to be a relic of one of the old sumptuary laws of the *Serenissima*.

Many of the boats were painted in gay colors, the sails decorated with gaudy designs painted on backgrounds of brilliant red or yellow. I recall one sail embellished with the crude portrait of a woman, presumably the *inamorata* of the owner. Others blazoned red suns or were inscribed with phrases in Venetian dialect.

No less picturesque and impressive were the guardians of the peace, strutting majestically in cocked hats, white gloves, and small swords.

Once I saw one of these fine fellows remove his immaculate white gloves, revealing the dirtiest pair of hands I had ever seen. Beautiful women were to be seen everywhere in Venice, many looking as if they could have posed for the originals of Titian's Madonnas. The children, especially the boys, look like dark-eyed cherubs, but except for the lads of Douarnanez in Brittany, I have never met with tougher little devils, nor any more mischievous to painters. Many times have I been interrupted in my painting by their antics and deviltry. One of their favorite feats was to creep up from behind, throw pebbles or dust at the canvas over my shoulder, and then run off. On the other hand, I must admit that the Venetian adult is severe to these little offenders, and very sympathetically disposed towards the foreign *pittóre*.

One day while sketching on the Guidecca Canal, a crowd of small urchins playing around me, I suddenly heard a splash and saw a youngster struggling in the water. In a moment I had got rid of my coat, kicked off my low shoes, and jumped into the water to save the child. My heroism was wasted, however, for before I could get to the child an Italian wharfman had the bambino in his arms. Helpful onlookers had thrown a rope and proceeded to lift up the man and the child, while I kept swimming about until it was my turn to be towed in. Nonetheless I received a hero's ovation, after which I repaired, perforce, to a neighboring shop, where I removed my remaining garments, wrapped myself up in a quilt, and waited until my trousers and other essentials had dried. I was in a pretty bedraggled state when I got back to our room, but the loan of a hot flatiron gave to my clothes an air of neatness and prosperity they had lacked before their forced immersion.

On another occasion while sketching on the iron bridge near the Belle Arti, I was suddenly warned and shooed off by a squad of police, who barred either end of the bridge.

Although I had noticed that banners and gay bunting were displayed at the windows and balconies of palaces and hotels and that there was a general holiday animation in the streets, I had not inquired the cause, festas being of such frequence in Italy. But now, noticing the large crowds lining the streets and thronging windows and balconies, I made inquiry and was told that the King and Queen of Italy were favoring Venice with a visit and that in their honor a magnificent water pageant had been arranged.

Their majesties, in a gorgeous super-gondola, were being rowed down the canal, escorted by gaily bedecked crafts carrying prominent officials. In view of this the bridges under which the royal procession passed were cleared as a precautionary measure against possible *attentati.*

The rousing ovation accorded to the royal couple seemed a sincere tribute of affection on the part of the populace; and the sovereigns, judging from their smiles and air of contentment, were genuinely pleased at the enthusiastic welcome accorded them.

That night there was a grand concert with illuminations in the Piazza San Marco, and I shall always remember the friendly, spontaneous spirit of those public rejoicings. I certainly remembered it with

melancholy and regret when, years later during another visit to Venice, I noted the changed attitude of the Venetian public, especially of the black-shirted youths. Swaggering insolence and marked impoliteness to foreigners were, at least on that occasion, what most distinguished the Fascisti from their fellow-beings. Everything had become "fascisti-cized," even the band playing in St. Mark's Square, whose program seemed to consist of a series of patriotic hymns, mostly unfamiliar to my ear. If, whenever a new hymn was started, the listener or passerby did not promptly remove his hat, he ran the risk of having it knocked off and of being insulted by the band of young ruffians who paraded as the representatives of the "Italianissima Italia." To avoid trouble with these gentry, I made it a practice of walking about bareheaded whenever I visited the great square at night. In the prewar days, however, and also later when the Great Fascist Revolution had "changed all that," kindness, tolerance, and courtesy toward the stranger were the most notable traits of Italian character.

Walking through the crowd on the night of that festive occasion, we encountered three American artists whom I had already met at the Café Lavenue in Paris: Percy Bewley, from Texas, Lester Rosenfield, and Charles Basing, a well-known American mural decorator and designer of theatrical sets, one of the merriest creatures I have ever met and a famous raconteur of fantastic tales "a la Munchhausen." The trio had spent the preceding day at Padua (a short distance from Venice), and their enthusiastic accounts of the Giottos and Mantegnas there seen by them filled us with the desire to view the works of these masters.

This was our third week in Venice, and we longed once more to walk on solid land where grass and green things grew out of mother earth and not out of the cracks and crannies of masonry, as in the Lagoon City. So it was decided to make an excursion to Padua.

The trip was well worth taking. The little church at Padua was liter-ally crammed from top to bottom with the masterpieces of Giotto. I bought all the photographs of them I could lay hands on, but of course they could only serve to evoke the forms and not the exquisite colors of the originals, which the passing of centuries seems to have left as fresh and beautiful as when they were first painted. Halpert and I were spellbound and passed the greater part of the day in the church. Magnifi-cent as are the Mantegnas in the little chapel behind, their merits seeem diminished by the naive and peerless beauty of the neighboring Giottos.

According to our calculations, determined by the state of our finances, we had another week to spend in Venice. We decided to include a visit to Chioggia, the nearby island peopled by fisher folk, famous for its gorgeously colored boats, in the hope that we might bring back a few sketches of those colorful scenes.

We found far more squalor and dirt in Chioggia than in Venice. Imposing architecture and *palazzi* were scarce, but color was plentiful and everywhere resplendent. We prepared to sketch when, to our aston-ishment, a soldier gave us to understand by signs and gestures that it was not permitted. And wherever we went in Chioggia it was the same

thing—*proibito*! or "forbidden!" The injunctions, though always polite, were firm. Neither then nor since have I discovered the reason for that prohibition. I was dressed in a light khaki suit that smacked perhaps vaguely of a uniform. But if I had been a spy (there are military works in the neighborhood of Chioggia) I should certainly not have worn military-looking clothes, to say nothing of the fact that it would have been easy to draw from memory the salient points of my surroundings. As far as we could see, all there was to paint were ramshackled old buildings and picturesque boats.

Our disappointment was to some extent mitigated by a succulent lunch of which we partook on the terrace of a little trattoria facing the quays, and which consisted of grilled fresh sardines, a dish of *pólpi* (small octopus) in a highly seasoned sauce, and a bottle of Asti. Thus comforted and refreshed, we began to see the humor of our frustrated painting expedition and speculated with amusement as to the possible reasons why the Italian military authorities had singled us out for special surveillance.

Our stay in Italy was drawing to a close. We had hoped to spend a few days in Milan before returning to France, but our exchequer was running low, despite the fact that we had lived very economically. The cost of replenishing our painting material and the purchase of photographs of the masterpieces we had most admired had run away with more money than we had expected. Fortunately, we had our return tickets, so we decided to chance a brief stopover in Milan.

An Italian painter had told me of the Albergo Popolari in Milan, where one could live at a very modest figure—an institution like the Mills Hotel in New York. So, staggering under the load of sketches, paintboxes, and valises, we left Venice early one morning, Olinsky alone coming to the station to see us off.

ARRIVED at Milan, after leaving our baggage at the luggage depot of the railway station, retaining only the essential toilet articles, we set out for the Albergo Popolari. We found a large, somewhat bare, but very clean hostelry. Among its advantages were free shower baths in the basement. The rooms to which we were assigned were tiny cells, each containing only a narrow bed and one chair. One of the rules of the institution was that we must be out of our rooms by 7 A.M. and must not return until evening. This arrangement suited both Halpert and me, and so did the price, fifty centesimi (ten cents in American money) per head.

We made a round of the various museums, not omitting to see the *Last Supper* of Leonardo da Vinci, before which we found a number of copyists at work. As for the famous picture itself, I was disappointed to see how it had been affected by time and deteriorated through dampness.

In connection with the *Last Supper*, a friend of mine, Samuel Cahan, a well-known newspaper artist who had been with the *New York World* for thirty years, told me of an amusing incident which occurred when he and his wife visited Milan a few years ago. Speaking no Italian, they

86

had asked their hotel porter to procure an English-speaking cabby to take them about. To the latter my friend very carefully explained that they wished to see the *Last Supper*. "Last supper?" replied the cabby, "yes, yes. Me understand!" Whereupon he started driving them round the town and finally into the country.

After the drive had extended for several miles, my friend, fearing that there must be some mistake, repeated his instructions to the driver. "Last supper?" he yelled back, "Sure! Me understand!" and continued to drive. Late that evening the two Americans were finally brought back to the city in a state approaching nervous exhaustion. Drawing up his carriage in front of a brilliantly lit edifice, the *vetturino* opened the cab and ushered his fares into a fashionable restaurant, proudly giving them to understand that he had brought them back in good time for the desired "late supper."

Obliged to practice strictest economy, there was no danger that Halpert and I would be enmeshed in "late suppers" while in Milan. Our menu, in fact, was reduced to bread, cheese, and fruit, which we ate that night in the great Arcades, near the famous Scala Theater, around which are located some of the most luxurious eating-places of the city. Sniffing the appetizing odors and listening to the strains of orchestras, we wandered about, munching our humble fare. Close by was the great Cathedral, an imposing and beautiful sight by moonlight. With its innumerable carved figures and delicate architectural tracings outlined against the sky, it gave the effect, despite its powerful bulk, of an exquisite edifice of lace. Late that afternoon we had explored the interior. Through the shadowy darkness fell a single ray of sunshine from an upper window, striking the figure of the Savior Crucified, hanging high on the opposite wall. The effect was truly dramatic, almost startling.

The little cell-like cubicles at the Albergo Populari housed us during our last nights in Italy. The beds were clean, though anything but soft.

The following day at the Art Museum we saw some very beautiful small frescoes by Luini, and the magnificent Christ, drawn in foreshortening and painted by Mantegna from the most difficult angle of perspective. The canvas itself, though quite small, gives the impression of size through the sheer art of drawing and composition. Only a great master of draftsmanship like Mantegna could have conceived and successfully accomplished so daring a work.

As for Milan itself, which is an entirely modern city, we found it architecturally uninteresting, compared with other notable Italian cities.

OUR MONEY had now practically given out, and we calculated, with the purchase of bread, fruit, and wine for the journey, we should arrive in Paris without even the few necessary sous to take a tramway back to the Quarter. Our provisions must last us over an eighteen-hour journey. As past experience had taught us that it was practically impossible to procure fresh water on the train, we obtained an extra empty bottle at the shop wherein we bought our wine, and by mixing water and wine in the two bottles assured ourselves of sufficient liquid for the trip.

We were fortunate in finding an empty third-class carriage, which we promptly "reserved" for our exclusive use by spreading our bags and packages on the vacant seats, according to the time-honored device for keeping off intruding fellow-passengers. Thus we could look forward to getting some degree of rest.

From the timetable we had gathered that our train was direct from Milan to Paris, where we should arrive about midday. But with the departure from Milan our troubles began. Halpert had carelessly placed the two bottles with our precious drinking supply under one of the seats. Came an abrupt curve—a crash of broken glass, and a small inundation on the floor. Our hopes of liquid refreshment were dashed indeed, and the thought of dry bread and cheese no comfort.

To cap the climax, we were told on our arrival at Basel late that night that the third-class coaches would be detached and go no further, only first- and second-class passengers being conveyed direct to Paris. The next train with third-class accommodations would not leave until the following afternoon at two o'clock. We were up against it! We had no money to pay for a room at a hotel, nor was there even the possibility of passing the night in the cold, cheerless station, as it was about to close up after the train pulled out.

The thought of wandering about the cold Swiss city, without food or shelter, was too appalling. So, deciding to chance it, we hastily transferred our voluminous baggage to a second-class carriage at the last moment before the train started. As there was no room in any of the compartments, we had to pile our luggage in the corridor and sit on our valises. Nor was that the end of our troubles, for we had still to deal with the conductor. When that official shortly afterwards asked for our tickets and discovered we were third-class passengers, we thought he would choke with indignation. What did we mean by intruding into the second-class with inferior tickets! Unheeding our meek and patient explanations that the schedule had read we were to be taken straight on to Paris, he hurried off and returned with another official. After heated argument and debate, it was announced we should be put off at the next station.

Fortunately, Providence in the shape of a kindly English traveller intervened in our favor. Hearing us from his compartment speaking in English, he came out to inquire what the trouble was. When he heard of our dilemma and lack of funds, he tried at first to placate the irate officials. When that did not help matters, he very kindly offered to pay the difference of our fares second-class as far as the French frontier, saying we could pay him back in Paris, where he would spend a few days. We could hardly thank him adequately, so great was our relief. Needless to say, we lost no time in acquitting ourselves of our debt when we arrived in Paris.

On crossing into France the same comedy had to be enacted with the French officials. But here Halpert was on his own ground, so to speak, as he was able to present our case in fluent French. The conductor, though polite and even sympathetic, informed us that rules could not be circum-

vented and that we should have to pay if we remained on the train. But after further pleading he relaxed to the extent of allowing us to continue our journey to Paris, but said he would report the matter by telegram to the station authorities and that, on arriving, we should have to answer to them for infringing the rules of the company.

Fortunately, we were able to quench our burning thirst with water from the station pumps when the train stopped. But we were weary, hungry, and depressed when finally we steamed into Paris at noon.

On alighting from the train we were met by a pompous official and two bulky gendarmes, who seized upon us. Feeling like two criminals who has robbed the Bank of France, we were unceremoniously ushered into the presence of the *chef de gare*, under the curious glances of the station throng, who naturally supposed that we had fallen foul of the law. After being kept waiting while our case was being looked into by the assembled authorities, we were demanded to give an explanation of our reprehensible conduct. Halpert again explained and pleaded our case, and as further proof that we were not hardened swindlers, but poor, honest artists, pointed to our paintboxes and sketches.

This bit of special pleading in the sacred name of Art elicited smiles. The added fact that we were American art students also stood in our favor, and we were finally told we should be allowed a week to pay up the deficit. Then, after our names and addresses had been taken, we were set free, evidently to the disgust of the scowling gendarme, who had been holding onto my arm.

As it was out of the question for us to carry our baggage from the station to Halpert's studio on the other side of the river, we deposited it in the parcel room, and with only our paintboxes slung over our shoulders, started out for the Quarter.

It was a long tramp and the sun was uncomfortably hot. On all sides were tempting cafés, with shady terraces and cooling drinks. Paris was *en fête*, gay with flags and bunting, in honor of the Fourteenth of July, the national holiday, the celebrations for which extend over several days. At the street corners temporary platforms had been erected for the dance orchestras, for in the prewar days street balls were to be found throughout Paris during this period of national rejoicing. But there was no prospect of our joining in the good time, for neither of us expected to receive our monthly remittance for several days to come.

Wilting with heat and exhaustion, we finally arrived at Halpert's studio in the Rue Moulin-de-Beurre, where, with the help of wet towels, in lieu of a bath, we performed much needed ablutions. Rested and refreshed, the next question was how to still our ravening hunger, which the excitement of our arrival and the joy of homecoming had so far held in abeyance, but which now was not to be gainsaid. Unfortunately, Kleminger, who had the adjoining studio, was out, so we had to turn elsewhere for temporary financial aid.

At Halpert's suggestion, we repaired to the American Artists' Club, then housed in what had once been the private hotel of the celebrated French painter, Carolus Duran, John Sargent's master, at the corner of

the Rue de la Grande Chaumière and the Rue Notre Dame-des-Champs, in the hope of finding some of our acquaintances. But luck was still against us, for we were unable to discover a single familiar face. Finally we located the club secretary, Moscowitz, in the library, and to him confided our adventures and troubles. Our tale of woe promptly brought forth a golden Louis (twenty franc-piece) which gave us joy and consolation. After a splendid repast and a café noir on the terrace of the Dôme, we both felt once more in tune with the gaiety around us and that all was well with the world in France.

·6·

1909-1910

THE NEXT DAY, a Thursday, was the thirteenth of July, and that night the public balls in the streets began. Every café terrace was crowded. Dancing couples disported themselves on the sidewalks and especially at the crossroads where the orchestras were established. Traffic was blocked and in some quarters suspended. "Paris *s'amuse*" in those happy days had a meaning that has been lost since the war and its aftermath of noisy, febrile pleasure-hunting. The era of jazz and cocktails seems to have, at least temporarily, killed the harmless gaity of Parisian crowds, especially on public fête days. Strangers would accost one another without formality, and a request to dance with an unknown fair one was seldom refused. Nowhere did I see a vestige of rowdyism nor drunkenness in the throngs at the cafés or among those dancing in the streets. The only cases of intoxication I remarked, to my regret, were among my compatriots and some of their English cousins.

Friday, the glorious *Quatorze Juillet*, there was naturally no abatement of the jollifications, nor was there time on Saturday for resuming work. And Sunday, of course, was Sunday, the good old French Sunday of prewar days. As for the following Monday, three successive days of celebrating made it a day of more or less enforced rest for many, a fact that was taken into account by Parisian employers, who were then less obsessed with the "time-is-money" spirit than is now the case.

Kleminger, who had left town to avoid the excitement and noise of the Fourteenth of July celebrations with which he was sufficiently familiar, returned after the weekend and was surprised to see us back from Italy, not expecting our return so soon. The recital of our misadventures on the train caused him much amusement. This reminded us that we had only a few days left before having to acquit our debt towards the railway authorities. Fortunately, both Halpert and I received our expected remittances in time. When we went to the Gare de Lyon to settle our account, we were once more lectured on our misconduct before we were allowed to depart.

We also called on the Englishman who had befriended us in our need and were given a hospitable welcome, including an invitation to dinner and the promise that on his return to Paris he would come to see the sketches we had done in Italy.

Kleminger, too, was anxious to see our work. Unfortunately, we found that several of our pictures, despite the precautions we had taken, had stuck together. This was no great loss in my case, as my work was

still crude compared with the excellent productions of Halpert. Yet I felt that what I had gained through the first-hand knowledge of great masterpieces would be a lasting asset. Incomplete as my Italian sketches were, there was a brilliance of coloring in them, compared with my previous work, which proved to me that a new world of light and color had been opened to me in Italy. It seemed as if I had been working in darkness. American painting, with its academic palette of earth colors only, now appeared to me to belong to a land of gloom and darkness.

There was now no doubt in my mind that Post-Impressionism, for all its glaring faults and deformities, had brought joy and color into a field of painting that had been degenerating into the cold, pompous, and photographic.

But there was, as in the case of every innovation, "the other side of the medal" to be considered. Every revolt against the "academic standards," conscious or unconscious, is exploited by a crowd of weaklings, insincere bluffers, looking for a shortcut to notoriety and commercial success. The unconscious eccentricities of the few geniuses were promptly noted, adopted, and systematized by these hangers-on.

The tremendous sincerity of Cézanne, which in many cases overcomes his deficiencies of technique, found countless imitators who only copied the defects, without ever being able to acquire the virtues and the simplicity which Cézanne aimed at. There was in his case another factor to be considered. Cézanne was not endowed with normal vision. He suffered from a form of astigmatism that made him see standing objects as if tipped towards him.* What in his case was a form of originality arising from a defect—as is so often the case with "originality"—was converted into a "manner" by his imitators, with the result that a school of still-life painters arose whose canvases presented nothing but rolling and reeling objects.

There was an attempt on the part of many to reduce the art of painting to its simplest, I might say, most rudimentary forms of expression. Even the most skillfully executed works of this "school" presented such a flat appearance that they resembled posters rather than paintings. Strange and meaningless arabesques were fitted into frames and exhibited at various galleries. Every day saw the birth of a new "-ism" or theory of painting. To the incompetent or the fanatics (are these not often identical terms?), these new manners were signposts to rapid fame and fortune. Painting, which had once been so "difficult," was now by a special dispensation of the gods to become easy. Trees were simply a green blotch with a heavy blue outline. Abstract composition was preached, subject matter disdained. The School of Two-Apples-on-a-Plate was instituted. A "self-made" critic, in a book on modern painting,

*Warshawsky should not be condemned too harshly for his misunderstanding of the distortions of forms in Cézanne's art. J.-K. Huymans and Emile Bernard were also convinced that Cézanne had faulty eyesight. Erle Loran has shown, however, that Cézanne purposely distorted objects to accentuate their volumes or to add dynamic tensions to his designs. *Cézanne's Composition* (Berkeley: The University of California Press, 1946), p. 29.

solemnly announced that an apple painted by Cézanne had more significance and art value than a canvas by Raphael. Snobs raved before canvases, flected here and there with vague touches of color, and felt uplifted at the sight of crude monstrosities that a sign painter might well have refused to acknowledge as his work.

Anyone who ventured to inquire as to the significance and the meaning of these strange productions would meet with contemptuous shrugs and be given to understand that if these works did not speak for themselves, convey their own message, any verbal explanations would be wasted. Hans Andersen's tale of the two weavers seems to me the best answer to this form of insincerity and snobbism.

The vogue of Matisse was already firmly established, but he, in turn, was having difficulty in maintaining his reputation for originality in view of the "daring" and insane works everywhere on view. At a prewar Autumn Salon he exhibited a large portrait, which was merely an oval with a neck and hair lightly sketched in. Features were conspicuous by their absence. Commenting on this strange work, a critic affirmed that the portrait by M. Matisse was so complete in design and harmony of color that to add features would have been "de trop" and would have only marred a perfect ensemble.

On another occasion Matisse showed a huge canvas with over–life-size figures crudely drawn and painted. The figures were in vivid red looming against a landscape of poison-green and a violently blue sky. Regarding this picture, an enthusiastic admirer of Matisse assured me with bated breath that the rhythm and composition of this work were so delicately balanced that the slightest deflection or modification of any of the figures or objects represented would have ruined that masterpiece. My impression, on the contrary, was that any of the figures or objects could have been moved for several feet without in the slightest way changing the general effect of pure idiocy.

The truth is that the cult of bunk and humbug had taken on such dimensions, and the "initiated" had grown so aggressive, that the average artist and art student was cowed into silence. Some were even finally convinced against their better judgment that there was no arguing against the new verities. To this must be added the fact that art critics on newspapers were so badly paid that the galleries where the new art was exhibited had little difficulty in bribing them to play up their wares and proclaim the genius of their exhibitors.

For the first time in history, art was being exploited according to the precepts of "pure business," with newspaper and stunt publicity in the most approved modern fashion. People unable to distinguish a chromo from an original oil painting were glibly talking of Post-Impressionism, Fauvism, Cubism. Since the great boom of the once-despised early Impressionists, dealers had begun persuading prospective buyers that to invest in "misunderstood" painters was the soundest form of speculation from which they were certain in a very short while to reap huge profits.

As the commercialization of art was placed more and more on a "pure business" basis, the jargon of the sellers and buyers, brokers, middlemen,

agents, and what not, developed into the "sales talk" employed in dealing with stocks and bonds; for this is what painting was beginning to mean to many people not otherwise interested in "Art." This was especially the case in the postwar period when the French franc took its precipitous tumble. Many people with some money and no reliable commercial investments in view took to buying pictures as a means for realizing profits.

Often a client would place an order with his picture dealer as he would with a stockbroker. One of these investors when asked by a friend about the latest work of a certain artist, whose pictures he had been buying through his dealer, replied that when he bought Suez Canal stock he did not have to see the Suez Canal.

In order to launch a new painter, a group of three or four dealers who were handling his work would often resort to fictitious sales. At a public sale—generally at the Hôtel des Ventes where the most important picture sales took place—the work of the painter would be put up for auction. Then the dealers, through their proxies, would bid up the pictures among themselves to a very high figure. The 8 percent government tax on auction sales was shared among the dealers, and the pictures purchased in this way went down on record as having fetched the often huge prices that had been bid for them. In this way not only were the works of the artist in question rated at extravagant values but future buyers would be assured that even at public sales these pictures would find a good market.

A flagrant example of this fictitious pricing came to light a short while ago. A picture by the Douanier Rousseau, *The Sleeping Bohemian*, had been sold at auction for half a million francs. The truth about this fake sale came out when Rousseau's heirs sued the owners. By French law the heirs of a painter are entitled to 2 percent on every sale of his works. No matter how many times a painting is sold, the heirs can claim their 2 percent. In this case it was proved in court that no bona fide sale had ever taken place and that the auction had been faked to boost the market value of the Douanier's work. The huge price paid for *The Sleeping Bohemian* would serve to send up the price not merely of all the Douanier Rousseaus in the dealers' possession but even of works merely attributed to the master, and which were often of dubious authenticity.

THIS WAS the period when every denizen of Montparnasse appeared laden with canvases and paintboxes. The production of pictures seemed the only important industry of this part of Paris. Painters and their easels were dotted all over the Luxembourg Gardens; as for the banks of the Seine, especially in the vicinity of the famous Pont Neuf (the "New Bridge," which is the oldest in Paris) a newcomer would have found difficulty in discovering a place to set his easel. There was an affluence of visitors at the art galleries on the boulevards and near the Madeleine, and a steady crowd to be seen outside of all shop windows where paintings were on view.

These street groups often contained the shrewdest of critics who were undeterred by the prevailing fashion of the moment in formulating sane judgments. Sometimes I have been surprised by overhearing really intelligent discussions among groups of day laborers regarding the various styles of painting exhibited in the windows—a proof that the Parisian, of whatever station, accepts art as one of the natural and essential activities of life, and not as a luxury for the wealthy and leisured classes, which is the conception of the average American citizen.

At the Louvre, Luxembourg, and other galleries, both public and private, I found all classes represented among the regular frequenters, including those too poor to possess even the humblest work of art. In France, and especially in Paris, the idea of the nude is not associated with morals and ethics. Public parks and gardens are peopled with graceful nude sculptures, and children habituated to seeing the human form thus represented in its natural state accept it as a normal thing and, if they have a sense for art, as one of the forms of beauty—not something about which to blush and whisper. A storm like that raised in Boston some years ago regarding MacMonnies's *Bacchante*—that piquant and wholly decent work of art, now to be seen in the Luxembourg Gardens—would be neither understood nor tolerated in any continental country.* It is only through the senseless addition of draperies, vine-leaves—by drawing attention to the veiled parts of the anatomy—that the nude becomes vulgar and indecent. When Pierre Louÿs in *Le Roi Pausole* visualized a society where all beautiful, well-formed people go unclad and only the old and ugly wear clothing, he was stating in humorous terms profound moral, as well as aesthetic, truths.

Toward the end of July, 1909, with the weather warm and muggy, I worked a good deal out of doors, along the riverbanks and in the parks and gardens. My Italian experience in out-of-door sketching had given me confidence, and I was no longer made nervous by inquisitive passersby stopping to examine my work. Yet wherever one went to sketch, there would be so many doing likewise that it was difficult to feel really at ease. I began to long for the peace and seclusion of the country. My last installment of money was not a large one, and I wanted to make it last as long as possible. That was an added argument for going to the country where living was cheaper than in Paris. As Halpert was also anxious to do some larger and more serious sketches than those he had brought back from Italy, we began scouting round to find a suitable spot in which to work.

*Frederick William MacMonnies (1863–1937) modeled the figure of a dancing *Bacchante* in 1893. He made a gift of the statue to the architect Charles F. McKim who placed it in the courtyard of the Boston Public Library, a building designed by his firm. The sculpture immediately aroused the indignation of Boston's bluenoses. Harvard's Charles Eliot Norton headed a list of petitioners demanding the removal of this "image of wanton, blatant nudity and drunkenness." Eventually, the library's trustees told McKim to remove the sculpture. The architect then gave it to the Metropolitan Museum of Art. In 1896 MacMonnies's *Bacchante* became the first work by an American to be purchased by the Luxembourg Museum in Paris. That same year the

VERNON on the Seine and Giverny, a well-known artist colony, both on the confines of Normandy, were within a comparatively short distance from Paris. So early one morning, with the lightest of baggage, we took the train for St. Germain-en-Laye, from where we intended walking the thirty-odd miles to Giverny. Keeping as much as possible to secluded country roads and river paths, picnicking by the wayside, we walked all afternoon with occasional rests until late that evening. The countryside was so beautiful that we hardly felt the fatigue of our long tramp. After a good dinner, we tumbled dog-tired into our cool beds at the inn where we spent the first night.

Soon after dawn we were again on our way, passing through quaint, delightful old villages and along picturesque roads, which in those prewar days were still unspoiled by motor traffic; for the few automobiles we met from time to time could hardly be said to interfere with the pleasures of what the French call "the footing."

It was toward dusk when we came in sight of Vernon. Its old bridge, quaint buildings, and tree-covered island quickly convinced us that this was an ideal spot for a painter. Giverny was opposite and we decided to visit it next day.

Before entering Vernon, we had taken a deliciously cool swim in the Seine and shaken the dust off our clothing. Halpert's experience of country hotels had taught him that the most practical arrangement is to go to the best "auberge" in the town, where prices are no higher and accommodation and food are better than at the more inferior inns, to say nothing of the greater cleanliness.

Close to the river, on the main road leading from Paris to Rouen, was a charming hostelry, the Hôtel du Soleil d'Or. One side was taken up by a picturesque cobbled courtyard, dating from the days of post chaise and traveling coach; on the other side, facing a shady alley, was a sunny terrace with tables set out for dinner. It was altogether the ideal inn dreamed of by the hungry wayfarer, and, needless to say, we "fell for it."

But my enthusiasm was tempered by apprehension as to the cost at this inviting hostelry. I noted that the price for dinner on the menu was two and a half francs (fifty cents), including wine and coffee, and I concluded that three meals a day and lodging would prove too great a strain for our slender purses. But Halpert assured me that pension rates per month would be much cheaper.

After the succulent and varied repast, we proceeded to interview the *patron* regarding a night's lodging, to begin with, and then inquire as to rates for a prolonged stay.

To my agreeable surprise, the *patron*, who was also the chef, spoke a little English, having once been employed by a prominent London club. In the customary French manner, we were referred to his wife, a frail, blonde young woman established at the case desk, to arrange

sculptor was awarded the Order of the Chevalier of the Legion of Honor by the French government. Wayne Craven, *Sculpture in America* (New York: Crowell, 1968), pp. 423–24.

about prices. We explained that we were artists and that we hoped to spend at least two months at Vernon if satisfactory terms could be made. I was delighted and astonished to hear that for a hundred francs a month (then twenty dollars), we should be provided with lodging and full board, the meals to be of the same prodigality and excellence as the one we had enjoyed that evening, and to include a choice of wine, beer, or cider. Accepting these terms, we promised to return with our luggage and painting material in a few days. Madame Espagnon, the *patronne*, graciously informed us that our dinner and room for that night would be referred to our pension bill and that we need not trouble to pay until we returned. Such proof of confidence served as the climax to our contentment.

Next morning, having bidden a temporary farewell to our hospitable hosts, we crossed the river to Giverny, three kilometers distant—a delightful little village, but somewhat wedged in between the hills and the creeklike river, Epte. The few hotels there were more expensive, and exclusively given over to an Anglo-American clientele of artists and writers, who had been coming there in increasing numbers, some as permanent residents, ever since Claude Monet, the celebrated Impressionist, had elected Giverny as his residence.

Monet himself, who was a good deal of a hermit and kept aloof from this foreign colony, employed a troupe of skilled gardeners who were constantly at work planting and transforming the beautiful grounds of his residence, so that every month he could enjoy new beauties and harmonies of color. Opposite these grounds, just across the railroad track, was Monet's Japanese garden. A tiny bridge, painted a Veronese green, spanned the famous pond of lilies, which he so often painted. I saw him only once—a tall, white-haired, majestic presence—and greeted him with a most respectful: *"Bon jour, Maître!"*

Charming and picturesque as Giverny was, we did not hesitate in our preference for Vernon. Compared with the former, which appeared a little cramped and over-cultivated, Vernon had a spacious and unspoiled air, with its wide river, lovely old moss-covered bridge on graceful arches, distant hills with which chalk cliffs showing through at happy intervals, its quaint streets with remnants of Norman and Gothic architecture, its fine old fourteenth-century cathedral, and its lovely paintable gardens.

At Giverny the majority of the American artists worked from the model, and I dare say they found the enclosed gardens and tiny river more conducive for figure work outdoors. Richard Miller had a summer class there, and Frederick Frieseke was painting some of his most delightful little nudes in his garden, through which the little Epte stream flowed. Sometimes he would do his figures standing in the shallows, or again it would be a gaily dressed girl in a boat, sheltered from the sun under a Japanese umbrella.

Among the other well-known American artists then at Giverny were Lawton Parker, Karl Buehr, and Karl Anderson, who did some of their best work there; A. B. Frost, noted illustrator and delineator of

Negroes, had a summer home there with his two sons (both active in the artistic and social life of the little colony); Anton Otto Fischer, illustrator of marine stories, who was helping to arrange the Frost residence; and Theodore Butler, son-in-law of Claude Monet, with his Anglo-American family.

The Hotel Baudet and the Villa Rose were favorite haunts of the American residents at Giverny. The little café at Baudet's was lined with painted wooden panels, each a contribution by one of the artists who had lived there. Many of these panels were signed by well-known names. Among those I noted a very clever little sketch of a masked party signed by Robert W. Chambers, the novelist.

We ate that noon in the garden at Baudet's, where Halpert introduced me to Karl Anderson and his wife, who were also lunching there. Bees were humming all about us in the fragrant garden, and one of them managed to get into my glass of cider, with dire effects to my lip, which was badly stung, spoiling my lunch and temper. The sufferings I endured then and for several days afterwards from my injured lip, which swelled up to huge proportions, provided an added reason for not prolonging our stay at Giverny.

The dining room at the Hotel Baudet was decorated with a number of beautiful canvases by Theodore Robinson, one of the best and most sensitive of American landscape painters. Robinson, who had lived for some time at the hotel, was so poor that he could not afford to pay his bill; so the proprietor had reluctantly taken paintings in exchange for his board. Some years after Robinson's death, when his pictures were in great demand and fetched very high prices, an arrangement was made between his heirs and the hotel owners, whereby the former were entitled to some share in the profits of the hotel business. Poor Robinson died in complete poverty, without even the prospect that he would later be acclaimed a great artist.

We walked back to Vernon and took a late afternoon train to Paris. A long two days' walking trip was covered by the train in an hour and a half.

FINDING PARIS hot and stifling after our delightful trip in the country, we hurried our preparations for departure. The first thing was to lay in a supply of painting material for our summer's work at Vernon. So early next morning we betook ourselves to Castelucho's.

Castelucho Diana and his lovely young Spanish wife had opened an art supply shop in the Rue de la Grande Chaumière in the Montparnasse Quarter. Castelucho had started out as a painter, but making little headway, he had invested what money he had in painter's materials, and with the very efficient aid of his wife, had opened a shop, which from the outset did a thriving business. His brother, a clever artist and a veritable virtuoso with the brush, soon after rented a portion of the building adjoining the shop, and with the financial assistance of Castelucho, started the Academy of La Grande Chaumière, which in a short while competed successfully with Colarossi's long-established academy in the same street. One of the inducements for going to Castelucho's was

that, besides paying cheaper prices there than elsewhere, an extra 10 percent reduction for cash payments was allowed.

Having equipped ourselves, we started again that afternoon from the Gare St. Lazare direct for Vernon. Arrived at the little station, we found a huge omnibus drawn by two fat Norman horses, bearing in large gilt letters the name HÔTEL SOLEIL D'OR. But for our arrival it would have returned empty. As it was, we made a stately, if somewhat leisurely, progress through the little township, for despite important whip-cracking on the part of our driver, there was no means of starting his well-fed team out of their ambling gait. At the "Golden Sun Hotel" M. and Mme. Espagnon greeted us as if we were millionaire guests.

A lofty and spacious room was allotted to me. It contained the traditional high Norman bedstead, as comfortable as it is decorative. From my window there was a lovely view over old-world gardens, ancient towers, and the Seine River. This on rainy days proved a valuable asset, for it afforded me a variety of motifs which could be painted from my window. But there was little call for indoor painting that summer of 1909, which, climatically speaking, was as near perfection as one could wish, and far better than one who knows the reputation of the Norman weather dares to hope for. Rouen, the wettest city in France after Brest, in Brittany, is only a short distance from Vernon. But the very dampness of this region gives a gray, luscious quality to the atmosphere and coloring which is missing in the gayer and sunnier climes of southern France, where contours are hard and definite and the coloring more commonplace.

We found only two other *pensionnaires* at the hotel, a young clerk employed at the local bank, and the inevitable army officer, in this case, a *major*, or military doctor. The hotel, located on the *route nationale* from Paris, drew most of its custom from tourists, on foot or on wheels. There were two other hotels in Vernon, the Hôtel d'Evreux across the way, which catered to commercial travelers, and the Hôtel des Sports, facing the Seine, near the old bridge. The latter was at that time in somewhat bad repute, owing to the rough crowd that made it a rendezvous, and the ever-familiar manners of the waitresses. Of late years, I am glad to say, the little hotel, which overlooks one of the liveliest parts of the Seine, has fallen into better hands, and its delightful terrace is now a favorite meeting place.

Owing to the vicinity of important military barracks, situated on the outskirts of the town, red-trousered youths added their note of bright color to the gray streets. And of course there were the fishermen! The Seine would not be the Seine if at all seasons, in all weathers, and all possible spots, whether in town or country, the votaries of the rod were not in evidence.

Though I had sketched a good deal in Italy, the main object of my trip there had been to see and study the works of the great masters. The overpowering impression of seeing myself surrounded by supreme works of art had a stultifying effect on my own modest efforts and to a great extent prevented me from expressing my personality freely.

At Vernon I felt, for the first time, conscious only of the influence of

Nature. I tried to forget all the pictures I had seen and the various techniques and methods of the masters I had admired. My sole aim and object now was to look on Nature and to endeavor to interpret her moods in a simple and direct fashion. Every morning, afternoon, and evening found Halpert and me on the riverbanks or in the surrounding hills, sketching away, busily and enthusiastically.

Objects that looked quite commonplace during the daylight hours would suddenly become gloriously transfigured by the slanting sunlight. Foliage would turn to a green gold and the walls of hovels take on tinges of rose and orange with shadows of violet. The old bridge, with its moss-covered copings and the water swirling rapidly about its base, was a continuous source of delight. Trees with a bit of blue sky reflected in the water composed themselves into lovely pictures, merely waiting to be transferred to the canvas.

I was beginning to realize that to paint an interesting picture it was not necessary to choose an impressive or complicated landscape. The elements of vision and personality in the treatment being the most important factors, one's choice could be limited to very simple subjects. In many cases it was more desirable to suggest than to realize faithfully. Monet's haystacks represented the simplest of motifs; yet bathed in the beautiful and atmospheric colors of different hours and seasons, as seen by his own peculiar and sensitive nature, they resulted in a series of masterpieces. Panoramic painting of sites of rare and even awe-inspiring beauty often leave the spectator cold, due to the fact that they are generally only visualized in an accurate and impersonal manner; whereas a few slender trees and a glimpse of a silver-shadowed pool by Corot give us a complete feeling of beauty and "the poetry of nature."

It is told of Whistler that while sketching some old barges and shacks by the Thames, he was critized by a writer, who remarked these objects were not actually as beautiful as they appeared on Whistler's canvas and that he, the observing critic, could not detect the lovely colors with which they were being endowed by the artist. Whistler's reply was: "Don't you wish that you could!"

How to express on a canvas the mood inspired by a certain subject is one of the problems that can never be resolved into words. Another problem is how to convey to the person who views the picture the mood in which the artist has painted his subject. The dominant factor may be movement, or it may be color. For some reason, the picture, though beautifully executed, remains flat—lacks vitality and life. A touch of light, an accent in a shadow, a bit of red or cold green, and immediately the canvas breaks into life. For the fact is that a good picture is composed and constructed with most complicated mechanisms, which must be carefully hidden, so that the completed work looks as if it were a spontaneous creation, giving no evidence of being labored over. To no art is the old adage of *"ars celare artem"* more applicable than to the painter's.

DURING THE HOT WEATHER, after our afternoon's séance of sketching, Halpert and I would repair to some sheltered spot on the

riverbank, put on our bathing trunks, and go for a swim. Halpert, who was timid in the water, would keep close to the bank; but I, being a robust and experienced swimmer, would venture out into the current, which at times was very swift and strong. On one occasion it got the better of me, and struggle as I would, carried me down the river. I soon found myself close to the old bridge, a good kilometer away from the spot where I had left my clothes. Fortunately, a lull in the current gave me the chance for getting to shore. Though out of danger, I was still in an awkward fix. It was impossible to swim back against the current, so there was nothing for it but to wade back the entire distance in the dirty, shallow water near the bank, feeling ridiculous in my narrow, striped trunks, under the amused glances of the villagers. I met my nervous and anxious friend, already dressed, and on his way to look for me, fearing the worst. Fortunately, he was carrying my clothes, so I was soon out of my troubles and none the worse for my adventure.

It is still a mystery to me how we managed to survive the gargantuan regime to which we subjected our stomachs during those months at the Soleil d'Or. Possibly it was the prospect of lean days to come which stimulated our appetites. Our usual lunch consisted of a variety of hors d'oeuvres, fish or omelette, a meat course with vegetables, poultry or game, followed by cheese and fruit, and a bottle of wine, cider, or beer. The evening meal would include as many courses, with the addition of soup. The cooking was delicious, and stuff ourselves as we would, neither of us ever suffered from indigestion or dyspepsia. M. Espagnon, who was a veritable artist, as well as a cordon bleu, would solicitiously inquire whether we were enjoying our meal. Although those were the heydays before the war when living in the French countryside was cheap, it is still doubtful to my mind that our excellent host could have materially profitted from his two *pensionnaires*.

Henri, the coachman, was also the man of all work, dishwasher, and general factotum. In his youth he had served in the French army and "done his bit" in Morocco. The thirst which he had developed under those sunny skies had lasted him for the rest of his life. All the wine that remained in the bottles after each meal would vanish down his inexhaustible gullet, with the result that he was ever, as the French say, "between two wines," although I have never seen him intoxicated. The kindly, somewhat vacant smile with which he moved through his own woozy world was the only sign of his bacchic temperament.

The Espagnon ménage had two children, Robert and Simone, the latter a bewitching little blonde elf. One rainy day I painted some flowers and inscribed the little picture to her, much to the gratification of her father, who had it framed and hung in the dining room in a place of honor. Another day a gentleman, who had arrived in his car for lunch, admired the picture and offered to buy it. But under no conditions would the "patron" consent to sell what had been offered as a gift. Needless to say, this little incident enhanced my artistic value in the eyes of M. Espagnon, who that night after dinner begged us to share a bottle of champagne with him to show his appreciation of my talents.

We also made acquaintance with some of our compatriots and col-

leagues at Giverny, who would occasionally come over to Vernon. Thus we met Arthur and Jack Frost, sons of A. B. Frost, the American illustrator, who were lunching at our hotel and invited us to visit them. And at Veruonet, across the bridge, I met Jack Casey, once a well-known newspaper artist in New York, whose hankering to become a painter had made him throw up a well-paid position on the *New York Journal.*

Casey had been sent by a friend to study art in France, but gradually the allowance from America was so reduced that he could hardly pay for board and lodging. He had been living for a long while in Giverny, and although by then thoroughly fed up with the place, was unable to leave until he had settled up his debts. I always think of Casey as one of the most temperamental Irishmen I have known, a strange mixture of extreme bohemianism and practicality. Adversity could never dampen his optimism, and he would spend his last cent with as much assurance as if he had a million in reserve.

Despite his apparent poverty and the fact that strong drink would often get the better of him, Casey never lost control of himself. After a drinking bout, which would sometimes extend over several days and nights, he would emerge serenely smiling, well-groomed and faultlessly attired. Unlike most Bohemians, he kept faith with his creditors, and whenever in funds, scrupulously paid back his borrowings.

During his short sojourn in Paris, Casey had acquired a French wife—Berthe, a tall, buxom, beautiful, brown-eyed Parisienne, and the mildest-tempered Frenchwoman I ever met. Her devotion to John Joseph Aloysius Casey was complete and boundless. His every whim was law to her, and her gentle humoring and tactful maneuvering with her often trying lord and master were worthy of all admiration. However obstreperous he might be after one of his drinking bouts, Berthe could always manage him, coax and soothe him, take his clothes off and put him to bed like a naughty little boy.

But Berthe was more than merely a motherly wife to Jack Casey. She would also act as his saleswoman, going into Paris to peddle his comic sketches, for he was a very clever pen-and-ink artist.

After various Casey drawings, thanks to Mme. Berthe's efforts, had been published in Parisian periodicals, a certain demand for his work arose and he was able to earn enough to leave Giverny and move over to Vernon, where he and his wife settled down at the Hôtel Soleil d'Or. Our table was enlivened by Jack's gaiety and endless fund of stories. But the loser by this new state of things was poor Henri, the coachman, who would now search in vain for anything left over in our wine bottles. With Casey about, there was no danger of any unclaimed liquor.

Unfortunately, improved finances did not solve the difficulties of the Casey ménage, for Jack's extra earnings would be invested in the flowing bowl, and it was not long before he found himself in the same position at Vernon as he had been at Giverny.

That summer my knowledge of boxing again proved a useful asset. While on a visit at Giverny, I saw some American boys sparring with

the large, ten-ounce boxing gloves, all of them obviously beginners. It had been a long time since I had boxed and I was itching for a bout. So when Rudy de Wardener, a tall, rangy chap, asked whether I would care to try them out, I accepted eagerly. Though very much out of practice, my superior science proved too much for my adversary, which he readily acknowledged, and in a short while I found myself popular and besieged with requests to show the young boxing enthusiasts "how it was done."

The keenest of the lot was Arthur Frost. Later I found out he was harboring a secret grudge against a member of his family, who never failed to give him a drubbing every time they boxed together. His dream was to learn enough in secret so as to be able to turn the tables on his boxing relative. He would come to Vernon in the evening and we would spar together.

I soon found another pupil in M. Espagnon's assistant chef, a large, raw-boned Normandy boy. He and Arthur would match each other—and how they would pound away!—the young cook's sabots falling off his feet every other moment. As the gloves were soft as pillows, no harm ever resulted.

Arthur Frost would often stay overnight at Vernon, and we soon became fast friends. He had a large studio in Paris, in the Rue Delambre (Montparnasse), in which he worked only occasionally, spending his mornings at Matisse's life classes, where he functioned as *massier* ("monitor"), while he lived with his family in their apartment near the Invalides. Having heard that I would be looking out for a studio on my return to Paris, Arthur Frost suggested that I move into his studio and share it with him, in return for which I was to give him lessons in boxing. Nothing could have been more welcome. The arrangement suited me both financially and physically, so to speak, and was an ideal solution to the winter's problems.

Late in August I ran into Paris with the intention of making a short stay, as I wanted to visit some picture exhibitions and also replenish my painting material. I had hardly arrived when I met a painter from New York who imparted the sad news of the passing of my dear friend and master, Louis Loeb. It was an overwhelming shock to me. I had received a very nice note from him in Venice, without any intimation of ill health. He had spoken of his plan to visit France the following year, and I had been looking forward to seeing him; for to me he had been a wonderful and generous friend.

During his student days in Paris, Loeb had been known as "the Prince," and no man ever had a better claim to his nickname. When still a very young man he had attained success and was on the road to greater things. American art societies had offered him all the honors and prizes they could bestow, but despite these tributes, he remained modest and unspoiled. He was only forty-four when he passed away, leaving the world much richer by his generous, though all too brief, existence.

Although many of the important collections and museums in America possess works by Louis Loeb, Cleveland, his birthplace, was

for a long time without an example of his art. But recently, thanks to the insistence of his friends and admirers, the Art Museum has acquired a very beautiful Loeb portrait.

I was so afflicted by the sad news that I cut short my visit to Paris and returned the same evening to the cool peace of Vernon and the shady banks of the Seine.

SEPTEMBER and October were, contrary to the general weather rule of the region, dry and sunny. Autumn tints were creeping imperceptibly into the landscape. Unlike the flaming, brilliant hues of our autumn foliage in America, the coloring here was discreet in its transition from summer to fall—delicate tints of violet, burnt orange, rose, and pale yellow, like an old and well-worn Paisley shawl.

Halpert, who was a *sociétaire* of the Autumn Salon and was going to Paris to send in his quota of pictures to the exhibition, suggested submitting some of my work to the jury. He offered to make a selection from my Italian sketches, which I had left in his studio, have them framed at Castelucho's, and send them in for me.

The Salon d'Automne was then (in 1909) already firmly established with public and artists as one of the three great Salons. Like the Salon des Beaux Arts, which had been a revolt against the stale formalities and academic clichés of the long-established senior Salon, that of the "Artistes Francais," dating from the eighteenth century, with its pernicious system of awarding prizes and all the lobbying and wirepulling that attends official rewards, the Autumn Salon represented a movement toward freedom and independence.

In the case of the official "Artistes Francais," the breakaway had been made by the "new" men—artists like Besnard, Puvis de Chavannes, Rodin, and Bourdelle, whose works, when admitted to the sacred show, were relegated by pompous old fogies to the places where they would be seen to least advantage. Raising the standard of revolt, these artists carried the enthusiastic young generation with them and founded the Beaux Arts Salon, which quickly became and still is the official competitor of the Artistes Francais, the two exhibitions forming together what is now the Spring Salon.

When the new radical movement, initiated by artists like Cézanne, Van Gogh, and Matisse, was proving a new power and attraction to the next "new" generation, it was found that even the Beaux Arts was too tame and cautious, too restrictive of the impetuosity of the youthful ardor which was for brushing aside all conventions in art. There must be a new Salon, and there was.

To the founders and guiding spirits of the Third Salon, which elected the autumn for its exhibiting season, the mere science of color, drawing, and composition meant little or nothing, as long as an Idea was expressed.

One of the rules and privileges of the new Salon was that all artists who had participated in the opening exhibition would henceforth be entitled to exhibit annually a certain number of works, which would not have to be submitted first to the jury.

When I first sent in, in 1909, the Salon d'Automne was already regarded as an artistic event of equal importance with the Spring Salon.

The number of pictures which could then be submitted to the Autumn Salon was not, as now, limited to four, and the jury was a lenient one and independent-minded. Not yet had the new Salon divided itself into clans and cliques like its two predecessors.

Halpert made a selection of seven among my smaller canvases. These, he thought, had a chance of being accepted by the jury. To my agreeable surprise I was notified some weeks later that five of my pictures had been accepted. But several weeks more had to elapse before the exhibition opened, for thousands of pictures and tons of sculpture would have to find places on walls and pedestals. I was naturally consumed with impatience and curiosity regarding this great event, when I should be able to see the latest achievements in modern art and compare my maiden attempts with the more mature works of my colleagues.

Leon Kroll and Olinski joined our little group at Vernon for the fall months. After long hours of enthusiastic work outdoors, we would wind up the day by a festive gathering at the dinner hour, often prolonging our symposiums until the stifled yawns and restiveness of the hotel personnel reminded us that it was time to go elsewhere. The "elsewhere" was generally the Café des Trois Marchands, near the little public square, where we repaired for after-dinner coffee, a habit I had adopted as part of the curriculum of French life. The café also owned an old billiard table, which gave us the occasion for a little mild exercise after our copious repast.

It was soon evident that our custom was more to the taste of Madame la Patronne, a buxom and sprightly young person with snappy black and very roving eyes, than to that of her husband, a small, rotund fellow with a shaggy, untrimmed beard, who was considerably her senior and correspondingly jealous—not without reason, as we soon realized. Although Madame did not show marked preference for anyone of our group, the warmth of her comprehensive welcome was obviously an added cause for conjugal dispute. The angry glances he would shoot at us and the constant scolding of his young spouse finally made the atmosphere too uncomfortable, and we transferred our custom to a larger and more frequented café, where our presence was less remarked.

We found ourselves in Paris early on the morning of the vernissage ("varnishing day") at the Autumn Salon. Workmen were still busy putting the last touches to the exhibition, and groups of artists were wandering from room to room, locating their exhibits. On all sides could be heard complaints and grumblings from those who were dissatisfied with the places allotted to their works, some of them even going so far as to take down their pictures and calmly rehang them in better positions, relegating other men's canvases to inferior places. Such proceedings were, of course, against the rules, but as there was little control by the Salon authorities, the nervy ones often got away with it.

After wandering and searching for over an hour through the great halls, I finally located my five *pochades* grouped together and looking like postage stamps on the vast expanse of wall.

Although many of the paintings exhibited at the Salon seemed to me inconceivably daring and crude after the disciplined splendor and power of the great masters I had seen in Italy, there were a number which impressed me by their skill and sincerity. Everywhere there was color. It was like being out-of-doors; and though I could not understand it all, the general effect was exhilarating and gay. Sunlight scintillated from the landscapes. There were shadows in certain pictures as luminous as the lightest parts of conventional paintings. I saw still lifes that were not merely accurate representations of objects, but masses and clusters of color, often arranged with decidedly decorative values. Pictures like these hung in a dark room would dispel gloom and lend a note of gaiety and optimism to the drabbest surroundings.

At moments this revolution in painting seemed a revolution in joy. But then would come walls lined with distorted monstrosities, colors that made one's teeth grit, and subjects repulsive beyond words. There were huge canvases upon which vague forms with hideous tints gibbered. One thing was certain about this exhibition: even the least interested spectator could not remain bored. It left one angry or enthusiastic, and, in either case, stimulated. Such terrific enthusiasm and originality marked the first shows of the Autumn Salon that it became impossible for the society to maintain the same level of intensity, and later this Salon, like its predecessors, degenerated, eventually housing demonstrations by charlatans of what is known as *blagues d'atelier* ("studio jokes").

WITH THE ENDING of October and the beginning of November, the weather grew rather chilly. Olinsky and Kroll left for the city, but Halpert and I intended staying on until the cold would drive us indoors. Following Halpert's example, I bought some wooden sabots, which I stuffed with straw. This and the thick wooden soles protected my feet from the cold and damp. But there were mornings so frosty that my fingers would almost freeze. A fingerless mitten through which I could grip with my fingers proved an adequate remedy.

The mist over the Seine on autumn mornings was like a dream of enchantment. The trees had lost most of their foliage. What remained of the leafage had taken on tints of old rose, russet, and gold, which against the dun and violet background of the hills made rare and subtle color harmonies. The river had become turbulent, and its waters were seldom calm enough to reflect the landscape. Belated autumn rains finally set in. With the aid of a large umbrella, I made several attempts to paint in some sheltered spots along the bank, but the dampness would penetrate me and gusts of rain wet my canvas and palette, so that I was forced to desist.

A letter from Arthur Frost confirmed my decision to return to Paris and share his studio. With many regrets for leaving our comfortable lodgings and well-provisioned table, we said goodbye to our charming hosts, and almost tearfully—I, at least—set out for Paris. The Casey

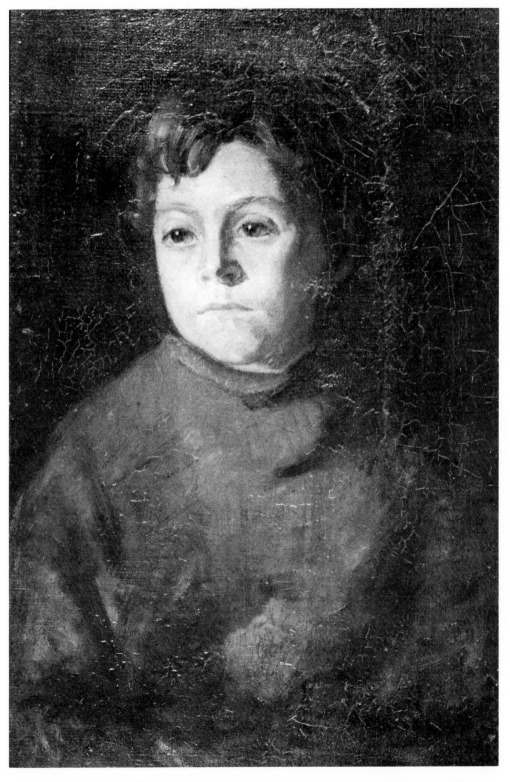

Plate I. Portrait of David Warshawsky, c.1904, oil on canvas (23½" x 15½").

Private collection, Cleveland, Ohio.

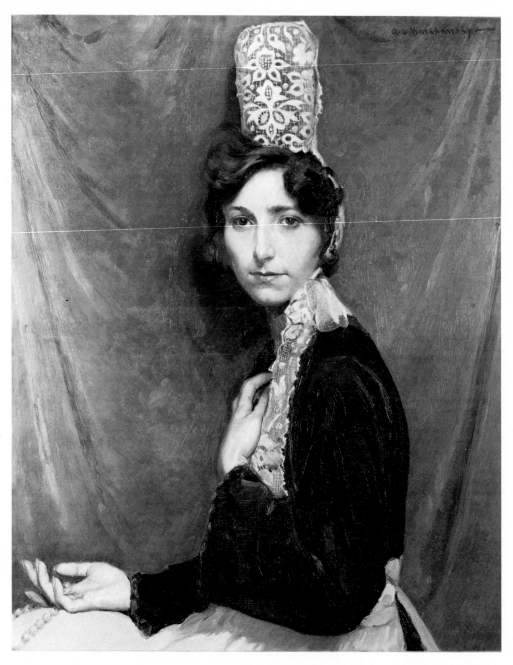

Plate II. Portrait of the Artist's Wife, 1934, oil on canvas (32" x 26").

The Cleveland Museum of Art. Gift of Louis Rorimer.

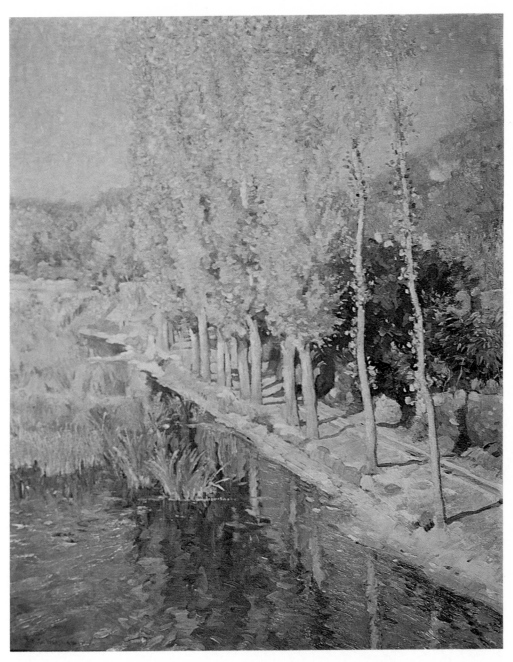

Plate III. Poplars near Vernon, Fall, n.d., oil on canvas (31¼" x 25").

Private collection, Cleveland, Ohio.

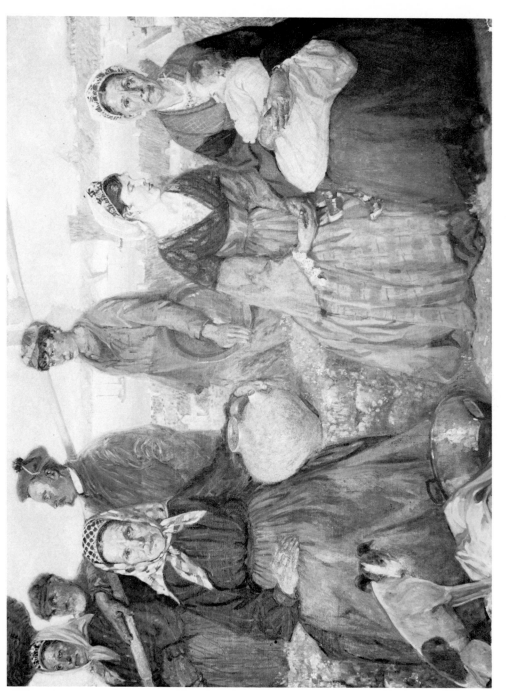

Plate IV. People of Brittany, 1913, oil on canvas, size and whereabouts unknown.

Plate V. Potato Planting in Brittany, c.1913, oil on canvas (31" x 37⅞").

Private collection, Cleveland, Ohio.

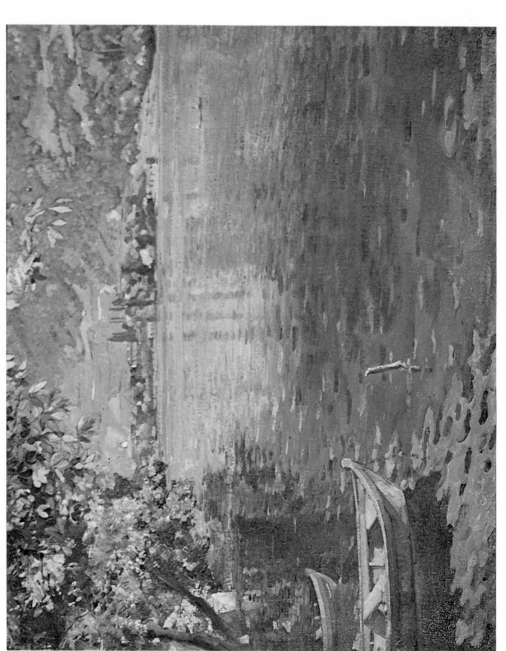

Plate VI. Lake Annecy, c.1923, oil on canvas (24⅞" x 31¼").

Private collection, Cleveland, Ohio.

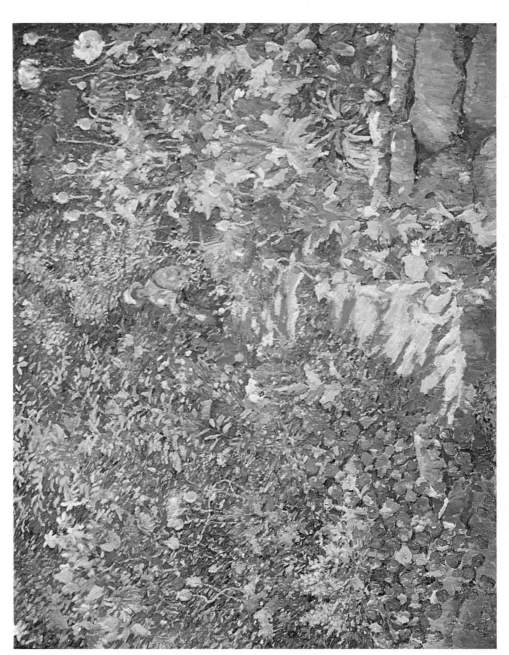

Plate VII. The Artist's Garden in Brittany, n.d., oil on canvas (31½" x 39¼").

Private collection, Cleveland, Ohio.

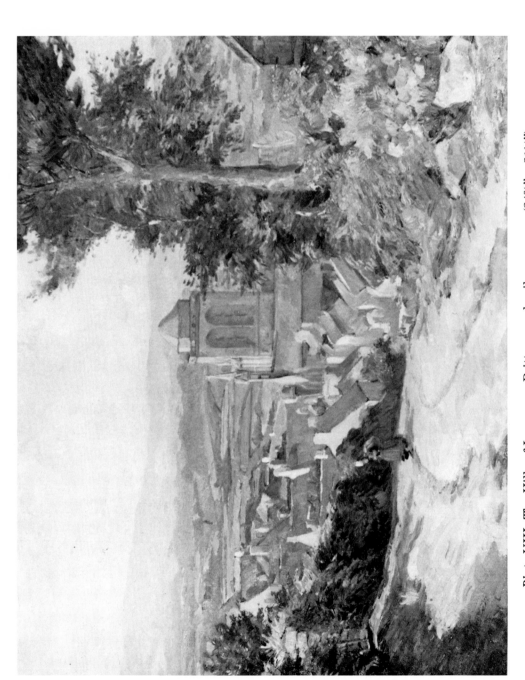

Plate VIII. The Hills of Locronan, Brittany, n.d., oil on canvas (24⅞" x 31¼").

Private collection, Cleveland, Ohio.

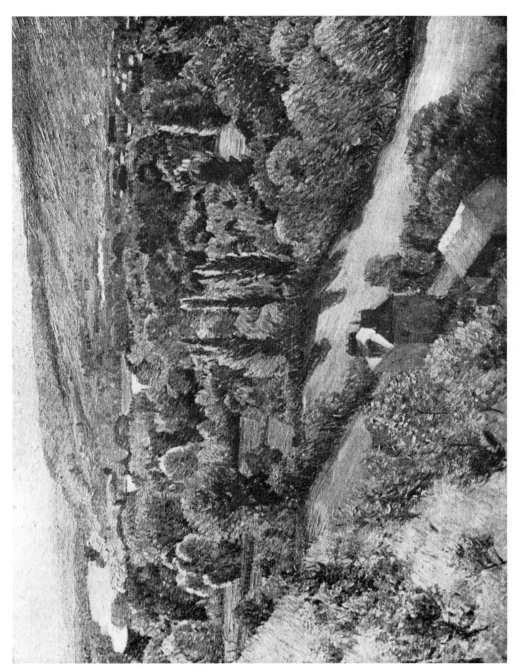

Plate IX. The Hills of Vernay, Autumn, c. 1912, oil on canvas, size and whereabouts unknown.

Plate X. Normandy Village along the Seine, 1923, oil on canvas (31⅜" x 38¾").

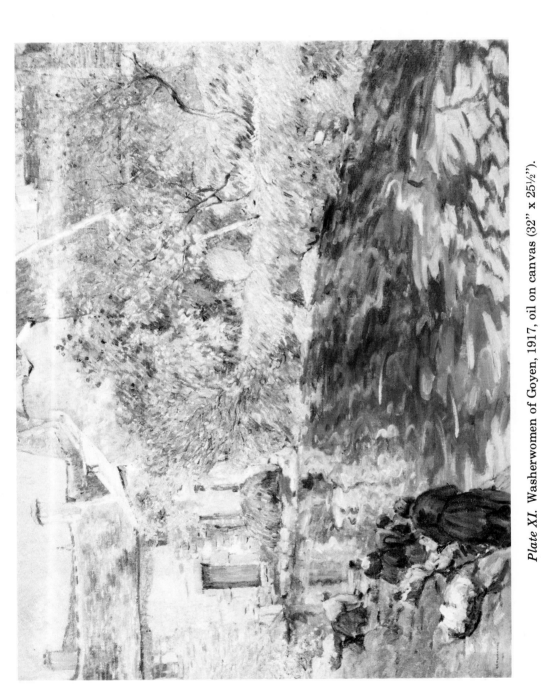

Plate XI. Washerwomen of Goyen, 1917, oil on canvas (32" x 25½").

The Cleveland Museum of Art. Gift of the Cleveland Art Association.

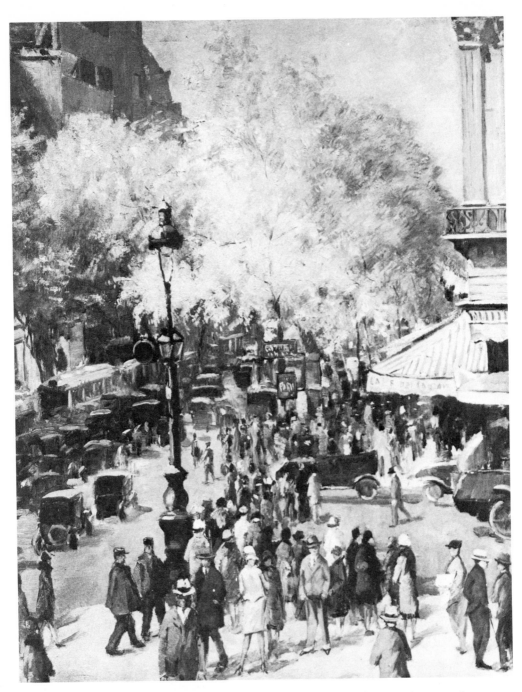

Plate XII. Place de l'Opéra, c.1924, oil on canvas, size and whereabouts unknown.

ménage, who were now in the same financial straits as they had been in at Giverny, remained at Vernon—a case of *force majeure*!

The studio on the Rue Delambre, where I was to have at least temporary lodging, was a large, high-ceilinged room on the ground floor, giving onto a small courtyard, which lay between the studio and a little hotel facing the street. The skylight, facing north, let in a dull light, which was further obscured by the hotel opposite. Near the center of the studio a long, steep staircase led up to a fair-sized and comfortable bedroom. A tiny room adjoining this held a small gas range and chest containing essential crockery and cooking utensils.

At the rear of the studio was an alcove for storing canvases, frames, and similar paraphernalia, the heating apparatus consisting of a large stove with immense pipes which stretched halfway round the studio. I was quickly installed and soon at home in my new surroundings.

The previous occupants of this studio had been Jo Davidson and Louis de Kerstrat. When Jo married de Kerstrat's sister, Yvonne, they had moved to less bohemian quarters.

Already the neighborhood, which is in the heart of the Montparnasse Quarter, had become a center for American artists and students, among whom I had made many acquaintances by this time. Our favorite haunt and general meeting-place was an unpretentious café at the corner of the Rue Delambre and the Boulevard du Montparnasse, which in recent years has acquired a worldwide reputation as the Café du Dôme.

The Dôme of those days had nothing to distinguish it from any of the myriad of café-bars to be found throughout Paris, or France for that matter. There was the usual zinc counter, across which drinks would be served direct to standing customers who could thus avoid the tip to the waiter, and a couple of rooms with small marble tables, somewhat dilapidated black leather sofas, and a "billiard." Nearby, close to the Montparnasse railway station, there were several more up-to-date cafés with music, such as the Brasserie Dumesnil and, notably, Lavenue's, where there were first-rate musicians. Yet despite its shabby air and lack of "attractions," the Dôme had for decades been the preferred haunt of artists of every denomination and country residing in the Montparnasse Quarter, which at that time was bounded by Lavenue's at the station end and the once famous but then neglected Closerie des Lilas facing the Bal Bullier on the east side; where that other thoroughfare of bohemia, the Boul' Miche (otherwise Boulevard St. Michel), after crossing the Latin Quarter joins the Boulevard du Montparnasse. The fact is that the Dôme made no efforts to please or attract customers. The *consommations* were neither better nor cheaper than those served by its rival establishments, and it played up no "atmosphere" to attract the stranger. Perhaps the only explanation of its power of attraction is that the Dôme had IT.

Even the American Art Club, which had recently moved to the Rue Bara by the Luxembourg Gardens, and therefore a close neighbor, could not cope with the lure which the Dôme had for the young American

artist, who preferred its shabby surroundings to the comfort and hospitality of the club. But thanks to the generosity of Rodman Wanamaker, this institution offered very solid inducements—comfortable quarters, a well-stocked library, a billiard room, and exhibition hall.* The premises were kept open until a late hour, and the lonely artist or student could go there free of cost and always be sure of a kindly welcome.

There are institutions which, like certain plants and vintages, do not bear transporting: of these are the French cafe and the Anglo-Saxon club. When the French talk of "clubs" and "clubmen," they have in mind something as different from what these terms convey to us, as our "bohemian cafe'" differs from the establishments which serve light refreshments in France. The French club, or *cercle*, to use the proper term, is an organization of an exclusive sort, catering to a special clientele and for a determined object, social or political. Very often it is a gambling society of rich and fashionable people. In no case is it merely a meeting place for kindred spirits, a relaxing ground or refuge, as it is in America or England.

The very fact of having to ring the bell to be admitted to the premises of the American Art Club, the enforced absence of the fair sex, and the more or less hushed voices of the club members, seemed, in the atmosphere of Paris, to have a dampening effect on the exuberant spirits of the American youth. Compared with the Dôme, where absolute and untrammeled liberty prevailed, the restrictions of club rules and club etiquette, and a certain cliquiness among the more prominent artists frequenting the club, were further deterrents in the eyes of the young men.

At the Dôme there existed not even an artistic Aristocracy. Students rubbed shoulders and hobnobbed on equal terms with celebrities, and a good storyteller or billiard player was of as much consequence in this little Dôme world as the man who had painted the picture of the year. The poor devil who played in a four-handed game of billiards at thirty centimes an hour, with a two-sou tip to the waiter, making his share in the game two cents, had his place there as well as the wealthy rancher's son from Texas, who could spend "*beaucoup francs*" every afternoon.

The two waiters at the Dôme, Andre and Eugene, were well versed in the ways and temperaments of artists, and if a chap did not voluntarily order a drink, would give him the polite and familiar welcome and leave him alone. A long leather bench behind the billiard table was often filled by impecunious or temporarily embarrassed artists, who would linger on throughout an afternoon or an entire evening, especially in cold weather, in the hope that a prosperous *confrère* would offer a drink or extend an invitation to join in a game of billiards. I can aver that among the senior members of the Dôme circle, the *anciens* of the Quarter, I very seldom saw any abuse of liquor. One glass of beer, a cup of coffee, or a whisky and soda was their limit. It was among the newcomers that one often

*Rodman Lewis Wanamaker (1863-1928), heir to the Philadelphia-based chain of department stores, studied art while managing the firm's Paris office from 1889 to 1899. He founded the American Art Association in 1899.

found tables piled up with saucers, every one of which represented a drink.

Meeting one's fellow craftsmen—talking shop, and exchanging ideas in general—was the main diversion at the Dôme. There was, however, a more serious-minded group, which foregathered there, sometimes of an afternoon, but certainly every evening, round a table especially reserved for it in the back room, raised by a few steps above the level of the billiard room where the more boisterous customers diverted themselves. Even the proximity of the kitchen and its pungent odors could not detract this coterie from its all-absorbing occupation—poker. They seldom broke silence except to stifle a sigh or mutter a curse, for on the issue of a game might depend a month's rent, and sometimes much more was at stake. So great was their passion for the game that on any day of the week and at any season of the year some portion of the poker club was in session. Only rarely would an outsider be admitted to their circle, and for years the group remained unchanged. The fact that there never arose any serious quarrel among the members and that their friendship remained intact despite gains and losses speaks much for the ethics and comradeship of the players.

Otto Ganzel, painter and sculptor, an *ancien* of the Quarter; Rene Billotti, an American sculptor of Italian origin, as his name suggests, and a handsome young devil; Cheever Dunning, the poet, tall, thin, ascetic, with a great resemblance to Robert Louis Stevenson; Alexander, an expert copyist of old masters, dark and swarthy with the features of an American Indian; Ashford, small and blond, familiarily nicknamed "demi-blond" (i.e., "a half measure of light beer"); a tenor called Buckley and nicknamed "Caruso"; and my friend Kleminger were usually to be seen in the poker corner, nervously awaiting the opening of the game. At intervals they would feverishly bite into a sandwich or sip a glass of beer.

To the older men the play was a great relaxation after concentrated work in the studio, but to many a youngster at the Dôme, living on a small allowance, which his family often stinted itself to send him so that he might have a chance to develop his talent, card-playing brought disaster. After a year or two in Paris, many a talented lad has returned to his home with no benefit from his stay abroad, and only an acquired habit of drinking, gambling, and loafing in cafés.

Paris and café life is no place for the weak. But for those who had the proper moral fiber, the Dôme was a great and valuable experience. It was a school of good fellowship and a leveller of values. Not only did it give the young men an opportunity of meeting on informal terms men who had "arrived" in their art, but it also showed the latter from their very human sides. To hear the "big fellows" talk as humbly and often as discouragingly about their own accomplishments as the merest tyro was in itself a valuable moral lesson to the beginner and a proof that there is no easy going for those who are in earnest about their art.

Friesecke, Miller, Max Bohm, and Robert MacCameron, then the leader of this little group, were always ready to help the young artists

109

with advice and criticism, going to visit them in their studios or their rooms.

My first acquaintance with Lionel Waldon, the well-known marine painter, was made early one spring on the terrace of the Dôme. Considerably over six feet tall, he appeared of very normal size when seated. He was generally bent over like a jackknife, and it was only when he stood up that it looked as if his head would strike the awning. He was blondish, with a thick Van Dyck beard, and always complained of being tired. The shortest sentences he would drawl out in an interminable fashion.

Another interesting character whose acquaintance I made at the Dôme was Max Bohm, the painter, originally from Cleveland. Bohm was a man of huge girth and massive proportions, and everything about him suggested great power and poise. He was very cordial in his greeting and invited me to see his work—dark, somber pictures, but powerfully composed and conceived. Bohm's success, like that of many other fine painters, was mostly artistic, for financial returns were small. It was only after his death that his pictures began to fetch large sums.

Bohm, who would take his evening aperitif at the Dôme, was fonder of talking shop than any other painter I have known. I gained his good graces the day I remarked that one of my favorite pictures at the Louvre was Titian's *The Man with the Glove*, which Bohm held to be the finest painting in that collection.

Miller conducted a successful class for American students in Paris and also had a large following at Giverny, where he painted during the summer. He was a very clever technician and a most able teacher. Unfortunately, his students acquired a lot of superficial tricks and mannerisms, and for a while there was an epidemic of little Millers to be seen at every exhibition.

Friesecke, a neighbor of Miller's at Giverny, a shy person, who did very sensitive and delicate work, was very kind to young painters and went out of his way to befriend the lonely. Both he and Miller were often to be found at the Dôme at the aperitif hour before dinner. Miller, blond, nervous, and bespectacled, could be distinguished from afar by his wide-brimmed Stetson hat—the kind worn by ranchers—which never left him throughout the years I knew him. He was a keen billiard player and knew a hundred percent more about the game than I did. And yet I often managed to beat him, for the slighest thing would put him off his game, so that he would succumb to my slower and steadier methods.

But no account of the Dôme and its clients is complete without including Charles Augustus Lasar, familiarly known as Shorty. He is the oldest denizen of the Quarter. Shorty, in fact, is an institution at Montparnasse. It is he who takes the young ones in hand, gives them good advice, and then tells them to forget it. His humor is irresistible and all-embracing, and no one would suspect that he has a tragedy of his own— a sick wife, almost a total invalid, whom for years Shorty has tended and comforted.

Shorty had organized and developed a painting school for women which had been the most successful of all such establishments in the Quarter. Cecilia Beaux and Violet Oakley were once his pupils.

When playing billiards Shorty followed a system of his own. As his head reached only just above the cushions, he had to climb onto the table for the majority of his shots. From that perch he, so to speak, drew his bow at a venture—in other words, he hits his ball so hard that in the ensuing commotion among the ivories there is a good chance of their kissing and scoring for him.

A companion and neighbor of Shorty's was Alfy Maurer, a sort of diminutive Mephistopheles, who had won a deserved reputation for lovely tonal pictures in a very low key, much in the manner of Whistler. Then suddenly Maurer had joined the New Movement and was painting high in key with the purest of colors. He was experimenting with a white, plasterlike surface upon which he could wash the colors, giving more brilliance than when painting on canvas with solid colors.

Other habitue's of the Dôme at this period were: Augustus Koopman, Lawton Parker, Alexander Harrison, Samuel Halpert, Jacob Kunz, Richard Brooks, Alex Bower Schofield, Arthur Carles, and John Marin, looking like Lorenzo de Medici; while Otto Ganzel and Morton Johnson, a pioneer inventor of the talkies, were the prize billiardists of our group. H. O. Tanner and Myron Barlow, who had their homes at Etaples, would also look in occasionally. John Russell, a popular Canadian portrait painter and much in demand in society, always appeared in evening dress, coming for a drink among the bohemians before going to a social function.

Among the younger men of the Dôme circle I recall Louis Rittman, and his roommate, Norbert Heerman, nicknamed "Dutchie"; Rice, a Kentuckian; Arthur Lee; Michael Brenner; Harold Dunning, otherwise "the Wreck" (brother of the poet Cheever Dunning); Lee Simonson; Morgan Russell; Huntington Wright; Carlock, a shy, strange boy, nephew of Elbert Hubbard; and, later on, Jack Casey, who became one of the pillars of Dôme society.

Alas, within less than a decade most of these men are no more! The first to go was MacCameron, who after years of struggle was just beginning to enjoy success, soon to be followed by Augustus Koopman, Bohm, Richard Brooks, Carlock, Alexander Harrison, Alfy Maurer, Ivor Campbell, the two Dunning brothers, Halpert, and Morton Johnson.

The Dôme was the center of the Quarter life. To some, it meant romance, intrigue, and the lure of the "Vie de Boheme." To many, it was a haven of comfort, a refuge from the cold and from discouragement, where comradeship could be found and the chance to borrow a bit in case of need from a temporarily prosperous pal. Very few foreigners mingled in our part of the Dôme. Jules Pascin, the Rumanian, was one of the few exceptions, and a French painter, Signac, a pupil of Bouguereau, and his wife, Berthe.

The cafe' room facing onto the Boulevard Montparnasse was generally occupied by Germans, Czechs, and Bulgarians, only the terrace outside being common ground.

M. and Mme. Berger were the *patrons* of the Dôme, Madame, as is usual in France, occupying the cashier's desk behind the bar and attending to accounts, while her husband superintended the serving of cus-

tomers. M. Berger, a quiet, repressed man, invariably polite and attentive, was popular with his clients, many of whom took advantage of his kindliness and timidity to run up bills or borrow money from him. As for his spouse, despite her marked dearth of physical charms, she was still able to inspire a fatal passion in at least one breast and to reciprocate it with equal ardor. That amour proved stronger than the lure of the cash register, and obedient to its call, she one day vanished from the scene. A few days later her daughter took her place at the cash desk, while "le Père Berger," a little thinner and even more subdued in manner, continued to greet his customers and go the round of his duties, "a sadder if a wiser man."

OF COURSE, there were girls at the Café du Dôme. They came and went. New crops were surprisingly like the last vintages. New names, perhaps, but with the same smiles—sympathetic and unworldly, strange to say— seldom a gold digger among the lot. Many were models. A few were shop girls with independent ideas, others were *"petites amies"* of the artists who frequented the café. I recall one lovely little dark girl, a Corsican, with a temper that flared up into sudden blaze. No one seemed to know her real name, but *"Cocotte"* (not necessarily, in French at least, a pejorative term, signifying something like "Chickie") was the name she answered to. She had an American lover, who sometimes came in on the poker game. On these occasions she would pester and scold him until he gave up his place to her. She was a skillful and shrewd player, and at times not too scrupulous.

Then there was Andrée Bayard, a comely model, with a lovely skin and a charming expression, who had come to Paris from the Auvergne country with her true love, a young medical student. The idyll had the prosaic ending so common in France. The young man was forced into a *"mariage de convenance"* with a girl of his own class, after having made what provision he could for his abandoned sweetheart, who accepted the situation with the philosophical resignation so characteristic of French girls in her position.

Far from becoming embittered against the other sex, her broken idyll seemed to have increased her natural generosity of character, for she would often pose gratis for the poor artist—yes, and even provide many of them with a much needed meal! There was Louise, a handsome, statuesque Alsatian, who had migrated from the atelier of the *modiste* to that of the painter, and revelled in the change of atmosphere. Though fidelity in love was not her strong suit, she was a true friend and a charming companion. To her the gods were gracious, for she married a wealthy Frenchman (such things do happen, even in bohemia!) and now lives the serene and sober life of a *châtelaine* on a lovely estate in the Loire country, near Tours. She and Andrée have remained fast friends, and each year the latter spends several weeks at the chateau of her more fortunate friend.

But of all the fair ones who frequented the Dôme, there is no doubt that Margaret Ducros was the fairest—a lovely figure, a heart-shaped

112

face, and starry blue eyes—in fact, a real beauty. A picture I once painted of her and which was exhibited at the Salon, showed her seated at a café table, a large hat shading her upper face, while the mirror behind her reflected musicians in red playing in the café. I called the picture *L'araigne'e—The Spider*. I regret to say that some of the girls, who read the title in a catalogue, seized on it as a nickname for Margaret and that it stuck to her for many years. Poor dear! If anything, she was the fly! She wandered off to more tempting pastures, and years later I saw her in a Montmartre cabaret, elaborately dressed and even more richly painted than on my canvas.

And of course there was Zezette. Not beautiful, nor even pretty, but a witty and intelligent madcap, whose admirers and lovers were legion. So great was her charm that even the flouted ones would swear by her. I remember a gory battle waged in front of the Dôme between two of her *pre'tendantes*. But instead of rewarding the victor in the traditional manner, it was found that when the fight was over Zezette had walked off on the arm of an American sculptor, who had struck her fancy for the moment. At times I see her seated at the terrace of the new Dôme, apparently unchanged after the lapse of twenty-odd years. She, too, is "happily married" to a distinguished philosopher, who appreciates in her a ripe philosophy not gained from books and a fund of wisdom not acquired in the schools.

As for the other fair frequenters of the Dôme, they seemed to lead a butterfly's existence, drifting in and out, here today, gone tomorrow, living for the happy moment. And, strange to say, despite all we have heard from moralists on the inevitable end of those who "tread the prim-rose path of dalliance," the majority have settled down with husbands of their own and children, too, making as good, and often better, wives and mothers than the *comme il faut* young ladies to whom in earlier days they had to resign their lovers when it was time for the latter to become "serious."

To the weary, discouraged, and often homesick art student, many of these girls have disinterested affection, revived their courage, and given them a new zest in life. Nor were these attachments necessarily of a sordid nature, aiming merely at pleasure and profit, as the purists would have us believe, when inveighing against the immorality of the Latin Quarter. As often as not, it was the man who profited more than his com-panion from such liaisons, for the moral atmosphere of these so-called *faux me'nages* is frequently less deleterious, more wholesome, than that of many legalized unions. Even the merely practical results are at times of lasting value. It is a well-known fact that many very successful artists and writers in Paris owe their initial start to the ingenuity, flair, and aggressiveness of a *petite amie*, who has acted for him as publicity agent, procuring him patronage and useful connections.

Of course there is another side to the picture. Dramas, even tragedies, do occur. The young man is forced to return to his native land, promising to come back, and for a while poor Madame Butterfly counts on the promise, until there is no use hoping any longer. She has been

lâchée, plaquée, abandoned—all is over! But it isn't always easy to seek death when one is young. On the other hand, to go on living may be even harder. And then there comes a new hope and a new lonely one to comfort.

In this ruthless, unromantic age, when Paris, like many other European cities, is becoming "Americanized," the skeptical-minded will tell you that the romance of Vie de Boheme and all that sort of thing is mere literary hokum, which if it ever did exist outside the pages of fiction, has long since been as dead as crinolines and *Brandeburg* coats with strapped trousers. To which the only answer is that romance—whether on Montparnasse or Broadway—like form and color exists for him who has the necessary perceptions to be aware of its existence. As for the peculiar species of romance connected with the Vie de Boheme, that is necessarily indigenous to Paris. For though some of the truest, completest, most incurable of male bohemians can be and often are found in other cities and in other countries, the veritable *Bohémienne* is only bred on the banks of the Seine. Without her special attributes and attitude toward life and love, bohemia can never be more than Greenwich Village or Chelsea. Manon Lescaut, Mimi Pinson, "Sappho," even the lachrymose lady of the Camelias have left no lineage elsewhere than in France. Their descendants (and they can still be found, for evil or for good) have, I will wager, never heard of sex appeal, sex equality, nor all the other sex compounds, or if they have, will show little interest in such matters. I also venture to suggest that no one of them will be persuaded to have her memoirs published in a deluxe edition, like those of the more advertised than famous "Kiki," which were recently brought out to advertise "life in the Quarter." The worst that these Franco-American publicity stunts can do is to transfer the real Quarter to some other part of Paris—a thing which has happened more than once.

AMONG THE WELL-KNOWN WRITERS who frequented the old Dôme in former days was Oscar Wilde; and in my day one would see there on occasion Booth Tarkington, Will Irwin, James Hopper, Wythe Williams, Samuel Blythe, Montague Glass, Forrest Wilson, George D. Gribble, and some others. Fred Fisher, tall, debonair, fur-coated, swinging a cane, was the Don Juan of the café. To his insidious charms, the fair denizens succumbed in wholesale succession, but not one of them ever laid him by the heels, for he had the inconstancy of his famous prototype, though all the French he learned from them during his many years in Paris never exceeded "*Allo Bébée!*"

Many of the men who frequented the Quarter played at the arts as an excuse to live the bohemian life. To prove to the folks at home that they were serious-minded and working at their jobs, they would contrive to get their work exhibited at the Salon. I know of cases where the *soi-disant* artists, incapable of excecuting any work that could hope to pass the jury, hired a clever and very needy young painter, who would paint pictures which these "artistic deadheads" would sign. One of them, a wealthy American, has managed through these methods to be elected a *socie'taire* of the Salon des Beaux Arts.

114

The two Dunning brothers, Cheever and Harold, both writers and habitués of the Dôme, maintained a curious relationship of mutual aloofness. On one occasion Harold asked me if I knew Cheever well enough to be able to negotiate a loan for him. Cheever, the poet, was one of the most expert and lucky among the poker players, sometimes winning considerable sums with which he would eke out his very meager resources. His lodgings consisted of a tiny room, furnished with a bed, two chairs, a table, and a stove, facing onto a small courtyard-garden in the Rue Notre Dame-des-Champs, for which he paid about six dollars a month. In this "Bird Cage," as we called it, he lived like a hermit for twenty years, nourishing himself mostly on milk, for he was a martyr to a bad digestion. He wrote poetry which some think will make his name rank among the best of America's poets. Although in his verses the poet reveals himself as a lover, in the most passionate and pagan sense of the word, lauding Venus as outspokenly as Swinburne, in real life he appeared timid and tongue-tied in the presence of the opposite sex, hardly daring to look at a pretty girl, and often blushing and stuttering when forced to talk to her.

As for Harold Dunning, "the Wreck," he was the opposite to his brother in every way—a devil-may-care good fellow, fond of a glass and a lass. His writing talents were minor. The Great Historical Novel was ever in his mind, but never got much further than the start. The only thing he shared in common with his brother was lack of money. One day he strolled into the Dôme wearing an overcoat of which he refused to divest himself. When pressed to explain, he finally admitted that the only pair of trousers he possessed had suffered serious injury in a delicate quarter, whereupon Norbert Heerman, the dandy of the Quarter, offered to loan him a pair. The garment, however, proved to be of such ample length—Heerman being very tall and slim—that the "Wreck" was forced to hitch them up almost to his armpits, as well as turning them up at the other ends. It was a comic sight to see the fastidious Heerman carefully wipe the dust off chairs and benches whenever Dunning wanted to sit down, so that his borrowed trousers might not suffer harm. Heerman was the son of the famous German violinist and teacher. His brother Emil, also for a while in the Quarter, is a well-known musician and concertmaster of the Cincinnati Orchestra.

The average art student comes to Paris for a year's study, the more favored ones for two years. A few, as in my case, came for a short stay and remained on. Others, like Robert MacCameron, because they had not enough money to return until finally success came their way. Under the best of circumstances, painting is a precarious profession, and in Paris, where one cannot throw a biscuit without finding a hungry artist ready to bite into it, competition is keen and unrelenting.

But when in the Quarter we spoke of someone "succeeding," the measure of his success was less a question of financial returns than of actual achievement in the art he cultivated, whether as painter, sculptor, or writer. It was the approbation of the discerning few whose standards we knew and respected that definitely "placed" an artist. He might die in poverty, like many good artists I have known, and yet be accounted a success. This evaluation appears incomprehensible in commercial

centers, where the great novel or the master painting that does not sell is accounted a failure, while the author of cheap thrillers or sexy stories and the artist who produces pictures devoid of any real artistic values look down on and sneer at the misguided nut who is willing to sacrifice material benefits so that he can express himself sincerely. In the eyes of a public which esteems an artist according to his income, Rembrandt is a poor fish compared with Howard Chandler Christie. True indeed is the popular American expression "getting away with murder"!

But I have yet to meet the artist who, deviating from his ideals and tempted by the fleshpots, has not at some time or other regretted his career of success and ease, and envied the more humble and truth-seeking brethren.

MY RESOURCES from America had come to an end, except for the amount of the return fare, which had to be left intact. Yet I was reluctant to return. Though I felt I had learned a good deal, I could not yet put enough into my painting to prove that my work had any real talent or definite value. Also I realized that if I were to return to the conventional, provincial atmosphere of Cleveland or the terrific commercial strain of New York there would be little chance of my making any real headway with my art, and at the same time manage to stand on my own feet. And if I should return to America, would I ever be able to get back to Paris?

Great things were going on around me. Here in Paris artistic giants from all parts of the world struggled, competed with each other, and had their first creations exhibited at the Salons and galleries. To become a painter it was necessary to live in paint, think in paint—eat paint. No denying that poverty was a handicap, but in a milieu where few commanded more than bare necessities, the pinch would be less felt; and I echoed the confession of faith of a Polish painter friend, who would affirm that the good Lord, who sees that no sparrow falls unheeded, would surely look after the humble artist.

So the die was cast, and I decided to devote the money set aside for my return journey to prolonging my stay in Paris. With no rent to pay (Frost was taking care of that), my chief items were my share of the coal and gas bills, my food, and, of course, colors and canvas. A model would be a luxury, but there were friends who would pose, and there was always sketching outdoors when the weather was fine.

Frost, who spent most of his time at the school with Matisse, would occasionally come in to do a still life. But he never failed to take his boxing lessons every evening. I showed him some setting-up exercises to be done in the morning, which we would work out in the evening. This training so toughened him that although he never developed into an expert boxer, he managed to stand up without getting breathless and in time I was able to get a good workout with him. We had a large zinc bath, and after our exercise we would squat down and splash ourselves with cold water, in lieu of a shower bath.

A number of the boys from the Dôme would look in at our studio in the evening to watch us work out. Among these I recall Walter Pach, now an eminent art critic, Leo Stein, the writer and one of the first collec-

tors of Picasso and Matisse, Arthur Lee, the sculptor, Richard Miller, Norbert Heerman, and Louis Rittman.

In the course of time a group of young German artists at the Dôme heard from Frost enthusiastic accounts of the physical benefit he was deriving from his boxing lessons and eulogies regarding the prowess of his professor in the gentle art of self-defense. The German circle at the time was in the throes of chauvinism. Whatever any individual or group belonging to another race could accomplish in music, science, art, literature, or sport, they felt certain they could produce champions to better these performances. Although as regards physical prowess there had never been any intimation of defiance on our part, some of these young Germans imagined that Teutonic *amour propre* in the matter of fisticuffs was at stake and should be vindicated. Thereupon they took counsel among themselves to find a champion who should take my unsuspecting measure.

Not one of these young Teutons had ever donned the gloves; more than that, I doubt whether any one of them had even seen a boxing match. When not at work in their studios, the majority foregathered at the cafe', indulging the national love for endless argument "about it and about." In their ignorance of boxing, they did not realize that two minutes of that strenuous pastime would wind and exhaust the average healthy individual living a sober life and taking average exercise, to say nothing of what it would do to those who drank copiously and seldom exercised.

Nothing daunted, they set to work going over the possible candidates for boxing honors, and by dint of elimination finally made selection of the future conqueror—a short, bull-necked, black-bearded sculptor. Though not over five-feet-five in height, he had massive proportions, very thick in the body, with short, powerful-looking arms and huge knobby hands. He had the reputation of being able to lift tremendous weights. Of mild and modest mien, it was yet hinted that one blow of his powerful fist could shatter an oaken plank. What matter if he knew nothing of the technique of boxing? Let him but smite me once, and it would require a surgeon to patch up the splinters. I must add he was very loath to accept the honor of posing as pugilist champion, but the arguments of his compatriots left him no choice. It was a case of *Deutschland über alles*!

When Frost broached the news of the intended boxing contest to me, I became very angry. I protested I was not a plug-ugly, nor by nature pugnacious. It was a different matter to put on the gloves with friends when all was done in a spirit of fun, but not to box with an individual whom I knew only by sight. This, too, was to be a real battle, not a mere sparring match.

Frost seemed so crestfallen by my attitude and insisted so strongly that my refusal to meet the German champion would put him and our American comrades to shame that I finally acquiesced. But inwardly I had misgivings. After all, it was possible that my adversary did possess a deadly punch.

The evening of the encounter found our studio packed with adherents

of both camps, German students and American colleagues. All my nervousness left me when my adversary stripped to the waist. His arms, though huge, were musclebound, and a vast protruding tummy was a mark that a blind man couldn't miss. So big were his hands that it was difficult to get on the large ten-ounce gloves we were using. The poor chap had never before put on the gloves, and he felt ridiculous and ill at ease with them.

I had decided to be careful and not to let him land on me, if possible, and to box him from a distance. With my left I tapped him lightly on the face and sent in one or two on his tummy, while he with his short arms made ineffectual swings. I at once realized he was not using his shoulders when he struck out, and that there could be no power in his blows if they did land. So I came in close and parried a few blows with ease. In less than a minute he was breathing with difficulty. He had no guard at all and it was easier than striking a punching ball. I feinted once with my left, and as he feebly raised his arm, I caught him a fairly hard right smack under his square black beard. Instead of falling over backwards, he just sat right down, with a most grieved look on his face, holding out his gloves to be removed. The fact is that in another minute he would have been forced to quit even without being struck. He was absolutely breathless, as anyone versed in boxing could have foreseen.

This sudden, easy victory left the German crew flabbergasted, but Arthur Frost was so happy he almost hugged me. I felt silly over the whole matter and went over to the side of my fallen adversary and tried to explain away the ridiculous encounter. Fortunately, he had the good sense to take the matter as a joke. Apart from a few red spots on his anatomy and a little stiffness in his jaw, no damage had been done, the gloves being far too cushioned to do much harm. It was all over very quickly. Though later my adversary and I had many a good laugh over the affair, he consistently refused to put on the gloves again, saying, and very rightly, that it was more important for him to battle with his clay and stone.

But I reaped some good results from this burlesque encounter. For Frost's enthusiasm about my exploit brought a few English friends of his who wanted me to teach them the American methods of boxing. So I arranged to give them lessons.

THESE EXERCISES, besides keeping me physically fit, were an incentive to resist the softening café habit; at the same time, my appetite, after so much physical exertion, was often ravenous. Vegetables, and certain other foods, purchased in the raw, were very cheap, and the long, crisp French bread was as delicious as it was filling. Vegetable stews, which I prepared in the studio, were a staple dish, for I could seldom afford even the cheaper cuts of meat. But when at times the carnivorous craving became too strong to be resisted, I would stifle my American qualms and slip off to the neighboring *boucherie chevaline* ("horse butcher's") and buy an ample steak. This, after pounding the toughness

out, I would fry in an all-enveloping garniture of onions, and never was there porterhouse which tasted more delicious.

Occasionally Halpert and Brenner would drop in, bringing divers provisions which would vary my ordinary, and we would then revel in a Lucullan feast. Despite the monotony of my fare and frequent longing for greater variety and quantity, it was seldom that I went hungry. Thanks to my two boxing pupils, I managed to crawl up a bit on my budget and decided to devote some of these extra earnings to the luxury of a model.

Some time before I had conceived the idea for a picture which I wanted to paint for the coming Spring Salon and for which Margaret Ducros was the ideal model—in fact, the picture, entitled *The Spider*, already referred to. Margaret was one of the most popular models and was generally engaged for weeks ahead, but I found out she would be willing to pose in the evenings, if desired, and accept a reduced fee.

This was a solution, but there were difficulties to be overcome. I had never yet attempted to paint by artificial light, and the only illumination available in my studio was gas, which gives a certain yellow hue to everything. I reasoned, however, that as the effect I had in mind was that of a café lit by night, my studio lighting would be in keeping with the theme of my picture. Strong shadows cast by the overhead gas light would give an air of mystery to the model's features and add strength to the composition.

I posed Margaret seated at a table, one hand holding a liqueur glass and the other supporting her chin. Out of the shadow cast by her hat over her forehead, her eyes, large and luminous, peered forth mysteriously, accentuating the pallor of her powdered face and the highly rouged mouth. The pose was one of expectancy, my idea—a very "literary" one—being to denote the femme fatale awaiting her prey.

In spite of the dramatic title and the "literary idea" behind it, the picture turned out rather amusing, both in color and as a composition. The difficulty I had to contend with painting in this light was to distinguish between the blues and greens. Even a strong yellow looked comparatively pale, and the violet tones which I mixed on my palette seemed to disappear, once laid upon the canvas.

The following morning I found my picture looking like a riot, and I was obliged to tone down the yellows and key down the blues and violets that screeched out startlingly in the light of day. In time and with experience I learned to modify and temper my mixtures, so that I painted as accurately as I would have in a normal light.

In the background of my picture a group of musicians, clad in red, was to be seen reflected in a mirror. The studies for these musicians were made at the Café d'Harcourt, on the Boulevard St. Michel, a favorite resort for students of the Latin Quarter, and were then supplemented in tone and color to harmonize with the main figure in the foreground.

During the dark winter afternoons I would frequent the sketching classes at either the Colarossi Academy or the Grande Chaumière. A book of tickets, each one good for a three hours' séance in the sketch

class could be had for a small sum. The poses were changed every half-hour and were generally varied, the models themselves choosing the positions, standing, bending, reclining, or lying down at full length. It was fine practice, for the student was often forced to draw in the most difficult of perspectives.

To draw well, like most other human accomplishments, demands constant practice. Only in that way can one be familiarized with every gesture and movement, and the various proportions of the human figure. During these winter months I made many hundreds of drawings. To give variety to these *croquis* ("sketches"), I often employed red chalks or sanguine. But I would warn the beginner that the practice is a dangerous one, because through this medium even a very mediocre drawing acquires a charm which is apt to deceive as to its intrinsic merits. Dominique Ingres, one of the greatest draftsmen of all time, preached, as a law for students, the use of the unsympathetic *mine de plomb*, or lead pencil, for it must indeed be a good drawing which looks well in that medium.

The practice of always carrying a sketch book is most valuable. On the streets, in cafés, or at home innumerable objects and studies are at the artist's command, an immediate inspiration for work, and a first-hand knowledge of form and movement. When searching for a subject, the artist often finds a myriad of suggestions by merely looking through his old sketch books. The eyes and fingers are trained to lightning quickness and to noting essentials with extreme accuracy. Many artists who make proficient drawings from models or fixed objects find themselves at a loss when painting or drawing a subject in movement. This type of craftsman generally does stilted, lifeless, and unimaginative work.

At this time, I also made the acquaintance of the sculptor Antoine Bourdelle, then at the zenith of his fame. Our meeting was brought about through an American sculptress, Sarah Moriss Greene, of whom I had done a portrait, which Bourdelle had remarked in her studio and pronounced to be "very interesting." This led to my posing for Bourdelle for a sketch he did in clay. It was cold, hard work, for the immense studio was only partly heated by a stove and the floor was wet and clammy.

Bourdelle, who himself had kept up a tremendous struggle against poverty and had for years "deviled" for other sculptors, proved very sympathetic. Being a close friend of the great Rodin, he wanted to give me a note to the master so that he might also give me poses, but I did not avail myself of the offer, not wishing to fall into the category of professional model at four or five francs a pose. I preferred to rely on my handiwork as a main source of revenue, for I was able from time to time to dispose of my sketches, although ten or fifteen francs (two or three dollars) was the average price they fetched. These small sums enabled me to buy colors and canvases. I especially remember a visit to my studio by Arthur and William Schneider, friends of Louis Loeb, as a red letter day in those difficult days. Both expressed their delight with my small studies, and the latter, to prove his appreciation, paid me the record price of seventy-five francs for one of them.

Besides the satisfaction of making headway with my art, I was also

given conclusive proof that my boxing pupil Arthur Frost had profited by the training he had undergone, and had achieved his main purpose—that of beating his former adversary. It was also an interesting example of what a man will do to satisfy a secret ambition, for Frost had taken his training with great seriousness, abstaining from all alcoholic beverages, even beer. Having finally reached the point where he could sustain a bout without losing breath, he felt that the time had come to achieve his purpose—the undoing of his former vanquisher.

The latter, who had recently returned from America and was unaware that Frost had been secretly improving his pugilistic science, was one day casually invited to our studio. Conversation having turned towards boxing, Frost began chaffing his old rival about the former lickings he had given him. This gave me my opening, and I made reference to the fact that Frost had improved in his boxing and could probably now give a better account of himself. Taking the hint, our visitor smilingly replied that if there were any gloves about, he would gladly spar a bit with Arthur.

But the smile of assurance vanished a few seconds after the bout started, and changed into a look of dazed surprise as my pupil began to apply his new science. In fact, for about two rounds Arthur pounded his opponent all over the place without mercy or respite, finally driving him against the windowed studio door where he held him at his mercy. Fearing damage to both door and visitor, I stopped the fight. Frost's triumph was complete. It was written all over his vanquished rival, whose discomfiture had knocked every trace of the pugnacity out of him. As for the expression on Frost's face, it might be imagined to compare with that of David after felling Goliath or of Battling Siki when Carpentier was being carried out of the ring.* But from that day on, Arthur seemed to lose interest in the game. His ambition was satisfied, his goal was attained.

APRIL in its traditional mood, half smiles, half tears, and sulkiness, had brought milder weather and, through showers and sunshine, was reviving the ancient and ever new enchantment of spring. In the nearby Luxembourg Gardens all was sprouting, budding, twittering. The white and pink candle-blossoms of the chestnuts, the exquisite pastel hues of the hawthorn trees, ranging from deep red to pure white, and all the other lovely aspects of reawakening nature were tempting one with easel and paintbox outdoors, whence, as often as not, a sudden deluge would send one scurrying for cover. Already I was dreaming of Vernon in its spring-

*Carpentier won the light heavyweight title in 1920. Two years later, fighting in his own arena in his hometown, Paris, the champion was knocked out in the sixth round by Battling Siki, a Senegalese who had learned to box while serving in the French army. After beating Carpentier, Siki, like a figure from a Dada cabaret performance, strolled around Paris with a lion on a leash. Siki had the misfortune to face Mike McTique, a New York City Irishman, in Dublin on St. Patrick's Day, 1923. McTique won on a decision. Alexander Johnston, *Ten-And Out! The Complete Story of the Prize Ring in America* (New York: Washburn, 1927), pp. 232–33.

121

tide glory, longing for the first warm weather to hurry out to the Soleil d'Or, revel in the sunshine, and, I must confess, the excellent cooking of Maître Espagnon, which after the winter months of slim fare would be doubly welcome. Friend Halpert, to whom I had broached the subject, was ready to leave at any time. So all was well, and I lived in hopes made even rosier by the possibility—a very remote one, I had to confess—that the jury of the Spring Salon (a severer Areopagus than that which presides over the Autumn Salon) might possibly accept my picture, *The Spider*, which I had sent in.

This period of waiting was enlivened and made memorable by my first attendance at one of the famous artists' balls, of which such lurid accounts circulated in America. This was the "Bal Julian," the first of the spring saturnalia, organized by the students at Julian's Academy—a veritable pagan riot of exuberant youth. A more intimate, "go-as-you-please" affair than the celebrated Quat'z-Arts Ball, it is, if anything, even more informal and quite as noisy. Every latitude was given as regards costume, which, provided it was unconventional, could be, and often was, reduced to the strictest minimum. In the case of the "ladies," a pair of slippers and a smile would be considered sufficient, provided that nature had done the rest in becoming fashion. The fact that these artists' balls, with their unbridled freedom of dress (or undress) and reckless rioting do not degenerate into disgusting orgies, as they certainly would in any Anglo-Saxon community, speaks volumes for the innate sense of measure which characterizes even the rowdiest manifestations of the French *joie de vivre*.

A few days before our departure for Vernon, I received notice that my picture, *The Spider*, had been accepted by the jury of the Salon. Although exhibiting at the Salon is no criterion of real merit, I felt that this was a feather in my cap, for it would inspire confidence in the new friends who were interested in my career. So I departed with renewed courage, feeling all was well with the world.

Returning to Vernon was like coming home. The hosts of the Soleil d'Or welcomed us as friends of the family, while Jack Casey and his wife could hardly contain themselves for joy at having us once more in their midst. So there we were again, feasting on the terrace in the gay sunshine, for the meal that Maître Espagnon served us might have been envied by the most pampered returned prodigal.

Along the river front and hills the trees for the most part were still bare, but here and there glorious patches of blossom were breaking out on the fruit trees, and the riverbanks were covered with that pale, deliciously fresh green that one only sees in springtime. The seasonable effects were very fleeting and elusive. Moving clouds and shadows would obscure the landscape, alternating with brilliant sunshine streaming in variegated patches through the breaking clouds. It was difficult, under these circumstances, to stick to one effect. So I found it necessary to take a definite stand as regards a certain mood I wished to transfer to canvas, and cling to it.

Painting a landscape is infinitely more than finding a lovely spot and

making an accurate copy of it. Cloud shadows and the sunlight are continually shifting, changing their form and quality; trees sway, and water often runs swiftly. The painter's mood may change a dozen times. And then there is the wind! Everyone has his pet grievance and bugaboo. Mine is the wind. It tears the easel from the ground, shakes the canvas one is working on into a mad St. Vitus dance, slaps a wet palette against your clothes, and often, when putting a delicate touch on an important spot of the canvas, a treacherous gust will sway the canvas or the brush, so that it lands inches away and obliterates a part that has been painted with extreme care and *con amore*. I've always felt that a landscape painter is made up of 60 percent martyr and the rest damn fool.

I have tied down and anchored my easel into the earth, attached the canvas so that it would not shake, and painted in a high wind, keeping my palette on the ground, so that it might not turn and spill over, cursing myself for a fool and an idiot, but all the while with a secret ecstasy, a joy beyond human expression. For one must suffer and love Nature greatly before she gives up any of her secrets. Of all mistresses a man may choose, she is the most exacting, tormenting, and fascinating, changing in all her moods—dark, sunny, gray, and misty, subtle, crude, cruel, and gentle. Even to the humblest and least expert of her lovers she often deigns to reveal untold visions of beauty, and always there is the lure of newer and more surprising charms.

One morning we awoke to find the trees in the orchards and on the hill slopes covered with pale rose- and mauve-tinted blossoms, appearing so ethereal and evanescent that we feared the slightest gust would blow them away. Early morning, afternoon, and evening would find me whacking away, with always the hope of luring onto my canvas a small meed of the beauty I found in my fragrant and fragile models. Helas! my pictures were pasty. The blue light would not flicker over the treetops, and often the blossom-laden tree I painted looked as if a fall of snow had descended on its branches. Again and again I would scrape and repaint the picture, until finally I managed to produce a few studies suggesting vaguely the rare beauty of my vision. All too soon wind, rain, and pushful green buds and opening leaves obliterated the rhapsody of springtime, and though the beauty of the countryside continued to unfold for a long while, it took on, in my eyes, a drab and commonplace air, deprived of the lovely fragile accents of the blossoming trees and shrubs.

Olinsky came to Vernon for a few weeks, to rest rather than to paint, for being par excellence a painter of figures, he was less interested in depicting landscapes than we were. He painted in his room from memory a Venetian fête at night, which was to include a display of fireworks, To achieve the desired effect, I remember that he loaded a wide brush with various bright colors thinned down. Then, having carefully covered parts of his canvas with newspaper, he splattered the colors on the dark ground of sky. It was a very clever stunt, and the result was striking.

Our spring idyll was soon spoiled by dreary rains, and there was nothing to do but loaf about the little town and while away the hours with billiards. One afternoon I suggested to M. Espagnon that I paint his

son Robert, a tiny tot of about five. My suggestion was welcomed, but it was feared that the little chap would prove a bad sitter. But as I was willing to chance it, "petit Robert" was dressed in his best clothes, his long brown locks curling to his shoulders. As long as his father was in the room, he sat fairly quiet, but as soon as the paternal authority was removed, the child became a *perpetuum mobile*, all squirms and wriggles.

Next day his father, hearing of my difficulties, devised an effective scheme for keeping his offspring quiet. Placing a bottle with a large cork near Robert when he was posed, he gravely informed him that if he moved or squirmed, the cork would jump out of the bottle and he would know what had happened, so *"Attention, mon fils!"* I never saw a child sit so still. For two entire afternoons, while I was finishing his portrait, he sat spellbound, in fear the cork might leave the bottle.

It was a fairly good likeness, and both parents were pleased with the result (a very modest achievement, as I realize now); so much so that the *patron* asked me to paint his wife. This portrait, done on a fair-sized canvas, was a more ambitious undertaking, showing the lady in a graceful pose, including the hands and also with a floral decoration. It was a creditable performance and my satisfaction with the result was greatly increased when the *patron*, as a return for my labors, generously offered me free pension for a six weeks' stay. So that for the rest of my visit I had no expenses, except the small tips to hotel servants and my *menus plaisirs*, which, as I had not yet started on tobacco and only drank what was provided at table, was a negligible item.

This unexpected windfall opened up pleasing prospects of how to organize other *villégiatures* in the country—possibly even in Brittany, which I was longing to visit; for glowing accounts from my colleagues about that painters' Eden had fired my imagination.

Just then to my surprise I received a letter from Henry Mathes, telling me he had arrived in Paris, where he hoped to study for a year. He had given up a profitable career as an illustrator for the doubtful one of painter. I answered, advising him to join me at Vernon, where he could do some sketching, after which we would return to Paris, where I might help him to settle down. He gladly accepted my proposal, for the first impact with Paris—the new life, language, and school of painting—had so dazed him that he had been thrown off his balance. He wanted to rest his mind and get his bearings. The broad Seine, which is at its loveliest at Vernon, and the wide river valley, filled him with enthusiasm, and so did the generous fare at the Soleil d'Or. Never had I seen a mortal dispatch food in such quantities!

When he joined our sketching party, I noticed that his palette, compared with ours, looked black and somber; but he soon remedied that. As for the sketches I was painting, he did not know what to make of them, and told me frankly that he thought them wild. I could not help wondering what he would have said about some of the works shown at the Autumn Salon. Mathes told me that New York was still a stranger to the newer painting, and so I gathered from his wholesale condemnation of all that he had seen since his arrival in France. In his opinion, the

124

painters of the new school were all fakers and crazy. In spite of my having written him about the new tendencies in art, he received quite a shock when he found himself face to face with what they had produced. Nevertheless, he started out to experiment with pure color in his studies from nature, and within a very short time his enthusiasm for the new method had capped ours.

Mathes, who was a very clever draftsman, in his experiments never went into distortion of form, but clung to the phenomena of color and light. Even some of the first things he did at Vernon, with little pure points of color, quite in the manner of Seurat and Signac, turned out very interesting.

Halpert intended staying another month at Vernon, but Mathes and I, who had talked over the Brittany idea, which I was anxious to realize while my finances still held out, decided to return to Paris for a week to obtain more definite information regarding the land of our desire. So, with Frost's approval, we both established ourselves in the former's studio.

WE FOUND the Quarter in its annual throes of preparing for the "Quat'z-Arts" ball. This yearly revel of the Four Arts, which enjoys a worldwide reputation, falls in the early weeks of June. For the world of Bohemia it is what the "Grand Prix" is to the world of *"tout Paris"*— the Big Event.

Only students attending the recognized art schools or bona fide artists are supposed to attend this ball, although, in fact, a certain latitude is allowed for strangers, provided they are sponsored by some atelier. Every male participant is allowed to bring a female partner, who has free entrance. The rules on costume are very strict, and failure to comply with them means being unceremoniously chucked out by the jury which presides at the door. All costumes, however fanciful, must be in keeping with the prescribed period, which varies from year to year. In that year, 1910, the hall was to evoke "The entrance of the Persians into Athens," so there was a choice between Greek and Persian dress.

For days before the event takes place, artists are busy decorating the huge hall, painting, building, transforming. The results obtained have to be seen to be believed. On this occasion there were temples, streets, prows of battleships, colonnades, with the most surprisingly elaborate evocations of what may be politely termed the Cult of Eros in all conceivable manifestations. Some of these erotic symbols were in the shape of huge moving figures, performing very amusing stunts. During the night there were various interludes, such as a beauty competition for female models, shown aloft *in puris naturalibus* and acclaimed below by the shouting crowd, and at midnight a grand procession—triumphal cars, chariots, mythological beasts, litters of unveiled beauties borne by slaves, proceeding amid a deafening din which continued crescendo throughout the night. I still recall, as in a hazy vision, the amazing spectacle of the dawn light filtering in through the dust and smoke of smouldering torches, when all was wrack and ruin, the vast dancing

floor strewn with shattered scenery, torn costumes, bottles and broken glass, among which more or less nude bodies had sunk to rest and oblivion, while pale-faced firemen and guardians of the peace stood stolidly surveying the scene, as if to see that things did not go too far!

Then in the early hours of the summer morning came the march home from Montmartre right across Paris to the Latin Quarter—an even more incredible spectacle—resembling, for all the world, the triumphal raid of a savage horde through a captured city. Half-naked figures mounted on cab horses, brandishing spears as outriders for a load of howling lunatics in the vehicles, some even perched on the carriage tops, led the vanguard of this wild mob, which, as it descended toward the center, swept the streets clear of every object it could lay hands on—dustbins, shop signs, milk cans, etc. In front of the Opéra, while a frenzied farandole was enacted up and down the monumental steps, uncouth figures could be seen climbing up the statues of the facade, unheeding the friendly remonstrances of the policemen who accompanied our march. And when we reached the fountain at the lower end of the great avenue, on the Place de la Comédie Francaise, more than one grimy hoodlum plunged in for his morning ablutions. I shall never forget the expressions of startled horror and bewilderment on the faces of two elderly English ladies, driving off to catch an early train, as our cab, with Arthur Frost astride the horse, and waving a spear, met them under the arches of the Louvre.

It took me several days to recover from the effects of this gargantuan spree. Champagne and mixed drinks had caused havoc to my uninoculated innards. For I am one of those unfortunates in whom alcohol reacts as a poison, and it is these physical reactions, and not any lingering puritanism, which makes me dislike strong drink.

ONE DAY at the Dôme, Renee Duchamp, a little model who had once posed for me, asked where I intended spending the summer. On my telling her that I was hoping to get to some place in Brittany, she informed me that she and her artist friend were going to St. Jean-du-Doigt, Finisterre, on the northwest coast of Brittany, a lovely spot, unfrequented except by a few painters. There was a little hotel, where for three francs a day excellent food and lodging were provided. They were leaving that night, and if Mathes and I would join them, she offered to reserve rooms for us. It all sounded so tempting that we accepted then and there. Our preparations were quickly made, and the following evening we embarked for our all-night trip to Brittany.

Arriving at Morlaix the next morning, we took the diligence for St. Jean-du-Doigt, in which a few peasant women, wearing their picturesque white coiffes, were already installed. It was a two hour trip over winding picturesque roads, flanked by shaggy hills, gay with patches of purple heather and golden gorse. Though the country through which we passed was lonely and silent, there was no feeling of desolation or oppression. Here and there were whitewashed stone cottages with thatched roofs. Groups of tow-haired, blue-eyed youngsters playing about their doors would gaze with awe at the passing diligence and our paraphernalia piled on its roof.

Sometimes we would pass a roughly clad countryman or a shepherd doffing his hat to the driver, who in response to his greeting would snap his long whip. Occasionally at some wayside inn—called *buvette* or *débit* in these parts, a withered branch hanging over the door signifying that there was a license to sell drink—a brief halt would be called to breathe the horses. We joined the driver at one of these "pubs" and, following his example, ordered a bowl of cider. But, unlike the sweet and delicious beverages we had tasted in Normandy, this Breton cider had a vinegarlike quality and an alcoholic content stronger than wine. The Bretons are a cider-drinking people, and the shocking condition of their teeth has been attributed to this drink.

To the staccato accompaniment of the driver's whip, we crossed at full speed a tiny bridge on the outskirts of St. Jean-du-Doigt and drew up in the quaint little square, the terminus of our journey. At the Maison Perrin, facing onto this square, where we were to put up, we were greeted by the luncheon bell, a most welcome sound after the long journey. Nor were we disappointed in our first Breton meal, which was as copious and well prepared as at the Soleil d'Or, of happy memory. Like M. Espagnon, Madame Perrin was a cordon bleu, having served as cook in a Parisian family, where her husband had been employed as manservant. After several years' service the proverbial *mal du pays* of the Breton had lured them back to their country, where they had invested their economies in a small hotel, which, thanks to Madame's excellent cooking and her husband's all-round efficiency, had prospered. In the eyes of their progeny, a nine-year-old boy, the arrival of two real Americans was an event, for it was his belief that we came from a land where pitched battles and pursuits between scalping Indians and leather-stockinged white men were the order of the day, even in the streets of New York. I doubt whether today the native small boy in the remotest corner of Brittany is able to entertain such happy illusions or to get such a thrill as young Master Perrin received from frequenting the society of compatriots of Buffalo Bill, for he was soon our devoted companion.

Mlle. Renee and her artist friend, a square-shouldered, frank-eyed young Frenchman whom we met in the dining room, made us heartily welcome, so that we soon felt as much at home as at Vernon. Surely once more *"la douce France"* had deserved its name!

As for Brittany itself, the vaunted Painter's Eden, that, too, was no usurped reputation. Within stone's throw of the hotel was the churchyard, containing the tiny cemetery, all abloom and fragrant with rose bushes and flowering shrubs, carefully tended, and happily masking, at least to some extent, the pitiful wire and glass wreaths piously suspended from crosses and tombstones, which disfigure French country churchyards. And clustering round the gray old church there were picturesque thatch-covered cottages with black-gowned, white-coiffed peasant women coming and going about their daily occupations just as they had been doing for centuries, bringing back childhood recollections of fairytale scenes in picture books.

About half a mile away lay the beach, a stretch of very flat sand, overhung by high cliffs, where at low tide one would have to wade out a

goodly distance before reaching sufficient depth for swimming. The road there lay through shady lanes, with lovely glimpses of the sea peeping through the trees, only here and there, more quaint old cottages in the foreground, pleading to be painted.

One afternoon when the tide had gone out an exceptionally long distance, Mathes and I, observing some strange-looking thing wriggling in the shadow of a rock, turned it over, and there, among damp weeds, we found a large, dark, shining lobster. I took off my old painting coat, and we managed to shoo him into its folds. Thus secured and bundled up, we bore our struggling captive back to the hotel. Next day Mr. Lobster, in scarlet magnificence, appeared on our table, as succulent within as he was splendid without. He was our first and last capture, for hunt as we would—and we did! leaving no rock unturned that could be turned—we never met his like again.

But we had no need to supplement our ordinary, especially as regards crustacea and all sorts of fish, for, unlike so many other seaside resorts where the best of the ocean's edible produce is hurried off to the inland cities, we had the pick of the hauls. Every morning neighboring fishermen would bring abundant catches to the hotel door for Mme. Perrin to choose from. The savory sea dishes she would prepare for us are among my most abiding gastronomic memories. There was a plentiful supply of good salads, but a scarcity of vegetables, the staple being potatoes, which were served at every meal; for the Breton, like his Celtic brother, the Irish, feeds mainly on the potato. Green vegetables, so plentiful in the other provinces of France, hardly figure on the Breton menu. Meat is also mostly limited to veal and pork.

The weather was delightful, warm and sunny, pleasantly tempered by the ocean breezes. I profited by the few rainy days we had in painting the courtyard below my window, which, with its grass-grown, flag-stoned pavement, bundles of fagots leaning against an old wall, slate-covered roofs, stained by gray and ocher-colored moss, against a background of neighboring fields, the various greens chastened by the falling rain, and a silver glimpse of the sea near the horizon, made a charming subject.

Window views are always a delight to me and a field for a variety of pictures. Humble, everyday objects, when seen from this higher angle, acquire an added pictorial significance. And so it is in sunlight and the rain, frost and snow, early light and evening shadow. Seen from a window they take on strange patterns, poetic fancies, and inner meanings, which I often fail to find elsewhere.

From the steep hills I experimented looking directly into the sea, striving to paint the sensation of depth; and the luminous colors playing over the shifting surfaces. My immediate foreground was the warm-colored earth and great patches of golden gorse, contrasting with the deep blue and purple of the water. I showed no horizon. The finished results were unconventional, to say the least, and a far cry from the academic conception of a picture.

It was vital and primitive to work in this way, influenced by nature

128

only and entirely untrammeled by conventions and academic theories and all that relates to the production of pretty pictures—an attempt of sheer self-expression, inspired by the all-enveloping wonders about me. After a few hours of tense and concentrated painting, I would find myself completely worn out, with a feeling of overwhelming disappointment and impotency after comparing my canvas with the majesty and beauty of my subject. Even the most beautiful colors on a palette are mud compared with the colors of nature tinted by the magic rays of the sun. A canvas is a flat piece of prepared linen upon which light, and, above all, depth must be suggested. Genius, of course, has overcome these handicaps through the miracle of imagination and tremendous craftsmanship. At times in front of the masterpieces of Claude Monet I have experienced the same sensations of delight that I have felt before Nature. Those unexpected effects of light and marvelous transitions of color playing over his canvases I have seen time and again outdoors.

Even a failure is well worthwhile. Out of many and mighty struggles may come the one precious and perfect work. The layman cannot conceive the agony of mind with which every creative artist is at times beset. Even material and physical distress, which is the artist's all too common fate, compares lightly with the mental anguish he endures while struggling to realize his idea. To the sensitive and sincere artist the gap between his vision and its realization is always an infinite one. Rembrandt, on his deathbed, ached for the greater works he wished to do; and the kindly Papa Corot had visions of even lovelier landscapes than the idyllic masterpieces he had created.

MY STAY at St. Jean-du-Doigt was nearing its close—through force of financial circumstances. The prospect of being stranded without funds in this corner of Brittany was an unanswerable argument for a return to Paris, where there were possibilities for facing the situation. How I envied Mathes, who was able to stay on for the whole summer in this lovely spot, which had captivated him as it had me! It was with a heavy heart that I packed my impediments and waved goodbye to St. Jean.

I arrived in Paris near the end of July. As was to be expected, most of my acquaintances had gone to the country, including Frost, who was summering at Giverny. But he had left the key of his studio with the concierge, which was the essential thing for me. My Breton canvases, put into frames, made a much better impression in the spacious, high-ceilinged studio with its sympathetic lighting than when face to face with the original sites they depicted, and I noted with a certain melancholy satisfaction that they retained enough of the atmosphere I had tried to capture to evoke the vanished paradise which I had so reluctantly been forced to quit—proof that my time and efforts had not been lost.

Norbert Heerman, the sentimental dandy of our Dôme circle, having resisted the blandishments of the countryside (or, as I rather suspected, being unable to resist those of some city-pent belle), would often beguile his leisure moments by "taking the cool" of my studio while I was working. Having one afternoon persuaded him to "sit" for me, I did what

appeared to me a rather vigorous sketch of him (if the term "vigorous" can be applied to such a genial loafer), which so delighted him that he there and then offered to swap his expensive Panama hat, with a good dinner thrown in, against the portrait-sketch. As the only headgear I possessed at that time was an old cloth hat, as ungainly as it was uncomfortable for summer wear, the bargain was clinched. In later years when I asked Norbert what had become of the sketch, he admitted, with little regret, that he had presented it to a fair admirer.

One of my acquaintances, a French doctor named Phillipon, who had remarked on the picture I had shown at the Salon, inquired whether I would do a portrait of him. The price agreed upon was one hundred francs (then about twenty dollars), which would be paid me upon completion of the picture. With my eyes still full of the outdoor colors, I painted him: hair and beard in green and purple tints with the fleshtones in colors approximating the rest of the picture. To my grateful surprise, he offered no adverse comments. Having already seen some of my pictures, he knew what he might expect of me in the way of color and treatment. It was my privilege, he said, to paint him as I saw him. Like many cultured Frenchmen, accustomed to various phases of painting, he willingly accepted from an artist that which represented the artist's own vision.

To the uncultured masses a portrait is, or should be, a hardset, photographic, frozen image, whereas in reality the great portrait painter aims at a synthetic and mobile likeness, searching out and finding among the many moods and phases of his sitter the characteristic and subtle moments, which the lightning flicker of the camera misses. But, as a rule, the mediocre painter, who slavishly copies or turns out a prettified resemblance to his subject, has the most popular success.

Sargent, with his uncanny and uncompromising search for character, seldom pleased his sitters, especially the ladies. His definition of a portrait was: "Something that always has something wrong with the mouth." There is an amusing anecdote concerning the portrait he painted of the wife of an English peer—a lady whose estimable moral qualities were not expressed in terms of physical beauty. This lady's husband, having anxiously inquired whether Sargent could not endow the portrait with some of the charms which were so obviously lacking in her person, received the blunt reply: "I can't paint a peach with a potato as a model."

Often in painting women, one is cautioned by the sitters: "Don't make it *pretty*. Be sure it is, above all, a good likeness." But when the finished work is scrutinized, the same sitter will suggest a little wistfully: "Don't you think my eyes are a wee bit bigger? And do the corners of my mouth really droop like that?" Many will plead to paint them thinner than they actually appear: double chins must be removed, and all salient characteristics softened, as in a retouched photograph. Women over forty have apologized to me for the desire to appear younger in their portrait by explaining: "I want my children always to think of me as I looked when they were young. Children are such idealists, you know!" And after shameful concessions are made by the painter, the husband will as like as not remark: "To speak frankly, you have not done your

130

model entire justice. You've made her look years older." Or a dear friend of the sitter's will observe: "It is a *fine* likeness, but I *don't care* for the *expression.*" From all of which one is led to believe that the popular ideal of a portrait is not the faithful human document, and that in order to please sitters should not be portrayed as they really are nor as they think they look, but as they would like to appear.

William Chase, distinguished and much sought after portraitist, had a great percentage of his work refused by his sitters, and it is said that even the genial and brilliant Gainsborough, who painted ladies to look like lovely goddesses and endowed his male sitters with incomparable masculine grace, was often hard put to please his aristocratic clientele. From documents and letters of the period, it appears that Dominique Ingres was severely criticized by his bourgeois patrons, who complained of lack of resemblance and unsympathetic expressions in the portraits he painted of them, which seems hardly credible in view of the powerful personality and strongly marked individual characteristics which distinguish his portrait studies.

An amusing story was told me in this connection by Robert Logan, the American etcher. A wealthy maiden lady of Boston had commissioned a local painter to do her portrait, and when it was finished had indignantly refused to take it on the grounds that the portrait was unrecognizable. Why even her pet poodle, she exclaimed, the loving companion of all her hours, had failed to recognize his mistress in the picture, which, as a matter of fact, was both an excellent painting and a first-rate likeness. Not wishing to risk the publicity and odium of a law suit to recover his fee, the portraitist in his dilemma turned for advice to a distinguished painter of his acquaintance, who also happened to know the recalcitrant lady. The latter in due course received a letter from the portrait painter, informing her that he had effected certain subtle changes in her picture and that if she would come to see it in his studio, she would, he felt sure, be highly satisfied with the result.

The invitation having been accepted, the friendly adviser appeared in the painter's studio shortly before the hour appointed for the lady's visit, bringing with him a piece of fresh bacon, which he proceeded to rub over the features of the portrait. When the lady arrived, bringing her poodle with her, she found the distinguished artist admiring her portrait and congratulating his colleague on the excellent resemblance he had obtained. To these eulogies the lady replied dryly that the portrait did not please her, and that even "darling Fido" did not recognize his mistress. "But, dear Madam," insisted her friend, "aren't you aware that dogs, especially poodles, are notoriously shortsighted? Hold the little darling close to the picture, and then see if he does not recognize you." Held close to the canvas, Fido, who sniffed the delicious aroma of bacon grease, made frantic efforts to kiss the painted image of his mistress, succeeding in applying several licks to her mouth, eyes, and nose. "See, Madam," remarked the painter, "how the dog recognizes and adores your likeness." Needless to say, the lady was won over to admiration and the portrait was paid for.

IT WAS DURING these summer weeks, when most of my friends had gone to the country, and Paris was in its canicular doldrums, that I became one of the longshoremen of Paris, haunting the river, either with my easel on the quays and banks, or on the *bateau-mouche*, the little paddle-steamers which ply up and down the river, from Charenton to Suresnes. Everywhere there were subjects and models in plenty: river craft, green islands, their verdure blending beautifully with the smoke of passing steamers, the perennial fishermen of the city quays, symbols of patient optimism, and the Paris navvy loafing by his side in his picturesque corduroy trousers hitched up with wide, red flannel belts. Next to being in the country, the Paris Seine was the ideal summer resort for the painter.

Wallace Methven, nicknamed "the Count," owing to his swarthy complexion, black snappy eyes, pointed moustache, and tiny goatee, often accompanied me on these sketching expeditions and river trips. Under the rustling trees of plebian Charenton or in the cool glades of the royal pleasure grounds of St. Cloud, we made many a picnic, faring sumptuously for a few sous on *moules marinière* ("mussels"), crisp fried potatoes, and a *chopine* of light white wine.

About this time I made the, for me, fortunate acquaintance of a wealthy American, who was residing with his family in a villa at Garches, a charming suburb in the wooded region of Versailles. His life's ambition, long thwarted, had been to become a painter. Having finally amassed sufficient money through many years of business, he was now setting about to indulge his passion for painting. Being in need of experienced advice, he turned to me, and it was arranged that throughout the remainder of that summer I should spend the weekend at Garches as his guest and give him instruction in painting. The arrangement proved both profitable and delightful, and I still look back with pleasure at those summer weekends. My pupil's villa was beautifully situated in wooded grounds on a hilly slope and gay with flower gardens. From the window of the room reserved for me I had an enchanting view of parkland with Paris and the Eiffel Tower in the hazy distance. During fine weather, meals were served outdoors, and seemed to me like heavenly feasts in such surroundings, where, besides being made heartily welcome by the family circle, I was allowed to work on my own, whenever my pupil did not require my assistance. In addition to paying me for my lessons, my pupil eventually turned patron and purchased several of the sketches I did at Garches.

That September I changed quarters and roommate owing to Frost's vacating his studio in the Rue Delambre, which I could not afford to keep up by myself. On Mathes's return from St. Jean-du-Doigt, we found a furnished studio in the Impasse du Main, close to the Gare du Montparnasse, which we shared together. As neighbors we had Max Bohm and Willard Simmons, another Cleveland painter. In a court facing our bedroom was the large studio of the famous sculptor, Bourdelle.

My sketching lessons now at an end, the problem of raising funds became once more acute. The few poses I could get were not enough to

keep me going. It was at this juncture that we resorted to an heroic measure. Having made the acquaintance of two prosperous-looking compatriots, Mathes and I decided that they could, and should, under suitable persuasion become clients. We determined to invite them to a studio feast, my share of which almost exhausted my remaining capital. The menu was copious, including hors d'oeuvres, roast chicken, cheese, dessert, and, needless to say, a generous supply of wine. To give the proper "bohemian" atmosphere, we made an artistic arrangement of our viands on the draped model stand, and laid cushions to recline upon.

We felt our efforts and expenditure were having the desired effect when one of our guests, replete with food and wine, remarked: "My! You artists certainly live the life of Riley!" Well, we were triumphantly assured of the fact when our fellow-feasters, before departing, purchased several of our canvases.

Unfortunately, this successful expedient could not be developed into a system, and our little deal had brought only temporary relief to my financial plight. Mathes, who had small funds to go on with, was however willing to share his all with me. So I had the choice of accepting his hospitality, or facing a cold winter with nothing in my pocket. I had not even the wherewithal to return to America, nor could I think of applying to my family for money, knowing how hard it was for them to make both ends meet. My brother Alex was studying at the National Academy of Design and working part-time as a gymnasium instructor at Columbia University, earning just enough to maintain himself. My other brothers and sisters were still at school.

The dilemma seemed without issue, when, as if in answer to a telepathic message, a letter from my eldest sister, Celia, arrived with a check sufficient to pay for my passage home. Although in my letters to her I had never mentioned my financial distress, knowing that her husband was earning only a modest salary, some deep sisterly sympathy must have read between the lines how matters stood with me, with the result that she sacrificed many months' savings to come to my assistance. The affectionate terms of her letter overcame any sense of humiliation I might have felt at accepting her generous gift—one that I can never forget nor repay.

It was late in October when this providential letter arrived. The weather had turned cold and rainy, and my only pair of shoes were leaking badly. To conceal their plight, if not to remedy their defect, I invested in a pair of spats, which gave an unwonted air of dandyism to my nether extremities. Further inroads on the miraculous check I dared not make, and I set about without delay to inquire about a passage to America. Informed at the Holland-America line that the *Noordam* was leaving within a few days and that a young American painter, Max Kuehne, a friend of Jack Casey's, was taking the same boat, I decided then and there to embark on that venerable tub, sharing a cabin with Kuehne.

Having only the suit of clothes I stood up in and only a few changes of linen, I was able to stow away my small sketches in the greater part

of my valise. The larger canvases, rolled up, with pieces of oiled paper between each picture, formed a voluminous, separate bundle.

With still vivid memories of the horrors of *mal de mer*, I sought counsel how to avoid this visitation. A French friend, used to Channel crossings, advised wearing a flannel belt tightly rolled round my stomach, while little Adrée, the model who had posed for me, insisted on presenting me with a liquid remedy she had purchased as a parting gift at the neighboring chemist's.

A little group, most of them as poor as I was, gave me a farewell lunch at Robardelle's, the patron contributing to the feast with a *fine* ("liqueur brandy") and coffee, and wishes of a speedy return to France with *"beaucoup de dollars"*—a wish I most heartily reciprocated.

It rained cats and dogs that October afternoon, and it seemed to me that the weeping heavens were in tune with my parting mood. Although I had arrived in Paris in the rain, almost friendless, I had been filled with ardent hope and a rosy vision of the new life I was to taste. But this parting in the rain was toward a future that seemed as clammy and depressing as the drip of the autumnal season.

On the railroad platform I found Kuehne, and Jack Casey, Mathes, Rigny, Ambrosio, and a few other lads and demoiselles of the Quarter who had come for the parting handshakes and embraces.

THE *NOORDAM*, for all her venerability, was as steady and seaworthy a boat as man could wish for, though our cabin, far down in her broad hulk, was somewhat lacking in ventilation. But I was fortunate in my cabinmate, for Kuehne was a merry and thoughtful companion, who, moreover, promised to interest his friend Daniels in my work when we got to New York. Another attractive personality on board was a tall, handsome American Negro, named Scott, an art student who had worked under H. O. Tanner, the celebrated American Negro painter, at Etaples.*
Scott, who was returning to his native Chicago, proved a great attraction to the Dutch girls, who did their utmost to engage his attention—but in vain, for he seemed oblivious of their blandishments. He sat at our table, where I had occasion to admire his exploits as trencherman, in which he could easily have established a world record.

I had armed myself with the flannel waistcoat talisman, recommended by my friend, but at the very first meal, had barely time to rush on deck and find the rail. Kuehne, having helped me to our cabin, I bethought me of Mlle. Andrée's remedy to soothe my qualms. But, oh ye gods! it had the most nauseating taste and the result was to leave me retching and sicker than ever. How I cursed the French chemist who had concocted it! But on the morrow, my curses were turned into blessings, for his vaunted potion had done its duty in miraculous fashion, and from

*This was William Edouard Scott (1884-1964), portraitist, muralist, and illustrator. Born in Indianapolis, Scott studied at the Chicago Art Institute from 1904 to 1908, then in Paris at the Academie Julian and Academie Colarossi. For more information see T. D. Cederholm (comp.) *Afro-American Artists: A Bio-bibliographical Directory* (Boston: Trustees of the Boston Public Library, 1973).

that time until the end of the trip I was literally "on the top of the wave," defying wind and weather, a rejuvenated being.

Most of the passengers were Dutch. The menfolk, solid, stodgy burghers, spent the greater part of the day in the smoking room, drinking large measures of rich, brown native beer, while their women sat chattering and eternally knitting. The little Hollanders were allowed to run wild, and I have seldom met with more impertinent youngsters. Even the youngest members of this unruly crew, little chaps of five years, could be seen smoking big black cigars. But a few days of heavy seas calmed their mischievous antics, and after several days below decks, they reappeared in a chastened mood.

The day before our arrival in New York, the weather turned freezingly cold. The rigging and bulwarks were covered with ice, and the sailors kept busy chopping it off and clearing the deck of its slippery surface.

·7·

1910-1914

TOWARD NOON of November 2, 1910, the *Noordam* docked at Hoboken—two years to a day since I had sailed for Europe. At the pier my brother Alex was awaiting the arrival of the boat, and as soon as he saw me, began cheering and waving his arms frantically. The customs officials paid little attention to my scant wardrobe, but my bundle of canvases had to be unrolled and examined to make sure I was not smuggling in any Old Masters. At the pier I said goodbye to Scott, who was leaving for Chicago that evening. Poor chap! We were never to meet again, for I was told that he died shortly afterwards.

Having made a date with Kuehne to be introduced next day to Mr. Daniels, I left to bunk with Alex in his little room on Amsterdam Avenue, close to Columbia University. Two old schoolmates of mine, Salvatore Lascari and George Davidson, were living in the same house.

Alex, who the year following my departure for Europe had applied and been accepted as head leader for Camp Wise, had the previous autumn realized his ambition of studying art at the Academy of Design in New York. An excellent all-round athlete, he had been engaged as assistant coach for basketball at Columbia and also as gym instructor—the youngest and most popular of the trainers in physical culture. His chief in that department, Professor George Meylen, was and still is an admiring and staunch friend of Alex's. As the gym classes took up his afternoons, he spent his mornings and evenings studying at the art school.

This academy had been, a few weeks before my arrival, the scene of a minor drama. Having from my letters learned something of what was being done in the art world of Paris, Alex, while working from the nude model in the life class, experimented with the device of painting green or blue outlines around the figure, about which I had written to him. Furthermore, instead of painting in mixed colors, he had, again following my suggestions, worked in pure color oppositions and with a much more brilliant palette than that which was usually employed (i.e., palette containing only earth colors). These experiments of Alex having interested several of his fellow pupils, the professors at the academy took alarm at what appeared the introduction of a dangerous new tendency—a violation of all accepted standards—and decided to stamp out this "revolutionary movement." Having learned that Alex was the innovator of these reprehensible practices, they informed him that he would either have to conform with the academic standards of painting or leave the school. Alex, with his sturdy convictions, preferred to quit the academy rather

than slave away at what he felt was useless and time-killing labor. Now he was working in his little room, painting studies from still life and portraits of his friends. Although his work lacked the technical excellence he has long since acquired, he even then showed great skill in the arrangement of his subject matter, and gave promise of that mastery and delicacy of color that is now acknowledged in his painting.

Max Kuehne had more than kept his promise in regard to interesting Mr. Daniels in my sketches, for when I called on him, I found him already genuinely interested in what I proposed to show him. Picking out three of the small pictures I had brought with me, he expressed his delight at the arrangements of color and paid me $150 for the three sketches—which seemed to me a staggering amount of money to possess all at one time. Daniels, who had made his money in business, was an enthusiastic bibliophile and lover of rare books. Through Kuehne he became interested later in painting and in artists, and when eventually he entered the art field as picture dealer, he quickly established himself as one of the leading exhibitors of modern American art.

Nor was this my only stroke of good luck while in New York. On Columbus Avenue there was at that time a small art gallery, owned by a Mr. Katz. Courageously entering his store one day with a bundle of my sketches, I succeeded in interesting that gentleman. Having told him of my sojourn in Paris and explained some of the new tendencies in French art, he ended by buying two of my sketches for seventy-five dollars and promising me an exhibit, provided that my larger canvases showed equal to that of my smaller pictures.

Having invested some of my new wealth in fitting myself out with a complete new wardrobe, my only thought now was to get home as quickly as possible and rejoin my family. With new clothes on my back and money in my pocket, I felt once more that the world was mine.

NO RETURNING prodigal was ever accorded a more tender and joyful welcome than that which awaited me at Cleveland. Dear Mother and I very literally "mingled our tears," while Dad, who looked suspiciously like joining in our emotion, had resort to his usual wisecracks, mingled with a selection of French phrases, specially got up for the occasion. I found brother Sam grown into a husky lad. Only recently graduated from high school, he was aspiring to become a writer. David and Morty were still at their studies, Flo was teaching school, and Ethel was helping Mother at home. As for little Minna, she was still the baby and our pet. Already the older children were contributing toward the family budget, for the care of so large a family was keeping Dad's nose to the grindstone. Flo's salary as schoolteacher was a considerable adjunct, while David and Sam, who had acquired a newspaper route, were earning enough to pay for their studies. So it was a happy and proud moment for me when I offered to return the money my sister Celia had so generously sent me. This, however, she firmly refused to accept for the present, telling me I could pay her back when I was finally established in my career, but not before.

THE CLEVELAND MUSEUM OF ART, which has come into existence since those days, has done much to bring the idea of art and painting nearer to the public. By means of exhibits representing various artists and schools of painting, as well as by intelligent publicity, the Museum has been of great service to all seeking to inform themselves and to keep in touch with the modern movements in art. But twenty years ago Cleveland's activities in that field were restricted to a few small art shops, exhibiting the most banal types of painting and the colored prints, then in almost universal vogue. As was to be expected, the studies I had brought back with me from Europe met with small favor among these art dealers, who regarded them as both crude and anarchic. The only one who, as in the past, showed interest and sympathy with my work was Louis Rorimer. Through frequent trips to Europe he was familiar with the new tendencies in the art world of France. Yet he seemed doubtful about the commercial value of my work, when he came to see it at our house, for, as he put it, "Paris was still a long way off from Cleveland." Nonetheless, he courageously offered me a large gallery in his interior decorating establishment to exhibit my work, and even promised to arrange a lighting system which would show off my pictures to the best advantage. Though he himself admitted the decorative qualities and harmonious color arrangements in my pictures, he warned me that, compared with the dark brown school of painting then prevalent, my canvases would appear to the public like a pyrotechnical display.

The cost of providing stretchers for my canvases and the necessary simple frames ate up most of my small capital. With what remained I rented a large room facing the north side of Euclid Avenue to serve as studio, for it was essential that I should keep on working. In this I followed the advice of Mr. Rorimer, who thought it would be an opportune place to show my work if any in Cleveland should be curious enough to venture in to see it.

The Rowfant Club, an organization of book lovers and of the elite of Cleveland's intelligentsia, announced an exhibition of work by Cleveland painters to be held at their club rooms. I was informed, on inquiry, that there was still time to send in pictures, but that they would have to be submitted to a jury of local painters. The picture I submitted was one I had painted at St. Jean-du-Doigt, rich earth and golden gorse in the foreground, the view plunging into the dark blue and purple waters of the ocean beyond. The picture, at first promptly and indignantly rejected by the jury, was eventually accepted after Henry Keller, a teacher at the Cleveland School of Art and member of the managing committee, had made violent protest, threatening to resign if my painting was not hung.

So hung it was, and in one of the best places. Surrounded by the conventional, somber-colored works of the period, my canvas, with its pure colors and simple design, produced a somewhat startling effect. Though the publicity it received was not altogether favorable, it served to stimulate curiosity regarding my coming one-man show at Mr. Rorimer's galleries.

For the preparation of this show Mr. Rorimer had spared neither trouble nor expense. Not content with removing the art wares of his firm

to make room for my pictures, he had tastefully arranged the showrooms with pieces of furniture, chairs, and lounges, so as to give the place an intimate air and enable visitors to view the pictures at their ease. When finally I stood gazing at my line of framed canvases, leaning against the wall, waiting to be hung, the worried expression of my face was too noticeable not to be remarked by Mr. Rorimer, who laughed when I explained that my entire fortune had been invested in the frames. And when finally my previous canvases were hung, my worry was increased by stagefright. So weak and amateurish did they appear in my eyes, I almost felt like apologizing for my temerity in exhibiting such beginner's work.

Thanks to Mr. Rorimer's efforts, the show was well attended, both by his friends and by the local contingent of artists and art lovers, whose mood varied between curiosity and hostility. Many of the comments I overheard were most unflattering, but there were also many who admitted a lifelike quality and gaiety in the pictures—an out-of-doors feeling. At any rate, I had the satisfaction of noting that even those who most disapproved were not left indifferent by the view of my work.

How pale and timid these first works of mine would appear in an exhibition of modern art today, when scales and keys of color pitched to the highest discords and the most shocking distortion of form scarcely suffice to *e'pater le bourgeois*—"make the bourgeois sit up."

The art columns of the *Cleveland Press* all noted the "extreme daring" of these works; the *Wachter and Anzeiger*, a local German newspaper, going so far as to speak of the evil influence which Cezanne had had on my work, and exclaiming against the crude handling of my colors. A canvas I had painted with my palette knife raised a particular outcry, being described as "painting with a spade."

Despite the disparaging press comments, I was approached by a group of young artists, some employed at lithographic shops, others studying at the art school, asking me to take charge of a painting class on certain evenings of the week, including Sunday. I gladly accepted the offer, both on account of the fees and the opportunity it offered of establishing contact with a group of sympathetic artists. There were also other tangible results from my exhibition—proceeds from the sales of half a dozen canvases, mostly due to the efforts of my good friend Mr. Rorimer. He would not even hear of accepting a commission, assuring me laughingly that my exhibition had served to advertise his establishment—a blessed white lie on his part, seeing that the conservative element of his clientele had, if anything, been shocked by his, to them, bad taste in sponsoring the exhibition of such daubs on his premises.

The first purchaser at my show had been Mr. Paul Feiss, well known in Cleveland as a connoisseur, bibliophile, and man of wide culture.* As president of the Chamber of Commerce, he had eminent social standing and influence. Thanks to his kindly efforts, his example was followed by some of his friends and relatives, while he and his charming wife con-

*The 5,000 volume collection of Paul Feiss (1875-1951) was acquired by the Kent State University Library in 1952. Some 450 of his books formed the nucleus of the Department of Special Collections.

tinued to take an interest in me, visiting at my studio and receiving me in their home.

My painting class was soon in full swing, and two evenings a week and Sundays found my studio on Euclid Avenue busy as a beehive. Some of my pupils possessed greater knowledge than I did in the technique of drawing, and their humble attitude toward me as their master was a little embarrassing. My class included Hugo Robus, my studio mate in New York, Gus Hugger, and William Sommers. The two latter, who were high-priced artists at the Otis Lithographic Company, had studied abroad, and only the urgent necessity of providing for their families had forced them into commercial art. My work, they said, had brought them a glimpse of colorful joy and shown them a means of escape from the sad and sour academic brown sauce that had been stifling painting.

As all my pupils were experienced draftsmen, I started them painting in pure colors. Behind and about the model I would arrange green, blue, yellow, or purple draperies so that these colors would reflect on the flesh. Instead of the conventional gray or brown, they would paint shadows in the tones of the surrounding colors—yellow, green, blue, purple—and then would juxtapose pure high colors for the lighter flesh tints. I explained that if a picture were painted only in warm or in cold colors, it would remain practically a monochrome, whereas a judicious differentiation, and color areas of warm and cold, would create a feeling of variety and light. Sommers, who instinctively possessed a beautiful color sense, soon arrived at very laudable results.

Henry Keller, Hugo Robus, and a few bolder spirits among the Cleveland painters, in sympathy with our new ideas, formed a group called the "Cleveland Independents" and launched a campaign in favor of a more modern style of painting. Again Mr. Rorimer came to the front and graciously placed his gallery at our disposal for an exhibition of the works of the new group. The New Movement was launched, and it soon included as many rabid addicts as the most violent Paris school of *fauves* ("wild men"). In fact, it was not long before I, who had brought the first glimmering of the new light from Europe, was accounted an "old hat," much as many an early leader of the French Revolution ceased to be "a Pure" in the eyes of his one-time disciples, once the latter had assimilated the new doctrines.

AMONG THOSE who professed to be won over to the New Movement was a wealthy lady residing in a near suburb of Cleveland, who proclaimed herself an admirer of my work. Although she could not be induced to add any of my canvases to the collection of those she had purchased from other local artists, she nonetheless wanted to take lessons from me at her home. Living some distance from the city, she offered to send her car to conduct me there and back. To discourage her, I named what I thought would be a prohibitive price for lessons, but to my consternation she accepted these terms. I was to come twice a week for a couple of hours to her home—a magnificient mansion, surrounded by vast grounds, which at this season of the year had the air of a snowbound forest.

These lessons turned out to be somewhat one-sided affairs, for when I arranged compositions in still life for her to paint, she inevitably made such a bad start that I would be called in to help her out of her difficulties, with the result that I would generally paint the greater part of the canvas. Later at an exhibition of pictures by Cleveland women artists, I saw a number of these still lifes signed with her name.

One morning, after about my twelfth lesson, she told me she was curious to see how a portrait was started and "laid-in." Would I show her how it was done? Her husband, appearing opportunely upon the scene, offered to pose as model for the occasion. He proved, in fact, to be an excellent model; his facial characteristics were striking, and the light and shade in his features were well marked. So I set to work enthusiastically to build up the portrait, and by the end of the morning the head was quite finished, and the resemblance sufficiently telling. Both husband and wife were loud in their praise of my study. But while they were eulogizing, I was seized with sudden rage, for I realized that this was only a shrewd trick to acquire a portrait for the price of a painting lesson. Some time before my hostess-pupil had commissioned a portrait of one of her children from a Cleveland painter and paid a good price for it—proof that she could well afford to pay me an honest price for the portrait—study which, as a result of being painted by way of this lesson, would now belong to them as a gift. Determined they should not get the better of me so easily, I decided to give them an extra lesson. So, while commenting on the manner in which I had painted the portrait as being the usual form of procedure, I took my palette knife and deliberately scraped out the study. Needless to say, my painting lessons ended that day.

EARLY IN THE SPRING I had sent a number of canvases to the Katz Galleries in New York. The show was hardly noticed in the press, only the *New York World* according it a brief but favorable comment. One small canvas was disposed of, the proceeds just paying for expenses of packing, shipping, and dealer's commission. I had hardly expected more. But my stay in Cleveland had better results than I had dared hope for. As for my brother Alex, who had returned from New York and was working every day in the studio with me, he expected to take his summer job at Camp Wise and return to New York late in the fall.

I obtained a few orders for portraits, which, to please my patrons, I painted in the conventional manner with subdued tones. The money I had earned was burning my pockets, and I was itching to get out into the country and paint with the freedom I had acquired during my two years abroad. But living in the American countryside costs considerably more than in France, to say nothing of the greater variety of picturesque places in that country. My urge to return to France grew irresistible. My family, I realized, had deluded themselves with the hope that I would settle down in America, if not in Cleveland, then in New York. But I feared that if I remained, I should sink down to the level of a local artist and possibly be forced to take up a job in commercial art. Though it would be hard to break once more with the loving influences surrounding me at home,

there was the comforting thought that I should henceforth be able to contribute toward the family exchequer; besides, my younger brothers were growing up and would soon be able to help my father in the task of bread winning. Mother, as usual, was of the opinion that I should not be tied down, and my friend and adviser, Louis Rorimer, agreed that a return to Europe was essential for my further development.

After calculating expenses for my trip to Europe, I found I should have enough left to paint for a whole year. It seemed to me that it would be better to work wholeheartedly and untrammelled abroad, returning to America at intervals to earn money for fresh studies, than to stay on in America in the hope of earning more money, without leisure to paint and study in the way I longed to do. Meanwhile Alex was to gain more experience in New York, with the hope that we could later join forces in Paris.

EARLY IN JUNE, 1911, I crossed on the Red Star *Lapland*, docking at Antwerp, where I seized the opportunity to view Rubens's magnificent *Crucifixion* and also the wonderful zoological gardens.

Without notifying any of my friends that I was returning, I arrived in Paris and put up at the Hotel Haute Loire, at the corner of the Bld. Raspail and the Bld. Montparnasse. My room was just above Pere Baty's restaurant on the ground floor. Looking across the street, I could see straight into the Dôme and recognize some old comrades sprawling in their chairs over their evening aperitif—Edgar McAdams, Harold Dunning, Zeno Alexander, and Lionel Waldon. To see them in their accustomed place, drinking their accustomed drink, made it seem as if nothing had occurred since last I saw them there, eight months ago. Nor did they seem a bit surprised when I appeared on the scene, so used are those who live in the bohemian Quarter to the comings and goings from and to all parts of the globe.

I, however, had one big surprise, and that was Jack Casey strolling along the boulevard, immaculately dressed in the latest fashion, with gloves and spats, swinging a silver-headed cane. The warmth of his greeting made up for the unenthusiastic welcome of my Dôme friends. He told me that some months ago he had been offered the directorship of the art department in an important printing establishment, the Imprimerie Vaugirard. Besides earning an ample salary, he had all his afternoons free for his own painting. Berthe and he had been able to quit the enforced hospitality of Vernon and had taken a comfortable villa on the Isle de Beaute, at Nogent-sur-Marne, near Paris, with a garden and a punt on the river, where he spent much of his time sketching. In his affluence, Casey never forgot his old comrades, several of whom he employed to work for him in the printing plant. He had also reformed in other ways, as I noticed, when at my invitation to take a drink, he ordered a glass of milk. By dint of will power, he had turned teetotaler. At times the old craving would become too strong. But these were only short bouts, which he would battle out, and then return to sober living.

Studying in the Quarter I found William Zorach, a Cleveland boy and

one of my early pupils. Billy, who had been an expert lithographer, and had saved sufficient from his earnings to come abroad and study for a few years, was steeped in the New Movement, with every chance of making his mark, for he was extremely talented. As Mathes was in the country, I suggested to Billy that he and I should share a furnished studio for a few months, to which he gladly assented.

As Anne Goldthwaite, president of the American Women's Club in the Rue de Chevreuse, was leaving for the country, we took over her studio in the Boulevard Raspail, just below Leduc's restaurant, close by the Dôme—a large, cheerful place, with a window facing the courtyard, through which the sun poured during the early morning. Billy, who was an early riser, would prepare a huge dish of oatmeal for breakfast, and then be off to his school, while I spent the mornings sketching along the streets. For the afternoons I engaged a model, from whom I was making a study in the nude.

Unfortunately, the proximity of the Dôme brought a flock of loafers to our place, and often at night would come knockings at our door and pleadings from intoxicated pals to be admitted, when, as sometimes happened, the belated visitors would curl up on the floor and go to sleep. The absence of the usual concierge made it difficult to keep away these disturbers of our sleep.

THE HEAT became oppressive in July, and Zorach departed for the country, where I should have liked to join him, had I not been immersed in my big canvas. So I continued alone in the studio. It was while I was working away with my model during the dog-days that I first heard of the delights and pictorial attractions of the Île-aux-Moines, destined to play a considerable role in the history of my career. A letter from Miss Goldthwaite, whose studio I was occupying, gave me such an alluring description of the "Monks' Island," which she was then visiting—its lovely land and seascapes, quaintly clad inhabitants, and the unspoiled atmosphere of this little island, lying off the coast of Brittany in the Gulf of Morbihan—that I decided to go there as soon as my lease of the studio had expired.

Mathes returned just then from St. Jean-du-Doigt, where he had done some beautiful watercolors. Finding the city too hot to work in, he was easily persuaded to join me in my expedition to the Monks' Island, especially after we had seen the series of sketches which Miss Goldthwaite showed us on her return to Paris. It seemed, indeed, a painter's paradise: colorful gardens with quaint thatched cottages, rockbound beaches with red lattern sailboats in the offing, pine-topped slopes with goats disporting themselves in the sunlight, and Breton folk in their old-world costumes. An added inducement was the cheapness of living in this favored spot.

It was an all night's trip to Vannes, the Breton port where we were to take the boat for Île-aux-Moines. Just before starting on our journey, Mathes, remarking that we must have wine to wash down our supper of sandwiches, disappeared to purchase a bottle, heedless of my remonstrances that there was not time. Alas, my fears were to be realized!

143

Hardly had he dashed off through the platform gateway toward the buffet than the train moved off.

At Vannes, where I arrived early next morning, I put up at the Hôtel de la Paix, which had been recommended to us, to await my companion, and as the next train from Paris was not due until that evening, I spent the day rambling about the little port. In due time Mathes turned up that evening, smiling and unabashed, and in reply to my indignant scolding, merely replied that I was quite right. And that was that.

Early next morning we set out for the Monks' Island, leaving our luggage at the hotel, for we had decided to make a tour of inspection before taking up our residence. The short distance from the hotel to the steamer led through narrow cobbled streets lined with picturesque wooden structures dating from the sixteenth and seventeenth centuries. Underneath the battlemented walls surrounding the venerable "Tower of the Constable" flowed a dark and sluggish stream, flanked by dilapidated, moss-covered *lavoirs*. Here Breton women in their still medieval-looking costumes and white coiffes were busy washing the household linen and chattering noisily as they bent over the swirling wavelets of soapsuds, or spread the gaily colored washing out to dry—an animated scene, full of brilliant coloring and movement. As it was market day, the narrow streets were teeming with squealing pigs and ill-kept cattle, driven and tugged along by stolid peasant women, while their men, in wide-brimmed hats (resembling the national Spanish headgear) ornamented with silver buckles and long, flowing black ribbons, bargained and argued over the sale of their livestock. The little whitewashed cafés were crowded with customers drinking bowls of *chistr mad* (the Breton term for high-grade cider). Here was the Celt in his native atmosphere, resembling, in many respects, his Irish and Welsh kinsmen. For it is a known fact that when the Breton sailor from the northern coast encounters a Welshman, they converse freely in their ancient language.

The boat that takes the round of the various islands in the gulf leaves at eight in the morning, but long before that hour the decks were crowded with peasant folks, who had finished early marketing and were returning to their island homes. Squirming piglets, held in tight embraces, were shrilling desperately, seconded by the cackling of fowls. This barnyard concert became a veritable pandemonium, with the arrival of a grunting fat porker, dragged tailwise on board

Amid the piled-up vegetables, butter, and livestock, we managed to find standing room near the pilot's cabin. A long walled-in mole led out to the gult, studded with tiny pine-covered islands, among which junklike fishing boats, called Senagots, with square-cut red sails, were scudding before the breeze, the scene evoking, more than anything else, a Japanese print. Not even along the Mediterranean are skies to be found so pure and limpid, while the frequent rainfalls at all seasons of the year lend a freshness and variety to the vegetation, in vain to be searched for in the sunnier southlands.

At some of the stopping-off places where there was no landing pier, our little steamer would lay to a short distance from the shore, while

fisherwomen in crude flat-bottomed boats rowed out to take passengers ashore. The Île-aux-Moines is the largest of the group of islands in the Gulf of Morbihan, which numbers some 365—one for every day of the year. Most of these islands are uninhabited and bare, except for the hardy, windblown pines, which take root even in the stoniest soil.

The greater part of the passengers being bound for Ile-aux-Moines, preparations for debarking, as we neared our destination, resulted in renewed squealing and cackling, as the livestock was forcibly maneuvered into groups for landing.

So we came in sight of the island. An enchanting picture unfolded itself: in the foreground the little harbor of the island partially blocked by five or six tunny boats, with gaily painted hulls, the visible portions of their furled sails showing a dark and velvety red (a stain procured from the bark of the pine tree) interspersed with patches of variegated hues. Beyond, a pine-shaded hill overlooked the landing pier, near which old ladies sat knitting on the low walls, just as we had seen in Anne Goldthwaite's pictures, while red-bloused fishermen pattered about the harborside in their wooden clogs. This charming sight, mingling with the sweet garden scents and the rich ozone from the sea, filled us with sheer delight and, there and then, captured our allegiance to the Monks' Island.

Having inquired from the fisher folk, who greeted us kindly as we disembarked, we were informed regarding a few modest hotels to be found on the island. At the Hôtel Petit we parleyed with the *patronne*, Madame Petit, who in every way belied her surname. Of enormous girth, her white coiffe perched on a triple-chinned countenance, and her whole vast person exhaling a massive dignity, she bore a striking resemblance to the late Queen Victoria, as she sat majestically ensconced behind her counter. But her hotel was full at this season, and her prices beyond our means. So we were referred to the village butcher, who occasionally took pensionaires. There at five francs a day for the two of us we obtained board and lodging, the latter consisting of a small room with a huge bedstead, overlooking a pleasant uncultivated garden. To clinch the bargain, our amiable host, M. Razalies, brought out a bottle of cider to drink a toast to friendship in the Breton manner.

Next day, having returned to Vannes for our baggage, we took up residence in the Monks' Island, where throughout our four weeks' stay we never had a drop of rain. Indeed, the heat at times was terrific, for that summer was one of the hottest Europe had known for many years; but, as a rule, tempering sea breezes relieved the extremes of temperature. Whenever we went sketching, as we were never very far from the shore, we would take our bathing suits and go for a swim after work. Our favorite swimming haunt was among some dark rocks, where we came in contact and soon made friends with the island lads, who frequented this spot.

From early childhood I had been a good swimmer and diver, and my plunges from the rocks into the deep waters surprised the little Bretons, who never took headers, preferring to let themselves slip cautiously into the water. We were, in fact, not a little surprised to learn that these

children of Breton sailors and fishermen, most of whose lives are spent on the sea, seldom learned to swim. The reason given me by their elders, when I expressed surprise at this fact, was that a man falling overboard in his heavy oilskins and boots would not have a chance to save himself, and that it was therefore useless to prolong the agony by battling with the waves. The fatalistic, hard-headed Breton temperament asserts itself even when it comes to saving their lives. All too often men are drowned in their harbors, when a few vigorous strokes might take them to safety.

It was fun to take the youngsters in hand, as I had done in my camp days near Cleveland, and soon I had them paddling about, the more daring ones even trying to dive. Some of the boys posed for me, sitting or lying on the rocks, and felt their patience amply rewarded with a few sous.

There was much gaiety among the youth on the island. Often in the evenings there would be dancing in the little square by the fountain or in the *salle des Fêtes* at Marie Faucher's. The music was invariably furnished by an accordion, manipulated by cripple Elie, who would play the same plaintive air over and over again, no one taking exception to this lack of variety in his repertoire, from which I gathered that the Breton ear is not, as a rule, very sensitive to music. The dances were as little complicated as the musical accompaniment. A large circle would be formed, youths and maidens holding each other by their interlocked little fingers, while they stamped their sabots on the ground, giggling and shouting lustily. On these evenings the *de'bit* of Marie Faucher did a thriving business; for in those happy prewar days, when cider only cost two sous a bottle, even the most impoverished swain could afford to treat his *promise* or his pal.

There were moonlight nights, too beautiful to be passed in our stuffy little bedroom, when Mathes and I would camp in the garden, or, after a nocturnal swim, stretch out on the still warm sand and go to sleep, *couches a la belle e'toile.*

Many retired sea captains and shipbuilders came to spend their last years in this beautiful haven, and with their wives and daughters formed an aristocratic circle. The young girls of the well-to-do class were coquettishly clad, often in beautiful Chinese or Oriental fabrics, brought by the men folks from their distant voyages; embroidered silk aprons and spotless coiffes with designs in delicate Irish point lace, the two white ribbons fluttering behind, giving their headgear an air of lightness and grace not to be imparted by the chicest of Parisian hats.

Unlike the peasant class, these Island women take great care of their hands and complexions, seldom walking in the sun unless shaded by a parasol. It was my ambition to paint one of these handsome girls, but they were very shy with the stranger, to say nothing of the fact that many of them worked at the convent with the "*Bonnes Soeurs*" as lacemakers. But fortunately, thanks to my being on good terms with the village lads, and young men, I was able to visit certain homes and become acquainted with their parents. Having made a sketch of *la vieille Mère*

146

Morice, I obtained permission to paint the portrait of her granddaughter Beatrice, who was the beauty of the island. She posed for me in the garden, under the chaperonage of her grandmother and aunts.

During the heat of the day, the women folk of the family would work in the large commonroom, facing onto the garden. Mathes and I painted a group of them at their lacemaking. Their sober costumes, set off by creamy coiffes, the white-washed walls flecked with sunlight and a glimpse of the garden through the open window, made a rare and fascinating subject for the painter. We became very friendly with this little family, and at times the old father or the sons, who were employed as coast guards, would take us out in their boats—often starting before dawn—to troll for mackeral. These the Pere Morice would grill on a little charcoal stove, installed in the stem of the boat, and serve for our breakfast with huge hunks of crusty peasant bread and a plentiful supply of cider—a feast for the gods!

IT WAS THIS first sojourn on the Monks' Island which brought home to me how essential it was for the painter who wishes to draw his inspiration direct from nature to break, at least for periods, with the constraint of city life, though that city be Paris itself. The very fact of living in the painter's metropolis, where art movements changed from season to season like the fashion of women's gowns, was bewildering to the young artist still seeking his way. For the harassed painter-in-the-making this Breton island had been a veritable sanctuary and refuge. The thought of returning here another year became so alluring that I decided, then and there, to assure myself of a suitable residence for next summer. Several delightful native cottages were available. So I arranged with the Morice family that one of them should be secured for me on the most favorable terms for another summer of painting. Apart from the inspiring surroundings and congenial milieu, the island was admirably suited for a regime of economy. Food supplies were easily obtainable and extraordinarily cheap. Eggs were sold for ten cents a baker's dozen, butter cost only two cents a pound, while for fifty cents one could purchase a pair of plump fowls. As for fish and crustacea, they could be had practically for the asking.

Hugo Robus had written me from Munich that he planned a visit to Paris soon and I intended broaching to him the subject of sharing my island home. Besides being a valued old friend of mine, Hugo was a good hand at cooking; so, by taking turns at running our household, we would both have time for our painting.

October saw me again installed at Vernon. Its autumn charms and proximity to Paris, to say nothing of the happy memories of the Hotel Soleil d'Or, had made me a faithful habitue. Several of my comrades, to whom I had sung the praises of Vernon, joined me there—Methwen, Mathes, David Karfunkel, from New York, Billy Zorach, and Hugo Robus, lately arrived from Munich. Unfortunately, in contrast to the fine, hot summer weather we had so enjoyed, the fall that year was wet and disagreeable. Billy Zorach would haunt the windows, watching for

signs of a respite in the rain, and between showers would dash out, often returning with a vigorous, if hasty, sketch, exulting in "having put one over on the sun."

Karfunkel, our senior by a few years, was a very quiet person, but possessed of a keen sense of humor. His air of paternal dignity had earned for him the nickname "Pap" among our little crowd. In spite of the rain, he was a prodigious worker, and any lull in the bad weather would find him outdoors, attacking some huge canvas. Cloudy, stormy skies were his forte, and these he painted beautifully. As a draftsman, few contemporary Americans can compare with him. His compositions are always distinguished and vibrant with poetry. Among the sketches and cartoons he has designed for decorations, I have seen many that are masterpieces. Yet through some freak of fortune Karfunkel remains unrecognized, except by a few, qualified people, and this man of great talent is often forced to commercial expedients in order to provide for himself and his little family. Under a regime of enlightened art patrons, such as the Medici, his great abilities would be employed in beautifying palaces and public buildings.

AS THE PERSISTENT RAIN made work outdoors impossible, our company turned Paris-ward, Mathes and Zorach returning to the United States, while Hugo Robus and I took a temporary abode in a little hotel in the Quarter. Thanks to the friendly offer of a friend of mine, Fred MacKean, who occupied a large studio-apartment in the Rue Boissonade nearby, I enjoyed the use of a workshop, without inconveniencing the owner, who was not a painter.

To Hugo, who was then working at the schools, I confided my project for the next summer season at Île-aux-Moines, and found him willing to become a partner in the cottage. I have seldom met anyone in whom physical appearance and character were so closely allied, as they were in Robus. Tall, well built, with close, curly blond hair, frank blue eyes, and a most winning smile, he was a sensation in the Quarter, and the girls literally fell head over heels for him. But Hugo seemed to be oblivious of the power of his charms—or possibly the memory of a girl at home to whom he had plighted his troth acted as talisman, together with his innate modesty, which I have seldom seen equalled. In all the years I have known Hugo, I cannot recall one act of pettiness or selfishness on his part, and though many years have passed since we last met, I know he is one of those to whom time and absence makes no change and that when we do meet again, we shall be able to start just where we left off, unchanged in our affection.

While working at MacKean's studio, I had the good luck to sell a large garden picture, painted at the Île-aux-Moines, to one of Mac's American acquaintances. This unexpected windfall enabled me to set up shop for myself. In the well-known studio building, at No. 9 Rue Campagne-Premiere, off the Bld. Montparnasse, known as the "Rabbit Warren," I rented a tiny studio for three hundred francs a year, at that time sixty dollars. It was a primitive dwelling, lacking all so-called "con-

veniences," such as water, gas, or electric lighting, to say nothing of the fact that located on the cheap side of the building it received the morning sun, instead of the desirable north light. But to compensate these drawbacks, there was an entrancing view into an old convent garden—one of those unspoiled relics of a bygone age, which still exist in unsuspected corners of Paris.

The furnishing of my new quarters was quickly accomplished. It consisted, I recall, of one deal table, serving for toilette and dining, a few chairs, a small mirror, my easel, and my flat steamer trunk, which latter, prolonged with a wooden box and covered with a thin mattress, served as a somewhat adamantine couch. A small "godin" stove kept the place well warmed and enabled me to do my cooking and even prepare a convivial *pot a feu* once a week for my friends.

Among my frequent visitors at that time was David Williams, an art student. He had been a chum of my brother Alex at the academy in New York. Williams, who at times would work in my studio, was never quite sure that his talent for painting would take him very far. Literature was already engaging his attention ever more seriously, and later won him over completely to the profession of writing. His brother, Wythe Williams, was at that time foreign correspondent in London for an important New York newspaper. Although David spent but a short time in Paris, going over to join his brother in London, it was through my meeting with him that my later friendship with Wythe was established.

At the Dôme the yearly lot of *nouveaux* had arrived from America. They could be easily recognized by their swagger and eccentric clothes, which were supposed to be in keeping with what a true Latin Quarterite should wear. Among the most picturesque of the new crop was Daniel Gale Turnbull. He wore a long and luxurious golden beard, and had blossomed out in the traditional *rapin* costume—*lavalliere* bow tie, wide corduroy trousers, tapering at the ankles, and an ample black cape in lieu of overcoat. He was a handsome and striking figure, and we soon became friends. Having found him a studio on the Blvd. Montparnasse, I helped him to do the moving, doing my usual stunt of carrying up the stove unaided, after which Turney stood us an excellent dinner at the Café Lumesnil.

Obsessed by Latin Quarter traditions, Turnbull would at times indulge his romantic fancies in the true Murger fashion. Late one evening, while walking down the Blvd. Montparnasse, we saw a herd of lean, miserable horses being led to the slaughter house. Turny, who had just received his monthly allowance from home and had been celebrating the occasion, was in a mellow mood, and all his sympathies went out to the unhappy victims. Then and there he determined that at least one of them should be saved from the slaughter, and straightway started negotiations with one of the drivers, whom liberal potations of vin rouge had rendered amenable to a nocturnal deal; with the result that Turnbull, after handing over several banknotes—the greater part of his month's allowance—was allowed to select the sorriest-looking nag in the drove, which he proceeded to lead off with a rope to the nearby Dôme, where

he insisted we must drink to the health of his steed. Having related with gusto the story of his acquisition to the American group in the Dôme, he invited them to come and inspect his "bargain." But, alas! when we came to the lamppost to which we had left the poor animal tied, we found Mazeppa had vanished—whether by his own means, or surreptitiously recaptured by the driver who had sold him, we never found out. In any case, the ransom money was not returned.

ONE MORNING in early December I noticed a stout, energetic-looking American scanning the numbers of the Rue Campagne-Première. Recognizing in me a compatriot, he came up and asked me if I knew an American painter by the name of Buck Warshawsky, who lived somewhere in the neighborhood. I replied that I knew him well and was, in fact, just going to look up Warshawsky, so that if he cared to come along? As we climbed up the steps of the studio building, the stout gentlemen asked me questions regarding Buck, explaining that a brother of his, while in Paris, had been on intimate terms with him, but that said brother was not much of a judge of character and as a rule his friends were a dull, uninteresting lot. To his astonishment, instead of knocking at the studio door, I unlocked it with my key and ushered him in. He took in the situation immediately and joined me in a hearty laugh. Then he introduced himself as Wythe Williams, brother of my friend David. Fed up with England and journalism, he had thrown up his job and come to Paris with the intention of devoting himself to writing in a higher form than daily newspaper correspondence.

On the ocean trip to France, Turnbull had made the acquaintance of two American girls, one of whom was Margaret Porter, daughter of O. Henry, the other a charming young Philadelphian, Viola Irwin, who had held an important position with a publishing company in that city. The two girls were now sharing a studio on the Quai de Bethune, high up, overlooking the Pont Sully, in one of the most picturesque quarters of old Paris. To celebrate Christmas they arranged with a girl friend to give a little dinner in their studio and asked Turnbull to bring a few friends to join them. Turney asked Wythe and me whether we would care to come to this party. We gladly accepted.

The young ladies were charming, and Christmas dinner, served in the picturesque studio with shaded candlelight, was a very enjoyable affair. As for Wythe and Viola, it was the most evident case of love at first sight I have even seen—a veritable *coup de foudre*, as the French say. It had been his intention to lead a strictly celibate life, devoting himself to his writing. But after this fatal meeting, there was a complete fadeout of all these plans, and the vision of connubial bliss with Viola seemed alone worth realizing. His conversation henceforth became a series of monologues, extolling the beauties and the wisdom of his sweetheart, to whom only the lack of a position prevented him from proposing immediate marriage.

William's newspaper experience had brought him into contact with important personalities, and he had a wide acquaintance with writers. On

one occasion he brought Samuel Blythe, a frequent visitor to Paris, to see me. When I was showing Blythe, with whom I had become very friendly, a series of my paintings, he dryly remarked that they were very interesting, "but what the h_____ are you going to do with them?"

That, indeed, was the question for most of us, and Williams was no exception. His collection of short stories, on which he had been working industriously, was invariably returned by the magazines to whom he submitted them. Many years later, after he became well known, these stories fetched much better prices than he had then hoped for. In a few months, having exhausted his resources, he was on the road to becoming as penniless as any *rapin* in the Quarter.

One morning, just as day was breaking, a knock at my studio door awakened me from my slumbers. Having obeyed the summons, a strange sight met my sleepy eyes in the dimness of the dawn light. There stood Williams, in evening dress and a high silk hat. His patent-leather shoes were covered with dust, his voice was husky, and he seemed about to drop from fatigue. From what I could gather, he had spent the night in various cabarets at Montmartre, having decided on a last fling before going dead broke—*mourir en beauté'*. After the last bottle of champagne had been paid for, he found he had not enough money left for cabfare back to the Quarter, so he had been obliged to walk all the way from Montmartre to my studio, right across Paris. He asked to rest awhile before returning to his room. In a few moments he was fast asleep, dead to the world.

When he awoke about noon, the savory smell emanating from a huge pot of beans, simmering on the stove, aroused a tremendous appetite in my guest. According to my calculations, the supply of beans in the pot was to last for several days, but I had reckoned without my guest. The onslaught he made on the bean pot was so ferocious that by the time we had finished, the pot was as empty as his purse. By way of retaliation, I made him pose for me, wearily leaning on his cane, his top hat tipped over his still somnolent eyes. Unfortunately, the sketch was destroyed, which prevented me from carrying out my repeated threat to Williams that I had in that disreputable portrait the means for blackmailing him in the future.

Through Williams I met Louis Joseph Vance, who bought one of my early pictures, and Montague Glass, who had come into great prominence as the author of the inimitable "Potash and Perlmutter." Monte's formidable height and bulk are the measure of his loving personality and unstinted generosity. He has countless funny tales to relate, as amusing as the ones he published. But few people who read his stories know that besides being a great humorist, he is an erudite and profound student of music. Had he chosen music as his profession, he would have made as great a success at that as he has with his writing. Rare and well-prepared dishes are a cult with Monte, but unlike other gourmets, he would rather not dine at all than eat the most succulent repast alone. He is not happy unless he can share his feast with others, and consequently he is invariably surrounded with guests at dinner. Not content with feasting his

fellow creatures, he is forever helping some of them out of difficulties, financial and otherwise.

Availing myself of an invitation by Peggy Porter and Viola, I painted from one of the windows of their studio a large canvas of the view below—the Pont Sully in the foreground, the yellow, sluggish Seine flowing under its arches, the further banks, with their quays and buildings and the dome of the Pantheon crowning the distant skyline.

As the two girls knew many prominent Americans in Paris, they suggested that I hold an exhibition of my works in their studio. Accordingly, invitations were sent out, and Williams, who was a personal friend of our ambassador, Myron Herrick, persuaded that distinguished gentleman to inaugurate my little show.

Climbing the steep stairs to the top floor studio left His Excellency breathless and puffing, but he was nonetheless charming, and complimented me as a fellow Clevelander. Thanks to these distinguished auspices, the newspaper people who attended wrote exaggeratedly glowing accounts of my modest show. The tangible results were the sale of several small pictures and a commission to do the portrait of a charming young woman from Philadelphia.

One of the purchasers was the well-known Monsieur Frederic, owner of the famous Tour D'Argent restaurant, who also invited me, together with Peggy and Viola, to a sumptuous lunch and gave me permission to paint from a window in his apartment, on the floor above the restaurant, commanding a wonderful view of Notre Dame and the Cité. The large canvas which I did of this view was exhibited at the Beaux Arts Salon in the spring of 1913.

While Wythe Williams's financial affairs were still very precarious, his short stories finding no publisher, he received a tempting offer to take charge of the *New York Times* office in London. The excellent salary made it possible for him to realize his fondest dream, and he and Viola were married and left for England. Peggy Porter, who accompanied them to London, shortly afterwards returned to America, where in due course she married Cesare, a famous American newspaper artist.

A LETTER from the Morice family in the Île-aux-Moines informed me that a little house had been reserved for me for the coming summer. As it contained a spare room, Hugo Robus and I found a third partner for our household-sharing plan in Jacob Kunz. "Jake," as he was commonly called, was an old timer in the Quarter and a native of Nashville, Tennessee. Besides his Southern drawl, Jake possessed a rich baritone voice, with which, on Sundays, he would swell the choir of the American Church. Though an inveterate cigar smoker, his voice seemed in no ways to suffer, nor did his alleged vice of laziness, about which he was wont to boast, affect his output as a painter, for I have seldom known a more energetic artist than Jake.

So, with a prodigious supply of colors and canvases, the three of us set out in the late spring of 1912, for our five months' sojourn in the

Ile-aux-Moines, where the Morice family met us at the landing stage and conducted us to our new domicile.

The little cottage, situated below the village church, close to the water's edge, was isolated from the neighbors by a field, and surrounded by a pleasant, walled-in garden, with a large apple tree spreading its branches over the entrance door. Simply furnished, but scrupulously clean, with plenty of room for the three of us, it was all we could have desired. As for the island and its surroundings, I found to my relief that my two comrades shared my enthusiasm for its beauties, so highly praised by me.

Our nearest neighbor was old Mlle. LeDuc, who lived in a little flowered cottage, alone but for a swarm of cats. We won her friendship by presenting her with the remainder of our stale crusts for her chickens, in return for which she would always have fresh eggs at our disposal. Many of the adult women on the island were spinsters, the *"genus homo"* being rare, owing to the great toll on male folk taken by the sea. The lives of these poor creatures were brightened by frequent visitors to church and by relieving their starved maternal instincts with coddling and caressing the small children of their luckier sisters, or their own household pets. Nowhere else have I seen such spoiled and well-cared-for tabbies. After dark, windows and doors of all the native dwellings were hermetically closed, night air being regarded as dangerous to health, and our neglect in that respect elicited many warnings.

Entire families slept in one room, breathing in the close and fetid air, and I could well understand why tuberculosis was so widespread on the island, despite the healthy outdoor life of the daytime. The local doctor told me that he had in vain advocated a cult for fresh air and great cleanliness among the islanders. Intermarriage and malnutrition were subsidiary causes of the prevailing malady which decimated this island-paradise. Every Breton community harbors cripples and a few idiots—"innocents," as they are termed by the kindly village folk—due to alcoholism and intermarriage, it is said.

The favorite "innocent" of our locality was a certain Xavier, who was employed to do the most menial jobs. An inveterate tippler, he would invest his day's earnings in getting thoroughly drunk. Often his flashes of repartee made me doubt whether his intelligence was really inferior to that of his fellow islanders. Xavier and old Jean Francois Criquer constituted the express company of the island, trundling trunks and boxes in their wheelbarrows from the landing stage to the village.

Like his colleague, Xavier, Jean Francois was blessed with an inextinguishable thirst. His wife, known popularly as *"la Grande Charlemagne,"* owned a little drinking establishment, or *de'bit*, near the port, but as she insisted on cash payments, her husband perferred to take his custom elsewhere.

THE MONTH of May was brilliant and warm, and so dry that there was

talk of asking M. le Curé to offer up prayers for rain, lest the crops be ruined. But we revelled in the sunshine, especially Jake, who would bask in it for hours like a lizard, while Hugo and I were boxing or "putting the weight" with a huge iron ball we had found.

In June rain came, and came with a vengeance, for I counted seventy consecutive days, of which not one was without some rainfall. We had to resort to the tactics of Vernon, dashing in and out between showers to get in some painting. Hugo and I managed to do some indoor work from models, but Jake, who was mainly a landscape painter, passed entire days seated on the floor, playing solitaire. During the very bad days, Hugo and I would devise new dishes for our menu, Jake doing the fetch-and-carry jobs. Our living expenses, including forty francs rent a month, maintained a steady average of two francs a day per head, which, to Hugo and me who were living on our savings, was very satisfying. As for Jake Kunz, his phenomenal consumption of cigars soon earned him the reputation of being an American millionaire.

Undaunted by the rain, the three of us would go for long tramps, exploring the island throughout its length and breadth (nine and three kilometers being the maximum respectively). After leaving the main village, situated above the port, houses and farmsteads grew rarer and ever farther apart until one came to desolate tracts, where nothing was to be seen except a few windblown trees, stony fields with shaggy vegetation, and, here and there dotted over the bleak landscape, "dolmens" and "menhirs"—those monumental stones set up by the ancient Druids, who once inhabited the island.

Often on Sundays, while the islanders were *en fête*, we would take the ferry boat across to the Port Blanc and the mainland. Nearby, overlooking the gulf, lived Rochefort Cassidy and his young wife. Cassidy, who had been an officer in the United States Navy, had abandoned his naval career to take up painting, and had bought this lovely house, both he and his wife having fallen in love with this corner of Brittany. His large yacht, moored near the house, enabled them to explore the Breton coast both for painting and sport.

But though along the coast such things as modern summer villas and pleasure yachts might be discovered, within a mile from the sea civilization seemed to have stood still for the last six centuries. There we saw community life as primitive as in the Middle Ages, and the natives who issued from their cavelike dwellings would stare at us as if we were beings from another planet, while the children would run away in fear and hide. The older inhabitants spoke only the ancient Breton tongue, understanding nothing of modern French except perhaps a few phrases.

Towards late afternoon we would stop at some small wayside *buvette* for refreshment. This would invariably consist of a large round loaf of coarse but delicious-tasting country bread, a huge pat of butter, and a bottle of cider. After eating and drinking to our hearts' content, the general reckoning would amount to about thirty centimes—six cents. Happy prewar days!

Despite the rainy weather, our days were fully occupied with painting—a proof that congenial company and mutual interests, even under

154

dripping skies in a Breton village, are the best incentive for work. One of the canvases I painted of peasants working in a field, with the village and church in the background, showed a marked improvement on anything I had yet done. This painting was shown the following year at the Pennsylvania Academy and was reproduced in the *Studio* as one of the interesting pictures at the exhibit.

With the return of finer weather during the latter part of August, we made an expedition to Belle-Ile-en-Mer, the largest island off the French coast, about thirty miles by water from our island. The savage coast, huge rocks, and varying vivid coloring of the sea greatly impressed us, and I promised myself I should take an early opportunity of spending some time in such paintable surroundings.

The hedgerows of our island were teeming with blackberries of a particularly large and juicy sort, with which Hugo concocted pies and puddings that were voted a great success—but only by our household, for the villagers could not be prevailed upon to touch this fruit, alleging that it was nefarious and accursed. According to a Breton legend, the Thorn of Crowns of the crucified Savior was made from blackberry brambles.

Superstitions were many, and all illnesses were attributed to "worms." The local doctor, nicknamed "Dr. Tant-Pis" ("so much the worse"), was only consulted when his advice would come too late. That of the "Good Sisters" at the convent was generally preferred; and their prayers and old wives' remedies were considered to be more efficacious than medical prescriptions.

While sketching in the port one day, I made the acquaintance of a celebrated Bohemian artist, Franc Kupka, well known in France for the illustrations and etching he had done for Elisee Reclus's book, *L'Homme et la Terre* and for his drawings in various European publications. Much as he admired the island, he had come there to rest, rather than to work. For, as he told me, in recent years he had ceased painting from nature and was limiting his pictorial efforts to the field of the Abstract. He was, in fact, attempting to realize a purely creative art, approximating music, since the latter was an art not dependent on nature or exterior forms. The "Fauves" and Cubists deformed, or, as they put it, reconstructed the elements in nature. But Kupka was working out his own method, which consisted in placing mere spots, long, short, or square, so as to form various arabesques, varying the tint or color as the spot differed in length or thickness. This conception of painting he called "Orphism."

Some of his *envois* at the Salon were remarked for their strangeness, but his influence never became strong enough to form a school. Though Kupka had his moments of notoriety, he was never taken up by the dealers. I saw a great deal of him later at his studio in Puteaux, near Neuilly. After the war, when his country became independent as part of Czechoslovakia, Kupka received an important appointment at the Ministry of Fine Arts in his native land.*

*Although it has been suggested elsewhere (*Frantisek Kupka, 1871–1957*, New York: The Solomon R. Guggenheim Museum, 1975) that the Bohemian abstractionist first visited Brittany in 1920, there is no reason to doubt Buck's memory about meeting Kupka in 1914. In fact, the authors of the 1975 catalog say that a certain Warshawsky inter-

OUR LONG STAY on the island, the wholesome fare, and outdoor life left us fit and husky for the coming dismal winter months in the city. In spite of the long rainy period, we were all tanned to a dark brown, especially striking in Hugo, whose skin showed almost dusky against his blond hair and bright blue eyes.

Not wanting to trust our precious canvases—which, with our painter's paraphernalia, made a formidable bundle—to the baggage car, we trundled them along into the train, crowded to capacity at this time with people returning from their vacations, with the result that we had to spend the night in the narrow corridor, squatting on our impediments.

Before leaving, I had arranged with the landlady, Mme. Martin, to take on the cottage for the next summer, even if my companions should not return with me. For I now had many friends on the island and needed neither companionship nor the facilities for working from models. Our departure from the island was an occasion for a farewell demonstration, most of the villagers assembling at the wharf. Many were the sighs wafted after handsome Hugo as he boarded the waiting steamer. As for Mme. Yvonne, the tobacconist, she embraced our friend Jake with tears in her eyes, declaring she had never known a client so *gentil* and so generous.

THE PENNSYLVANIA ACADEMY of Art had constituted a jury in Paris to judge and send over works by American painters living in Europe. The preceding fall three of my pictures had been accepted, and this year three more were taken. As the entire selection for each year only amounted to thirty, I had good reason to be satisfied. I had asked my family to send the large nude of the *Resting Dancer*, painted at the end of my first stay in Paris, to the jury in Philadelphia, but it was refused. It was later sent to the Academy in New York, where it was accepted and generously noted by the critics of the New York press. The following year it was once more sent to Philadelphia, where it was again refused, though in the meantime the Paris jury for Philadelphia had accepted some of my work. The picture was then sent to the biannual exhibit at the Corcoran Galleries in Washington—a very important show—where it was accepted, the *Studio* drawing attention to it as a particularly strong work. On several occasions I have had canvases exhibited at the Pennsylvania Academy, but they have consistently refused the *Resting Dancer*. Later when I brought it back to Europe, it was shown at the Paris Salon. It was eventually purchased by Will Irwin, who saw it in my studio. The chances are that my landscapes and the figure pictures, which were accepted by the Paris jury, would have also been turned down by the more academic- and less modern-minded jury at Philadelphia.

viewed Kupka for an October 19, 1913, *New York Times* article titled " 'Orphism' Latest of Painting Cults." It is pleasant to think that the *Times* correspondent who visited Kupka at his studio in Puteaux was Buck himself.

THERE WERE SEVERAL interesting and notable picture shows in Paris that winter and the following spring. At the Galleries Druet there was a retrospective exhibition of the works of Vincent Van Gogh. These superb works, imbued as they are with a spirit of revolution, appear, nonetheless, when compared with the "Fauves," as those of a delicious classicist. His color and drawing were complete in harmony, and his subjects of the simplest—a field of furrowed earth, some trees on the horizon and a burning sun, seen with the naive intensity of a peasant who loved the land. Earth, water, and sky vibrated and lived through the forceful, direct technique he employed. His trees, one felt, swayed and fought with the wind, and always there was a great unrest—the unrest that filled and tortured his own unhappy self.

In contrast to this was Bernheim Jeune's exhibition of the paintings of Renoir, representing over three decades of the master's work, from the earlier colder style, influenced perhaps by Courbet, to his later period of warm, luscious, happy landscapes and voluptuous figures. Here was painting for sheer love and color. No heart struggle was apparent in these works. The landscapes were smiling and serene; his portraits lovely and contented "bourgeoises"; the sun-flecked nudes, bathing in limpid streams, were plump and rosy nymphs in Arcady. But though at times the color would become luscious to the point of cloying, his work never descended into the merely pretty and vulgar.

TO CELEBRATE Thanksgiving, Fred MacKean had invited Louis Rittman and me to dine that night with him at Le Duc's restaurant in the Quarter. Having arrived at the appointed time, we waited for the best part of an hour for our host. When he still failed to show up, we decided to start dinner, as we were getting very hungry. Knowing what a generous host our friend was, we ordered a copious meal, including turkey. When nine o'clock came, we were still without our host, the other diners had left, and the waitresses were preparing to close up. It was evident from their glances that we had worn out our welcome. But the question was, how to settle for the dinner? For between us we had not enough to settle the reckoning for so elaborate a meal. The only thing was to throw ourselves on the mercy of the *patronne*. When I explained to her our dilemma, she smiled sympathetically and told me I could pay the bill at my convenience. Fortunately, we had enough to tip the young woman who had waited on us, and so could save our faces.

The next day "Mac" calmly told us he had entirely forgotten about his date with us. But he made up for his forgetfulness by standing us an excellent dinner that night.

THE PICTURE I had sold the previous season had gone a long way towards paying for my stay at the Île-aux-Moines. The money I had brought over with me was calculated to last a year, and thanks to strict economy, I could keep going through the winter. The spring, however, would once more see me up against it. My brother Alex had sold one of

the pictures I had left with him in New York for a small sum, but this would soon be swallowed up.

The problem was solved for me quite unexpectedly through the good offices of Richard Brooks, the well-known American sculptor. Brooks, whose kindness to young artists was proverbial, and who had a laudable habit of persuading his wealthy friends to invest in the works of the younger generation of painters and sculptors, told me that he might be able to dispose of some of my pictures, if I cared to let him try. Needless to say, I did care! So he selected a few of my canvases, among them being a large study I had painted along the Seine. A few weeks later he brought me the astounding news that this picture had been sold to Mrs. Harry Payne Whitney and handed me a check for 2,005 francs ($500), a sum which far exceeded my fondest hopes.* Hurrah! I was set for months to come!

This was one of the many good turns Brooks was always doing. With complete disinterest, he would give up his time to helping other artists, often himself buying a sketch from a needy colleague. His wife kept open house at their studio in the Rue Falguiere and many a poor student has replenished his empty stomach at her copious teas. Poor Rickie Brooks's all too early passing has left a void in the Quarter that has never been filled.

WITH THE FIRST fine weather in spring, I left for my happy hunting ground in Brittany—this time alone, for Hugo Robus, discouraged by the rain of the previous summer, had joined Karfunkel in the south of France, where he could be sure of getting sun. Jake, too, lacked the courage to risk another rainy season on the island. But later in the season, I had the company of Parke Dougherty, a well-known American painter, who had been residing in Paris for many years. I had known "Doc" for some time. As a member of the Paris jury for the Pennsylvania Academy, he had always voted for my pictures and shown me many kindnesses. He would often visit me in my cottage and go out sketching with me.

Close by my dwelling, adjoining the church, was a large, gray, dismal building, called "Noah's Ark," in which were lodged the indigent and homeless ones. Among them I found many interesting models, eager to earn the small fee I offered for posing. One of my favorite models from "Noah's Ark" was a tall, gaunt, old woman, with red-rimmed eyes, resembling a sea bird, nicknamed "La Ouistrack," being the Breton for "bird of prey." Dressed in greasy black, with a handkerchief tied round her head in lieu of a coiffe, she seemed the living incarnation of her sobriquet. Another interesting model was old Franchette, a fishwife by profession. Her life-long contact with marine creatures had turned her into something "rich and strange"—a veritable Old Woman of the Sea. I

*Gertrude Vanderbilt Whitney (1875-1942), an artist herself, supported many American artists by purchasing their works, and, in a few cases, by providing stipends to help them get their careers started. She founded the Whitney Museum of American Art in 1930.

painted her holding a basket full of the colorful rockfish she would peddle from door to door.

A large garret in a neighboring house served me as studio, a place full of mysterious shapes and corners. The light, coming from a door set very low, illuminated my models in a strange fashion—much like the footlights of a stage. There during several weeks I worked on a large canvas, representing *"La Ouistrack,"* her pathetic little grandchild and old Franchette seated on a low wall, overlooking the sullen waters of the bay below them, against a background of gray, cloudy sky. My idea was to show the women folk waiting for the return of the seafarers, and I believe the title I gave it brought the picture some measure of success—*Those Who Remain Behind.* It was shown the next season at Philadelphia and widely reproduced. The pathetic figures and the gray, sad coloring made a touching, and for my part, too sentimental appeal for the picture to have any real artistic value. Later I did a portrait of Parke Dougherty, sketching in the port.

Most of the season I devoted to figure work, but in the evenings I occasionally made notes of sky effects and passing clouds. At twilight I would seek out my favorite spot in the Bois d'Amour, overlooking the bay. Toward sunset the fisherman would set sail for home, and I would watch the square red sails of the primitive-looking barks gliding noiselessly by, like visions in a dream. Certain currents in the gulf, especially at ebb time, were extremely powerful, and often the sailors would have to veer and maneuver for a long while before they could continue their route. Between the island and Port Blanc were undercurrents and suction pools that were a constant menace to seafarers. The slightest carelessness or ignorance of sea laws in these parts would spell disaster.

To many my life on the island that summer might appear a lonely one. Intellectual companionship, except for Dougherty, was limited to conversation with fishermen and peasants on the state of the weather, the haul of fish, and the prospects of the potato crop. But these folks were interesting, their politeness hid no hypocrisy, and their solid primitive virtues made up for the lack of veneer and superficial intellectuality of the cities. From Paris I had brought a stock of books, and the schoolmaster loaned me some delightful volumes by Anatole France. With a petrol lamp by my bed, I would read far into the night. My isolation was filled with lovely visions, and the natural, simple life I led imbued me with the will and energy to realize some of them. I was observing the painter's maxim: "To arrive, one has to live in paint, think in paint, eat paint."

Never did time pass so quickly. Before I could realize it, the end of September had come, and with it a definite change in the weather. The wind had begun stripping the leaves from the trees, and its dismal howling awakened in me a vague, forgotten sense of loneliness, a desire to get back to beings who spoke my own language, the company of comrades at the Dôme and of the Great Masters at the Louvre.

AT VARIOUS GALLERIES in Paris new manifestations by the Cubists

were taking place. Many of the works exposed resembled puzzles or algebraic problems, while the prefaces of the catalogs, often covering several pages, had the air of philosophical and metaphysical treatises, employing terms that had nothing to do with painting.

It was then that the Futurist School suddenly sprang into being. The Italian writer, Marinetti, sponsored and led the group, among which were several able and talented artists. Marinetti's revolutionary manifestos, demanding the destruction of the "romantic past," the razing of ancient monuments, and the filling up of the canals of Venice, were the talk of the day among the "intellectuals," "*avant-gardistes*," and the "misunderstoods" generally.

The impression produced by the first exhibition of Futurist art in Paris was both striking and unexpected. Many of the Futurist artists showed marked technical ability. In contrast to the gray, dead-colored surfaces of the Cubists, their pictures had vital color patterns, and the deformations of their subjects were often logical. Unfortunately, the underlying idea of Futurism was also a literary one—an attempt to depict on a flat surface sensations that only the moving picture camera could impart.

I recall one picture of delightful pattern. It represented diners in a crowded cabaret. The waiter had been called to serve a group in a far-off corner. To suggest his passage through the room, his legs were shown in one corner of the room, his body in another, while his arms, holding the plates, had reached the table to be served. A woman flirting with a man nearby was suggested with her eyes painted next to the latter's forehead.* An automobile race, with the crowds coming and going, was expressed in like manner.

The Futurist experiment proved of great value to designers of textiles, the decorative arts, and even styles in women's apparel. Color and fantasy were brought to the heretofore drab multitides. Stage ideas and scenic effects were renewed. However, the term "futuristic" was everywhere misapplied to things novel and original, but having nothing in common with the basic idea of Futurism.

In general, the American artists in Paris, especially those among the older groups, were little affected by the revolution in art going on about them. The periodic exhibitions at the American Art Club consisted mostly of academic work, vaguely tinctured by Impressionism. Charles Thorndyke and Roderic O'Connor, who in his youth had been an intimate friend of Gauguin, were the only two among the older men to strike a newer note at the Club shows.

Though primarily intended for painters, the American Art Club of Paris counted among its members a few musicians, some writers, and

*While the Futurists assembled major exhibitions of their work during 1913 in Rome, Rotterdam, Berlin, and Florence, the important show Warshawsky refers to here was held at the Bernheim-Jeune Gallery February 5–24, 1912, and featured works by Boccioni, Carra, Russolo and Severini. Joshua C. Taylor, *Futurism* (New York: The Museum of Modern Art, 1961), p. 122. The painting Buck admired was probably Severini's *Dynamic Hieroglyphic of the Bal Tabarin* of 1912 (Museum of Modern Art).

businessmen interested in art, as honorary members. Among these was Mr. Holden, the representative of an important jewelry firm in Chicago, who frequently exhibited works by Club members in the anterooms of his Paris offices. At his request, I left some of my paintings with him.

AFTER MY RETURN from the country, Turnbull and I had made a round of the various art galleries in the Rue Lafitte and the Rue Drouot, then the center for art shops and picture dealers, in the hope of disposing of some of our sketches. But when, in answer to the invariable questions, we had to admit that we were not painters of recognized standing nor members of any of the official Salons, we were not even permitted to show our works—a bitter and humiliating experience. But as one of the art dealers told me, they were perpetually pestered by hordes of professional and amateur artists, and were rarely shown a canvas that indicated the slightest talent, so that they had made a rule of applying only to artists who had already attained some success with other dealers or at the various Salons.

All the more welcome was the news, imparted to me by Mr. Holden one evening at the Club, that two of the sketches I had left with him had been sold to clients of his establishment, a young broker from Chicago and his newly wedded wife. The young couple had expressed the desire to meet the painter and through Mr. Holden had extended an invitation to dine with them and Mr. Holden some evening at the Café Lavenue.

They were charming hosts, the young wife a lovely blonde—a genuine type of American beauty. In the course of the evening, her husband asked me whether I had ever done a portrait, and if so, whether I would paint his wife. Such opportunities came rarely my way. Yet I hesitated before accepting, reflecting that my tiny, poorly equipped studio would make an unfavorable impression on these prosperous young people, to say nothing of the fact that the light to paint by was bad. The dark, unclean stairs of the "Rabbit Warren" they would have to toil up would suggest the struggling, poverty-stricken artist—an impression which, however justified, was one to be avoided if possible.

Remembering the adage that "nothing succeeds like success," I replied that I would gladly paint the portrait, but that I could not make an immediate appointment, being fully occupied for the rest of the week. Later I would sent them my address and make a rendezvous for the first séance. Meanwhile I ran over in my mind the various friends who were becomingly housed and who might loan me a studio for a short while.

The most eligible victim seemed to be my friend, Lawson Adams, who lived in a *pavillon* in a courtyard off the Blvd. Raspail. There on the *entre-sol* floor he had a well-furnished apartment, while the entire upper floor served as studio and dressing room. He was also one of the rare artists in the Quarter who possessed a bathroom, of which his needier friends took frequent advantage. On such occasions good-natured Adams would not only supply us with soap and towels, but even with drinks after our ablutions. A homeless and penniless colleague was always sure

of finding shelter in these quite luxurious surroundings. Decidedly, Adams was my first choice on this occasion!

Early next morning I dragged him out of bed and explained my case. Not only did he promise me the loan of his studio for as many mornings as were needed to paint the portrait, but he also informed his servant that I was the temporary master and that she must receive and usher in my clients. The concierge was also duly tipped to point out where my studio was to anyone who might inquire.

Jubilantly I sent off a note arranging the date for the first sitting, and when at the appointed hour the Chicago gentleman and his wife were ushered in by the maid, I was happy to note that my clients were duly impressed by my affluent surroundings.

Every morning my charming model arrived at the appointed hour, and at noon her husband would call for her, when Lawson's maid would serve aperitifs. The finished and approved portrait was framed and put under glass to protect the still wet paint, after which it was taken off to be packed at Lefevre Foinet where I bought my painting materials. Calling at the shop a few hours later to see that all was well with the packing of my portrait, I was greeted by the good Madame Foinet with looks of consternation. The workman, who had brought the picture from my studio had, in carrying it, inadvertently pressed the canvas and the still wet paint had stuck to the glass.

On hearing of this catastrophe, I passed what the French call "a very bad moment." Poor Madame Foinet, almost in tears, vowed she would discharge the careless *commis*, who was offering profuse apologies. Fortunately, the harm done was less than I feared, and I succeeded in restoring the portrait to its original condition, though some of the freshness of the colors was lost in the process.

The Maison Lefevre Foinet was an old, established family firm, dealing in art supplies in the Rue Vavin, off the Boulevard Montparnasse. Whistler, Sargent, Carolus Duran, and many of the better-known American and French painters were among its customers, the Foinet colors having the reputation of being superior in quality to the machine-manufactured articles supplied by the wholesale dealers. In the back of their shop one could see the workmen grinding the colors by hand on long marble-topped tables. The Foinet family, who were proud of the quality and durability of their wares, were continually experimenting in mixtures that would not darken or fade. On several occasions I had had recourse to them in regard to shipping packages to America, and I had found them so efficient and obliging that I became one of their steadiest clients.

Knowing from experience the financial straits in which most young painters find themselves, Monsieur Foinet of his own accord had offered me credit for my art materials. It was necessary, he declared, that a young painter should be able to work continuously and not be hampered by lack of materials.

Though Monsieur Lefevre Foinet had given me unlimited credit, the moment came when I began to fear that I was taking undue advantage of

his kindness. Many months had passed since I had paid him anything on my already long account. To be able to keep on working, I resorted to drawing and sketching in colored crayons—a very inexpensive medium, but unfortunately also, at least in my case, a very unsatisfactory one.

A knock at my door one morning ushered in Monsieur Foinet. My guilty conscience made me fear he had come in the guise of collector of debts. But he laughed away my qualms, scolding me amicably for not having been to see him for so long. The important thing for me, he said, was to keep on working, and as long as he made paints and canvases, I was welcome to his wares. He assured me that he was certain I would pay him whenever the fortunate opportunity arrived. I told him that the money received from the portrait would enable me to return to America, where I could show my work with a possibility of selling some pictures.

Knowing that my resources after paying for my steamer passage would be very slim, Monsieur Foinet offered to frame my canvases and pack them for shipping, saying that he would charge these items to my account. Seeing that I was leaving for distant shores, where so much—or so little!—might happen, such confidence and generosity seemed to me nothing less than sublime. But I also knew that I was not the only one to benefit by such kindness, and that many a struggling artist had been thus befriended by Papa Foinet. I am glad to say that his confidence has been seldom misplaced.

MONTE GLASS and I had already had some correspondence. On my return to New York in the spring of 1914, I was delighted to see his smiling face greeting me at the pier as my boat came in. Owing to some customs formalities, which are still a mystery to me, my pictures had been sent to the government warehouse in bond to be examined by the art experts. Pictures by American artists pay no duty on entering the United States, but owing to some technicality, works of art of which the declared evaluation exceeded a certain sum were submitted to certain formalities before they were handed out. This often causes considerable delay and expense. But "it is an ill wind. . . ." Monte Glass happened to know an important customs inspector who examined my pictures. The light in the warehouse was favorable and so were the comments of the customs inspector, who had a fondness for pictures, with the result that my friend Monte then and there purchased two of my Paris studies.

It was he who suggested I show my canvases to some of the New York picture dealers with whom he was acquainted in the hope that I might be able to arrange an exhibition of my work. But remembering my first attempt a few years previously, and fearing that my painting had not yet gained the qualities which further maturing would develop, I decided to wait a few years before again showing in the big town.

A new dealer had come to Cleveland, George Gage, who was more thoroughly acquainted with what was going on in the painting world than was the case with his backward and conservative colleagues. We arranged a series of exhibits of works of the better-known Eastern

painters and also got into touch with collectors and art lovers in Cleveland. Gage's galleries were housed in an old mansion on lower Euclid Avenue, the upstairs rooms of which were occupied by several well known local painters and illustrators. This building was becoming the center of art life in Cleveland.

Mr. Gage, who was always in quest of something new to show his public, remembered having seen some of my work at previous exhibits, and offered to sponsor a show of my pictures at his galleries. Good advice and moral support were given me by Henry Keller, instructor at the Cleveland School of Art. Within a few years the prestige and knowledge of this distinguished painter had so raised the status of the local art school that it was now reckoned as one of the best institutions of its kind in the United States. In recent years Keller's pupils had won many first prizes in national art school competitions.

During the exhibit at the Gage Gallery I made the acquaintance of Paul Reinhart, then one of the leading art dealers in Chicago. He advised me to come to see him, saying that, if possible, he would arrange an exhibit of my works at his gallery. I was also corresponding with my friend, Harry Solon, portraitist, who had a studio in the Fine Arts Building in Chicago. Solon urged me to come to Chicago, offering me the use of his place while there. Joe Gonzales, manager of Reinhart's gallery, also came to see my exhibit and offered to arrange for a show, but the only available date was several months later and I was unwilling to wait so long. It was then that Solon interested Carrol Anderson, of the Anderson Galleries, who offered me a two weeks' show in his exhibition rooms, which were on the ground and first floors of the Auditorium Building.

My experience with picture dealers, at least in America, has convinced me that they are, generally speaking, maligned persons, whose role and services to the artists are often misrepresented and misunderstood. The fact is that in arranging shows for newcomers in the art world, the dealer's profits are problematical, while his liabilities are certain and considerable. Besides having to pay high rental for his premises, which are generally in an expensive neighborhood, he is responsible for the salaries of his salesmen and for the cost of advertising the exhibition, to say nothing of giving up valuable space to the works of the exhibitor. There are, of course, artists who rent the galleries at their own expense. But in many cases like my own, the only remuneration the dealer can hope for is the problematic commission of the sale of works exhibited. The fact is that in such cases the dealer very seldom recovers his expenses. The principal advantage of such shows to the dealer is that they serve to advertise his gallery, keep his clients interested, and furnish an opportunity of disposing of some of the dealer's stock, for he invariably has a private gallery where his clients can view a selection of canvases which the gallery owner is offering for sale.

The record of my own dealing with the showmen of my profession in New York, Chicago, and other American cities has been a happy one. Despite general opinion, I have found that the American art dealer is far from being avaricious, and is often both generous and helpful to the

young painter struggling for recognition. My first exhibit in Chicago at the Anderson Gallery resulted in a long and lasting friendship with the owner. Apart from commercial considerations Mr. Carrol Anderson is sincerely and enthusiastically interested in all phases of painting. To my knowledge he has exhibited works of many painters whose chances of appealing to the public were very remote. It was his genuine enthusiasm for their work which made him willing to incur expense and put himself to great trouble.

The popular conception of picture dealers as a race of harpies, who crush the spirit and squeeze all the profits out of the unfortunate artist, who is left to die in a garret—although doubtless there are Shylocks among this profession as in every other—is one of the legends which in all fairness should be exploded. It is, in fact, the dealer who often makes known the unknown artist struggling in obscurity, and who creates a demand for his work.

It is no less true that the type of picture dealer who prevails in Europe, and especially in Paris, is practically unknown in America. The Parisian dealer, for instance, will buy in all the work of a promising young painter at a nominal figure, and will often contract with the latter for a number of years, an essential condition of the contract being that a certain number of canvases must be produced within a given time, an arrangement which the young and generally needy artist accepts with alacrity, with nearly always lamentable results to his art. For it is impossible to hitch Pegasus to a plow, and few artists have the creative vitality not to sacrifice quality to quantity and to avoid submerging their personalities, which means their ultimate destruction as artists.

My first stay in Chicago was a delightful one. Harry Solon was a perfect host and his studio at my entire disposal. The Fine Arts Building was a rendezvous for the literary and artistic lights of the city. Alex Fournier, the painter of moonlights, was my fellow exhibitor at the Anderson Galleries—a genial and delightful chap, who related "Canuck" stories with an inimitable accent. He had exhibited for many years and showed no discouragement when the elusive purchaser of our exhibited works failed to materialize.

The two weeks of my exhibit were drawing to a close, and though press and critics had praised my work, no sales were forthcoming. Fournier helped to sustain my courage, when, lo and behold, on the last day of our show the miracle happened! On entering the gallery, Mr. Anderson informed me that three of my pictures had been sold to prominent Chicagoans. He also offered to prolong the show for a week, as interest was now ripening. That extra week brought very tangible results and assured me the wherewithal to return to Paris and resume my painting. While in Chicago I also was commissioned to paint the portrait of a charming old lady, Solon generously putting his studio at my disposal.

I also had a good deal of fun making sketches of my fellow craftsmen, Alex Fournier, Solon, and Pierre Nuytens, the etcher, who has since then become the owner of the famous nightclub, Chez Pierre. Only two hours were allowed for each sketch, and on time being called, the brushes were

165

taken from me. The result, though not always satisfactory, was amusing and perhaps more interesting than the highly finished product people expect in portraits. An amusing trick was played on me by Solon when he sat for me. I saw there was something queer and unfamiliar about him, but had not discovered the cause, when he burst out laughing and removed a wig from his almost bald head—an adjunct, which I, the portraitist, had failed to notice!

Among the many fair visitors at Solon's studio was one who seemed to me the most beautiful woman I had ever seen—Dolores Cassinelli, then a cinema star, employed by the Essenay Company, acclaimed by vote as the most beautiful screen actress in America. It was my great good fortune to have her pose for me for a sketch. This lovely person— a perfect Madonna type, tall and graceful—had dark hair, an olive-gold complexion, and eyes so luminous and changeful that I could hardly grasp the colors. Her complete naturalness, which had remained untouched by all the adulation that had been bestowed on her, merely served to enhance her manifold charms. Eventually she abandoned her cinema career and studied for the opera. Many years later I was thrilled to hear her voice over the radio.

From Chicago I went for a few weeks' stay to Cincinnati with letters of introduction to some well known Cincinnatians. There also my luck held good and my work met with considerable favor. The thought of New York and trying my luck there tempted me for a moment, but I decided that discretion was the better part of valor and that it would be wiser not to attempt too much at once. So back I went to Cleveland, where I found my brother Alex, who had made great progress in his work. We resolved on going to Europe together. The parting for me was made easier this time by the satisfaction I felt of at last being able to contribute to the family exchequer.

·8·

1914-1916

IT WAS THE *ST. LOUIS* which carried us to Europe. The trip must have been as uneventful as it was comfortable, for the things I can recall were the deluxe cabin and private bathroom in which we disported ourselves for the price of fifty-five dollars each, and Alex getting his money's worth at mealtimes. However lengthy the menu, there was not a dish he would skip. He would even have started on the passenger list, if that had been added to the bill-of-fare.

Our stop in Paris was of the briefest. Having met Kunz there, we decided forthwith to go to Belle-Île off the Brittany coast, for the summer, and to postpone all sightseeing until the fall. To reach Belle-Ile, which is off the main coast, we embarked at Quiberon on a small and very dirty boat, in which for an hour we suffered exceedingly—Alex in stoical silence, sucking on a pipe, a study in greens—while I leaned over the basin which the cabin boy had brought me, sacrificing to Neptune. Our plight was so bad after that hour's crossing that for two days we rested at a hotel.

It was there that we heard of the "Château des Anglais," a charming, rambling house, on the other side of the island, known as the "Côte Sauvage," which was for rent for the following six weeks—a commodious abode, with a large studio, rose garden, and several living rooms, which we rented for the modest sum of one hundred francs (then twenty dollars) a month. A kilo of butter and a weekly ride in the farmer's cart to the neighboring town of Le Palais was included in the price. Close to our residence was the lighthouse, of which the base would be strewn with bodies of dead seagulls after every storm. The unfortunate birds, attracted by the shining beacon, would be dashed to death in headlong flight. The wife of the lighthouse keeper took care of our household, consisting of Jake Kunz, my brother Alex, myself, and Hermann Wessel, of Cincinnati, where he had already made a name for himself as painter and instructor at the Art School.

Life at the Château des Anglais was delightfully quiet and calm. For weeks the only human beings we encountered were the baker from the nearest village and the postman, who also brought us our meat. Occasionally we caught glimpses of a stray tourist on the shore or of sailors taking a shortcut through our grounds. But outside diversions were easily dispensed with when there was so much to occupy our eyes and stir our imagination—marvels of sea and cloud forms, forever changing, and,

above all, huge, fantastic rocks of a deep purple coloring, such as I had never before seen.

I made a study of one of those rock groups, which under the title of *Purple Plume* (a title chosen for the picture by Miss Cary, the well-known art critic of the *New York Times*) met with some success when shown later in America. It was while working on this picture that I had a technical experience which was something of an eye-opener. While working on the canvas, I had left some spots of the painting uncovered at first, which gave a vibrating effect to the whole. The cause of this I only discovered when later, in painting out these small omissions, I noticed the picture went dead. The vibration was gone, but it returned immediately when with the edge of my palette knife I replaced the little white dots. I learned later that many painters resorted to this process to lend life to their compositions. The rich, vivid coloring of the Breton seascapes also had their effect on Wessel, who was in the habit of painting even sunlight in such low key that there was a moonlight atmosphere in all his outdoor paintings; and it was not long before "Wessel's moonlight palette," as Jake Kunz called it, discarded these lunar effects in favor of warmer, gayer tones, more in keeping with his new surroundings.

That summer of 1914 lingers in my memory as perhaps the most peaceful and least eventful of any I had ever spent, whether in America or in Europe. The only incident I can recall which for a moment startled us out of our rustication was a bathing alarm, occasioned by my brother Alex. A poor swimmer then, he had gotten into trouble while bathing off the beach. Catching his signals of distress, I hurried to his assistance, with such impetuosity that I swam out of my bathing trunks. My return to shore with my rescued brother was made embarrassing by the crowd which had assembled to watch the rescue. Having seen my brother safely ashore, I returned in quest of my lost trunks, for to face that crowd in *"puris naturalibis"* was more than my American modesty would permit; instead of which I regaled the onlookers with the spectacle of myself, diving porpoiselike, until finally I recovered the lost garment, and could emerge from the waves unabashed.

THE NEWS that an Austrian archduke had been assassinated in an obscure town in the Balkans was hardly calculated to upset the even tenor of our life. Serajevo, Franz-Ferdinand, Prinzip—what concern was it of ours? It seemed absurd that such a one-day story could cause the slightest flutter in our remote island. And yet it was evident that for some inexplicable reason this *fait divers* was attracting more attention than the spectacular trial of the wife of an ex-prime minister of France for the shooting of a leading newspaper proprietor, which was then going forward in Paris. Something indefinable had crept into the ambient air of peaceful Belle-Île, which was causing uneasiness and a sort of apprehension. So we were not sorry when the termination of our lease of the Château des Anglais and the arrival of new tenants obliged us to go elsewhere.

The Île-aux-Moines, my former happy hunting ground, was only

some fifty kilometers by sea from Belle-Île, and we determined that we would pass the rest of the summer there. So, chartering a sailboat, we embarked for that island of happy memories. It was a lucky move, as things turned out, for had we remained we should certainly have shared the fate of Arthur Frost and other Americans summering in Brittany, who, as soon as the war-cloud burst, fell under suspicion of being spies from the mere fact that they were foreigners. To prove that one was not an enemy subject it was at least necessary to have a passport, and in those days very few travelers in Europe possessed such a document, as it was never asked for, even when crossing frontiers. As none of our party had any official means of identification, it is highly likely that we also should have risked a beating or even imprisonment, as happened to several of our compatriots.

But on the Monks' Island, where I was known as a visitor of old standing and good reputation, we were on safe ground, and my word at the Mairie was sufficient guaranty for obtaining for all of us the necessary police papers to protect us from being molested by patriotic busybodies.

We rented a house facing Marie Faucher's bar, and engaged as our maid-of-all-work Natalie Morice, sister of the Mère Morice, who had sat for me. It had been Natalie's life-long ambition to use a cooking stove instead of the rudimentary charcoal hearth which was usual in the parts she belonged to, and it was the fact that our house was provided with such an up-to-date contrivance as a kitchen range which tempted her, more than the modest salary we offered, to enter our service. Her nephew, Gaston, had just arrived home after his four years' service in the Marines, but the soon forthcoming declaration of war found him mobilized for another four years' service to his country.

It was during those hectic August days that we made the acquaintance of a charming and hospitable compatriot, Signora Centanini, an American opera singer, who had married a well-known Venetian musician, for several years secretary to Gatti Cazzaza, director of the Metropolitan Opera of New York. This couple, besides being accomplished artists, were the most genial of hosts, and their house was the meeting place of artists of every nationality. Mrs. Centanini cooked as beautifully as she sang, and her American apple pies were as manna to Israel in the desert for our comrade, who had been languishing for a slice of pie ever since his arrival in Europe.

While we painted and made music, and ate and bathed, there was still no answer to the question—war or peace? Looking back, it seems incredible that we could have borne the suspense so lightly. But who can affirm even today that the answer was inevitable?

At last it came. From shore to shore, across the summer sea, the shrill alarm cry of the tocsin bell: "*Aux armes, citoyens! La Patrie est en danger!*" Then at the Mairie the stunned, silent crowd reading the Order for Mobilization—a death warrant for so many of those Breton fisherfolk, who were among the first to be hurried to the front line and suffered in proportion. Every day saw shiploads and trainloads of them de-

169

part. In the confusion and uncertainty of those days, one thing alone seemed certain. The ordeal, however cruel, could not possibly last long— a matter of weeks at most. For by then, even if there had been no decision by arms, every belligerent country would be bankrupt. That was easily proved—and thank God for that!

Nonetheless, there was uneasiness among the foreigners, who suddenly began to feel themselves undesirable intruders in a domestic drama. This uneasiness became positive panic when suddenly foreign money lost its prestige and the dollar dropped by a fifth. To many of my compatriots that was sufficient warning that it was time for all good Americans to return to their own country. Wessel advanced his return by several weeks as his teaching position called for his return early in September. And Kunz, who hadn't been back to the States for fifteen years, decided to make the return trip with him.

With the arrival of the first war bulletins, local strategists set to work expounding the mysteries of modern warfare to the islanders. The most authoritative was an ex-sergeant of the French Army, who was always to be found at the boat landing, explaining the significance of troop movements. A favorite theme of his was the famous "Russian Steam Roller," which was to overwhelm the adversary by sheer force of numbers and was yet endowed with such resilient powers that it could afford to roll backwards in order to recoil for a devastating forward spring. Muscovite cunning was more than a match for Teutonic brutality, and by Christmas the merry Cossacks would be in Berlin, devouring all the candles of the yule trees. Finally, after weeks of hoping and wondering, came the great news. The German hordes of Von Kluck, crushed and demoralized, were on the run. Joffre had dealt the enemy a knockout blow on the Marne, and the war would soon be over. Our neighbors, an inspector at the local Post Office, brought us the joyous message.

BY NOVEMBER, though the Germans had stopped running, preferring, like the poor sportsmen they were, to dig themselves into French soil, and the "Russian Steam Roller" had got stuck fast in the Masurian Lakes, things still looked bright enough to warrant special preparations for Thanksgiving. So I invested in a turkey, the first of its species which had been seen in the island—in fact, "gobble-gobble" so startled some of our Breton neighbors that I had to calm their fears by assuring them it was an American eagle, but of a harmless and edible type.

It was an ideal season for painting, and Alex and I revelled in the beautiful autumn tints. Never had the fall seemed so lovely as in 1914. The picturesque character of the pollard trees, which are a distinctive note in the island scenery, gained a new and fantastic quality when despoiled of their branches, which were lopped off for fuel; for the price of coal was already rising rapidly and would soon be rationed.

Alex by now had decided to return to America, so I took the opportunity of accompanying him as far as Paris, and got a glimpse of the capital in war time. I found little change. The first flush of war fever had disappeared, and Paris was "settling down to the war." There was no

170

"kick" to be got out of this dull, heavy atmosphere, and I made haste to return to my island, to the little group of kindred spirits at the Centanini home, with their music and friendly gatherings by the fireside. Above all, I was glad to get back to my painting. This war, with its bloodshed and misery, might be a European tragedy, but what concern was it of mine! I was neither a soldier nor a patriot defending his hearth. I was an American painter, and my business, first and last, was to paint.

Early in March of 1915 I wrote to Monsieur Foinet, telling him I intended returning shortly to Paris, and asking him whether it would be possible to find me a furnished studio by the summer. He replied immediately to say a very desirable studio was available in the Rue Boissonade, in the Montparnasse Quarter. It was situated in a quaint old courtyard with a garden leading to the entrance. My friend, George Oberteuffer, the painter, with his wife and family, were living close by.

PARIS seemed even calmer than when I last visited it. Many of the larger commercial establishments were closed, but small shops, creameries, and groceries, which could be run by women, were doing their usual business. People seemed yet hopeful that the war would come to a sudden end. Rumors of great happenings were constantly floating about— reports that the famished Germans were surrendering in thousands for a slice of bread, and that the mere sight of French soldiers approaching was enough to make entire regiments of *boches* shout, "*Kamerad!*" and lay down their arms. Letters from the *poilus* announcing they were soon returning on leave brought joy to many families. To many others, alas, there came other messages, in official envelopes, and in official, pompous wording, announcing that another hero had fallen for his country on the field of honor.

As the tide of sorrow rose, the already somber hues of women's apparel took on gloomier shades. But nowhere was there any trace of the much talked of excitability of the French. A Zeppelin raid found many calmly looking up at the sky, while the less audacious ones repaired quietly to the bomb-proof cellars and underground stations when the wailing scream of the sirens warned them of the approaching danger, resignedly waiting there till the welcome cuckoo call of the Paris fire-brigade gave the "all clear" signal. Then they would issue forth in the most casual, matter-of-fact way to regain their homes.

The few foreigners, notably Americans, still residing in Paris, were in no ways troubled by the police or military authorities. Naturally, our habits and records had been noted down by the very efficient Secret Service. But never once during the course of the war was I subjected to personal indignity or petty vexation, though there would have been nothing surprising if such a contretemps had befallen a foreigner in times of such stress.

In fact, the average Parisian showed himself more kindly disposed than ever before, and quite often my French acquaintances or tradespeople I dealt with would remark, without a trace of envy or sarcasm, how glad they were that I could be spared the tragedy of bearing arms.

Misfortune had toned down many of the apparent faults and pettinesses of the small bourgeoisie and tradefolk.

Charity and mutual help were practiced on a scale unknown in prewar times. In all quarters of Paris canteens and soup kitchens were being organized where the *poilu* on leave or the needy in general could satisfy their hunger for a purely nominal sum.

The artists had organized several such canteens for their special groups. The most picturesque and popular of these caravanseries had been started and was managed by Mme. Vassilief, the Russian Cubist painter and inventor of portrait dolls, in collaboration with Desiré DeHoorn, the Belgian writer, whose handsome, bearded head resembled that of Peter Paul Rubens.

Vassilief's huge studio, on the Rue du Depart, near the Montparnasse station, had been converted into a restaurant and general meeting place, where there was always a warm fire and a welcome no less warm. The price of a meal was ten sous, an extra two sous being charged for wine. Usually after dinner there would be music and sometimes dancing. Vassilief, tiny as Tom Thumb, in Circassian costume and high boots, would stamp and circle about in her native Russian dances, and often guests would be called upon to contribute their turns to the entertainment in cosmopolitan style and polyglot idiom. I remember Will Irwin giving his protean one-act thriller, "The Great North-West Drama," in which he personified sixteen characters—from Little Nell, who had been done wrong, to the bearded Sheriff, who righted the wrong—a sufficient number of his audience understanding enough English to appreciate the performance.

James Hopper and Will Irwin were fairly regular attendants at Vassilief's canteen, where at times I would also meet Paul Scott Mowrer, Paris correspondent of *The Chicago Daily News* and an accomplished poet to boot. Another habitué of the canteen was the famous Modigliani, then almost unknown as a painter. Emaciated, haggard-eyed, with a complexion yellow as saffron, he was already in the last stages of consumption, and it was small wonder that he had taken to drugs to alleviate the pains that racked him. At that time he was so poor that he would jump at the chance of selling a painting or a drawing for a few francs, sufficient to buy the drug he craved, or even merely the consoling drink that helped him to forget his misery. Holding forth in a loud voice and gesticulating violently in his Italian fashion, Modigiliani would give way to fits of rage if his auditors disagreed with him. On one occasion he even drew a loaded pistol and only prompt intervention prevented a catastrophe.

The money realized from the sale of his pictures after the war might well have sufficed to prolong his days in comfort. Lacking the barest necessities of life, his end was hastened. His mistress, who at that time was expecting a baby, slaved for her adored painter, but the little she could earn barely sufficed to pay the rent of the squalid room they occupied in a sordid hotel. On the day of his death, the unhappy creature

committed suicide by throwing herself out of the window.

PUBLIC restaurants and cafés, of course, were closed at an early hour, and at nightfall the city would be plunged in darkness except for the few scattered streetlamps, dimmed with blue glass and shaded from above. As a result, crimes were frequent, and it was dangerous to be abroad after ten o'clock. A few cinemas and theaters were kept open for the public, but the latter had suffered heavily through the toll the war had taken on the actors at the front.

Moonlight nights always held a menace, for then enemy planes could find the city by following the silver trace of the Seine. On such nights the population did little sleeping, waiting uneasily for the shrill wail of the sirens, announcing the coming of the enemy's bombing squadrons. On such occasions all was held in readiness for taking hasty refuge in the nearest subway station or cellar shelter. In every street certain cellars, considered as particularly bomb-proof, were officially designated as public shelters in case of air raids.

When these took place, the whine of the sirens, the terrific explosions of aerial bombs, and the pounding of anti-aircraft guns were enough to instill terror in any breast. Yet not once have I seen the Parisian panic-stricken. In the cellar shelters, while the raids were in progress, someone was always ready with a witty remark or wisecrack, and though faces were sometimes pale and haggard, I have never heard or seen fear expressed openly.

Of an evening, we Americans would foregather at each other's homes or studios, taking turnabout as a rule. As coal was both expensive and difficult to procure, the host of the evening would supply a crackling warm fire for his guests.

I saw a good deal that season of Karfunkel, to whom I posed for my portrait, which now hangs in my studio and is a prized possession. The subject of Île-aux-Moines, its peaceful charm and picturesque inhabitants, recurred so often in my conversation that Karfunkel and his young French wife felt tempted to investigate its possibilities and decided to accompany me there on my next visit.

Only a few simple formalities were necessary to travel in those parts of France which were not in the war zone. On presentation of one's passport to the local *Commissaire de Police*, a *permis de circulation* was granted, stipulating that upon reaching one's destination, the *permis* must be presented and stamped at the *mairie*. During my frequent meanderings through France during the war not once had I been called upon to show my credentials, although everywhere the countryside was patrolled by the gendarmerie. Least of all was there any question of this on the Island and in the surrounding districts, where I had become a local character and was regarded almost as a native.

NATALIE MORICE had her little cottage looking its best for our arrival, and the plump, fluffy white ball bounding at her heels gave

173

unmistakable signs that she had done her duty towards my little friend, "Bicot."* What leaping, boundings, and caresses I submitted to! Had Bicot forgotten me? I should rather say not! He whined, snapped, and yelped, jumping round me in circles, and it was only when I took him in my arms that he finally subsided. It was a wonderful welcome and homecoming, for by this time I considered the Island truly as my second home.

The Karfunkels found comfortable lodgings with Mme. Bulles, the wife of the village schoolmaster. As for Monsieur Bulles, he was at the front, together with all other able menfolk of the Island. The summer of 1915 was a season of beautiful warm and sunny days, and Dave Karfunkel was as enchanted and enthusiastic about the Island as I was. There we also found my friends, the Centaninis, as hospitable as ever, so that our evenings were made gay with music and discussions. Except for an occasional soldier home on leave or convalescing, there was hardly a hint of war. People seemed to have accepted the new condition of things as a matter of course. There were, however, frequent murmurings against the increased cost of living, and occasionally an island boy would come home in a flag-draped coffin; then there would be another house in mourning, a few more red-eyed women, and old men bending lower over their sticks with the quiet resignation of their race.

As Marie Faucher's large hall, which in the happy prewar days had been used for dancing, had now fallen into disuse, I arranged with her to rent the place as a studio. Besides four large windows facing north, which gave an excellent light for painting, there was the advantage of a small enclosed garden, which could be used as an outdoor studio. There I could deposit my paraphernalia and let my canvases dry in all security.

Marie Faucher, large of hip and deep of bosom, would sometimes drop in and chat with me, starting each conversation with the remark of how disagreeable the smell of paints and turpentine was to her sensitive nose, ignoring the fact that from her adjacent little store came odors of stale fish that could not be outclassed for sheer potency and penetration.

As for models, we had the pick of the marvelous old natives, to whom the small fees we paid for posing were a godsend, since for the most part they depended entirely on the pittance allowed them while their breadwinners were at the front. Karfunkel and I also painted the village boys, perched on rocks or frolicking in the water. Three of the boys were our faithful models—Denis Guenec, son of the customs officer (one of six brothers, of whom it was said that possessing only one cap among them, the earliest riser was its owner for the day), and the brothers Joseph and Marcel Le Cor. Joseph was a talented and artistic lad, and with the scrapings of our colors would paint delightfully naive pictures on bits of cardboard or wood. His younger brother Marcel, being cross-eyed, was nicknamed *loucheur* ("cockeyed") by his comrades. He had an ungov-

*Bicot was Buck's dog, acquired on the Ile-aux-Moines in the fall of 1914 and lovingly described, but at somewhat too great a length, in an earlier, excised passage.

ernable temper. When in a fit of rage, he would frighten even the biggest boys. Some years ago I met Joseph at Marseilles— a big, fine, husky sailor. He told me that his brother Marcel, while doing his naval service, had undergone a term of imprisonment for stabbing a comrade.

Breton tradition, in spite of the war, kept to many of its fete days, especially the religious ones. On one occasion, when I had been painting a neighbor's garden—columbines, narcissi, roses, and flaming poppies, with a glimpse of the sea beyond—I found when I had returned for a final séance that all the flowers had been shorn away. I found them later, together with the floral produce of other gardens, strewing the path that led to the village church in honor of a saint's day.

Occasional trips to Vannes on the little steamer threading its way through the devious currents and islands in the gulf was a welcome diversion from the all-too-pleasant monotony of my enchanted island. On these occasions Bicot would follow close on my heels. On the boat he would post himself as far front as possible, overlooking and sniffing at the water, as befitted a sea dog born and bred on an island. Yet, like many seafolk, he hated getting into the water, and for hours after his enforced daily bath he would roll in the warm sand until all traces of the salt water had been eliminated from his person. And—ecstasy of ecstasies!—he would finish the job by rolling on the decayed remains of an old fish.

Sometimes Bicot would take the boat trip to Vannes all alone, getting off at the landing place and wandering about the port to frolic with his city brethren. But at the tooting of the steamer whistle, he would hurry back to the boat. He had all the nerve of an American hobo. Fortunately, Bicot was known to the crew of the steamer who caressed and treated him with the respect befitting *"le chien de Monsieur Abel."* As I often treated the pilot and his assistants to cider and occasionally to cigars, I was regarded with favor.

Bicot was used to sea craft of all sorts, but the sight of a cart drawn by horse or oxen was enough to set him wild—whether with fear or anger, I was never able to make out.

The Karfunkels, finding themselves comfortable and happy on the Island, decided to stay on till the late fall, but early October saw me preparing to return to Paris. The thought of parting with Bicot was, however, becoming absurdly painful. For the last few months he had been my constant companion, lying by my easel while I worked, ready to fly at any intruder who threatened to interrupt me, and at night burrowed into the foot of my bed, growling if I cared to stir. At first the idea of taking such a little savage to Paris seemed out of the question, but when I saw the uneasy way in which he hovered about me while I was packing, as if he apprehended the coming parting, my heart got the better of my judgment, and I decided to take the little animal with me and chance the inconvenience.

For the journey I bought him a new collar of red leather with two little bells, which pleased him beyond measure, for he would toss his head and listen with delight to the tinkling. But at Vannes, when I got him

into the cab which was to take us to the station, I thought he would go mad, barking and snapping at the horse. Finally I stopped off at a shop and bought him a wicker basket. Fortunate that I did so, for in the train he cringed and drew himself into a tiny white ball, looking at me with terror-stricken eyes. The brave Bicot of the Island was thoroughly cowed.

AS THE STUDIO I had occupied in the Rue Boissonade was still vacant, I again took up my quarters there. It had the advantage of giving onto a garden, where Bicot was able to roam about at will. But when walking in the streets, he had to be taken on a leash. Soon I became a victim of his affectionate tyranny, fearing to absent myself too long when I left him at home; for if I returned late at night, his sobbing and whining would make me feel a selfish brute. For these petty vexations he would reward me by a thousand little attentions, as if to show me that "the friend of man" was not a meaningless description of his race.

George Oberteuffer, who had been charged by the Pennsylvania Academy of Arts to choose some pictures for its coming exhibition, dropped in to see my latest work, and I was highly gratified when he picked out a large canvas I had painted that summer, representing two old Breton women seated on the rocks with a basket of fish between them. This picture, which I entitled *Humble Lives*, was well hung at the Philadelphia show, where it attracted attention, and was later reproduced in the *New York Times*.

Fred Pitney, correspondent of the *New York Tribune*, commissioned me to paint a portrait of his wife, and some of his newspaper friends bought several of my latest sketches.

The proceeds of these sales enabled me to continue on in Paris, but my family at home were becoming very much concerned about me. Newspaper reports told of constant air raids on Paris, and though in my letters I kept assuring them that we were far back from the lines, and that I was practically as safe in Paris as I would be in New York, there was no allaying their fears. My mother had been ill, and my absence in Europe and the worry it entailed had aggravated her condition. So I decided it was my duty to return to America for awhile.

Since my return to France in May, 1914, I had been continuously at work and had produced a considerable number of canvases, many of which showed advance in technique and general accomplishment. I decided that on my arrival in America I would approach the New York dealers in the hopes of an exhibit.

LATE IN DECEMBER, 1915, I booked passage on the *Rochambeau* then sailing from Bordeaux. To make sure that my baggage would arrive on time, I had the three huge cases containing my canvases shipped several days in advance. Edgard Varèse, the composer, was leaving by the same boat to do propaganda work for the French government. Being old acquaintances, we decided to share a cabin.*

*Edgard Varèse (1883-1965), the avant-garde composer later associated with Picabia and the Dadaists, boarded the S. S. *Rochambeau* on December 18, 1915. He hoped to

176

The parting with Bicot was a severe wrench, but happily my Island friends, the Centaninis, then in Paris, offered to take care of him during my absence. Nonetheless, I stole away from him with a guilty conscience.

Arrived at Bordeaux, I found to my dismay that my cases were neither to be found on the ship nor on the docks. As the ship was to sail that evening, my distress can be imagined! Fortunately, a railway official, to whom I explained my dilemma, put me on the right track, by suggesting the cases might have been left at the station, as in those days there was great laxity in the handling of baggage. To my joy, his tip proved a good one. My cases were waiting in the depot yards. As the *Rochambeau's* departure was delayed for twenty-four hours, I had the satisfaction of myself supervising their transfer to the ship.

As there were few passengers on board, Varèse and I were very comfortably accommodated. The weather was bitterly cold, and we soon ran into high seas. No dinner for me that night! I took at once to my cabin, where Varèse, who had made an attempt to face the dining table, soon joined me. The weather continued bad, and we ran into storm after storm, tremendous waves pounding the decks, with the result that several sailors were badly injured. For three days and nights Varèse and I kept to our bunks, but despite our qualms, my companion kept me laughing and cheerful by his irrepressible gay spirits.

On the pier in New York, awaiting our arrival, I found my cousin, Jack Kasner, the violinist, whom I found to my surprise to be an old pal of Varèse's, both having been fellow-pupils in Berlin. Jack had taken a large apartment in Madison Avenue, and offered to put me up, as well as Varèse, until the latter could find suitable quarters. My cousin's parents had been dead for some years, but the brothers and sisters kept house together, living in the best accord. David, the youngest, whom I had painted when first in New York and who was now working for the Berlin art shop and knew many of the dealers, offered to help me get in touch with them. Martin Birnhaum, manager of the Berlin Art Company (later head of Scott and Fowler), offered me a show at his gallery, but much later in the season. Happily, however, I did not have to wait so long. With my limited means delay would have been a sore problem. Gerald Kelly, who with Philip Ortiz had charge of the Braun and Co. Galleries on West Sixty-fourth Street, came to see my pictures at the house, enthused over my work, and there and then, to my great joy, offered to give me a show within the next few weeks, assuring me that my work had artistic value and was bound to succeed.

Varèse found New York, with its skyscrapers and teeming streets, a joy and inspiration for his ultra-modernistic tendencies. He declared that the noise and racket inspired him with leitmotifs for new musical compositions. To produce the desired effects, new instruments would be needed—a problem which occupied his mind constantly. One night at a Negro cabaret, in company of Picabia, the Cubist, and myself, he heard

find employment in America as a conductor. On the trip he played the piano in a traditional shipboard concert for the benefit of sailors wounded in the war. Louise Varèse, *Varèse: A Looking-Glass Diary, 1883–1928*, Vol. I (New York: Norton, 1972), p. 119.

for the first time real Negro jazz and found, to his chagrin, that the instruments he was dreaming of were already in use!

Picabia, the son of a rich Cuban planter, was a painter of talent, whose private means permitted him to indulge his fancy for doing stunts to amaze the snobs and dilettanti. Some of his *blagues* ("studio jokes") were celebrated in the art world. He had exhibited old-fashioned crayon portraits, canvases containing nothing but his friends' signatures and paper cuttings in gold frames. His serious productions had been sensitive studies from nature with the impressionistic technique. He genuinely favored all the -isms and found beauty to admire in all the schools.*

THE EXHIBITION ROOMS at the Braun Galleries were spacious and well lit. Gerald Kelly himself supervised the hanging of my pictures. Among the several critics who called to obtain their impressions of my work was Miss Elizabeth Luther Cary, who showed a keen interest in my canvases. It was she who named the view of Belle-Ile, dotted with white spots, *The Purple Plume.*

On the Sunday preceding the public opening, Gerald Kelly and Mr. Ortiz arranged a tea vernissage. The sight of my pictures hung up for public inspection, filled me as usual with stage fright, which was increased when, during the hanging, a chance visitor was seen scanning them close-up, sniffing and grunting in apparent disapproval. In my dismay at what seemed an ominous start for my exhibition, I beat a hasty retreat from the gallery. On my return next morning I was informed that one of my pictures, a view of the Luxembourg Gardens, had already been sold, to the alarming individual in question.

In response to the invitations sent out by the Braun Galleries, there was a fashionable gathering for the opening day of my show, including smartly dressed women engaged in fashion and luxury industries, and many members of the French colony. The latter were especially appreciative of the views I had painted of their *"douce France,"* mingling their praise with sighs of *"mal de pays."* Pleased and flattered as I was to see this gathering of feminine elegance paying tribute to my work, I felt some apprehension, lest the vivid coloring of the many smart frocks should make my painting by contrast appear drab and dull. I recall the gratifying thrill with which I remarked that certain canvases seemed to receive special attention from the fair sex; but the elation was turned into dismay when on closer inspection I realized that the pictures which made such a special appeal to the ladies were those framed with glass, which

*Picabia had been in New York since the early summer of 1915, when he had gone AWOL from a French military mission en route to the Caribbean to purchase sugar for the army. With France burdened down with the war, Picabia and other artists from Paris joined with American artists—Man Ray, Joseph Stella, John Covert, Charles Demuth, and others—to form an exciting community in New York devoted to the furtherance of modern art. Picabia began to work in his "machinist" style that year. In the fall of 1915 Picabia's wife arrived in New York to persuade him to resume his military duties. Camfield, *Francis Picabia*, pp. 22-26.

from certain angles had the reflecting properties of a mirror, and could be used as such, *pour se faire une beauté*.

The press, especially the Sunday editions, gave my little show a reception more cordial and flattering than I had dared hope for. My esteem for our much maligned journals rose quite sharply, and I felt certain that the *New York Sun*, which devoted an entire page to reproductions of my works, and certain other of its leading contemporaries that treated its readers to views of paintings by A. G. Warshawsky were among the most enlightened newspapers in the world. My heart went out especially to Miss Elizabeth Cary, the well-known art critic of the *New York Times*, who devoted a long lead article to my exhibition, commenting on the "marked individuality and expressive technique" of my painting, praising the expression of character in the figure subjects, the "serious research into the secrets of light and shade," and ending with the inspiring phrase that "this refreshing exhibit was a proof that force and delicacy still can live together in modern painting."

The sight of my pictures affected Charles Caffin of the *New York American* "with exceptional enjoyment." He found them "distinguished by radiance and buoyancy," and yet noted that their manner revealed "thoughtful and conscientious study of the painter's problem and a certain maturity of accomplishment," and—perhaps sweetest praise of all to the artist—declared that I possessed "a distinctly individual vision"; while the *New York World* clapped me on the back with "work full of charm and balance." Royal Cortissoz in the *Tribune* discovered "the stamp of an ingratiating individuality" in "works bathed in sunlit tints" in which there was no "undue emphasis" in the brighter colors, my rich schemes being "admirably harmonized"; my work, in short, being "meritorious and deserving a warm welcome." *The International Studio* also noted my show with favor.

Many of these articles, reprinted in western newspapers, resulted in confirmation of dates for exhibits in Chicago, Cleveland, and Cincinnati.

Like so many artistic successes, my show at the Braun Galleries could hardly be called a money-maker. A few canvases were sold, but after deducting expenses and commission to the dealer, the net benefit was far smaller and I had fondly hoped, yet enough to carry me on for a while. But the main practical result was that my position was now assured as regarded further exhibits in New York.

Many old comrades from Paris, who had returned to New York, looked me up at the Braun Galleries. Among them was Turnbull, who asked me if I had seen our friend, Adrien Voisin, the sculptor of Indians, on board the *Rochambeau*. I had not, the reason being, as I found out later, that poor Voisin had been, like me, "in cabin pent" owing to seasickness almost for the entire voyage. Another case of "so close, and yet so far apart!"

HAD I BEEN a wounded war hero, returning from the front, I could not have received a warmer welcome than that given me by my family and friends in Cleveland. Dad, much grayer, was still his sturdy and happy

self, but dear little mother had aged greatly. Brother Sam, married during my absence, had gone to live in Culver City, California, where he was employed as publicity director by the Triangle Film Company, and my sister Flo had waited for my return to celebrate her wedding. The birdies had grown up, as Dad was wont to say, and were flying off to their own nests. Mort was following in Sam's footsteps, reading insatiably and trying to write, while David, temperamentally perhaps more fitted to be an artist than any of us, had graduated from high school, where he had reaped oratorical and histrionic honors, and was settling down to a prosaic job. I fear he sacrificed himself from a sense of duty, feeling that some member of the family would have to resign himself to the task of breadwinning on orthodox lines, with the hope of making money some day. Minna, the baby, now almost grown to a young lady, showed marked artistic talent and painted beautiful watercolors. But the fact that there already were so many aspiring artists in her family was a constant discouragement.

As for Alex, having met with many discouragements on his return from Europe, he had taken various jobs, quite foreign to his artistic abilities, sticking pluckily to his painting in between times. His abilities finally won him some recognition, and he settled down to paint portraits in a studio on Euclid Avenue. Among his sitters were Mr. Lynch, manager of the *Cleveland Plain Dealer*, who had commissioned him to paint portraits of himself and his wife, so that Alex had hopes of an early return to France and serious painting.

Availing myself of the offer of Miss Georgina Norton, director of the Art School, which had lately moved into new and spacious quarters, I organized a show of my paintings in its large new exhibition hall, which, thanks to the publicity I had received in New York, especially Miss Cary's article in the *New York Times*, proved a success, financially as well as artistically. One of the happiest moments of my life was when I presented my Dad with the check I received for one of the pictures sold at this exhibit, the largest sum I had yet earned for a single painting. When he read the inscription, "pay to the bearer the sum of one thousand dollars," he thought at first I was playing a joke on him. Poor Dad, who for the greater part of a year worked for a smaller sum, could not believe his eyes. "Is it true, my son," he asked incredulously, "that you have received this for one picture?"

A few days later, passing by a furniture shop, we saw exposed in the window a large "genuine hand painting," enshrined in an elaborate gilt frame, the whole to be purchased for $7.89. I confess I was embarrassed when my father asked me to explain how it came about that so much paint and canvas could be bought for such modest price, when people were willing to pay one thousand dollars for his son's far less gorgeous picture. Often, when viewing some such superlative chromo, I had asked myself a similar question. But Mother never questioned. Her belief in the talents of her boys was so great that she felt no reward they received could be commensurate with their achievement.

One of the pictures I exhibited represented a wan, sad-eyed little

Breton maid huddled up to an old woman, against a background of sea and rocks. This canvas, originally entitled *The Orphan*, was later renamed *The War Orphan*, when it immediately had a considerable vogue with the public, many journals and magazines applying for permission to reproduce it. It was eventually purchased in Cincinnati by a prominent citizen. What's in a name, indeed!

WHILE in the Queen City I ran across my old friends, Jake Kunz and Herman Wessel, the latter now a teacher at the Cincinnati Art School. Norbert Heerman and his brother Emil, the violinist, were also there. Cincinnati I found endowed with an old-world charm and picturesqueness that in America can perhaps be rivalled only by New Orleans. Its cafés were as Bohemian in atmosphere as any to found in Paris or Munich Foucar's Café, with its gathering of painters, musicians, and journalists, could more than hold its own with the Dôme.

In spite of the city's German antecedents and prevailing Teutonic atmosphere, there was already a good deal of war tension, and one night at the Cincinnati Art Club I was surprised to hear a large group singing the "Marseillaise." "Preparedness meetings" were held all over the city. Jake Kunz was among those hoping that America would join the Allies, in which case, he assured me, he would enlist at once and go to Europe. In Chicago I found the same state of affairs. At the Anderson Galleries, where my pictures were exhibited, the fact that the subjects were French brought a large public, and the newspapers in general were sympathetically inclined in noticing the exhibition.

A few portrait commissions, added to the results of various sales at the exhibition, made me feel quite affluent and turned my thoughts once more Franceward, and above all, I confess, to peaceful Brittany. But how hard it was to convince my family that in war-ridden France, where every minute of the day a dreadful toll of human life was being taken, there were still happy, smiling spaces, untouched by war, where I could work as safely as in the suburbs of Cleveland! France to them meant war and bloodshed. To me it meant much else—quiet Breton country lanes with peasants working in the fields, peaceful sunlit bays, where floating mines and submarines were less to be feared than the famous Sea Serpent; a front door in Paris, where, as friend Centanini wrote me, Bicot sat for hours on end watching, listening for the returning footstep of his master!

·9·

1916-1919

ON THE MORNING of July 10, 1916, this time armed with an American passport, I sailed on the *S.S. Rochambeau* once more for France. In spite of warnings about submarines and similar wartime scares, the passenger list was fairly complete, including a number of distinguished persons, among them ambassadors and ministers of various allied or neutral countries. At our table were Billy Gard, the genial and witty press agent for the Metropolitan Opera, with his wife, and Philip Ortiz, who had assisted in organizing my first show in New York. For once the sea and I remained on good terms. The weather was warm and the ocean calm as an inland lake.

A charming Parisienne, returning to France on a visit, helped me to get back into the flow of French, which I had not spoken since I left Europe. At night portholes were closed and all lights, even those of cigarettes and cigars, forbidden on deck. But "captain's orders" could not prevent the moon from shining serenely, nor could the fear of German frightfulness impede the usual love-idylls on moonlit decks.

Early one morning we were awakened by a fearful explosion. The vessel shivered and rocked again and again amid the din of bursting shells. Barefoot, in pyjamas, I rushed out of my cabin. The corridors and stairways were already filled with a pushing crowd, mostly in night attire, scrambling for the deck and lifeboats, in the belief that the ship was being attacked by a German submarine. It was only when we reached the deck that a ship's officer calmed the panicky crowd with the announcement that the gun firing was only in honor of the national holiday, July 14. The ship's authorities had merely forgotten to warn the passengers—a typical example of Gallic *m'en-fichisme*, in other words, "don't-give-a-damn." But this culpable negligence, which might have had serious results, was more than compensated for by a gala dinner and dance that evening. On this occasion the usual ship's concert for the benefit of sailors' orphans was supplemented by an auction of objects contributed by the passengers. My donation was a series of caricatures I had made of some of the prominent passengers, which were sold for a good sum, Philip Ortiz making a very successful auctioneer.

A few days out from Bordeaux we were met and escorted by French torpedo boats, and we steamed safely into the harbor. Although the port officials made a minute examination of our passports and papers, there was no undue delay on landing. Bordeaux itself seemed to have profited by the war, at least materially, for the quiet provincial town of prewar

days had now become a hustling city, where restaurants and cafés did a trade that Paris well might envy.

IT WAS A LONG, hot, dusty ride to Paris, but the greeting of the Centaninis and little old Bicot—coal-eyed and fluffy, twisting and turning with joy like a miniature ballet girl—made this homecoming worth a dozen weary railroad trips. Paris appeared gayer and more colorful than when I last saw it. Thanks largely to the variety of uniforms in the streets and cafés—British, Belgian, Italian, Russian, Portuguese—it had recaptured something of the throb and rhythm of prewar days.

Joffre's plan of nibbling at the enemy until he was worn hollow as a shell had evidently by this time seeped into the minds of the people, who were now resigned to a long and tedious war. Many were actually satisfied that it should be so, for they were reaping rich profits from the holocaust of human lives. Comfortably lodged and fed, far from the danger zone, they were prepared to fight to the last man and spend the nation's last sou.

At the Dôme, teeming with uniforms and creaking with leather, the sight of a painter in civilian clothes was rare. As for its still modest rival, the little Café de la Rotonde, across the way, a war cloud had descended on it for the nonce—it had become suspect! It was the scene of frequent police raids, which, it was alleged, resulted in frequent arrests of suspicious persons, whose papers were not in order and who were consequently, in the official French phrase, "pushed back towards the frontier"—*refoules vera la frontière*—i.e., dumped into someone's else's territory. The café girls were also being subjected to strict supervision, as these votaries of Venus were known to be responsible for numerous casualties among soldiers home on leave. This menace from the rear had so increased with the duration of war that large concentration camps in out of the way places were organized for segregating these unfortunate "daughters of joy," who had become a public danger.

A FEW DAYS of the variegated, unwholesome excitements of wartime Paris made me feel thoroughly fed up, so, with Bicot packed away in his basket, I took a train for Brittany, my objective this time being Perros Guireo on the northwest coast, close to the birthplace of Ernest Renan. Huge, fantastic rocks outlined this stormy coastline, the blackclad inhabitants blending with the solemn harmony of the landscape. This rugged solemnity was, however, relieved and sweetened by a divine peace, a serene beauty, that invited self-concentration and work. Here in a thatched cottage, surrounded by a lovely garden, Bicot and I lived like hermits, Madame Nedelee, wife of the local postman, bringing us our frugal meals. She and her husband were the only persons with whom I conversed.

The days were spent painting and sketching among the rocks, with faithful Bicot at my heels or under my easel. Once while exploring a narrow chasm leading abruptly down to the sea, Bicot suddenly leapt forward, barking furiously, and made for an outjutting rock, on which I

now for the first time noticed an artist had installed himself and his easel. At the onslaught of my little terrier, the painter had a hard time maintaining his footing and was forced to cling to the rocks to keep from falling. Whistling Bicot to my side, I made humble apologies to my colleague, whom I already knew by sight to be Victor Charreton, a talented French painter, whose works, exhibited at the Dudensing Galleries in New York, are well known to the American public.

Painting among those rocks was no sinecure, as I found to my cost one day when an incoming wave soused me and my canvas on my rocky ledge, while a Breton girl on the cliffs above me, who had witnessed my mishap, shouted with laughter. Happily little Bicot had been saved from a watery grave, having wandered off among the rocks on an exploring expedition. As for my canvas, the ducking it sustained seemed to have brought it luck, for it was later sold for a good price to a collector at home.

On one of my excursions I ran across the Canadian poet, Robert Service, who was living in the neighboring village of St. Ephraim, together with his friends and compatriots, Mr. and Mrs. Frank Armington, who had come there to sketch—a chance to speak English again and get some news of the outside world.

At times our little community would be stirred by reports of the campaign waged by the German submarines in neighboring waters. It seemed a needless and cruel thing to sink the fishing craft of poor sailors. In some cases German submarines would suddenly appear among a flotilla of these little fishing smacks, and, instead of wasting powder and shot, burn them with kerosene, allowing, however, their crew to row off in their boats.

HEARING in September that my brother Alex had started for France, I packed up and left for Paris to meet him. He arrived in torrents of rain, but so glad to be back in France that even the rain seemed, as he put it, "just a bath of French atmosphere."

Meanwhile in Paris conditions had become more stringent. Owing to the scarcity of bread, flour, and sugar, the rationing system was being adopted by means of cards delivered at the various *mairies*. There were days when meat was not served at restaurants, and the coal problem was becoming serious, only a limited supply being allowed each person. It was not a cheerful outlook for the approaching winter, but thanks to pooling our supplies, Alex and I were fairly well provisioned and managed to keep our studio comfortably heated, with the result that it was a favorite meeting place at night. On one occasion, Alex and I, having hired a hand cart, were bringing home our coal supply when an elderly woman asked us if we would bring her sack along also. We willingly acquiesced, but on reaching her domicile were somewhat alarmed when she requested us to carry up her sack to the seventh floor! It was a case of noblesse oblige, for the old dame insisted on rewarding our labors with a tip. The good soul was under the impression that coal carrying was our profession!

Those were the days when necessity proved once more to be the

mother of invention, especially as regarded improving fuel. One of the favorite and successful methods was to soak old newspapers in water, pack them into tight wads, and put them aside to dry. Once dried, these paper rolls were very useful to maintain a stove fire and save coal.

As in all times when the rhythm of life is quickened by the pressures of outside events and the scent of a common danger not far off, human relationships were closer and more cordial, and casual acquaintance quickly ripened into friendships destined often to be of long standing. Such was my meeting that winter with a young Californian, Larry O'Connor, who had recently come from Oxford and was branching out into literature. His early training for the priesthood, his wanderings in Italy, where the lure of pagan art had supplanted theological discipline, and his residence in the old university city with its hoary traditions—added to his Irish-Spanish ancestry—had transformed the American college boy, aspiring theologian, and successful athlete into a complete and thorough-paced Romantic of a type which is becoming rare today, even in Europe. In the world of Murger, Larry O'Connor would have been welcomed as the eccentric foreigner, and a little later would have found spiritual affinities in the circle of Baudelaire and the demon-ridden school of late Romanticism. In modern Paris, where he has lived for nearly twenty years, he remains one of the many anachronisms of the Left Bank, but very much a part of that strange world.

Another literary friendship of that winter was that of Paul Scott Mowrer, correspondent of the *Chicago Daily News*, who varied journalism with poetry of delicate charm. From the windows of his spacious offices, overlooking the Place de l'Opera, after a heavy fall of snow, I painted several views of that famous square with the adjoining boulevards. Among the writers who frequented those hospitable offices that winter I met the American poet, Arthur Davison Ficke, then a very gallant major, and his friend, George Dunning Gribble, the English playwright, then engaged in wartime journalism.

The frequent snowfalls that winter made Paris seem more paintable than ever. There was an *embarras du choix* of fascinating street scenes. The snow swirling through the trees and the blurred figures of passersby gave an entirely new note to familiar corners and brought out unsuspected values in often studied scenes. One canvas that I painted from Mowrer's office window late one afternoon, looking down the Rue de la Paix with the Vendome Column in the distance and vibrant with multicolored groups of Allied soldiers interspersed with soberly clad civilians and scurrying taxi cabs, was acquired by the Minneapolis Art Museum during an exhibition I held there in the winter of 1920.

The winter of 1916–1917 passed amid varying hopes and fears for the Allied cause. French successes were played up by the press to look like veritable victories, while defeats were never more than temporary setbacks. The great game of *bourrage de crânes* ("tripe, eyewash") was being systematically developed by those in control of the press. Lord Northcliffe and Lord Curzon were cited as cheerfully opining that the war might last ten years. Meanwhile, we Americans were still neutrals,

and some of us, like Alex, Larry O'Connor, and myself, were still thinking of life in terms of art. Not that we did not try in our several ways to "do our bit" for suffering humanity. There were the Artists' Canteens, notably the American one in the Rue Huyghens where Larry employed his spare time, and similar welfare institutions where neutrals could help out. But these patchwork activities seemed more an excuse than a justification for living in the war atmosphere of Paris, and we were longing to get back in earnest to what we felt was our real job in life, painting and writing. Alex, who had been inspired by his short stay in Brittany to return there to work, had no difficulty in persuading Larry O'Connor, who was dreaming of getting into the country to write, that my old happy hunting ground was the place for them. Pont Croix had been strongly recommended both by Lester Hornby, the etcher, and John Noble, who had been inspired there to paint some of his beautiful moonlight effects. Accordingly, with the first good weather in spring, Alex and Larry set out for Pont Croix, where I promised to join them as soon as I had finished the large canvas on which I was then working.

MY BROTHER Alex and Larry O'Connor had written enthusiastic descriptions of Pont Croix, its beautiful scenery, picturesque inhabitants, and the good fare at the hotel. At Douarnanez, where we changed into the local train for Pont Croix, Bicot bounded out of his basket, jumped onto the platform, and sniffed the heavenly fish odor emanating from the nearby port, yelping and grunting to show his pleasure at once more finding himself on his "native heath."

The Hôtel des Voyageurs lived up to the reputation the boys had given it. The menu of the table d'hôte was ample and varied, the rooms large and clean, and in the courtyard there were studios at our disposal for painting. All this was included in our monthly pension of one hundred francs. Adjoining the hotel was a spacious barn in which pigs, geese, horses, and other livestock were housed, and under the studios was a dance hall, which Alex and O'Connor had already converted into a very satisfactory handball court. There, after the day's work, clad in our bathing suits, we played violently until we perspired like the proverbial porpoise. A bathing pool, known as the "frog's pond," only a few hundred yards distant, was a favorite rendezvous for the youths of the neighborhood, and there we would repair to cool off, Bicot following on our heels, but taking care not to get too near the water, for fear of a ducking.

While Alex and I were busy with our painting, Larry O'Connor was seriously disciplining himself for the literary career on which he was embarking, writing in his room until the hour of recreation. From his Irish-Spanish forbears he had inherited marked racial traits, being subject to fits of dreaminess and "Celtic gloom," alternating with bursts of impishness and high spirits. On one occasion he played an ingenious practical joke on the huge waddling geese, which were forever promenading in the courtyard, ready to peck at anything that could be devoured. He tied two hard crusts at either end of a string and threw them to the geese, which immediately gobbled the crusts and then started a tug-of-war to break

186

free of the string. After a few repetitions of this joke, however, even these stupid birds became wise and would warily step aside whenever they spied the treacherous string.

Larry, who had originally studied for the priesthood, was a fine athlete, excelling in swimming and boxing. To see him spar with one of the huge gendarmes, who were quartered near the hotel, was a treat. Avoiding his ponderous opponent's thrusts, the little Irishman would attack him on all sides with whirlwind pokes. But his greatest enjoyment was to take little Blaise, our landlord's youngest child, on his knee and spin him wonderful yarns, at the same time keeping his handkerchief busy, as little Blaise seemed to suffer from a perennial cold in the head.

A considerable number of convalescent soldiers were quartered in the civilian hospital. The officers and military doctors, mostly men of culture, dined as a rule at the hotel. The gendarmes who frequented the café after lunch and in the evening were less fastidious. Larry's boxing partner often joined us at billiards, a game at which he excelled in the gentle art of what used to be known as "correcting fortune," for a more unscrupulous player than this guardian of the law I have never met. When caught cheating, he would fly into a temper, and his long black beard would wave about like a pirate's banner.

The inhabitants of our village and the peasants of the countryside spoke very little French; among themselves they only employed the Breton idiom, locally called "*Brezonnec.*" To make myself understood, especially with my models, I set to work to learn the rudiments of this strange tongue, and in time acquired a small vocabulary, sufficient for exchanging small talk.

Among my most frequent models were old Virginie, the hotel cook, and her husband, Thomas, the basketweaver. Once they posed for a large canvas I was doing. Virginie, who spent most of her time over the kitchen furnace, had the pale yellow facial tints of old ivory and the proverbial bad temper of the excellent cook, while Thomas was ruddy, clear-eyed, and good natured, as fits a man who passes his days in front of his door, weaving sweet-smelling rushes. While they posed, Virginie would continuously scold and nag Thomas, who would calmly puff away at his old pipe, grunting good-naturedly. He still wore the ancient Breton costume, known as the "*brag a braz*"—short velvet coat with large silver buttons, knee-trousers, and canvas leggings. When I first met him, he was wearing an old pair of wooden sabots, which time had painted to a wonderful color. But to my dismay I found, when he entered my studio, that he had carefully covered them with shoe-blacking to make them more presentable.

Alex was working steadily, making great strides. His pictures of the Breton folk were done in a manner recalling that of the old Flemish painters. A small portrait he did of old Virginie had a precious ivory quality which compared very favorably with the work of some of these old masters.

During our handball contests, at which we were all three quite proficient, Alex and Larry, fairly matched, would engage in Homeric bouts.

187

But whereas I could beat Larry without much difficulty, Alex would wipe the floor with me. His game, which suited Larry, so disconcerted me that I was licked from the beginning. It was excellent exercise, and I lost pounds of superfluous flesh at the game. Perspiration would roll from us like rain, and our bathing suits looked as if we had come out of the water.

WHILE we were thus devoting our days happily to painting and good fellowship, great changes were happening in the outer world. In Russia revolution had broken out, and there were increasing rumors that America was coming into the war on the side of the Allies. If the United States should declare war, it would be impossible for three healthy Americans to keep their self-respect and stay out of uniform. Already then I was what I now am more firmly than ever—a convinced pacifist—and cannot see how the waste and horrors of war can right any world wrongs. My brother and Larry O'Connor, though sharing my opinion, felt that we must get back to Paris and do something—Red Cross or welfare work at first, and find out the formalities for enlisting in the army.

Having announced our decision to "do our bit," the officers at the hospital and Madame Gloaguen, the proprietress of our hotel, gave us a farewell feast. Then, heartily regretting departure from our pleasant surroundings, we set our faces towards Paris and the stern horizons of duty.

Paris was already full of American faces and uniforms, but at military headquarters we were informed that it would not be as easy to enlist as we had imagined. There was, however, great need for English or Americans who could speak French for welfare work. Among the American organizations Alex first joined a building squad which was putting up Y.M.C.A. huts for American soldiers at Gondrecourt. From there he wrote to me about the trials and discomforts of working in mud and rain—a bitter change from the ease and pleasure of the summer months we had just passed.

I, in turn, had an offer to take charge of a labor squad—mostly French soldiers on permission, or Arabs—at the big warehouse in the Villette region, which had been turned over to house "Y" stocks. These included carloads of tinned stuffs, biscuits, candies, chocolate, soap, razor blades—every conceivable article that a soldier might need, which were shipped over from America and first deposited at the warehouses, whence, after being listed, they were sent out to various American camps. A dozen secretaries were at work supervising details. Since I was the only person there who spoke French, I found myself in constant demand.

The physical work, though tiring, was welcome in comparison with the tedious labor of making our reports every day. The secretaries were men of middle age and over, mostly professional business men. One of them, Mr. Marshall, had been editor of several prominent magazines in the States. These gentlemen, with the traditions of the Y.M.C.A. in their minds, were at first shocked at my methods of getting the most work out of the members of my squad, to whom I promised extra liters of wine

if they got through their work in good time. In their leisurely way, these workmen lost much time loafing and chatting, with the result that shipments were often delayed; but the stimulus of extra *pinard* had excellent results on their flagging spirits—so much so, that often they would finish their job with time to spare.

A notable example of American hustle was Jim Frazey, a school-teacher from Kansas. In his exasperation at French dilatoriness, he would store half a car by himself, while the squad could hardly keep pace with him. While they stopped to admire his herculean efforts, Jim would rail at them in English, raising his voice and emphasizing his words, in the hope of bringing home his meaning to these "bone-headed" foreigners, whose faces would grow blanker and more expressionless the more he raged.

Wholesale thieving and petty pilfering were going on constantly—to such an extent that we were finally forced to employ a detective to put a stop to these malpractices. Often dozens of cases, on being opened, proved entirely empty. Several of the workmen were caught hiding articles. On one occasion a one-legged man, an ex-soldier, employed in sorting out small articles, was brought to me and searched. In the wide sash serving him as waistband were found hundreds of packages of Gillette razor blades. In such cases, when a man was caught red-handed, I would just discharge him without notifying the police. But several times I received anonymous threatening letters, which I turned over to the *commissaire de police*. This official authorized, and even advised me, to carry a gun; but I preferred to waive that doubtful privilege. One of the anonymous senders of the threatening letters was apprehended and turned out to be the one-legged man with the passion for Gillette blades. However, I persuaded the *commissaire* to let the poor devil off after a severe lecture.

However useful the work I was doing at the warehouse, there was no persuading myself that it was in any way congenial. Happily one day I received the joint visit of Dr. George Meyland, head of the Physical Culture Department of Columbia University, and of Edwin Hewitt, a well-known architect from Minneapolis. They had come to Europe to take charge of departments connected with the *Foyer du Soldat*, a French welfare work to ameliorate conditions in the army huts of the French *poilus*.

Dr. Meyland wished to get in touch with my brother Alex, who had been an instructor under his orders at Columbia and, knowing of my past athletic experience, wanted us both to help him organize sport centers and competitive games among the French soldiers in the leave areas and back lines. Hewitt also looked to us to assist him in planning the decoration of army huts, with a view to bringing some semblance of cheer into the dark surroundings of the barracks. At their request to "Y" headquarters I was quickly released to be transferred to their organization, a polyglot friend taking over my duties at the warehouse. Through their efforts Alex was also returned to Paris from the Gondricourt region, and we were soon congenially at work planning with paint and color. Mean-

while, I had rented the studio in the Rue Delambre, which I had shared with Arthur Frost during my first Paris stay; and which I had taken over with furniture left by a defaulting *locataire* at a nominal figure. There Alex, Bicot, and I found plenty of room wherein to work and disport ourselves. Mr. Hewitt first suggested that we paint decorative panels which could be placed on the walls of the huts, bits of color to catch the eye of the saddened *poilu* and cheer his morale. For about a month Alex and I painted literally hundreds of these panels. Some artist friends contributed to the work, but the total of our combined output could only be a drop in the bucket, for the army huts were legion and springing up in every direction.

A visit to some of the barracks proved to me that this idea of panels was an impractical one, the pictorial effect being swallowed up in the surrounding gloom. What these dreary interiors really needed was light paint in great quantities. The floors were of beaten earth and the walls of rough unpainted wood. We first experimented at one hut, the commander of the locality placing a dozen men at my disposal. I put six of them to work painting the ceiling and joists with a cream-colored glue paint, while the others nailed building boards over the inner sides of the barracks and placed laths on the walls at equal distances so as to form panels. The building paper was painted a dark cream color, and the laths a bright blue or yellow. Picturesque railroad posters, framed with laths, were nailed into the center of the various panels, Alex and I painting out the advertising matter, with the result that the posters had the air of real pictures.

The benches and rough tables were stained with walnut juice and varnished, and in lieu of glass for the windows oiled canvas was used, through which the light filtered with a warm, pleasant glow. On these windows we painted decorative motifs with thin washes of color, which gave an impression of stained glass.

The commandant and Mr. Hewitt were much pleased with the result of our work, and it was decided that we should go to various centers and decorate other huts in like manner. The *Foyer du Soldat* being under army supervision, we were fitted out with uniforms and the requisite papers to give us official standing and the usual facilities of transportation. The region of the Fifth Army Corps, with Chalons as headquarters, was to be our first field of endeavor.

On arriving at Chalons, where our papers were carefully scrutinized, we had no difficulty in finding the *Foyer* headquarters and the regional director. But further instructions of how to proceed were very vague, and we were entirely at a loss to know how to procure the painting material we needed for our work. The few shops in Chalons which dealt in painter's materials carried very limited stocks. The only advice that was forthcoming was for us to "employ System D.," slang for *Débrouillez-vous!*—in plain English: "Get results no matter how, but get them!"

Chalons was an important center for army camouflage, and contained at that time a numerous crew of artists and sculptors. Knowing

they employed large quantities of paint for their work, I went to inquire about our own needs, when to my joy I ran across my old friend, Louis d'Ambrosio, the sculptor, whom I had not seen since the war began. In his immaculate uniform, which set off his splendid physique, he appeared a smiling god of war, as delighted to see me as I was to see him. Having explained matters to my friend, he put me in touch with the officer in charge of the supplies, who at once placed at my disposal a quantity of paint sufficient to decorate several dozen *Foyers*.

This city, the most important in Champagne, was close to the fighting line, and had already been bombarded by long-distance guns. Hardly a night passed without an air raid. Often a German aviator would fly over Chalons in the daytime and drop notices warning the inhabitants of a coming attack. On such occasions toward evening long lines of civilians would be seen wending their way to the outskirts of the city or taking refuge in the cellars of a huge brewery, as the ordinary habitations of the Chalonais were of too flimsy a construction to offer any security, even in the cellars.

All day long the rumble of the distant guns could be distinctly heard, and for the first few days I felt a tense and disagreeable sensation in the pit of my stomach. On the night of my meeting with Ambrosio, having decided to celebrate the occasion, we dined with two American officers at a famous hostelry, the Hôtel Mère Dieu, renowned for its cooking. The delicious *vin gris* of the country and a plentiful supply of champagne soon had us in a mellow mood. Before the repast was over, the alarm for an approaching air raid was sounded, and soon the night was made horrible with the terrific din of exploding shells and torpedos. A house across the street rocked amid the crash of breaking glass, warning us that a hit had been registered close by. But since such occurrences were, as I was informed, in the daily program at Chalons, we decided to carry on where we were and to continue making merry.

I am not ashamed to say that, at times, I have been horribly afraid. Only a person devoid of imagination can go through life without ever knowing fear, and I soon realized in Chalons that keeping cool in the face of danger was, with most of us, but another form of fear—that of showing the white feather before comrades who were in the same situation.

A certain Colonel Viaud, who had visited our decorated huts, invited Alex and me to lunch one day. His dining room, close to the lines, was in a deep dugout, covered over with huge logs and earth. It was an impressive occasion for both of us, as the invitation requested us "not to forget our gas masks!"

At Chalons we were comfortably lodged, but when at work in the huts of the surrounding district, we had to make shift with whatever the *Foyer* had to offer. I have vivid and none too pleasant recollections of a certain shell-ruined village, significantly called La Veuve ("the widow"), where we slept in our bedrolls on a table for a week, continually on the *qui vive* lest a bombing squad should locate the huge munition dump close to the village, camouflaged only by a screen. It seemed incredible that in such surroundings people could live as merrily as those

French boys, who had for a long period been facing hell in the front-line trenches and were so soon again to return there.

For the evenings Alex and I, with the assistance of the *Foyer* director, arranged a program of sports and games. The boxing evenings enjoyed the greatest success, the ring being the small stage at the end of the hut, duly roped off. The bouts were improvised matches, open to all, with participants paired off according to height and weight. On some occasions a couple of *poilus*, nurturing grudges against each other, would seize the occasion to work off their rancor. What was lacking in skill—and of that there was very little evident—was replaced by enthusiasm and vim. Beyond a bloody nose or a blackened eye, however, there were no casualties among the combatants. The gloves employed were large and cushioned. Exhaustion and lack of wind generally terminated the contests by tacit agreement, and amid loud cheering, the adversaries would be reconciled in the French manner—i.e., by kissing each other on both checks.

On one memorable occasion, a tall, husky automobile mechanic delivered a sweeping challenge to all comers. As rumor had it that he had been one of the sparring partners of the great Carpentier (their number must have been legion, judging of the many I have met or heard of), there was obvious reluctance to accept the invitation, whereupon the challenger indulged in sarcastic remarks, ending with a pointed invitation for me to take up the glove. The suggestion was supported by most of the audience, but before I could make a decision, my brother Alex, much smaller than I, insisted on taking up the challenge.

The big fellow laughed and kidded Alex, telling him to grow up, to which my brother retorted that he would cut him down to his own size, and then give him a lesson. Overshadowed by his opponent, Alex stepped in, around and under him, stabbing with hard lefts and rights, ending the contest with a sudden wallop on his opponent's jaw, which sounded like the smack of a wet towel. I caught the stricken gladiator just in time to prevent his falling to the floor, while the spectators cheered and cheered for the little American, crowding up to shake his hand and shower congratulations upon him.

OUR MODEL of conveyance from camp to camp was the push-bike, which, weighted down with ourselves and our paraphernalia, we propelled through the chalky mud of the roads—a veritable labor of Hercules. The cold was often so intense that I was sure I was on the point of freezing. Yet that winter of hardships left me fitter than I can ever remember having been. Nor do I recall having suffered from a single cold. At one of the huts where I slept, bundled in my clothes and overcoat, I remember being awakened by the snow filtering through a chink of the roof, covering floor and blankets. I was none the worse for it, nor for my morning ablutions in ice cold water, stripped to the waist, like the other *poilus*. As for our early breakfast, the menu consisted of the so-called "soldier's juice"—thin coffee with lots of chicory—and chunks of stale bread. No breakfast at home ever tasted better.

The *Foyers* were supervised by two directors, a Frenchman—usually a *re'forme*, i.e., declared unfit for military service—and an American disqualified by age or physically defective for active duty. Their lot was not an easy one—plenty of work and hardship. Among the American directors, I recall meeting men prominent in business or social life at home, and several college professors. One of these was a very charming and erudite person, Professor Spencer of Princeton, a colleague and close friend of President Wilson. He put on overalls and helped us paint the interior of the hut which he was directing at the Camp of Mailly—much to the amazement of his French colleagues, who feared his dignity would suffer.

A very remarkable *Foyer* director was Franklin Babcock, over six feet in height and tremendously muscled, but so nearsighted that he could scarcely see without glasses. His hut was one of the most popular rendezvous in Champagne and he was a great favorite with the *poilus*. He would himself run the movies at his nightly entertainments, which were extremely varied, and in lieu of instrumental music he would sing in a rich baritone while the pictures were thrown on the screen. His repertoire seemed to include every popular song in America. It was an amazing one-man performance, and the audience would show their appreciation by prolonged applause.

On one occasion when Alex and I set out on our bikes for a camp nearly five miles distant, Babcock accompanied us on foot, dog-trotting all the way and arriving at our destination no more tired than we were. He was the most fearless person I have ever met, entirely devoid of imagination, but endowed with insatiable curiosity. One night at Chalons, during an air raid, while I ducked for a cellar, he wandered about the bombarded city, where there was nothing to be seen except flashes of guns and exploding shells. That night dozens of houses were shattered, and there were large shell splinters scattered all over our courtyard. But "Babby" went unscathed.

At Vallon St. Georges, a little town far beyond the fighting line, Alex and I were commissioned to decorate a *Foyer*, which had taken over a disused chapel as its headquarters. It was a fine opportunity to do an interesting job, so we set to work gaily, with a squad of men helping, to repaint roof and walls in clear gay colors, which we adorned with mural subjects. We felt not a little proud of our work, until a peasant, who had looked in and was watching us work, made the remark that our frescoes, though not bad in their way, could not compare with those of a certain Raphael.

TOBACCO was one of the essential luxuries which the French soldier had difficulty in procuring, except for the very small rations allowed him. Alex and I, however, had laid in a good stock of American cigars and cigarettes, supplied to us by the American commissary. These we found of great assistance in facilitating our work. Where fair words, and even bribes would prove of no avail, the offer of a cigar or a package of cigarettes would often work wonders. Arriving late one night at a certain

camp, the adjutant in charge informed us to our dismay that no sleeping quarters were available, everything was full up; even the outlying barns were occupied by resting troops. It was cold, and the thought of sleeping on the bare ground was not alluring. Casually I took out a box of cigars and a package of cigarettes to offer the adjutant a smoke. The officer's eyes lit up and his manner changed, as he thanked me and told me how difficult it was to procure tobacco. I prevailed upon him to take several cigars and a few packages of cigarettes, whereupon he at once suggested that he would again consult his register to see whether something could not be done to solve our problem. The upshot was that an orderly took us round to a peasant's cottage, where we found a spacious room with a very comfortable feather bed, and a large hearth well heated with wood. A hot wine punch and the warm depth of that feather bed, with the glowing log fire, on that cheerless winter night are among the happiest memories of my campaign in France. Our sense of gratitude to the American Commissariat was never more profound.

Wherever we went I carried my paintbox and watercolor set, for in my spare time I drew and painted portraits of the soldiers and officers. I must have done several dozens of these pictures, but I was able to keep very few. After posing for me, the *poilus* inevitably begged for the portrait to send home to a mother, wife, or sweetheart—a request hard to refuse. Among the few studies I was able to keep were those of a Negro orderly who was under my orders at a camp of *Malgaches* (Madagascar troups). His coal-black face with blue and purple highlights made a colorful subject. He wanted me to do just an outline drawing of him to send home, requesting me to leave the complexion white! The studies I did of him in full colors were not at all to his liking.

The *Malgaches* were being trained as assistants to the French gunners. Every day I would see them march to the river close by for their daily baths, magnificent fellows, resembling bronzes of ancient Greek heroes as they came out of the water. Their success with the fair sex was considerable, for besides being splendid physical types, they were known to be open-handed, more liberal, in fact, than most of their white comrades-in-arms, who made no effort to conceal their jealousy of these dusky heroes. A most engaging spectacle was the graceful dancing and improvised singing in harmony of the *Malgaches* soldiers at the camp entertainments.

Our work was beginning to attract favorable comment from the *Foyer* and military authorities. We had now developed a system, and with good cooperation would get a hut in shape within four or five days. A request from the American Y.M.C.A. was forwarded through the *Foyer* headquarters in Paris, asking for our services to decorate a large double hut at Issoudan, the most important aviation training center for student officers of the American forces in France.

I found the "Y" director of Issoudan far from cordial and attractive. However, the officer in command of the camps supported the plan and, at my request, supplied me with assistants trained as painters and carpenters. Contrasted with the amateur help I had had from the French

camps, the efficiency of these fellows was a delightful surprise. Within a few days the murky ceilings and joints were painted in cream gray, the bare walls covered with boards and paper, and canvas stretched on the end wall for painting mural designs. The counter and shelves where supplies were sold had their dingy color transformed into harmonious tints, and cretonne curtains framed the windows. The general effect was so cheerful had gay that hardly a doughboy failed to make favorable comment.

DAVID SHILLINGLAW, head of the building department of the ''Y,'' played a doubtful trick on us during our stay at Issoudan. He wired the ''Y'' physical director that the Warshawsky brothers were expert boxers and would take on any man at the camp, where weekly boxing contests were held. One of these was to take place just as our work was finished. The idea of pugilistic exhibition as pseudo-expert was not at all to my liking. But the physical director, backed up by some of the officers, pleaded so hard and so well that we should take part in the program that it would have appeared graceless on our part to refuse. It was short notice, but fortunately both Alex and I were in fine physical shape through our long bicycle rides and camp sports.

A certain Scott, the heavy hope of the camp, was chosen as my boxing opponent. Further to reassure me, I was told that our contest was more in the nature of a sparring exhibition than a regular bout. A light-haired, nice-looking boy was chosen as Alex's opponent.

In the dressing room, Scott, who had all the earmarks of a third-rate professional pug, but had become puffy and out of shape, encouragingly assured me that he would treat me easy and not cut me up, a psychological ruse to get on my nerves, which, indeed, were a bit shaky. The bouts preceding ours were anything but tame affairs. Though hardly more skillful with the gloves than the *poilus*, the American boys went hammer and tongues at each other, trying for a knockout, with the crowd yelling for blood.

Alex had a very easy time with his lad, toying with him and dominating him from start to finish. As for my adversary, he had nothing but a wide swing, technically called a haymaker, and no guard whatever. I hit him at will, but not very hard, as it was understood that we were merely sparring. But to my amazement, he cut loose at me with all his power, swearing and cursing with every obscene oath at his command. During a clinch—the referee having cried, ''Break!''—I obeyed the rule, which is to drop arms to the side. But Scott swung at my face, giving me a beautiful black eye. The crowd booed and hissed, and the officer, acting as referee, told my opponent in soldier's language what he thought of him, after which he wanted to stop the bout. But my blood was up and I insisted we carry on.

Scott's left jaw was always unguarded, and I smacked him there at will. He tried getting close to hold on, but I pushed him to the ropes. There he tried an old boxer's trick, that of swaying far back on the ropes and using the forward impetus, lashing out at the same time. But my

right caught him flush on his always ready jaw, and down he went. The crowd was now yelling like the mob at a Roman circus, and when my opponent staggered to his feet, yelled for the knockout. Scott's eyes were glazed, and he offered no defense, but I now also found myself at a loss. The relentless quality, the tiger strain, that make the real prizefighter was lacking in my makeup. I had turned chicken-hearted, and to the disgust of the doughboy audience, let Scott hold on without striking him. At the beginning of the third round he was still dazed, and the referee stopped the bout.

THE AVIATION camp of Issoudan was some miles distant from the town. Whenever the boys got permission, they would go there by truck, also utilizing a small-gauge railway. The distractions offered by Issoudan were those of the typical small French town—the cafe' and the brothel— of the latter there were a few licensed establishments, but not enough to supply the demand due to the vicinity of the camp. I have seen queues of at least a hundred doughboys lined up outside one of these "pleasure resorts," waiting their turn to be received by the seven women, who were dispensing their favors as quickly as possible, while a mechanical piano was pounding out popular airs and drinks were being dispensed in the salon. Waiting in those brothel queues were many refined and even intellectual faces, and I could not help reflecting that if the folks at home could see this aspect of the war, it would do more than harangues and peace talks to dampen enthusiasm for the noble profession of arms. It made me realize that if war is a great leveler, the common level to which it reduces most men is that of the primitive beast. Here was the grim humor of Maupassant's *La Maison Tellier* a thousandfold intensified, for I should add that at ten P.M. the rank and file had to retire to make room for their officers, who then came to pay their respects to these indefatigable damsels.

At the camp of Mailly where official brothels were provided for French soldiers, but forbidden by army regulations to American troops, it was a common practice for the latter to change uniforms with the *poilus* so as to be admitted into these haunts of pleasure.

It was during my stay at Mailly that I obtained another glimpse of the war which made me appreciate its grim humor. A batallion of British troops which had been at rest there moved out one night to return to the trenches. Never shall I forget the dirgelike effect of "Tipperary" dying away in the moonlight, as the columns disappeared in the distance. A detachment of Portuguese troops was to occupy the barracks evacuated by the British next morning. For over two years no air raids had taken place in this district, but that night German planes flew over the camp and blew up the empty barracks. One of the enemy bombs landed on the latrines, with results better imagined than described! Suffice it to say, the effects were so overwhelming that a territorial group employed at the Mailly arsenal and which had never been at the front rushed for its gas masks, thinking a gas attack had taken place.

On returning to the *Foyer*, we were sent with Gabriel Martin, a

French scene painter, to decorate huts at Somme Suippe, about twenty-seven kilometers from Chalons. The railway track had been shelled, and the trip by train lasted seven hours instead of one. Somme Suippe itself had been gassed and shelled until the very ruins were pulverized. In the outskirts a few battered houses were still standing. One of these I shared with some officers, Alex and Martin being housed in another. As the Germans sent a few shells regularly every half-hour toward the main road in the hope of catching a supply convoy, we could see shells popping frequently.

The *Foyer* hut close to the main road had as yet been untouched. But one morning, when we were there to look over the place, there was a terrific explosion in front of the building, and we saw part of the doors ripped off. We dashed outside with the shells falling, and arrived in the middle of the stone-paved street in time to see a shell explode twenty feet from us, but fortunately in the sand close to the hut. If it had struck the stone pavement, the ricochet would have mowed us down. Alex returned to his sleeping quarters for his belt, but on arrival there, found the house had disappeared. It had been blown up by a shell while he was away. An American ambulance car picked us up and brought us and our belongings back to Chalons.

The Germans were making desperate efforts to break through the Allied lines. American troops were landing daily in France in thousands, and French morale was picking up at sight of these husky reinforcements.

While we were working on some huts close to Epernay, the roads were suddenly filled with refugees fleeing from that region. The Germans had broken through at Chemin des Dames. The bridge at Epernay was already mined and measures were being taken to evacuate the city. Ambulances filled with wounded were constantly arriving at hospitals already full to overflowing. I recall a magnificent-looking colored colonial soldier literally bleeding to death in the street for lack of attention. It was ghastly! A French officer told us that an American ambulance with several badly wounded soldiers had broken down near Dormans. The Germans were advancing rapidly, and he asked me to try and get help to them. Fortunately, at "Y" headquarters there was a truck, which we commandeered and drove to the rescue of our wounded compatriots. We were just in time, for German troops occupied Dormans early next morning.

On our bicycles we pounded back to Sézanne and there managed to board a freight train which in an all-night trip brought us back to Chalons. On the straw-strewn floor, in company of a squad of French soldiers, we slept as soundly as in the best Pullman car.

BUT THE THRILL of the adventure was now over, and we were weary of being sent from place to place, loaded down like truck horses. We were neither soldiers nor civilians and yet we endured the discomforts of both. Headquarters in Paris had promised us motorcycles, which, however, were never forthcoming. The muscles in my legs were beginning to feel

like knots, and my steed of steel had lost all attraction for me. So Alex and I did a Soviet and decided to go to Paris and throw up our jobs.

Mr. Coffin, head of the American Department in Paris, tried by flattery and praising our work to dissuade us from carrying out our resolution, but I reminded him that headquarters had not kept their word with us and assured him that our decision was final.

Meanwhile, Percy Carpenter, director of physical education at Worcester College, had replaced Dr. Meylan, who was called back to his duties at Columbia. Carpenter had been approached by the French army authorities regarding a plan for organizing a group of American athletes to direct the sport centers of the French troops. Seven or eight of these centers already existed where convalescent and *re'formes* soldiers were given physical instruction for recuperating health. The scheme was to train a corps of French athletes at these centers and to employ them as training instructors in various army units. School teachers were also to be given rudimentary training so that they could teach calisthenics and games to their pupils.

French athletics and training methods appeared crude and primitive when compared with the American system. The prevailing idea of an athlete in France at that time was that of a man bulging all over with muscles. The French had plenty of weight lifters and acrobats, but in running, throwing, striking, and swimming they were still far behind. With vital racial qualities, especially their physical courage and nimbleness of mind, there was no reason why French athletes should not be world leaders in sport.

A necessary qualification for the appointment of physical instructor was a sufficient knowledge of French to explain things to the *poilus*. Among a host of American applicants, Alex and I applied for a trial at Joinville, outside Paris, headquarters of the national monitors' school and, before the war, the most important athletic center in France.

As there were only seven vacancies for American instructors, competition was keen. The work and methods at Joinville I found very similar to those of our playgrounds at home, in which both Alex and I were well versed. After a three weeks' tryout, we both were lucky enough to be among the chosen seven.

Many of the French monitors at Joinville were record men, but many of their records, especially in throwing the javelin and putting the shot, could be beaten by high school boys at home. French boys seldom learn to throw correctly. Most of their games are played with the feet, kicking a soft rubber ball about and stopping it with their feet or heads. The accuracy and distance in the throwing of Americans never failed to fill the French soldiers with admiration. Officers were also impressed by the fact that such methods of throwing would be very useful for effective handling of hand grenades.

At Joinville we taught different sections the comparatively easy game of volleyball, but basketball was a more difficult proposition. Involuntarily the Frenchmen would butt the ball with their heads or kick it, and it was difficult to teach them how necessary it was to pass

the ball to a teammate. Frenchmen are born individualists, and each would try to play the whole game by himself.

We also tried to introduce baseball. There were lectures with illustrations on the blackboard and demonstrations by two American teams on an improvised ball field. But nothing came of it. The monitors were all ball-shy, and the ball to them seemed a veritable brickbat. Later I found some Basques who could throw and catch as well as the most expert American player, but they were helpless with the bat. Americans, who are brought up to play the game from childhood, cannot realize what a difficult and expert sport baseball is.

Among the monitors at the school was the famous boxer Georges Carpentier, but his services were never utilized. The popular legend concerning the national champion—and I should be loath to explode it—was that he had been a war hero and had distinguished himself at the front. According to official history, however, his experience in the fighting zone was limited to a short period, during which he was utilized as chauffeur, after which, through "protection" he was sent to the Joinville monitors' school. He gave many boxing exhibitions, always under the supervision of his manager, and pocketed the gate money for his own benefit. His summers were passed at Dinard, where he was under very little military restraint, going about as he wished. He was unpopular among the other monitors, who considered him selfish and conceited. In my many talks with "Gentleman Georges," I found reason to concur in this opinion; in fact, the Carpentier mentality seemed to me that of the ordinary pug. It has always appeared a mystery to me how a country like France, which reveres savants and artists, could send the latter to the firing lines while carefully protecting the life of a professional pugilist whose business in life was to fight.

One day an amusing incident occurred while we were giving a baseball demonstration. "Shorty" Lasar, always a keen fan, was out in the center field, where he made a splendid catch, after a run and a flying leap at the ball. Watching the game was a group of French officers, the oldest of whom could not have been over forty. "Won't you try and play the game?" I asked one of them. "*Mais non*," they replied, "we are too old for such sport." I responded, "How old do you suppose is the man who has just made that wonderful running catch? He is sixty-three!" They thought I was making fun, the thing seemed so incredible to them, until I brought "Shorty" to them, and they could see for themselves I was not trying to put one over on them.

THE MILITARY school at Royan to which I had been delegated was situated in the building and grounds of the Casino, overlooking the sea. The beach, covered with a fine white sand, extended in a slightly curved line for several kilometers and was hard enough to drive an automobile on. In normal times Royan, which is not far from Bordeaux, was a favorite, though by no means swagger, resort for the French bourgeoisie. The town itself, like the surrounding country, lacked picturesque qualities and had little to tempt the artist. Small villas and chalets, sur-

rounded by pine woods, straggled down almost to the water's edge. The rocks were colorless and puny. Compared with the thunderous Breton coast, the outlook was tame and uninteresting. By way of compensation, there were early morning and evening light effects in sky and water which were startling in their fugitive beauty.

As regards equipment, this athletic center lacked everything except very ordinary gymnasium apparatus, a set of dilapidated boxing gloves, and a football that had been battered into shapelessness; and there was not, as far as I could ascertain, any budget for acquiring new material. So my arrival with a complete outfit for various American ball games, including football and baseball, and a supply of boxing gloves, all furnished by the *Foyer du Soldat* in Paris, was a welcome event and helped to dissipate a natural apprehension on the part of the French officers regarding the advent of an American instructor to teach them new ways. They were also not a little relieved when they found that I could speak French.

It didn't take me long to discover that the second lieutenant had no high opinion of the first lieutenant, who, in turn, thought the captain arrogant, while the latter did not conceal his conviction that he was far more capable than the major in command of this section. Taken individually and apart, I found these officers to be charming fellows, well bred and well informed. But as regards the first principles of physical culture, I found them totally ignorant, except the major, who had made a life work of athletics. With one of them, Captain Le Bihan, a Breton as his name indicates, I soon became friendly after I had told him that I had spent many months in his beloved land of *"Armorique"* and that I was well acquainted with his native town of Quimper. With Lieutenant Andrivet, in civil life a schoolteacher, I also established friendly relations based on a mutual interest in French literature, and a special cult for Anatole France.

When I explained to my colleagues the proposed program of American sports, I found them appreciative and even enthusiastic about the innovations in the dull curriculum of their daily physical drill. It was interesting to see on what a democratic footing the monitors, who were merely newcomers, met their superiors. They would greet the lieutenants and captain with a military salute and then shake hands. Only the major, as commanding officer, preserved a certain aloofness, merely returning the salute.

With the help of Captain Le Bihan and Lieutenant Andrivet, we made a summary French version of rules for basketball. It was only several months later that we received the official version from Paris headquarters. The basketball courts were set out, for fine days, in the casino grounds, and on wet days, in a vast, now unused balloon shed, which had been converted into a gymnasium. Volleyball was an immediate success, as the rules are simple, and it was even taught by us on special days to the young women and lads of the town.

In learning basketball, the main difficulty for the French mind was to convince itself that it was a team game, and not made for individuals

to shine in. Fortunately, a group of American sailors, attached to a submarine-chaser base at Royan, gladly lent a helping hand in instructing their French comrades in the niceties of the game.

But with baseball I had as little success as at Joinville. The men were all ball-shy. However, with a mixed team of young gobs and monitors, we enjoyed the indoor variety of the game on the sandy beach in front of the casino. The large, soft ball was less terrifying than the regulation baseball. A large canvas, with a bull's eye painted in the center, was set up at a distance of thirty yards. Against this I had the men throw at full speed, trying to teach them the free-arm throw. Eventually, at the cost of many sore arms and lame shoulders, I got them to throw fairly well.

One day, with the assistance of a gob armed with a catching glove, I gave a demonstration of throwing curves, having the men line up behind the catcher. The old-fashioned wide outcurve had them dodging with alarm. I then explained how the ball left the hand and the necessary twist which revolved the ball and caused the curve to break. "Ah," exclaimed the men, "like the twist on a billiard ball!"

What a time I had with my boxing class! I would take each man separately, show him how to set himself, and teach him the first lead and counter. While explaining to my pupil, I would often drop my arms to my side, when invariably the nervous Frenchman would sock me in the face, before I could duck, with the result that I was generally adorned with one or two black eyes. Of course, these blows were dealt without malice, but I seriously thought of applying for a face mask.

The townspeople were very kind to me and I was often invited to their homes for dinner or social gatherings. In this way I became acquainted with some very good-looking young girls, who consented to pose for their portraits. For, whenever possible, I painted. Among other things, I did a series of posters, depicting the various activities of the center, and many evening sketches along the sea front.

RUMOR of the dreaded *grippe espagnole* and the ravages wrought by that scourge had begun to filter through the well-censored press. At Royan there had only been a few cases of a mild nature, but at Bordeaux close by, where there was a concentration of troops and several large American camps, great uneasiness prevailed.

In company of my two French sergeants, Berthoneau and Dieudonne, I was sent on a mission to various towns in the southwest—Bordeaux, Perigueux, Lourdes, Tarbes, Pau—with a view to establishing subsidiary centers of physical reeducation. All went well until we arrived at Bordeaux. There while lunching with some American officers at the famous restaurant Le Chapon-Pin, I was seized with a queer giddiness and nausea. I broke out into perspiration, and at the same time felt clammily cold. My companions, of whom one was an army doctor, lost no time in rushing me in their car to the American hospital, on the outskirts of Bordeaux, housed in a large school building, where I was immediately put to bed, the diagnosis being "acute influenza." Having sent

for my two sergeants, I instructed them to continue their journey and asked them to mail home postcards I had already prepared at the various places they stopped off, so that my family would have no cause for worry.

The hospital treatment for grippe was simple. One was put to bed and given the omnipotent "C.C" pills, regarded as a veritable panacea in the army. Despite the sharp cold, the windows were left wide open. I cannot remember the doctor prescribing anything else for me. There were several nurses in constant attendance, who took our temperatures at regular intervals. It seemed to be just a case of lying in bed and waiting. The French treatment was quite different. In the hospital barracks where influenza cases were treated, windows were kept hermetically closed and the patients plentifully dosed with hot grogs, consisting mostly of rum or cognac to cause perspiration. From all accounts, this old-fashioned remedy was generally most efficacious—a proof that the efficacy of remedies depends often on racial habits and dispositions.

I cannot recall, once I was put to bed, feeling any pain or giddiness. In fact, on the third morning I felt so strong and normal that I reached out for my clothes, neatly folded at the foot of my bed, and began to dress. When the nurse inquired what I was doing, I replied that I felt well again and wished to return to my duties. I was informed that there were formalities to be first observed, and that it was easier to enter than to leave a military hospital. The doctor passing by asked the nurse to take my temperature. One look at the thermometer sent me back to bed, much to my disgust. That day and the next I ran a high temperature, with a feeling in my chest as if a saw were cutting me in two. Then the pain left me and drowsiness set in. Everything seemed blurred—evidently a serious crisis in my illness—for I remember that a screen was placed around my bed, which, as I learned later, is an ominous sign in hospitals. Several days passed before I was out of danger, and then I was so weak that I could hardly stir. The nurses throughout showed themselves to be true angels of mercy and wonderfully efficient. Nor was I forgotten by the officers at my center, who frequently sent inquiries and good wishes for recovery.

Meanwhile the grippe epidemic was taking its almost daily toll of human lives which the war had thus far spared.* The funeral processions passed under our windows to the solemn strains of Chopin's death march, regardless of the depressing effect they had on the morale of the patients, and left one wondering on the strange vagaries of the military mind!

As soon as I was judged fit to leave the hospital, I wired my two sergeants, who hastened back to Bordeaux. I was still very shaky and thinner than I had been in many years, but rejoicing in my luck to get out alive, for during my stay at the hospital many a comrade had joined the army of shadows.

*Warshawsky was one of the survivors of the worldwide influenza epidemic of 1918–1919 that killed an estimated twenty-one million people. Edward Robb Ellis, *Echoes of Distant Thunder: Life in the United States, 1914–1918* (New York: Coward, McCann and Geoghegan, 1975), p. 475.

Neither looking nor feeling like an athlete, I managed, in the company of two assistants, to visit the few schools remaining on our itinerary, after which I was glad to get back to Royan.

REPORTS of continued Allied successes—the retreat of German troops, the capitulation of the Turks and Austrians—had made a great change in the morale of the French. But the suddenness of the Armistice was overwhelming. Elaborate fêtes were at once organized in our little town and on that day of days, I, as a representative of the great American nation, almost had my hand shaken off by the male population, while the ladies kissed and embraced me with an enthusiasm which only the occasion could justify. I have also to admit that in company of my fellow officers at the center I for once that afternoon became ignominiously soused. In honor of the occasion the proprietor of our favorite café brought forth from its hiding place a bottle of prewar and since prohibited absinthe, and invited us in a barroom argot to *e'trangler le perroquet* ("strangle the parrot").

But worse was yet to come. The following day an elaborate program had been arranged, including an outdoor concert, followed by dancing. I received a message from the Mayor of Royan, asking me to call on him at the City Hall. There, after congratulating me as a worthy example of the American nation which had helped to save the world from barbarism, M. le Maire invited me to sing the national anthem of my country before the assembled people. "But, Monsieur le Maire," I protested, "I am not a singer (as all my friends can testify)!" This protest was unavailing. Was I not an *"artiste?"* I was, but an *artiste-peintre*. No matter. An artist was an artist, and to the popular mind of France implies theatrical talent of some sort. Seeing there was no way out, in my alarm I applied to the American sailors at the port to help me in my dilemma, and succeeded in rounding up a few brave lads to stand by me in my need.

The platform for the performance was set in the public square and was surrounded by all the inhabitants of Royan. After a few patriotic addresses, the "Marseillaise" and various other national anthems were sung by professional singers. A popular opera singer had just given a splendid rendering of the "Brabancon," the Belgian hymn, when we were announced to sing "The Star-spangled Banner." The four gobs with me were frozen dumb as we came onto the platform, which to me seemed to be swaying like a ship, while the sea of upturned faces was a nightmare haze. Suddenly I heard the opening bars of our anthem and a high shaky voice, that I could hardly recognize as my own, singing the first words. How we ever got through the ordeal is one of the minor mysteries, but we evidently did, for I was awakened from the nightmare by a burst of applause and cheering, such as might have greeted Caruso at the height of his career.

After the peace was signed and while preparations for demobilization were going forward, enthusiasm for the work at the center quickly dwindled. The only thought of every man was to return home. Although discipline and military restraint were relaxing, the authorities felt it was

more necessary than ever to continue for work of physical reeducation, both for the great numbers of war victims who could thereby be made fit for resuming work, and, above all, for the youth of the country, which needed instruction in the methods of sport. In view of the terrible losses and the weakening of an entire generation of young Frenchmen through the war, it was more than ever necessary to think of the coming generations.

My own engagement was terminating on March 15, and no *poilu* looked forward more eagerly to his release than did I. In spite of a particularly rainy and dreary winter, I had long recovered from my illness and felt strong and fit. The longing to return to my painting had almost reached a point of anguish, and I decided with the return of the first fine weather to make a dash for the country.

Early in March I received a long letter from Percy Carpenter, congratulating me on my success as instructor at Royan and urging me, to my dismay, to accept a six months' reengagement, but this time at Antibes, between Cannes and Nice. Knowing I was a painter, Carpenter expatiated on the beauties of the Mediterranean coast and the delightful climate, assuring me I should find plenty of time for my brush. These arguments, added to the prospect of continuing to earn a salary while painting—for a large part of my war pay had been sent home—finally convinced me.

Before leaving for the south, I had the happy surprise of a visit from Louis Rorimer and a group of men from the Cleveland Chamber of Commerce, who called at my studio in Paris. At their request, I showed them the pictures I had painted in Paris and Brittany before I entered the army. Evidently they pleased my visitors, for they purchased half a dozen of them then and there.

WITH my faithful Bicot and a plentiful supply of paint and canvases, I started for the Midi, my first trip to the joyous southland since my memorable voyage to Italy with Halpert ten years previous. This time, however, thanks to my official status, I was traveling first class. My first glimpse, after the weary night trip, was the sunlight flashing on the walls and towers of Avignon—a sight still fervently remembered—then Marseilles, where we had embarked for Italy, and finally our destination, Antibes, radiant in sunshine, the sparkling blue waters of the Mediterranean bathing the walls of Vauban's old citadel; with palms, pepper trees, flowing cactus, and other exotic plants making a riot of color along the garden walls and shady walks, while in the distance the chain of Maritime Alps, the higher peaks still clad in snow, piled upwards, tier on tier, in the blue haze of summer skies. It was a picture, which to my eager eyes, was sufficient excuse for wanting to settle down here.

Old Antibes, then still unspoiled, with its monuments dating from the days when, as Antipolis ("the city opposite"), Roman ambition had destined it to be the rival of Nice and Marseilles, offered countless motifs to the painter. That and the glorious sunshine, the first I had seen for many months, filled me with unwonted joy and optimism. The towns-

people were going about in light summer clothes, the ladies carrying parasols—an almost incredible sight to me who the night before had left Paris, still muffled up in winter garments.

At the Port Carre I presented my credentials to the commanding officer, who introduced me to the other officers, one of whom kindly offered to help me find a lodging. Facing the fort was a modest hotel which commanded a wonderful view of sea and mountain—an ideal place for a painter, and there I took pension, preferring to take meals at the hotel rather than at the officers' mess, for the sake of greater independence. My duties were of the simplest. Every morning at six I held a few classes, lasting for barely two hours. This was followed by a swim in the sea; after that I was free to do as I willed for the rest of the day.

I was soon at work on one of the lovely subjects I could see from my windows—a view of the old fort reflected in the calm waters of the Mediterranean, with cloud-shadowed mountains in the background. Soldiers and officers from the fort also served as models. Never did I work so eagerly and with such enthusiasm. On a hired bicycle I explored the surrounding country, and passed Saturdays and Sundays, which were free, in the mountains back of Nice and Monte Carlo. Little Bicot, who accompanied me on my trips, despite his hardy Breton forebears, had a hard time trailing up the steep hillsides, and many times I had to carry the little fellow over particularly difficult places. Eze, the antique Saracen stronghold, seen from the upper Corniche road, terraced with orange groves and gray-green olive trees climbing up the slope, perched high above the ever-changing Mediterranean, afforded me inexhaustible motifs for sketching.

On one occasion, having missed the funicular from La Tourbie to Monte Carlo to make connections for my last train to Antibes, I started to clamber down the narrow, winding goatpath, a truly killing performance, which made the muscles in my legs and the soles of my feet feel like hamburger.

After a while I was fortunate enough to discover a small furnished villa on the road to Cap Antibes, within fifty yards of the sea. A lovely grape arbor and garden did ideal service as outdoor studio, while a spacious basement room was a cool refuge in which to work during the heat of the day. The owner, Madame Figuera, furnished my meals and attended generally to my well-being. I was interested to hear from her that my old friend, John Ferguson, the Scotch painter, had passed many seasons there before the war. It was only a short bicycle ride from the fort to my new residence, and by nine A.M. I was out of my uniform and in my painting togs.

Life would have been ideal had it not been for the swarms of mosquitoes, which set in at sundown and made it necessary to sleep under a netting. The ground was also infested by tiny ticks, which tortured poor Bicot, burying themselves in his skin under his busy coat, till finally I had to have him shorn. Never have I seen human or beast so humiliated as he was after his shearing. The truth, and he seemed to realize it, was that Bicot's only claim to beauty was his fuzzy coat.

The large house and grounds adjoining our villa were inhabited by Paul Signac, the noted French painter. Having one day on the beach made acquaintance with him and his wife, he invited me to see his work. I was familiar with his pictures, which I had seen at exhibitions and Salons, and was curious as to his methods of work. He very seldom painted in oils from nature. His large canvases, some of immense size, were painted from drawings in charcoal or pencil, and retouched with watercolors. In early youth he had been influenced by Seurat, the pointillist, who juxtaposed pure bits of color in mosaiclike touches, which at a distance vibrated and gave an effect of light. Later this method was simplified and made more scientific by the researches of Monet. Signac, however, kept closer to the earlier methods of Seurat, but his work was mechanical, each square being a touch of color precisely the size of the other. His method of procedure in painting was equally mechanical, a certain amount of space on the canvas being alloted to a day's task. Often in looking at his pictures I was reminded of a tiled bathroom. In his drawing and watercolors he showed more enthusiasm, but no matter what the subject or line, the same colors would recur with unfailing regularity.

Paul Signac was a power in the art politics of Paris and has for many years been president of the Salon des Indépendents. In appearance he was a short, stout man, full-bearded, with a spectacled, elderly face. A lover of the good things of life, he was compelled by an impaired digestion to restrict himself to a vegetable and noodle diet. At his house I met many well known artists of the day, and on one occasion he took me to see the great Renoir, then living at Cagnes, near Nice.

We found the veteran painter in his studio, propped up among a heap of cushions, in front of a huge canvas, on which he had painted a variety of tiny fragments of subject—something glimpsed from his studio window, some fruit and other pieces of still life. In a corner of the room was a model, ready to pose at a moment's notice. A spark of the old fire was still burning within him, but he was physically undone and at times his fingers were so stiff that he could not grip the brushes, which were tied to his fingers. Picture dealers and their representatives hovered about him like ghouls, waiting to snatch every brushstroke he painted. The little notes of color on his canvas would be carefully cut out for these gentry, and each carefully mounted by itself. As these fragments had never been signed by the master, his widow, after his death, authorized a facsimile stamp of his signature to be made which was applied to the unsigned work.

For the sake of art and Renoir's glory, it would have been better if much of his later work had perished. For compared with the masterpieces he created in his finest period, these last efforts of an aged man failing in health were often deplorable. His color, which had been delicate and luscious, had degenerated to a mixture which resembled rose-colored jam, so cloying as to be nauseating. But his work was in such demand that anything from his brush was a highly marketable commodity for the middleman, who for the sake of personal gain is continually dragging

down the level of art. Were it not for him and his like, that level in our day would stand higher than it does, and with it, public taste in general.

ALMOST daily companionship with Paul Signac and the magnificent scenic surroundings stimulated my ever-hungry instinct to try and capture some of this beauty on canvas.

Opulent, but at times dry and arid, this southern land was in disconcerting contrast to my painting haunts of Normandy and Brittany. There motifs were less obvious, effects discreeter and shyer. The skies and atmosphere were limpid and rain-washed, colors soft and gray, with unlimited variety of greens in foliage and herbage. Here the ever-brilliant sun of the Riviera had baked all colors into an almost universal sameness. The summer sky seemed a metal bowl, blinding and colorless in its intense light, utterly unlike the rich dark-blue I had hoped to find, as presented by traditional artists of the Midi on their canvases. What I actually saw was very different. Bricks and tiles in the gleaming rays were faded into neutral orange, violet, and red. The roads and by-paths were covered with a thick, often blinding white dust with which the over-hanging trees and shrubs would be powdered at the slightest gust of wind. Distances lacked mystery, the slightest details looming up all-importantly against the horizon. Only during the midday hours heat mists, hovering over distant summits, would shroud and modify sharp contours, while villas and small towns, nestling on the nearer, lower slopes, gleamed like encrusted and irridescent gems. Evenings, however, were invariably glorified by symphonies of magnificent color. Sunsets burned by opal-shaded fires, waters tinted in every hue of blue, lapis lazuli, azure, and turquoise, with intershifting spaces of violet and emerald, offered happy contrasts to the sun-baked grayness of old walls.

Olive trees predominating everywhere on the surrounding hills, their grotesquely twisted trunks, overhung with silver-gray foliage, stood out in sharp relief to the dark accents of the cedar, here and there studding the landscape. Shadows in glittering light were dark and intense, unlike the delicate blue and mauve of the northern lands. Here they appeared almost indigo or at times a purple reaching into red. In the open it was necessary to work under an umbrella, not only as a protection against the heat but also to keep the light from refracting on palette and canvas. In addition to this protecting shade, I would add a wet cloth, placed inside my wide-brimmed straw hat. Otherwise I found, after a protracted séance, that I would be suffering from a splitting headache. Sometimes a subject would offer itself from where I could work underneath the spreading foliage of an olive or a eucalyptus tree, when it was an agreeable experience to feel how cool and pleasant such shade could be.

The little garden and vine-covered arbor surrounding my villa now served me, as I had hoped, as an excellent studio. There I could experiment with models in outdoor portraits. A great advantage for a painter in a steady climate like that of the Riviera over his fellow-craftsmen working in less sunny lands is that he can be reasonably certain of light and weather conditions at the appointed hour for posing his model

outdoors and not be forced to quit on account of showers and overcast skies.

MY DUTIES as instructor at the fort entailed very early rising. Every morning at five I was out of bed in time to enjoy the last moments of a beautiful dawn. Then, after a refreshing dip in the nearby ocean, and a simple breakfast, I would bicycle to the fort in time for my classes which started at six. These physical exercises gave the needed zest and energy for my painting. Except for meals and the necessary siesta after lunch, all my waking hours were spent at the easel. Never had I been able to devote so much time to outdoor work, which was only interrupted on the few occasions when the sandladen sirocco blew in a stifling gale across from Africa, making it impossible to remain outside the house. Save for these rare interruptions, the days were perfect and canvases and studies were piling up in imposing numbers.

The glorious season had seemed just one long day, the sun slowly climbing to its zenith and then gently down toward the cool horizon of the sea.

My brother Alex, whose duties at Fontainbleau had come to an end, had gone to Pont-Croix in Brittany, being as paint-hungry and keen to get back to his life's work as was I. At the Fort Carre at Antibes all the nonprofessional officers and many of the monitors had been demobilized and gone back to their civil occupations. Though only a few short months had passed since the Armistice, already memories of the horrors and tragedy of the long war seemed to have vanished from the minds of the gay chattering folk basking in the sunshine of the Riviera. No longer was the military uniform the dominant note. Life was again becoming a pleasant monotony.

My engagement with the French Army ceased at the beginning of September. The thought of forever being rid of a uniform was some compensation for leaving this pleasant land, where there were still many things I wanted to paint. The restlessness and leave-taking all about me were getting on my nerves, so when a letter from Alex announced he would be in Paris the middle of September, I was not long in making up my mind. With my pile of canvases packed up, and the faithful little Bicot installed beside me, I embarked for Paris.

·10·

1919-1931

A DECIDED change had come over the Paris I had left six months ago. At the railway station I found the porters lacking their former eagerness and amenity and dissatisfied with the usual tip for carrying luggage. Cabbies were insolent, and on the streets groups pushed in and out with a brusqueness and lack of civility surprising in a French crowd. On my way to the Quarter I saw many old landmarks in course of demolition or alteration, often to make room for modern constructions. The quietest corners seemed now humming with a new alertness. Everywhere there was a feeling of pushfulness and go-getting. In every quarter new banks had appeared, replacing business and commerce of other kinds. Out of the tragedy and disaster of war huge fortunes had been garnered. A new class of rich had sprung up. Spenders, wastrels, often completely ignorant, were declaring they could buy everything, even culture. Thrifty, honest folk, who had toiled a lifetime, found themselves contemptuously pushed aside by the parvenu.

At the Dôme, where I had arranged to meet Alex, we found few of the old crowd of painters, although the new element, a hard-drinking lot, was almost wholly American—relics of the army, Red Cross workers, officials of welfare organizations, and the various Reparation Committees then sitting in Paris. Everywhere, even in the quietest streets, new restaurants and night clubs were sprouting up. American Negroes, who already before the war had found the French idea of racial equality to their liking, and had lingered on or returned, often finding employment as musicians, were introducing jazz, which still appeared horrible to the older generations, but was being eagerly taken up by the new element, which found the Negro rhythms more in keeping with their hectic mode of life and more "up-to-date" than their own slow and somewhat melancholy dance music.

Among our old acquaintances at the Dôme we found a thin and tragic-looking Jack Casey, who had fortunately survived many sanguinary combats in the Foreign Legion, and Moise Kissling, who had served in the same regiment. Cheerful Andre, the waiter, had been killed shortly before Armistice. Only Shorty Lasar seemed the same.

Living conditions were rapidly changing in Paris. Rents were being raised, and the prices of foodstuffs and restaurants were following suit. For unknown reasons these economic changes were being blamed on the Americans, who in the eyes of the French were rapidly becoming unpopular, after having been adulated as heroes.

209

The galleries and exhibits were crammed with pictures and studies depicting war incidents, while commissions for war monuments were causing a flood of unwanted prosperity among sculptors. Painters of every class were likewise reaping a rich harvest, as the *nouveaux riches*, in their desire to become cultured, were buying up works of art, or whatever passed muster as such. As a result, the seedy, down-and-out *rapin* of prewar days was becoming stout and prosperous.

In spite of the fact that the American was becoming persona non grata with the average French citizen, the French government, to show its appreciation of our aid in war and to establish bonds of artistic sympathy between the two nations, invited a demonstration of modern American painting through the medium of the official Beaux-Arts. For the first time in its history, the Luxembourg Galleries were to be devoted entirely to an exhibit of contemporary American art. M. Benedite, curator of the Luxembourg, chose the exhibitors among the American artists residing in Paris, while a special committee made selections in America. All the well-known American painters were represented. Whistler's portrait of his mother and Sargent's *Carmencita* were given places of honor. Both Alex and I were invited by M. Benedite to exhibit, the canvases selected being those we had painted at Pont-Croix. Mine was a view of the little River Goyen that runs through the pastures at the foot of the town, with several washerwomen in the foreground. This picture was later acquired by the Cleveland Museum of Art. Energetic Jo Davidson showed portrait busts of President Wilson and General Pershing. But the exhibit brought nothing new either in technique or subject. The tendencies shown denoted either the influence of the French school, or were merely academic and reactionary.

THE AFTERMATH of the war, with its spreading discontent among soldiers returning from the front and the general feeling of social unrest which was pervading the atmosphere, added to the increasing cost of living, had for the time being tarnished the charm of living in the French capital, with the result that many of the Americans who had stayed on in Paris during the war were beginning to feel homesick for their own country.

It was nearly four years since Alex and I had been home, and letters from our family were constantly urging us to return, at least for a visit. America, after all, was still the only fairy godmother we possessed, and it was on her soil that we were most likely to find purchasers for our work. A considerable number of the Old Guard of the Quarter embarked with us on the *Touraine*. Among them was George Oberteuffer, the American painter, his French wife, also a talented artist, and their two children. For over two decades Oberteuffer had been absent from his native Philadelphia. His wife and children, ignorant of the English language, were apprehensive of the new land which they were about to enter as American citizens. When some years later I met them in Chicago, where Oberteuffer was teaching at the Art Institute, Mrs. Oberteuffer told me she was far happier in America than she had ever

been in her native France.

Among our fellow travelers were also my old friend, Fred McKean, with his wife, and Bobby Robinson, one-time secretary of the American Artists' Association.

Of all the vessels sailing the seven seas, the *Touraine*, I believe, was the most venerable. Of passenger ships she was certainly the most antique. The way she pitched, swayed, and rolled over added something new to my experience of sufferings on the high seas.

Most of the passengers were American officers and soldiers, who had been detained in France by after-war duties. The smoking and dining rooms were always full of doughboys shooting craps and begging the dice to "buy baby a new pair of shoes."

Alex supported the bad weather and pitching of the ship like a real salt, while I, true to form, lay stretched out on deck as sick and helpless as a trussed calf.

A wonderful surprise awaited us at the port of New York. Our three brothers—David, Mort, and Sam—were at the pier to greet us. Sam and his wife were now living in New York, and Mort had also come to the big city to tempt fortune. As for David, he had just arrived on a brief visit. For the first time in many years we five brothers were united. David had taken a large room for us at the Pennsylvania Hotel, which during the next few days, thanks to the many friends who came to see us, looked like a convention hall.

I got in touch with the Howard Young Galleries on Fifth Avenue near Fiftieth Street, and was offered an exhibit of my pictures on their premises within the next few months. During the interval, in company with Alex and David, I returned to Cleveland for a joyful reunion with our family.

The exhibit at the Young Galleries was well noticed by the metropolitan art critics, but it seemed that the newspapers thought they could get better copy out of me personally for a "H. I." story. As an athletic instructor in the French Army, my publicity value, so reporters assured me, was far greater than as a mere painter, as a far greater proportion of their readers were interested in sports than in art. One reporter wanted a photo of me in boxing togs. My answer was that I had only done my bit in the army, but that all that was past. My life's work was painting, and I expressed the wish that they would henceforth regard me as a painter, and not as a pugilist. One of these wags, having promised to respect my wishes, kept his word. In his article there was mention only of my artistic career, but it was headed "Artist Puts Punch in Pictures."

The favorable reviews of my exhibit, which appeared in the eastern press and in several magazines, evidently sent up my stock, for the Cleveland Museum of Art offered me one of its galleries for an exhibition of my works. For the first time in my homeland I was afforded a favorable opportunity to exhibit a large and comprehensive collection of my paintings. Those who were genuinely interested in my career would now be able to see what progress I had made. As for my dear parents, their naive pride, though I realized it was quite unwarranted, filled me, I

admit, with shamed satisfaction. But tributes were not confined to the home circle. The local newspapers covered my work with superadulation, and, best of all, my friends and fellow townsmen showed their appreciation by the more solid homage of paying money to acquire my pictures. The Museum purchased the painting I had shown the previous autumn at the American exhibit at the Luxembourg Galleries. I had, in fact, every right to feel that my native city had treated me as a prodigal son.

On the first evening of my show I was eagerly welcomed by a dear old lady who had been my teacher at Brownell School. Proudly she presented me to several of her friends, telling them how she had predicted a great career for me as an artist from the early days when I attended her classes. She forgot to add that it was she who had sent me home on account of an unwashed neck, decrying my lack of artistic ability, and thereby almost making me forswear art forever. Nor was it for me to remind her of this incident while she was wishing me from the bottom of her kind old heart a career equal to da Vinci's.

This exhibition had other good results. Mr. Edwin Hewitt, the architect, connected with the *Foyer du Soldat* during the war, and who had taken an interest in my career on reading some of the reviews of my work, had entered into correspondence with me. As one of the directors of the Art Institute at Minneapolis, he now invited both Alex and me to hold an exhibition at Minneapolis, as well as offering the hospitality of his home if I wished to come myself, an invitation which I gladly accepted.

My stay in Minneapolis was made delightful by a reunion with old friends of the Miller Building days in New York, Clarence Conaghy and Hicks Culberg. In spite of their early bohemian life, both had now settled down as prosperous commercial artists and good, solid, married citizens. The Institute acquired one of my Paris pictures, a view of the Rue de la Paix in wartime. Several commissions for portraits added to the success of this visit.

THE GENERAL FEELING of prosperity in the early years following the war was very beneficial to the arts, and for once the artist who had succeeded in his career enjoyed the opportunity of reaping substantial profits. In cities like Chicago and Cleveland, there was a demand for portraits. I was tempted to take a studio and settle in the United States. Though I had lived abroad for many years, I still felt myself to be essentially an American. There was no doubt that life was far more comfortable, and that there was more kindliness and generosity among my own people than in Europe; to say nothing of the fact that the prospects for earning money were incomparably better in America. But despite these advantages, I felt that life in the States lacked the mental stimulus and the possibility of isolation and solitude necessary for the development of the artist. I realized that at home people had to conform not only in dress but in ideas and actions. It was necessary to belong to a group, a club, a church, otherwise one was put down as an eccentric or a nut. To be successful meant to make a lot of money. If I wished to make

headway as an artist in America, it would mean giving up all ideas of experimenting. I should have to keep on painting pictures of the kind that had proved saleable and portraits that would please. In other words, I should have to abandon all ideas of personality and liberty of conscience.

This new America was too fast for me, too turbulent and energetic, a place for businessmen and builders, not for a dreamer or an individualist in art. I had fallen out of step, and lived away for too long. The men of my generation had been drawn into the current and had fitted into the established order of things, while the younger generation had developed into go-getting salesmen, with get-rich-quick mentalities, which sneered at the conventions, the ideas and ideals of the past. Already I felt the old urge for work leaving me. A salesman of pictures, that is what I should ultimately become if I remained here. I only painted when a commission was forthcoming. The idea that money was the end and aim of all effort was beginning to get hold of me in spite of myself.

The realization that I no longer fitted into my homeland was a bitter feeling and one I could not convey to my family. My attachment to them was great and deep, and the thought of leaving Dad and Mother as hard to bear as on my first departure for New York. Two natures were struggling within me: love and comfort on one side, on the other a primitive, often incoherent urge for what is misnamed "self-expression," and could hardly be described as ambition.

For ten months I remained in America, the last few in a struggle with myself before I came to the decision of returning to France. The withering heat of the Middle West filled me with longing for the cool, primitive haunts of Brittany, where I could go about in old canvas trousers, barenecked and bare-armed, without shocking the community.

A few days before my departure, I received word from friends in Paris that poor Bicot had suffered the fate of so many of his brethren—he had been struck by a motor truck and killed. I hardly dared show my face at home for fear of being mocked at. How could I explain the grief I suffered through the loss of a mere dog? It seemed impossible to convince even the most sympathetically minded that I had lost a dear friend, more devoted and nobler spirited than most human beings. All I could answer in response to solicitious inquiries concerning my depressed spirits was that I had received the news of the death of a very dear friend.

PROHIBITION in the United States had drawn a new American population to Paris. It almost seemed as if Greenwich Village en masse had emigrated to the Quarter. What had formerly been real bohemianism now became a sham, a part of the Montparnasse sideshow. The Dôme Café was crowded to the limit, and the sidewalk terraces stretched almost to the curb stones of the now famous boulevard. Across the street the once modest Rotonde had blossomed forth into a rival of the Dôme. Adjoining shops had been annexed, and the whole transformed into a mammoth café. The interior was of a magnificence heretofore unknown in

the Quarter, the entire wall space being devoted to a permanent exhibition of the paintings and drawings of artist clients, while upstairs every evening a large dance orchestra played jazz to a jostling crowd of gyrating couples. The center of Paris night life had been transferred from Montmartre to Montparnasse. As a result, the Quarter was rapidly losing its former air of quiet and unpretentiousness. Cafés, American bars, and "dancings" were springing up all along the Boulevard du Montparnasse. A new Babylon had been launched in Paris.

An innovation in Parisian cafés was the new "Coupole," for the construction of which an entire block of buildings was sacrificed. The interior, vast as a railway station, was of the latest Teutonic design and ordering, with the clatter, chatter, and scurrying of a German *Bier Keller*. Here were to be found the lesser satellites of the cinema, clandestine vendors of drugs, political refugees from the two hemispheres, unattached female adventurers, secret police agents. Only a very small sprinkling belonged genuinely to the artistic professions.

The older Dôme clique was beginning to frequent the new Café Sélect, which, however, soon degenerated into a resort of perverts and inverts of both sexes, marcelle-frilled and painted, perched on high stools, simpering and flirting unabashed. Here of an evening many of the coterie of new writers, then coming to the front, were to be found: Konrad Bercovici, James Joyce, Eugene Jolas, Ernest Hemingway, Peter Neagoe, Lyon Mearson, Lillian Day, and certain old-timers like Gelett Burgess, who, for a while at least, found amusement in this new Montparnassian sideshow.

Nearer the Seine, facing the venerable church of St. Germain-des-Près, with its hoary tower dating from Roman days, was another popular café, that of the Deux Magots, which still maintained its prewar status of an "intellectual café," then as now perhaps the most important of all maternity wards for artistic gestation.

In the neighboring Rue de Seine and Rue des Saints-Pères, and also in the Rue de la Boetie across the river, were housed most of the galleries of picture dealers. There almost every day new talents were being "discovered," exploited, heralded, flashing rocketlike across the skies—a bang, a flash, and then, as a rule, silence. In most cases the announced rockets never showed above the housetops and merely fizzled and sputtered out on their stands.

The public's innate taste for the chromo was being exploited to the full. The masters of the day were Kissling, Vlaminck, Utrillo, and the Russian Soutine. Kissling's paintings, clumsy in form and sour in color, still held a sentimental sadness found in the crude chromos of earlier days. Vlaminck, who had started out in mature life as a cabaret actor in Montmartre, exhibited plaster-colored landscapes, which resembled the "genuine hand paintings" seen in furniture and barber shops in my youth, the main difference being that the latter were generally adorned with mother-of-pearl incrustations.

Utrillo in his youth undoubtedly showed great promise, but a drunkard's existence brought about an early decay of his talents. In spite of the

fact that for years he had been confined in a private institution, the picture markets were flooded with his views of Paris—crude copies of photos and postcards, mechanical lines of the T-square and triangle showing clearly through the paint. This finally resulted in a scandal in which his mother, the painter Suzanne Valadon, was implicated. It was proved that she had contrived in the spurious output of so-called works by her famous son. Soutine, one of the latest glories of the new school, specialized in still lifes representing smoked herrings on a dark background, or weird hallucinations revealing a "technique" that even a sign painter might refuse to acknowledge as his own.

A decade of revolution in favor of purer, freer color was now decried. The new school, now in favor, depicted their subjects in dark, dirty grays, browns, and oily blacks. Othon Friesz owed his first gleams of fame to an acquaintance with Cézanne, though his works had few of the virtues and most of the defects of his master. Dunoyer Segonzac, who painted formless landscapes in a muddy paste of black and gray, and Derain, with drab, thinly veneered evocations of his academic background, reflections of his own joyless, perpetually down-in-the-dumps existence, were acclaimed as world influences in painting. I have found artistic snobs in front of one of Derain's landscapes raving about the "marvelous color" which was conspicuous only by its absence. His best landscapes were inspired from compositions by old masters in the Louvre. Those he evolved from his own conceptions were entirely lacking in life and movement.

Foujita, the Japanese artist, a draftsman of great originality and charm, found the demand for his work so great that at times he resorted to making several tracings of each drawing, which he signed as originals. Etchings and lithographs signed with his name for sale in the various galleries could be numbered by the hundred. Unfortunately, the desire for notoriety got the better of his dignity as an artist, and he resorted to the publicity methods of a cinema star. He could be seen in public places adorned with a nose ring. With the aid of touring agents, he organized visits to his studio, where so-called artists and students could be seen at work from a variety of models posing in the nude, so that the "personally conducted" visitors got their money's worth.

The art galleries and picture dealers were reaping huge profits. The New Rich were buying art by new masters to give them standing in matters of taste and culture. In addition there was the clientele of speculative buyers, who purchased the new masters not because they admired them, but because they counted on making large profits when the new "values" had been boomed in the art market; for people remembered the huge sums paid for works by Monet, Sisley, Pissarro, and Cézanne, which had once been so disdained that they could hardly find purchasers even at the ridiculously low prices asked.

In many well known instances, when their pictures were put up for auction at a public sale, artists in vogue resorted to tricks practiced on the stock market and in certain lines of business. In order to keep up the commercial value of their pictures, they would, through a proxy, bid up

215

the prices to a figure far in excess of that for which the work had been sold originally. It was notorious that one of the principal leaders of the new school had spent a fortune in this matter. On every possible occasion he had bought in his own pictures, thereby giving the public the impression that their market value was steadily increasing and that there was a great demand for his work.

A great source of revenue to dealers was the renting of their galleries to young, more or less unknown artists who wished to show their wares. The slightest, crudest efforts of these tyros were encouraged. Eulogies of their "works" would be printed in the newspapers (at so many francs a line). For a consideration, critics of high reputation could be found who were willing to write favorable notices in the catalogs of these exhibitionists; while magazines consented to print flattering reviews with reproductions, provided the author of the works reviewed paid for the plates and undertook to buy several hundred copies of the magazine.

All these youngsters had "genius" at twenty. But, as Balzac said, it would be lucky if one of them could be found to have mere talent at forty.

Never before had art been so blatantly advertised. Artists, and all who pretended to be artists, were treated with respect as potential producers of marketable wares. No longer were they regarded as idlers and bohemians. The fact is that artists were qualifying for the esteem of businessmen by the attitude they were adopting. Instead of wasting time discussing problems of aesthetics and talking mere artistic "shop," their conversation now turned on questions of prices, salesmanship, and the prevailing modes in favor with the public or about to be launched by the picture dealers. Terms such as "beauty," "ideals," "sacrifice for ideals" had been eliminated from the vacabulary of the up-to-date artist as so much sentimental bunk. The test of the successful artist was to get rich— the quicker the better. The surest means to do so was to be a vigorous promoter, if possible an originator, of a new -ism. The art atmosphere had become so steeped in these -isms, one more nebulous than the other, that it seemed to the honest seeker no clear path was discernible amid the thickening fog.

In the midst of this chaos, at a critical juncture in the history of art, the director of the Beaux Arts arranged a series of exhibitions of the masters of the early nineteenth century. The series was initiated with a comprehensive show of the works of Dominique Ingres. As a result, this much decried painter, who for long had been scorned by the new generations as the prince of *pompiers*—cold, academic, and unimaginative— was hailed once more as a genius, endowed with all the qualities which distinguished the ultra-modern Picasso. To prove the point, certain magazines reproduced a Picasso drawing side by side with one by Ingres. One could hardly have imagined a more ridiculous contrast. Side by side with Ingres's powerfully constructed, well-designed drawings, the grotesque, emasculated images of the Spaniard appeared as if drawn by a wire nail. In speaking of the latter, critics, totally ignorant of draftsmanship, employed terms which had nothing to do with art. One of the

most popular of these catch-phrases was "tremendous volume and intellectual line," which seemed to gain in significance the thinner and more cretinlike the inventions eulogized by these sham connoisseurs.

Subsequent exhibitions of the works of Corot, Delacroix, Courbet, Degas, and Manet gave art student and public further pause, and forced them to think for themselves, with the result that the charlatanism of so many of the "new masters" became ever more obvious. People began to wonder what really was their contribution to art. Was it the poetry and delicacy of a Corot, the profound science and color of a Delacroix, the solidity of a Courbet, the draftsmanship and daring of a Degas or a Manet? As for the intellectual and decorative qualities, which the new schools claimed as their essential prerogatives, they were surely not lacking in the works of these old-timers, which in addition, possessed the sanity, soundness, and consummate craftsmanship so sadly lacking in the "new masters."

IN THE QUARTER, as elsewhere in Paris, the housing question had become acute. Studios at a moderate rent were practically undiscoverable, since in the scramble for lodgings, they had been snatched up often by people who had nothing to do with art. Everything habitable was an object for speculation, the concierges demanding exorbitant gratuities before allowing a new tenant on their premises; the smaller the rent, the greater in proportion the *denier à Dieu* to the porter.

Having searched in vain for a workshop, I felt the discomfort of living in a small hotel; and the futility of the café chatter wore on my nerves. Once more I realized it was necessary for me to escape the sheeplike crowds, to isolate myself at the true fountainhead of inspiration—Nature. This time the decision for voluntary exile was made all the easier. My long anticipated return to Paris, its remembered quiet and charm, had been marred by an unexpected turbulence and feverishness as violent as that from which I had fled in America.

A season of artistic adventuring and wandering now began for me. That summer I passed on the tree-lined Loire River, at Briare, a quaint old village, which had been a favorite sketching ground for Harpignies. Through the lower town ran an ancient canal, the first waterway constructed in France. There I was joined later by my brother Alex and Ward Lockwood, a talented young painter from Kansas.

With the approach of winter, memories of the pleasant days I had spent at Antibes sent me south once more; this time to Cassis, a fishing village, nestling among the hills and rocks of the Mediterranean seaboard. At the little Hôtel Ducros, facing the port, I found several friends already installed: Emile Lejeune, the Swiss painter; Tor Arozarena, the writer and critic; Ethel Mars and her inseparable companion, Maud Squires. Instead of dark, dripping Paris days, we reveled in sunshine of glorious warmth and gaiety five days out of every seven. The only fly in this perfect ointment was the mistral wind, which created a local hurricane at regular intervals, and, as at St. Tropez, made work outdoors impossible. These wind storms, which last three, six, or

nine days at a time (at St. Tropez I have known them to continue for two weeks without a letup), are especially exasperating to the painter, for then the sun shines its brightest and the wind-swept sea, with ever-changing colors, looks its loveliest.

Late in the spring I was tempted on to Martigues, close to Marseilles, famed among artists for its fishing boats and picturesque habitations. This "Venice of the Poor," as it is often called, proved to be a painter's paradise, for every quay was lined with painters, their easels almost touching one another. Within a space of fifty meters I have counted as many as fifteen painters, many of them well known in the art world, for Martigues' subjects have always been in great demand among dealers.

The artists here worked in many mediums and in every technique and style, from the old-fashioned chromo to the latest manner of the "wild men." Bonamici, whose pictures are now well known in America, worked exclusively on wooden panels, painting with a palette knife. With that instrument he was a versatile virtuoso, and the rapidity with which he worked was amazing. Every morning and every afternoon he began and completed a new picture. For several years he was under contract with a well-known Paris dealer to supply one hundred pictures a year.

Ziem, celebrated for his Venetian scenes, had built himself a home along one of the canals. There in later days he turned out his most marketable Venetian scenes.

The quality of light and color along the lagoons glorified the wretched huts and dingy boats, transforming commonplace objects into subjects of gemlike color. But—and a great But it was!—one had to be of sturdy fiber to resist the odors emanating from the canals and dirty alleyways. Despite electricity, gasoline motors, and silk-stockinged Martigues beauties, the local sanitary and sewage systems remained as they had been in the days of the earliest inhabitants.

A writer friend, Lillian Day, the brilliant author of *Paganini*, after one visit to Concarneau, wrote an article declaring that painters possessed no sense of smell, for otherwise it would be impossible for them to flock to Concarneau to work there. Fortunately for her, she has never visited Martigues. In my various peregrinations I had sampled most odors, but those I found in Martigues provided a new experience. They suggested neither fish, flesh, nor fowl (unless one change the *w* to *u* in the spelling of the last word).

How potent these odors could be, I was to learn from personal experience. One day I went out to sketch on the shore facing a small canal known as La Mare aux Oiseaux—otherwise, "The Pool of Birds"—because of the birds which were always hovering above it. The picturesque, tumble-down hovels fringing the quay and the colorful boats below them, reflected in the waters of the canal, were incredibly beautiful. I was carried away, sketching busily, when suddenly I turned faint and found myself reeling for support against an old wall, which fortunately was there to sustain me, or I should have collapsed. Only then I detected the cause, which in my first enthusiasm I had not perceived—a stench so overpowering as to be almost blinding in its effect.

It took all my will power to finish that picture. It now hangs in a friend's house in New York. Whenever allusion is made to the ambient atmosphere of the picture and the lovely site it depicts, something akin to hysteria takes hold of me, as if the unforgettable odor of Martigues had been painted into the canvas and was about to detach itself and work havoc, diffusing its poison, fit subject for a Baudelaire or Edgar Allan Poe!

IN MAY, when I returned to Paris, I found the housing problem as insoluble as ever, made worse by a crowd of tourists and the stifling air of a heat wave. Wherefore, storing my collection of new canvases with Lefevre Foinet, I left for Les Andelys, a picturesque town close to Vernon, on the Seine, clustering in the shadows of the huge ruins of Château Gaillard, the famous feudal fortress in which Richard Coeur de Lion had been imprisoned on his return from the Crusades.

There I found an interesting colony of Americans. One of them, the genial Gilbert White, one of the wittiest raconteurs I know, and an able mural painter, whose work is well appreciated in America, had acquired a permanent summer residence there, as had Wythe Williams, who with his little family lived close by. There also were George Slocombe, representing an English Communist paper, whose opinions were as fiery as his beard, Albert Webb, the etcher, and Russell Patterson, the illustrator. Though still a novice at painting, Patterson showed considerable talent as a colorist. Had he continued in the painter's career, he would certainly have made his mark. As it was, he returned to the States within a year and achieved a phenomenal success as an illustrator.

A letter from Foinet announced that the miracle had happened, a studio had been found and reserved for me. Within a few hours I was in Paris looking over the premises, which consisted of a large studio, with balcony loft above, a store room, and a kitchenette, the whole situated in a delightful courtyard, adorned with a garden and overshadowed by old trees. Added to these advantages was a very low rental, and the comparative quiet of the locality and the still unspoiled neighborhood of the Lion de Belfrot Quarter. It was, in fact, an ideal *pied-à-terre* for a roving painter, such as I was.

Although I had exhibited at the various Salons and with smaller groups of painters from time to time, I had not yet thought of having a one-man show in Paris. Now I was granted my opportunity. To encourage members of the American Art Association, the directors had decided to invite various painters to show their works in the club galleries, and I seized the occasion to hold my first exhibition in Paris.

The result was agreeably surprising. The Paris-American press, and even some French newspapers and magazines sent their critics, whose pronouncements on the whole were very favorable.

Best of all, a Beaux Arts official, who had come to see my show, purchased one of the pictures I had done at Cassis for the foreign collection at the Luxembourg. *L'Art et l'Artiste*, one of the best-known art magazines in Europe, published an article on the exhibition with repro-

ductions of my canvases. As for the picture purchased by the government, entitled *The Mountains of Provence*, it was widely reproduced in France and England, and all over America.

I began to receive letters from friends I had not seen for years. From Boston to San Francisco they wrote me, stating they had seen reproductions of my work in the various newspapers.

Following this show, several galleries in Paris requested me to hold exhibitions. It was no little satisfaction that one of these offers came from a dealer who some years previously, when in company of Turnbull I had come to show samples of my work, had curtly refused to let me so much as untie my bundle of sketches. Finally I came to terms with the Barbazange Galleries in the Rue Faubourg-St. Honors, one of the well-known art galleries in Paris.

IT LOOKED as if the heavens were beginning to smile upon me and the road to success was open, when suddenly, without any previous warning, I received a disconsolate letter from Cleveland, urging me to come home at once if I wished to see my dear mother again. My sister Ethel, who had been on a visit to me some months previous, had told me that our mother was somewhat ailing, but neither she nor any other member of my family had revealed the fact that the illness had been a serious one. By a fortunate coincidence, my brother Alex had sailed a few days previously for America and was on his way home.

The afternoon I had received the letter I booked passage on the *Aquitania*, sailing the following day. It was a fast boat, and I arrived in New York a day ahead of the slow steamer on which Alex had embarked.

Feeble little Mother, reduced to a shadow of herself, had with indomitable will power garnered her remaining strength to await her sons' arrival. It seemed as if our arrival had revived her strength and given her a new lease on life. For a while she seemed to improve steadily, and we who adored her began to have hopes that she might recover. Her happiness to have us with her once more was so moving that I assured her I would never leave her again—and meant it. What were success and ambition compared with this all-transcending mother-love? But for all her indomitable spirit, her poor, frail body had been worn out with sickness and a life of toil and struggle to bring up her nine children. She had a relapse, and in despair we watched her slowly passing away. To her last lucid moments, her thoughts were of her children. How she would worry if I were not clad sufficiently warm or were caught in the rain! To her I was still the little boy, unprepared to face a hard world against which I had been fighting for the last twenty years.

Though I knew the end was inevitable, when it came the shock of it left me numb. Thoughts before of her departure had filled me with agony, but the actual happening found me frozen. To this day I find reason for self-detestation when I recall how the inexorable eye of the painter was noting the expressions and attitudes of my grief-stricken family. My subconscious would do this as on an invisible canvas.

The drama of Death had been enacted among us. How could we ever eat or drink again? The very thought was repugnant. Yet when kind neighbors later prepared a meal for us, we ate and drank, and I noticed with shame the satisfaction my palate took in various delicacies.

Poor Dad, however, refused to touch food for several days. His sturdy self had suddenly shriveled, leaving him withered and bent. His beloved companion in the brave battle they had fought together had left him. Yet he was blessed in his firm belief that he was destined to join her some day in a happier world.

The night before Mother was taken away, weary with grief, I fell asleep. In a dream, which was more like a vision, I saw Mother, young and beautiful as I had known her in my boyhood, standing on a shining beach, her lovely face illuminated with sunshine, while it seemed that I was at my easel painting her, and several times I heard her say: "Sonny dear, I am so happy, so happy!"

I have never been a believer in any particular creed, nor have I gone in for superstitions and mystic cults. Yet, on awakening next morning, I felt that some great divine truth, hitherto hidden, had been revealed to me. When I told Dad of my dream, his gray, sorrow-lined face lit up. Placing his hands on my head, with a voice that trembled, and with all the fervor of a great and simple faith, he gave me his blessing.

Since my homecoming, I had hardly touched a brush. The illness and suffering of my mother had banished all desire to paint. Some weeks after my return, a number of my recent canvases arrived from Paris, and an exhibit of these works was held at the New Anderson Galleries in New York, then the most spacious in the city. This show of sixty canvases was the most important I had held and, in many ways, the most successful. The public was led to believe I had "arrived."

At any other time, this result would have made me very happy, but in my present state of dejection nothing seemed to matter. Finally even my family urged me to go away, as my remaining could no longer help matters at home.

My old friend, Adrien Machefort, and his Scotch wife, had been living in Cleveland for some time, where the former was employed by a commercial art firm at a large salary. This couple, who had been saving to get away for a long visit to the island of Majorca, where Machefort intended to resume painting, persuaded me to join them. I promised to think it over. It was something to keep in mind for the coming winter, when I had had enough of France. But for the moment it was there, to my second homeland, that I was drawn.

THE BEAUTY of France is so comprehensive and changing that only a few hours journeying bring marked differences in costume, climate, and topography. My friend Forrest Wilson and his family were spending the summer at Annecy, and I decided to join them there for the summer season.

The charming old Savoyard town, situated in a romantic valley on the lovely lake that bears its name, has an idyllic beauty all its own, a

commingling of France, Switzerland, and Italy. The mountains, seeming to rise sheer out of the blue, still mirror of the water, have nothing of Alpine ruggedness, and yet all the vaporous tints of Italian lake scenery. But, charmed and elated as I was at so much beauty, I was never able to grasp these subjects sufficiently to transfer them to my canvas. Except for a few unambitious studies of the lake, my summer's work there was a total failure.

The fall found me once more in Venice, as delighted as ever with the "Queen of the Lagoons," despite the increasing number of noisy gasoline boats plying the canals in lieu of the graceful gondolas, which were becoming scarcer. As usual, every vantage point along the canals, piazzas, and bridges was occupied by wielders of the brush and pencil, busily sketching for the thousandth time the well-known motives. As for me, the sight of the irridescent waters, looking as if they were illuminated by a lamp from underneath, the incomparable tones of the weather-beaten palaces, and the old squares tempted me as violently as on my first visit to transfer them to canvas.

At the Hotel Gabrielli, facing the Schiavoni embankment, I found a view overlooking a lovely vista of the harbor and the San Giorgio Church. There I found as fellow boarders Maurice Mathurin, director of the Beaux Arts at Tours, and Adolf Boehm, a well-known Bohemian painter. If all roads lead to Rome, many of the bypaths find their way to Venice. The first day, when I was sketching near the Bridge of Sighs, I was hailed by a shout of "Hello, Buck!" To my great surprise I saw Louis Schroeder, a famous athletic instructor, who had been delegated by the French government to train their athletes for the Olympic Games of 1920. In the afternoon I was accosted by three other acquaintances, two Americans, and my old friend, Dino Centanini, of the Ile-aux-Moines, who had come on his annual visit to his family, which owns one of the old patrician *palazzi*.

Fascism, in its earlier and most disagreeable form, had invaded Venice, and the characteristic politeness of former days had given way to aggressive xenophobia. Several unpleasant experiences with the black-shirted gentry marred this visit, and I was not sorry when the September rains put an end to my outdoor sketching so that I could once again leave for France.

Machefort and his wife had written enthusiastically about the charms of Majorca, where they were passing the winter, and urged me to join them. An added argument were the splendid paintings of the island by the Spaniard, Anglada, which I had recently seen on exhibition. Before winter set in I was off once more on my travels.

A long day and night trip brought me to Barcelona, where I embarked on a tiny steamer for Palma de Majorca.

To escape as long as possible the hot, stuffy atmosphere of my cabin, I decided to remain on deck until I was ready to turn in. About one A.M. I descended for my berth. But, alas, I could not remember the number of my cabin. After groping and searching, I finally found what I took to be my rightful habitat. The upper berth was occupied by what

appeared in the dim light to be an ecclesiastic. As we were to land very early, I lay down fully dressed in my bunk. About five in the morning, the noise on deck roused me and I realized we were coming into harbor. Fortunately, I was the first to rise, for as I got out of bed I discovered to my dismay that my night's companion was a woman, and not a priest. What a scandal if we had been detected together on that Spanish boat!

Machefort piloted me through the harbor and old town, whose interest far surpassed my expectations. In 1924 the island, except for a few English and Americans, had not been exploited by the tourist agencies and the foreign population was a very small one. Never had I found a kinder, more generous people than those happy islanders.

On the outskirts of Palma, in the little village of El Tereno, the Macheforts had found a lovely villa for me. The terraces, overlooking the Mediterranean, afforded a beautiful view of Palma. All about there was an atmosphere of calm and serenity, such as I had never before enjoyed. Except for the mosquitoes which pestered me after dark, I felt I had at last found perfection on earth. The island seemed to breathe forth perfumes of orange blossoms and a myriad, exquisite flora; the only disagreeable odor I encountered being the smell of rancid olive oil in the village streets. On New Year's Day the sun was so warm that I painted out of doors in my shirt sleeves. But after sundown the air grew chilly and sharp, and it was necessary for nonnatives to keep a fire going. The hardy islanders seemed content with a large brazier containing a small quantity of smouldering charcoal by way of heating their spacious living rooms.

Our little American colony, consisting of Alex Bower Schofield, the well-known marine painter, Ronald Hargrave, and Conrad Albrizio, both talented artists from New Orleans, were soon joined by our friends, Bertha and Jack Casey. Jack, who had stuck to his commercial art work in New York, had found prosperity and decided on a season in Europe to resume his painting.

The weather remained perfect until March, 1925 when torrential spring rains set in abruptly. At Soller, where I was spending a few weeks, the generally dry stream-bed was converted to a turbulent torrent, which overflowed the high embankments and inundated a great part of the town. The lower room, where I stored my canvases, I suddenly found full of water and my pictures floating about. A cyclone also caused much havoc. As usual, the oldest inhabitants could remember nothing comparable for the last seventy years. Such phenomena, I find, happen more frequently than most people care to remember.

These, however, were minor worries. The sunshine soon returned to bless us, changing the colors of the mountains into tints of glory. Not even the shores of the Riviera could compare in beauty with the infinite variety of blue, purple, and emerald seen from the steep, rocky coast of Majorca.

THAT SUMMER, 1926, in company of Joseph Kleitsch, the California painter, and Leon and Natalie Gordon, I revisited Vernon, where, except

for a fleeting visit, I had not stayed for fifteen years. Despite its propinquity to Paris—less than fifty miles—hardly anything had changed in this quiet Norman town. True, the old Hôtel Soleil d'Or had had its facade repainted and its charming name replaced by the more up-to-date title, Normandie Plaisance; a motor car had taken the place of the old hotel coach with its fat *percherons*, and running water was now to be found in all the guest rooms. But the amiable Madame Espagnon was still installed behind her counter, and the kindly *Patron*, grown a little grayer, was there to greet us with his former hospitality. Even my old room with the well-remembered view of towers and landscape greeted me unchanged, with a familiarity that was almost a pang. How much had taken place since I had sketched from those windows! Youth had fled with illusions and hopes which would charm me no more. But for all these changes within and without me, I felt, as I drank in the beauties from my window, that my enthusiasm to paint was as keen as it had been when I had my first glimpse of these lovely scenes.

But, alas, it was no longer possible to work by the roadside as in former times on account of the steady flow of motor traffic, which sent clouds of dust and sprinkled gravel over the easel. But the riverbanks and hillsides still offered many quiet nooks where one could work undisturbed.

Giverny, across the river, had undergone considerable changes. It had been rediscovered by a new group of Americans, very different from the old crowd, who had come there to work. To cater to these pleasure-seekers, and their weekend parties, several swagger hotels had been erected.

Fortunately, Vernon still retained its old atmosphere of simplicity and tranquility, and my friends were as charmed with it as I had hoped they would be. Kleitsch declared that Vernon resembled his native town in Rumania, which he had left in his early teens when setting out for America. Joe was the most astonishing mixture of ingenuousness and cunning I had ever met. His attempts at French were terrifying, yet in some mysterious fashion he managed to convey his every wish to the hotel personnel, though they spoke not a word of English. He was a competent and thorough artist, and while at Vernon painted many fine canvases imbued with poetical feeling.

Leon Gordon was one of the pleiad of brilliant commercial artists who in conjunction with Edward Penfield and Armand—both under the direction of William Jean Beauley, the architect, himself a gifted watercolorist—had helped to revolutionize commercial art in America, and greatly raised its artistic standard. For some years past Gordon had abandoned his highly paid special line for the more precarious career of portrait painter, in which he was rapidly making headway. He had painted various celebrities and well-known people. At intervals he had come to Europe, visiting Spain and Italy, where he studied the Old Masters. He was now painting outdoor scenes in the hope of keying up his palette.

Amongst others in our little colony at Vernon that season were

Ethlyn Middleton, correspondent of the *New York World*, and Sam Chamberlain, the etcher, who was at work then on a well-known series of old Norman farms and chateaus.

During a brief stay in America brother Alex had acquired a charming and talented young wife, well known in the style and commercial art world for her original and striking drawings of children. With my younger brother, David, they had come to join me for a period over the hot spell. To David, with his practical American slant on things it seemed preposterous that so much time could be wasted on outlandish *char à bancs* and trains for the daily excursions which we had planned to quaint villages and picturesque sights of historic interest. Hired taxis and cars proved themselves altogether too expensive, so David ended up by selling us the idea of buying a car. As an additional incentive he offered a generous share towards the proposed purchase, suggesting only that we make a motor trip through Brittany. For years he had heard our comments on the beauty of that country and seen the studies we had painted there. The upshot of it all was that some weeks later the trio returned from Paris with an eight-horsepower Mathis.

As main objective we made for Treboul, a tiny fishing village within two kilometers of Douarnanez. From this center we could make daily visits to the colorful spots of this primitive land which David had hitherto seen only in our canvases.

David and Alex did the driving. By special favor, and with much coaxing, I was allowed to drive the car when the road was clear, and we were secure from the traffic of the cities. The amount of criticism and advice to which I was subjected by my brothers was sufficient to have made a Barney Oldfield of me. My slightest deviation from the rules and code of the route elicited such harsh remarks that finally I observed many expert autoists and truck drivers were perhaps no more intelligent than I, and that, if they exercised a little patience I, too, might learn to drive. My sarcasm, however, had little effect on their fraternal minds, and I was, perforce, obliged to retired to the back of the car with my sister-in-law, Bertie.

In passing through some of the quaint villages David, to whom all this was new, would break forth in enthusiastic exclamations of praise. Invariably, however, Alex would say, "Just wait, this is nothing." And until the very end of the trip he kept David in a constant state of expectancy for ever greater wonders and scenic marvels.

The tiny hotel at Treboul, overlooking the Bay of Douarnenez, housed us only for the evening. Up at early dawn we took a chill dip in the water, followed by a hasty breakfast, then off in our eight "dog-powered" car, as David called it, on one of our innumerable excursions.

The nearby town of Douarnenez offered us moments of colorful delight, marred, perhaps, by the inevitable smells native to the fishing industry.

Eventually came word from old painter friends that we must come down to Concarneau. They had penned glowing pictures of its picture possibilities. Accordingly, this became the next battleground for my

brush and palette.

A first sight of Concarneau, if favored with the late afternoon light, is unique and startling in its beauty. The tunny fleet at harbor, a forest of masts gilded by the sun, with multicolored sails and gaily painted hulks, lines the moss-grown quays. The near vision of medieval walls and towers of the ancient town, and the populace of sailors clad in faded red and blue canvas, interspersed with the Breton womenfolk in sober black, relieved only by the white accents of their coiffes, is picturesque and colorful. One can well understand why this Breton port has long been a mecca for artists from every land and clime.

As at Martigues, all available space lining the waterfront and the overlooking windows were peopled by enthusiastic wielders of the brush. Sailors and fisherfolk jostled in and out at their various duties, but never interfered with or annoyed by their curiosity the painters who were as traditional to the port and as much a part of Concarneau as the fishermen themselves.

For decades the Hôtel des Voyageurs had been a favorite residence for American painters during their stay there. Charles Fromuth, Alexander Harrison, "Shorty" Lasar, and Lionel Walden stayed there in the olden days; and now the terrace for the evening aperitif found Cameron Burnside, Jerome Blum, Charles Basing, Sig Skow, and many others I had frequently seen at the Dôme. Though claiming New York as his residence, Sigurd Skow had been coming to Concarneau every summer for perhaps fifteen years with classes of American art students. The sight of boats and the smell of salt water awakened within him the old ancestral Viking blood. His English retained a strong Norwegian accent which betrayed his Scandinavian birth. The studio he had acquired in the outskirts of the town was furnished in fine taste with old Breton furniture which he had from time to time discovered while rummaging through various parts of Brittany; and his collection of ship models must have proved of value to one who employed the arts of a marine painter. He had planned on giving up his American residence altogether and spending his remaining days here. Unfortunately, he met with a tragic end before he could realize his dreams.

At night the cafés were literally jammed with the sailors, starved for the lights, the amusements, and the questionable gaieties of the port after weeks, perhaps months, at sea in their boats. Closing time found them reeling and zigzagging in their clattering sabots through the streets, and it became a mystery of ever-increasing proportions to me how they returned safely to their ships without falling overboard and being drowned.

One of the most popular resorts along the quays was owned by plump and comfortable Madame Eveno and her more than rotund partner in connubial bliss, Louis. Their wharfside café, close by the Hôtel des Voyageurs, was very popular with the younger American art students, many of whom boarded there. Though the rooms were primitive and not too clean, the food was excellent and prices correspondingly low. Many of the boys stayed on even though their funds ran out, but Madame Eveno

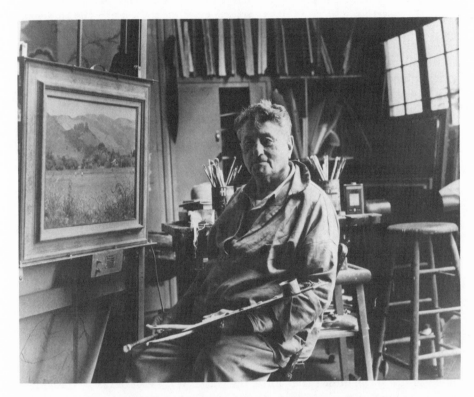

Abel Warshawsky in his California studio.

would extend them credit, relying on their honesty to send their payments after they had returned to America.

There are no idlers in Concarneau. While the men are at sea fishing, the women are busily employed in the huge canning factories. Here sardines and tunny fish are prepared for a world market. The smells attending from the factories and nearby quays, especially the latter, when the tide was out, made me think of the more southerly and perfumed water of Martigues. Alexander Harrison had renamed Concarneau, rebaptizing it for its pervasive odors, "Sarineopolis." On a first visit there with me Monte Glass took an evening walk when the tide was far out. I advised him to bravely take three deep breaths and, if he survived the inhalations, he could consider himself inoculated and find himself forever immune from the perfumed airs of Concarneau. It is surprising how quickly one may become habituated and overcome prejudices in a like case.

When the fishing haul was good it seemed that the entire female population would be mobilized at the canning factories. Despite the hard labor their pay was ridiculously low, but outside of knitting there seemed to be no other employment available.

Often it was my good fortune to successfully persuade some of the elderly dames to pose for me. La Vieille Quittic, known, it seems, to generations of artists, frequently sat for me. Her face, full of humor and intelligence, resembled the mask of Voltaire. While posing she would comment on the different current events, and retell the gossip and scandal of the village. A portrait which I did of her was reproduced on the cover of the August number of the *Literary Digest* of 1930. When she received a copy of this number from me her face lit up with pride at the thought that her protrait had been chosen and printed in colors on the cover of a magazine. The cottage wherein she lived with her old, worthless husband and a parrot was unlike most of the Breton habitations. Though bare and primitive it was scrupulously clean. Within this cottage of only one room her sailing sons, in between cruises, would often find hospitality in the bunks that lined the walls. With a patience and loyalty nothing short of sublime this sturdy old Breton peasant woman would wait upon her husband and sons, no matter what their condition, whether sullenly sober or hopelessly drunk, often putting them to bed late at night after some ungodly carouse. It was her constant boast that her sons never struck her, even when intoxicated; yet I found her on one occasion with a black and bruised eye. "It was nothing," she said. Her husband, after an unusually prolonged drinking bout, had found some slight fault with her cooking and had punished her. This sort of treatment, although the Breton as a rule is a kindly person, is often accorded their womenfolk, and reflects a custom not altogether condemned.

WITH THE RETURN to America of Alex, Berthe, and Dave, the little car came into my possession.

Thereafter I wandered the highways and byways of Europe, most often in the congenial company of fellow craftsmen. On one occasion,

however, during a trip through Italy and Austria, I was accompanied by a talented pianist friend, a former pupil of Leschetitsky, Nathan Fryer. Nate insisted that I had a fine eye for music while I reciprocated his compliments by declaring that his ear was well attuned to the painter's art; for he had extolled the beauties of the Austrian Alps, and the Dolomites, assuring me I would find marvelous motifs to paint.

Ignatz Friedman, the famous Polish pianist, had a summer home in the little mountain village of Colla, and had invited us to sojourn there with him, also affirming enthusiastically that his was a painter's paradise. But, while the scenery was magnificent, it was altogether too grandiose for the artist's brush—at any rate, for mine. Disappointed in the scenery from a painter's viewpoint, I hoped at the very least to find compensation in the artistry of my brilliant musical friends. Alas, they were both on a vacation, and the only playing I came across was that done with cards, for both Ignatz and Nate spent interminable hours over the game of rummy. Sometimes of a morning I would find Ignatz at the piano, a newspaper on the rack before him, busily taking in the day's news while subconsciously his fingers ran over some difficult theme of Chopin.

The return over the Italian and Swiss mountains with all their turnings, ascents, and descents gave me the feeling of a squirrel in a cage, all the mountain scenery going to waste as it was dangerous to take one's eyes off the center of the road for even a fraction of a second.

France seemed fairer and more delicate than ever before, and the little "Escargo," as I had nicknamed my car, lost no time in making a beeline flight to Concarneau and Brittany, where once more I found myself among those who spoke my own language, and among subjects eager to be wooed. Thereafter came memorable voyages to the Midi, with damp, foggy Paris deserted for the sunny Riviera; trips across the low snow-laden mountains around Lyons; radiant sunshine at Avignon; and, best of all, the journey through central France with Lex Szabo, the merriest and most congenial grig of all. Short, squat, with powerful, slanting eyes set in a mobile Magyar countenance, Lex is an unforgettable personality. His good nature and enthusiasm were unflagging during these adventures. An early riser, he would massage my weary bones and knead my old tired flesh with skillful fingers until I felt that I had been bathed in the fountains of Ponce de Léon. A painter of potential genius, Lex had foresworn the true paths of Art for the more prosaic and better paying commercial fields. His specialty was church decoration, due perhaps to the fact that his home environment was a religious one. His father, a dear, sweet soul, a holy man in every sense of the word, was a Greek Catholic priest. Often Szabo would rise far above the heights of what was expected by his clients. In this respect I recall a commission which he had executed for a church in Cleveland. The walls and ceiling were done in lovely color, and the subject matter treated with a naiveté and beauty nothing short of startling, suggesting many of the qualities of the early Giotto or Cimabue.

Through central France and the Auvergne country, little known to

tourists, or painters for that matter, we wandered, stopping off wherever fancy led us, to sketch and admire. Hill-topped cities, now in picturesque ruins, once the rendezvous for troubadour and knight of old; lovely flowered meadows; brawling, shallow streams teeming with trout; and old bridges that might have been built by the Romans were almost commonplace sights. One evening, down through the hills, we glimpsed a vista of a wonderful medieval town set high up on a ridge, its castles and turreted towers in the ambient evening light making us feel that we were riding veritably to a courtly engagement with Good King Arthur. An old, gray bridge led to the foot of the town, and on its very edge we found a most inviting little auberge. Just as we had completed our crossing I heard a ripping sound that shook us right out of our medieval fancies, and brought us back to twentieth-century realities. A rear tire had blown out on us. But what luck! Just a few feet away was a garage, and ere long our little Mathis was snugly stored, and we found ourselves at a cheery table with a smoking tureen set before us.

ESPALION with its red granite bridge dating from the eighth century, old houses overhanging the river where one could always find a hopeful fisherman angling for an elusive trout. . . grim and primitive Najac, high up on the hills. . . on to the flat lands of Toulouse. . . Collioure, close on the Spanish border with the old fort built by the Knight Templars of the Crusades, ever wrapped in its mantel of high winds sweeping across Pyrenee Orientales. . . but, inevitably, finding myself back among the haunting and humble beauties of Armorique, my beloved Brittany.

August, 1931. An exquisite haze over the distant seas luring me on over the slippery rocks, burdened with my painting paraphernalia, to the vantage point from which I plan to make my study. Stupidly I trip, fall on the rocks, injure my knee, and experience excruciating pain. No one around to assist me, I drag myself painfully to the far-distant village where I sojourn. There the kindly village doctor diagnoses my injury as serious, insisting, if possible, that I return to Paris to be x-rayed and place myself under the care of a specialist.

On my return to Paris the professor issues the harrowing verdict that chances are I will never again be able to walk. For eight months I am unable to leave my studio, undergoing medical treatment, most of the time forced to lie on my back to ease the pain in my leg. At times this becomes so irksome that I force myself to rise and drag myself into the studio, prop myself up in a chair, and, with brush, color, and canvas, struggle to resume my work and satisfy my insatiable hunger to paint.

But I am a prisoner. No longer am I able to go out and face-to-face with nature capture its illusive and refreshing beauties first hand. At first I am a creature of despair. I feel that all is lost. And then comes blessed Imagination to my rescue. Within the four walls of my prison it reveals images and beauties hitherto hidden from my sight. I find work, ample work, at hand.

Index of Names

As the reader has no doubt learned for himself, Abel Warshawsky knew or came in contact with an enormous number of fellow artists and people connected with the world of art and letters in France in the first quarter of the century. Most of the names of those people are listed in this index, along with their dates and their profession. Some figures—Raphael, Rembrandt, and Ernest Hemingway, for example—need no introduction, of course; most of the other painters and writers have all but disappeared from history and deserve at least the modest identification that accompanies their names. In some cases it proved to be impossible for the editor to furnish even that. Another purpose of this index is to correct errors made by Warshawsky in his memoirs. Emphasis throughout has been on significant figures in the artistic community of Warshawsky's day.

232

233

234

painter and muralist, 38, 47, 76, 104